MINI LOFT BIBLE

LO MINI FT

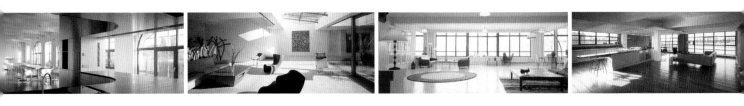

BIBLE

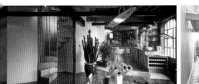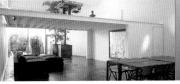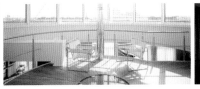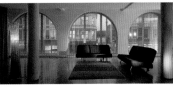

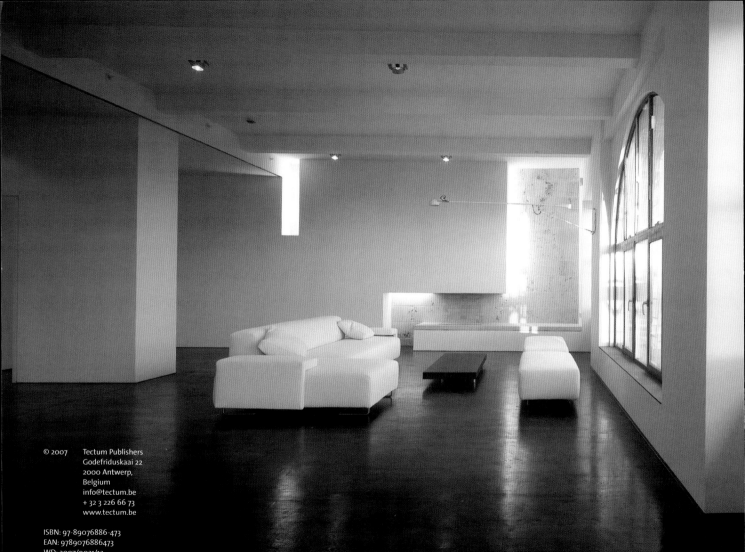

© 2007 Tectum Publishers
 Godefriduskaai 22
 2000 Antwerp,
 Belgium
 info@tectum.be
 + 32 3 226 66 73
 www.tectum.be

ISBN: 97-89076886-473
EAN: 9789076886473
WD: 2007/9021/42

PREFACE

Tectum Publishing was founded in late 1999, when it was decided first to publish a series of books on the lofts in several European cities.

Lofts usually originated as storage spaces, but Tectum took a broader definition so as to include any former industrial building that has over the years been converted into a home. So they are not only warehouses, but also factories, schools, post offices, churches and even water-towers.

As the one whose job it was to collect all the material for each one of these books, it was my great privilege to explore the selected cities in my quest for notable lofts.

On my visits I met numerous interesting people, including architects, estate agents, project developers, location scouts and loft owners, who all wished to share with me their great passion for this alternative way of living, and so familiarized step by step me with the unusual world of lofts. By now I have visited more than 600, including the world's most beautiful. It was an instructive and enriching experience.

I am often asked what makes a loft so special. It seems to me that the strength of a loft lies mainly in the fact that it is never completely finished. People evolve and are shaped by their experiences. Since the design of a loft is a reflection of the occupants' personalities, it has to be able to evolve with them. In a loft this is perfectly possible, and as a consequence they are subject to much more frequent changes than more conventional forms of dwelling.

In this book we would like to take you on a tour of a wide range of remarkable lofts. Since lofts are generally spacious, we thought it appropriate to use large pictures so that you are drawn into the interiors and can take inspiration from them.

I would like once again to thank everyone who has helped me. By now there are far too many to mention by name, but their names and faces are forever engraved in my memory.

PHILIPPE DE BAECK

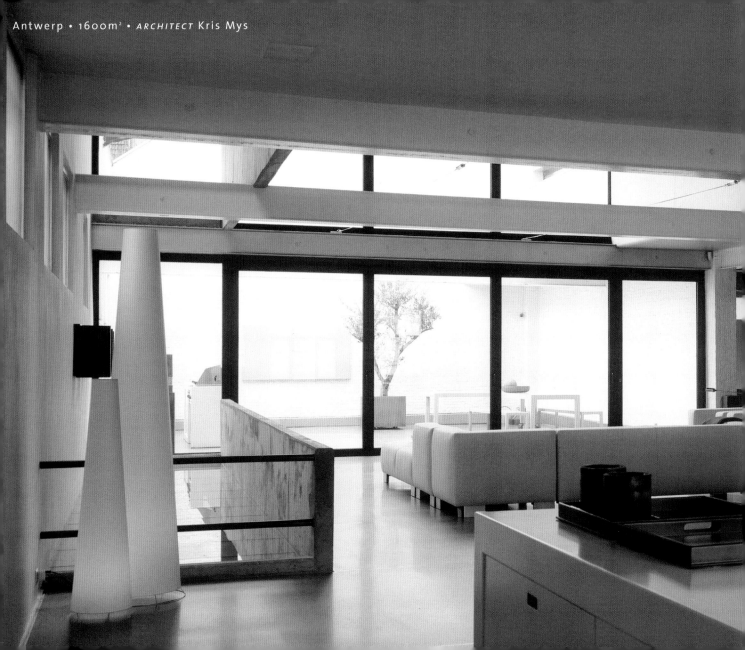

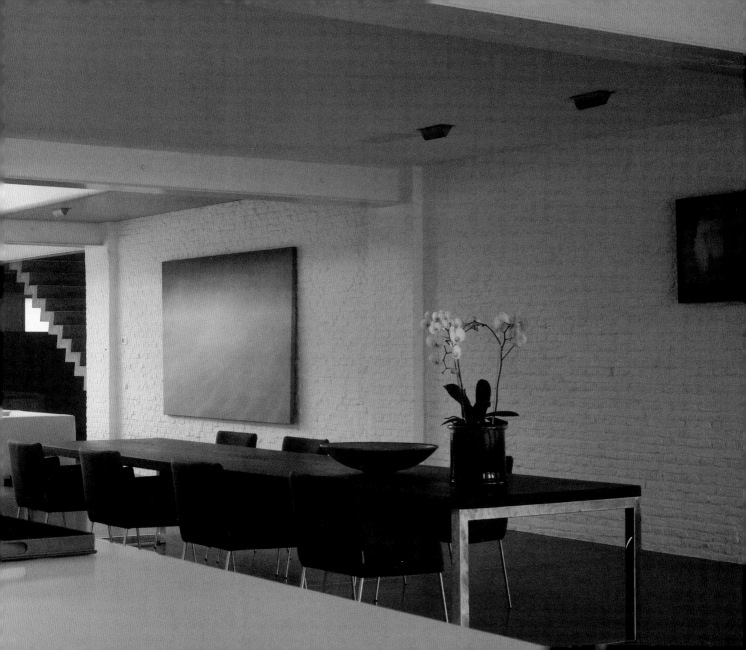

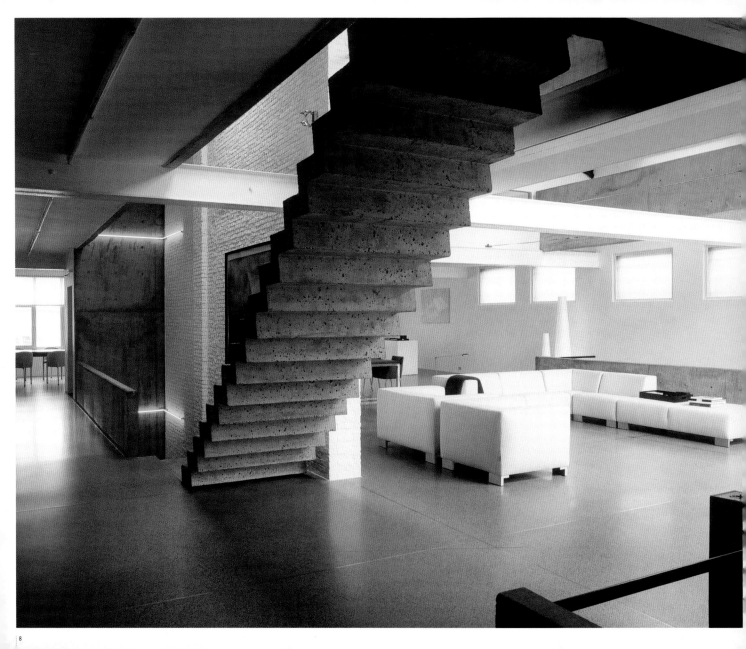

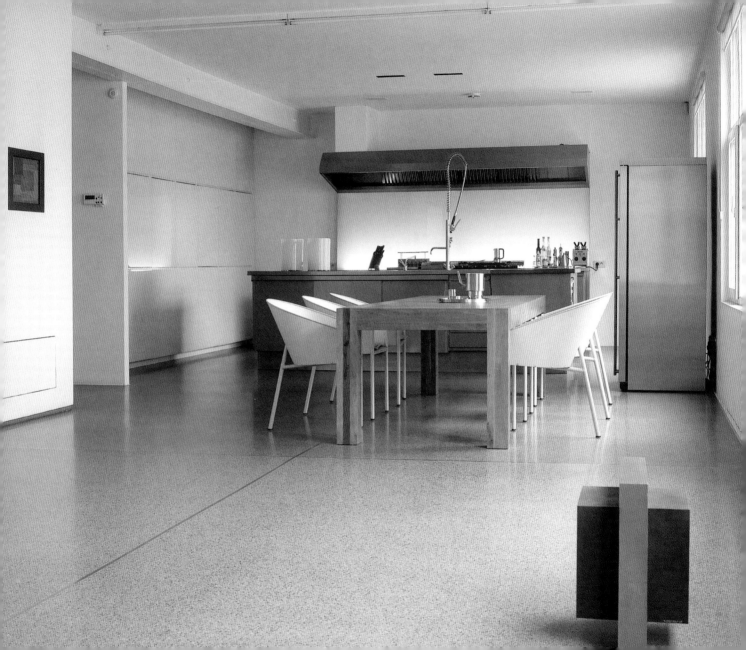

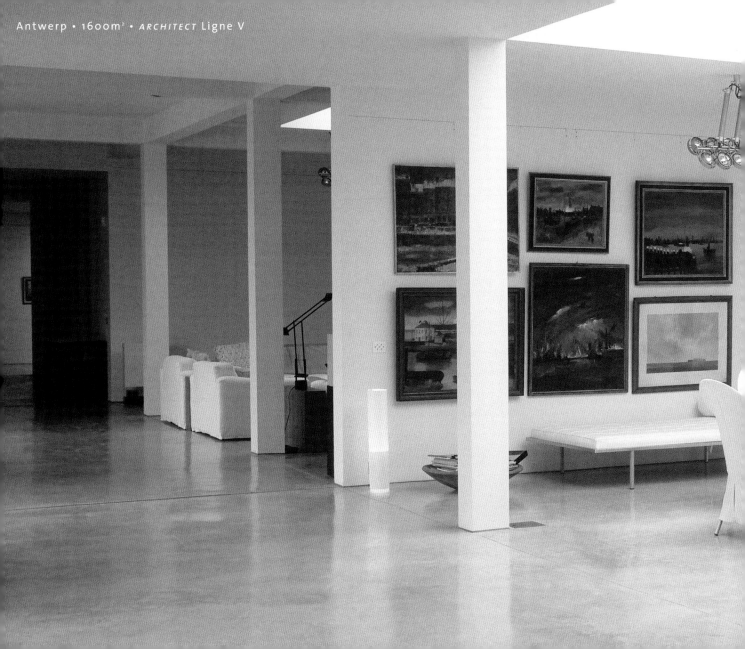

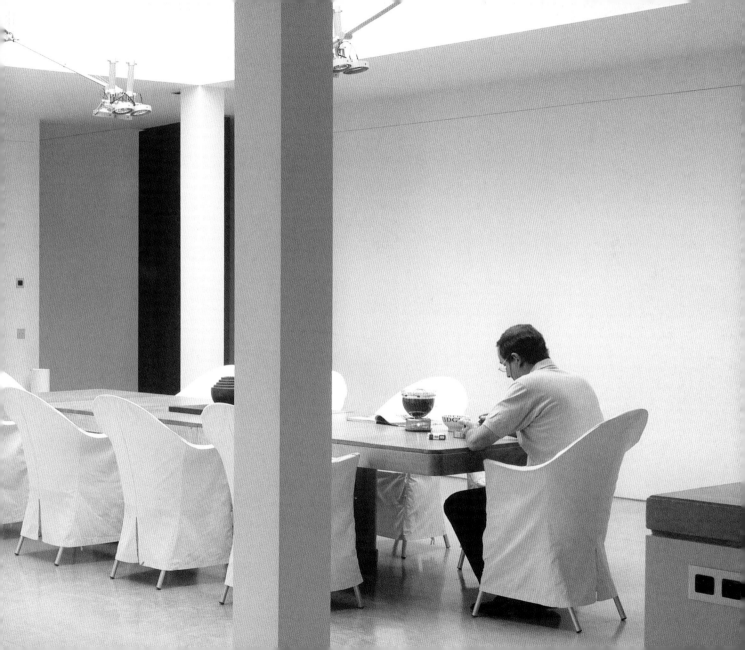

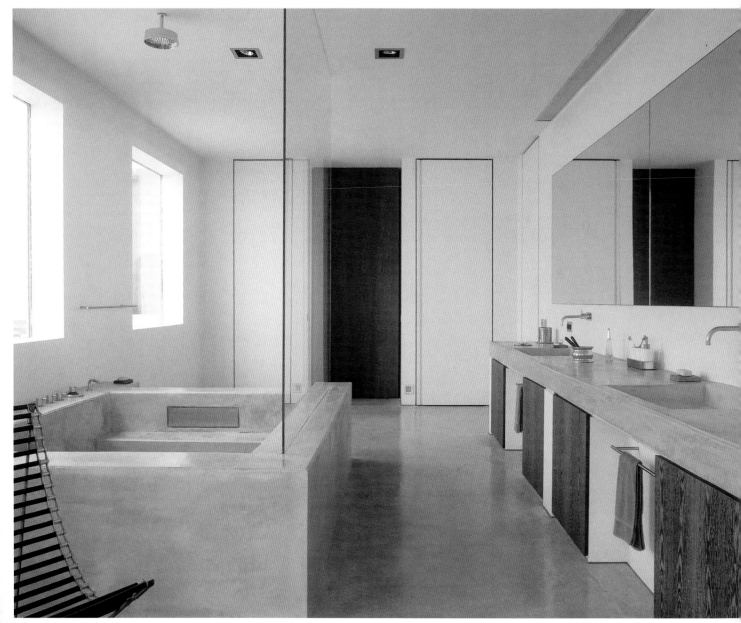

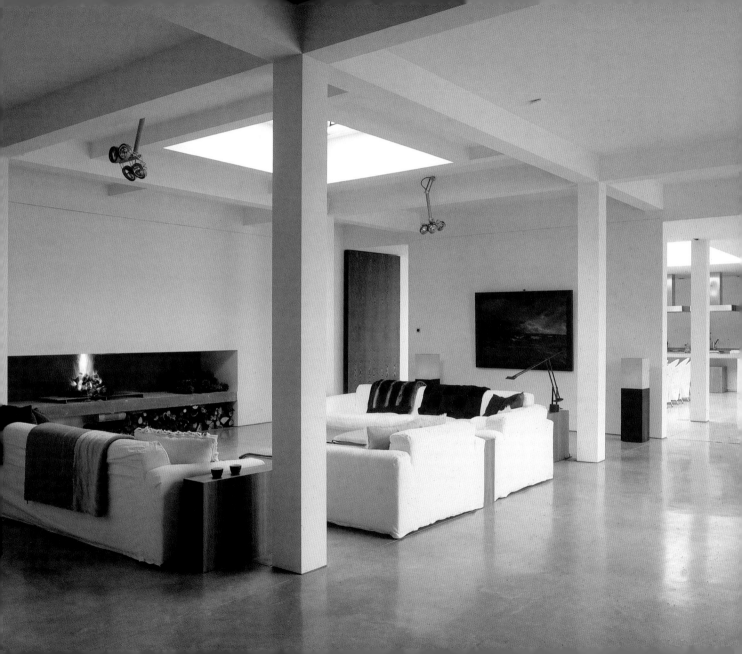

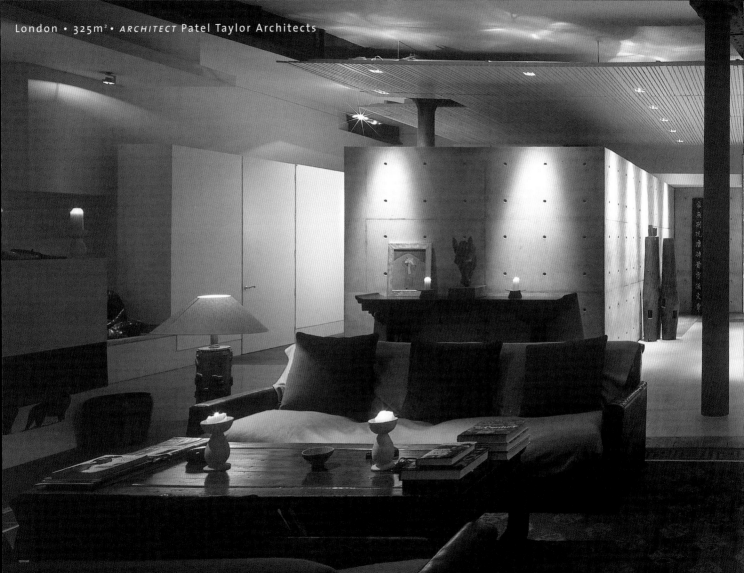

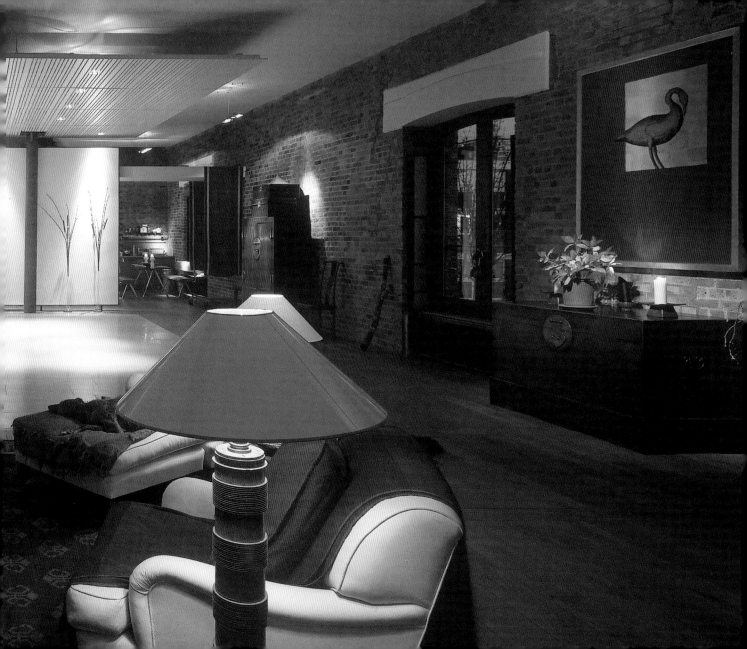

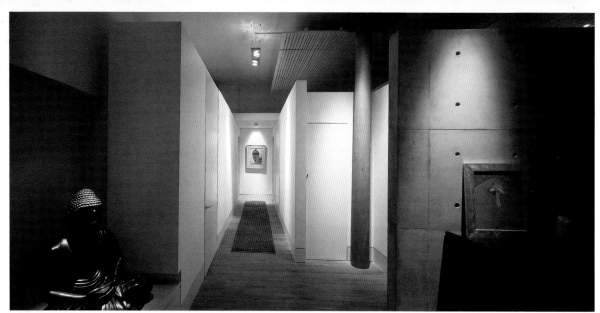

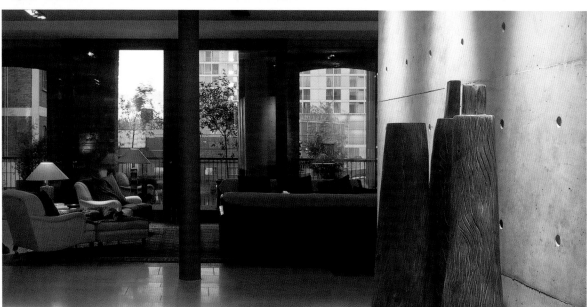

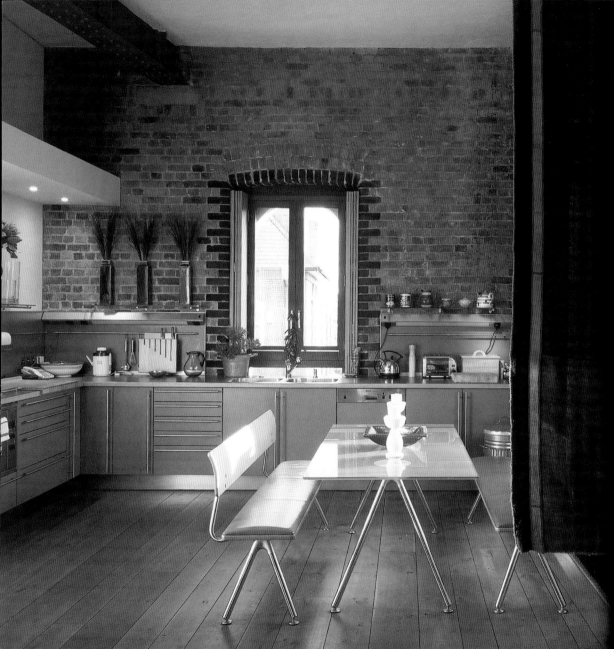

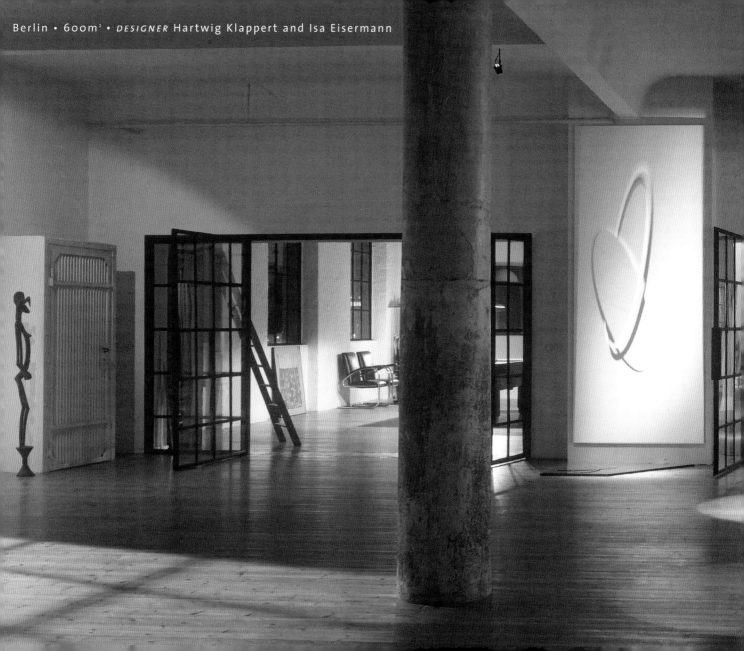

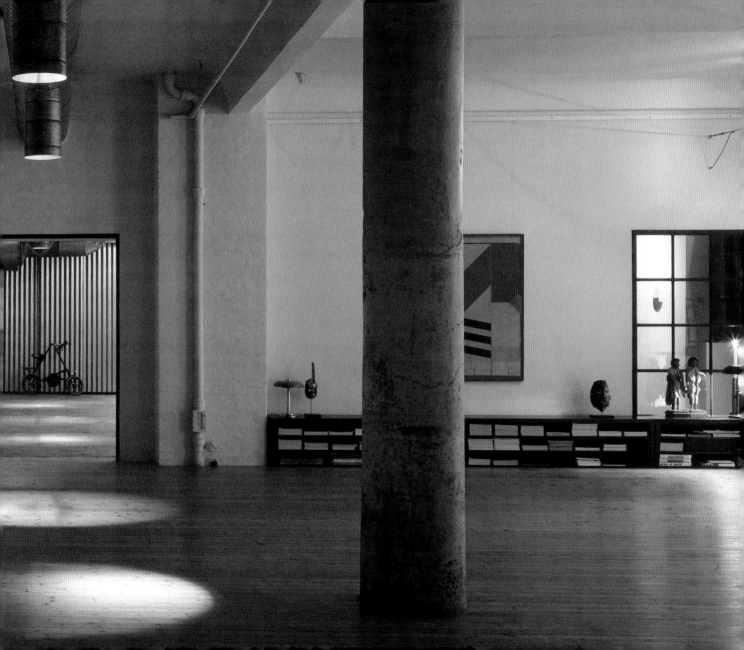

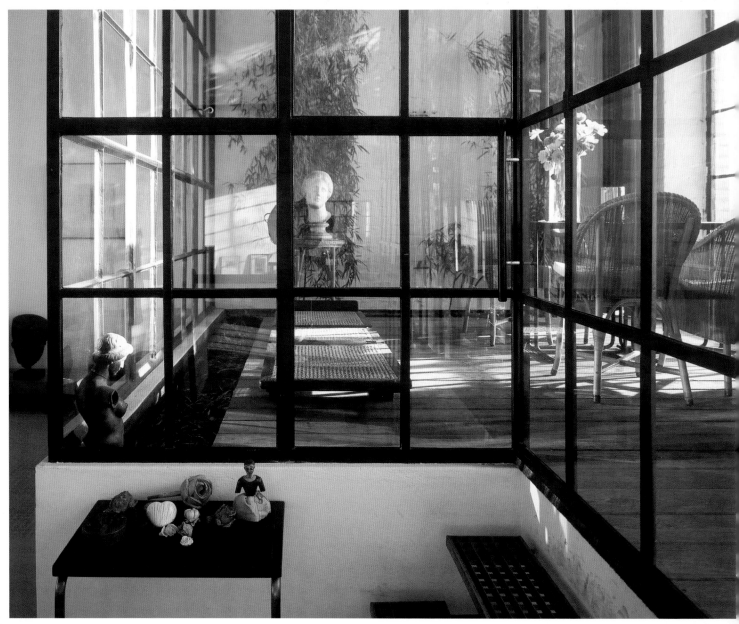

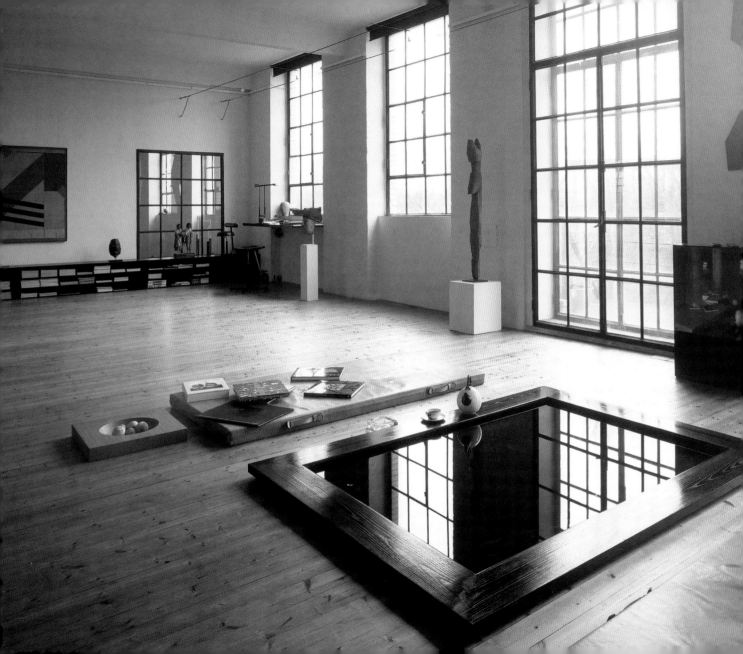

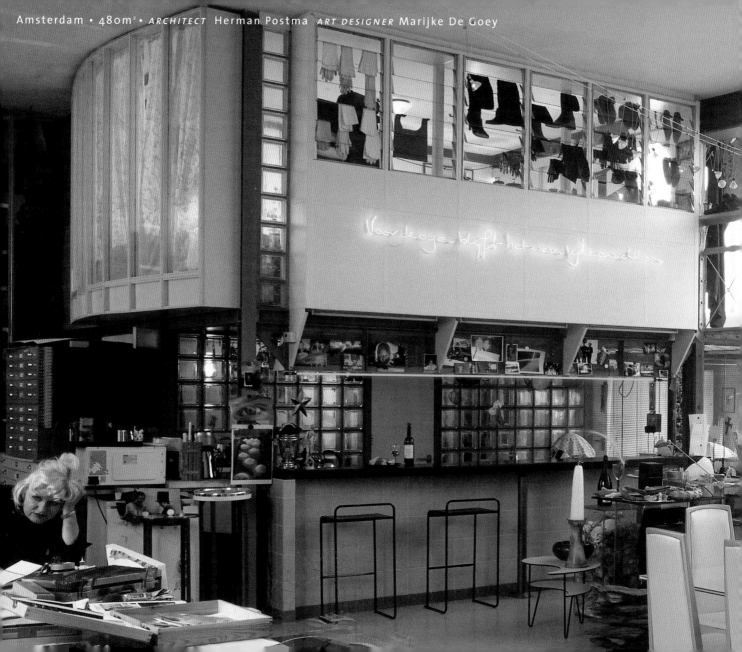

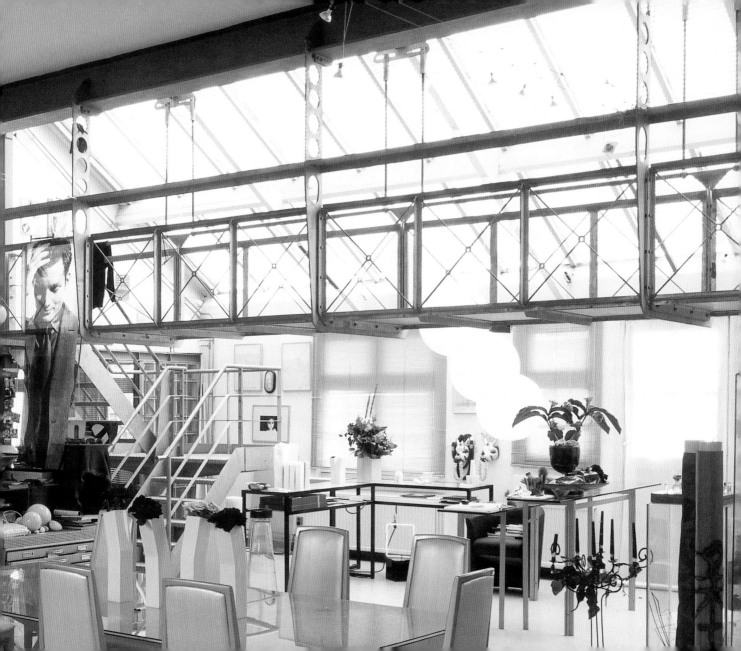

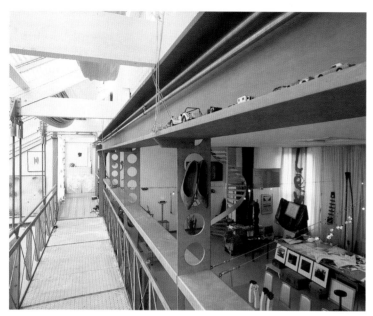
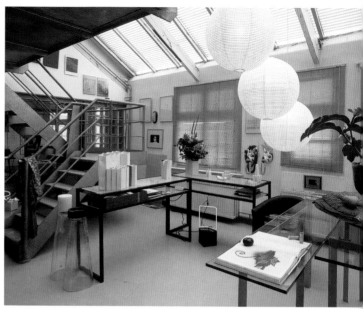
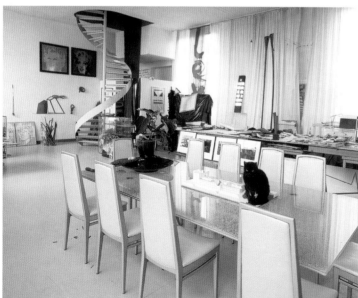
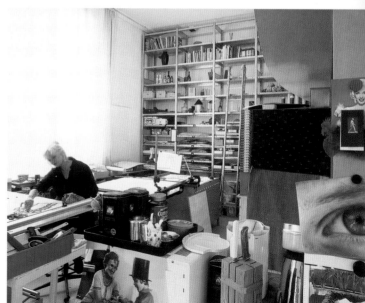

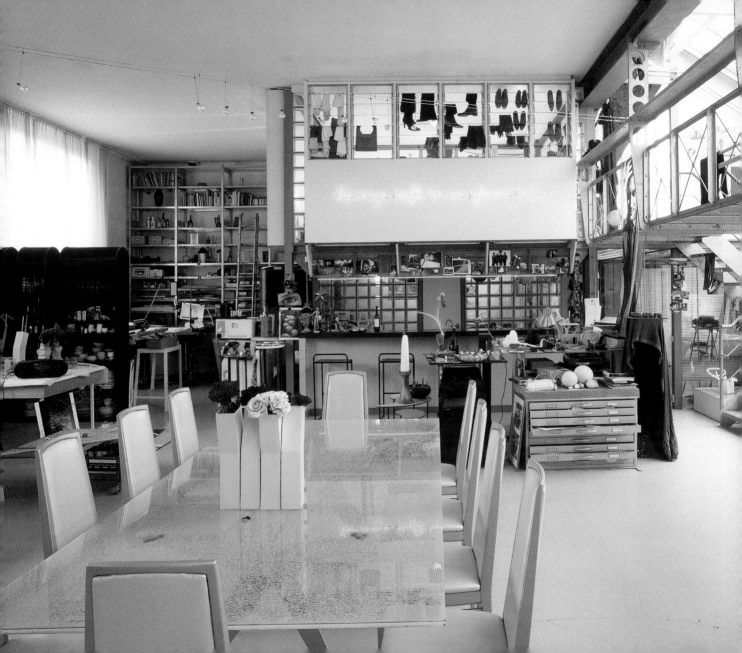

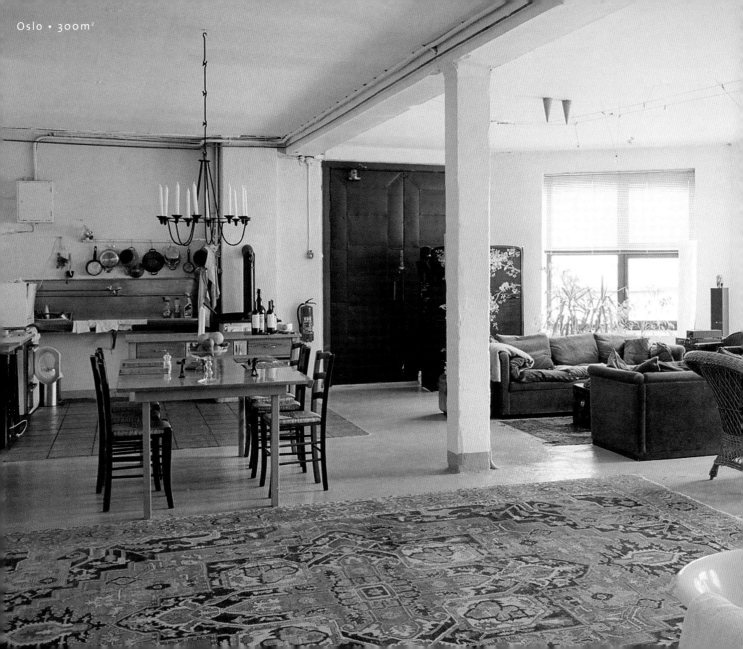

Oslo • 300m²

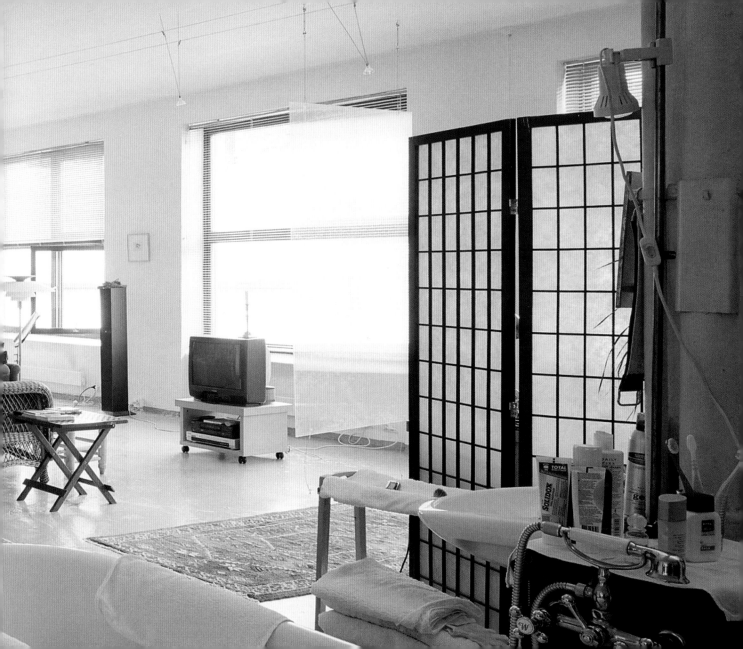

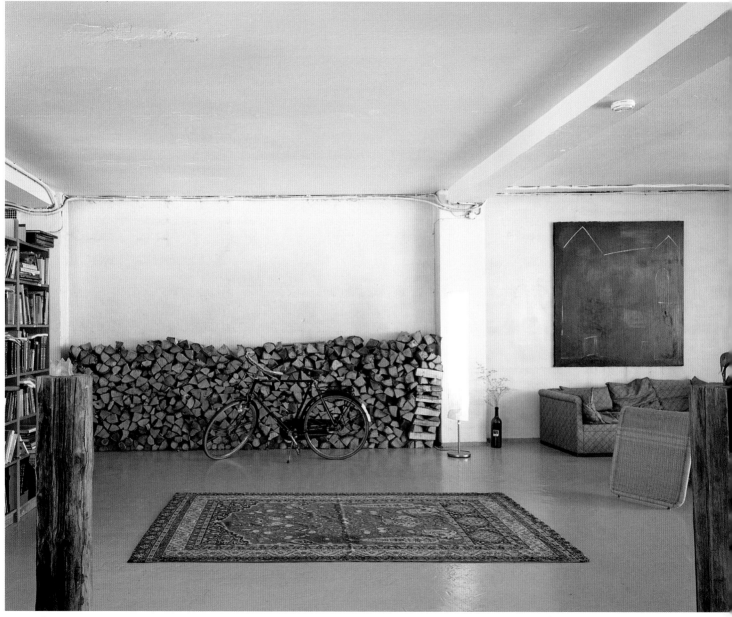

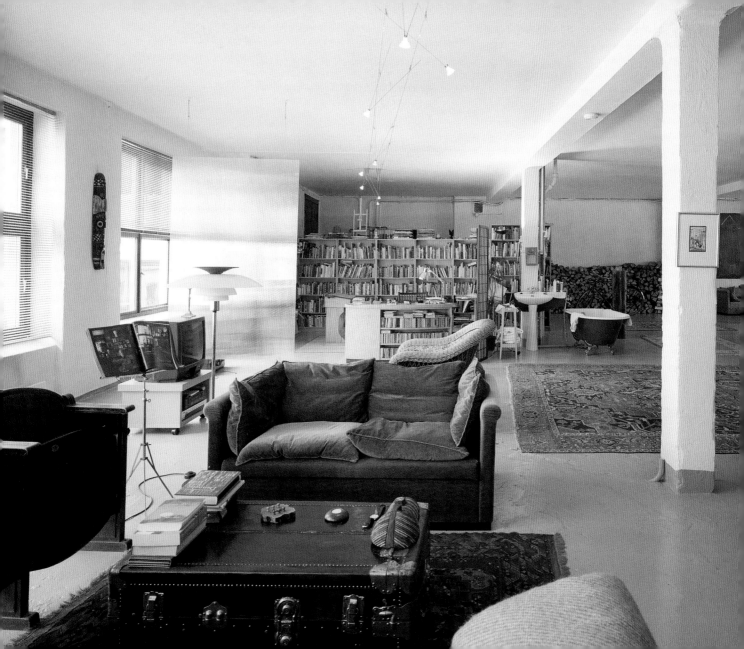

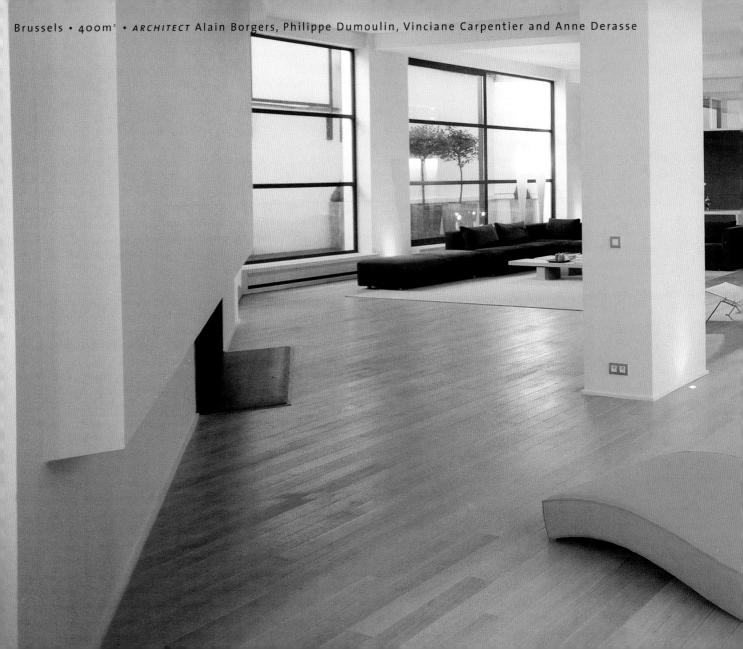

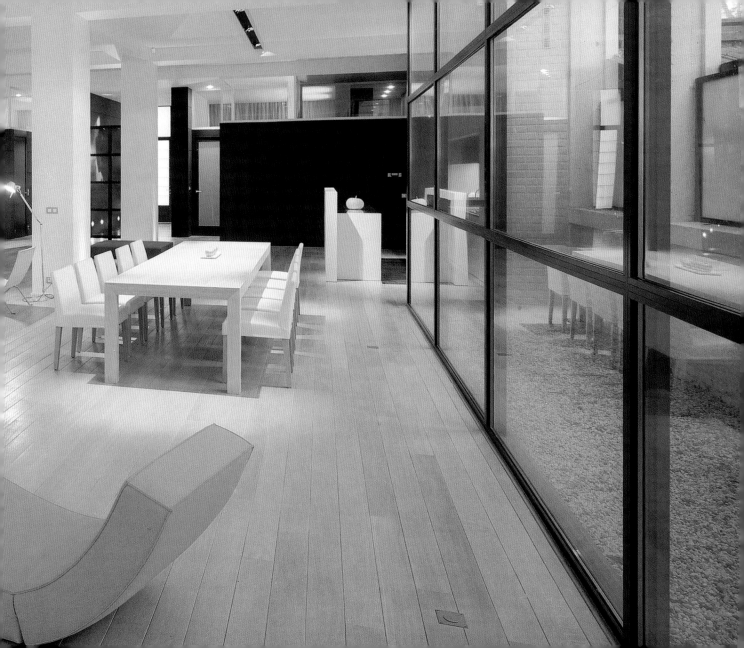

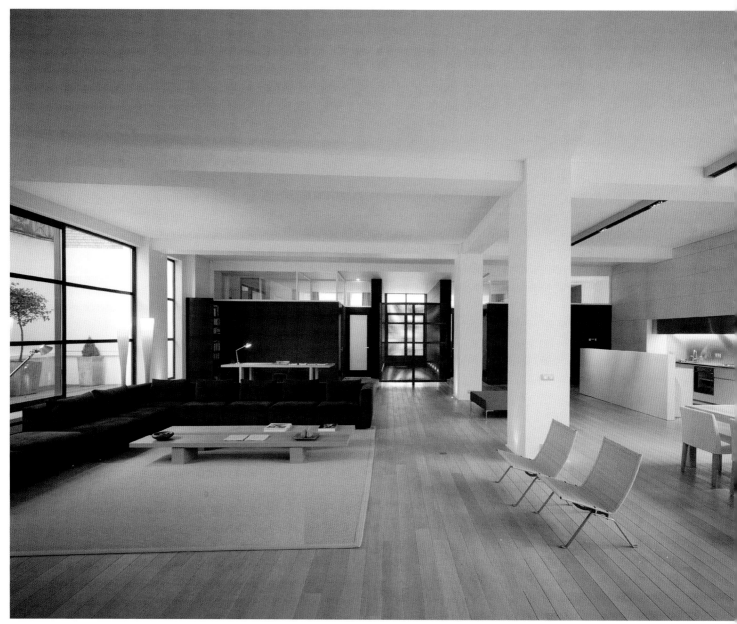

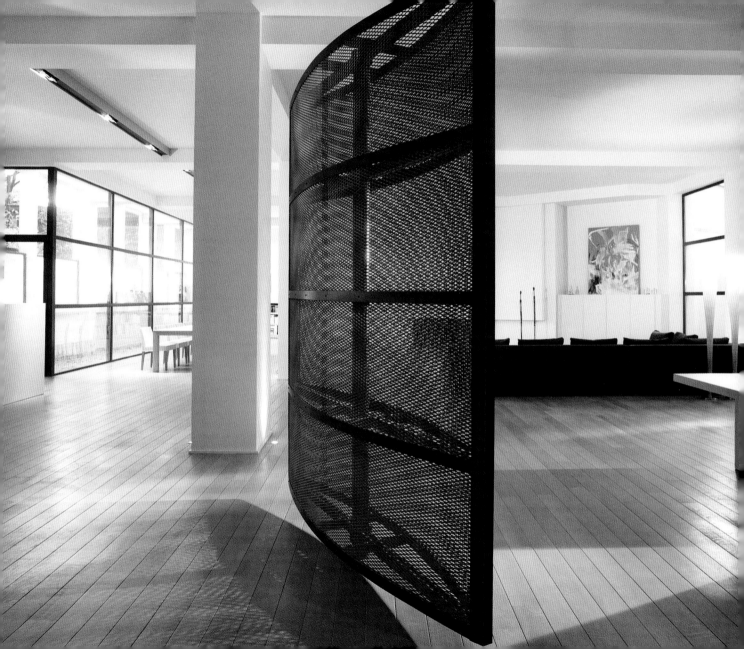

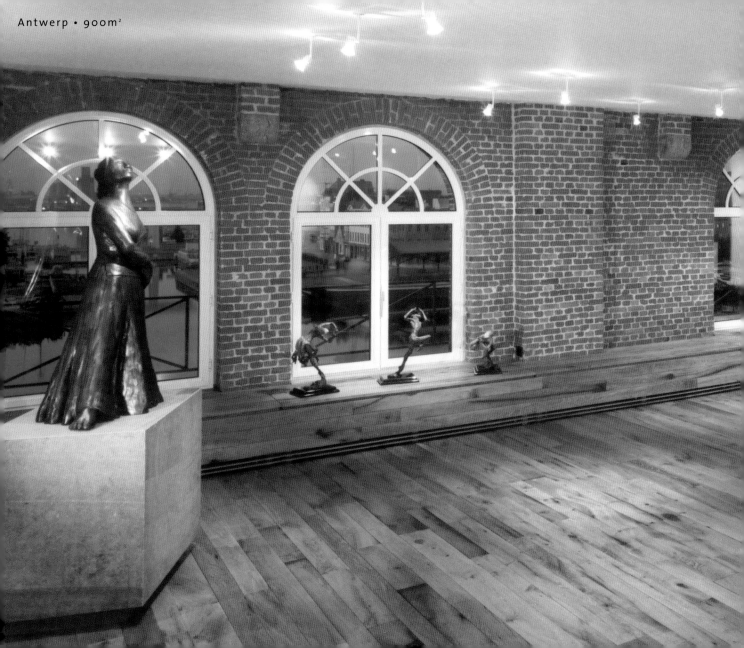

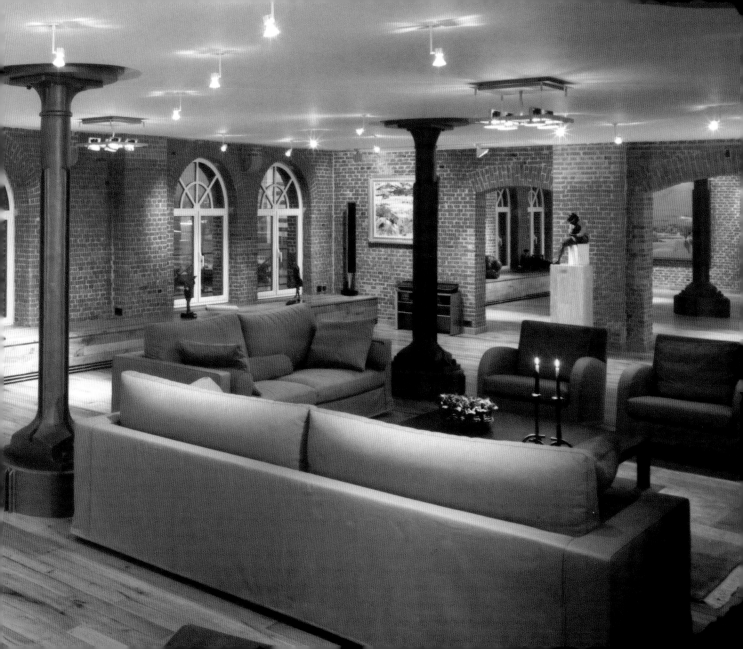

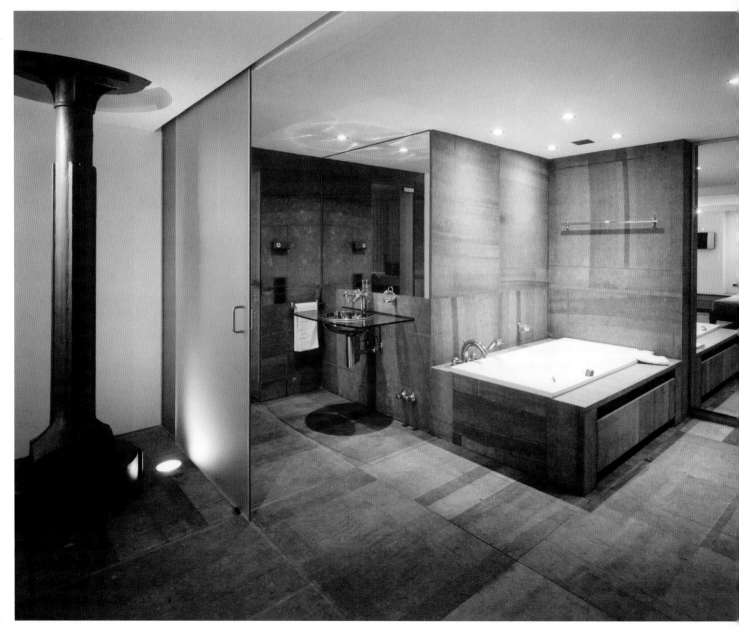

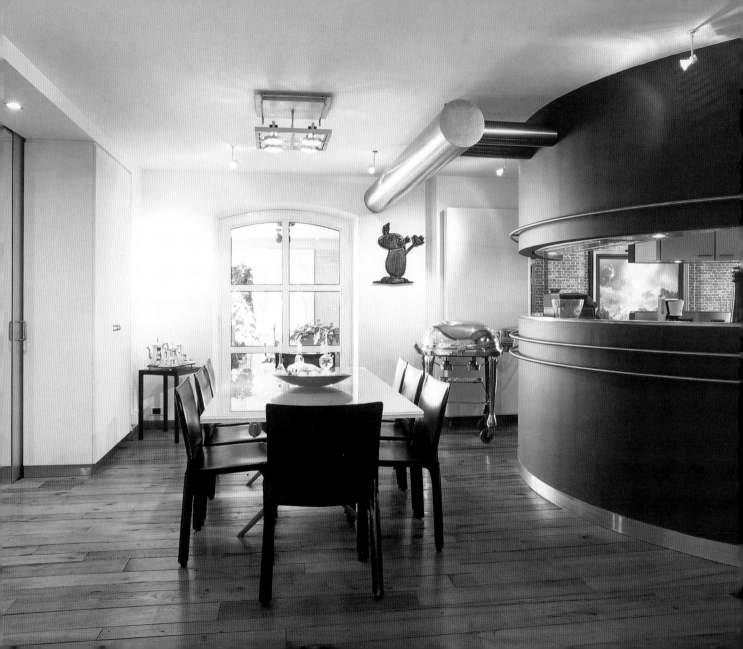

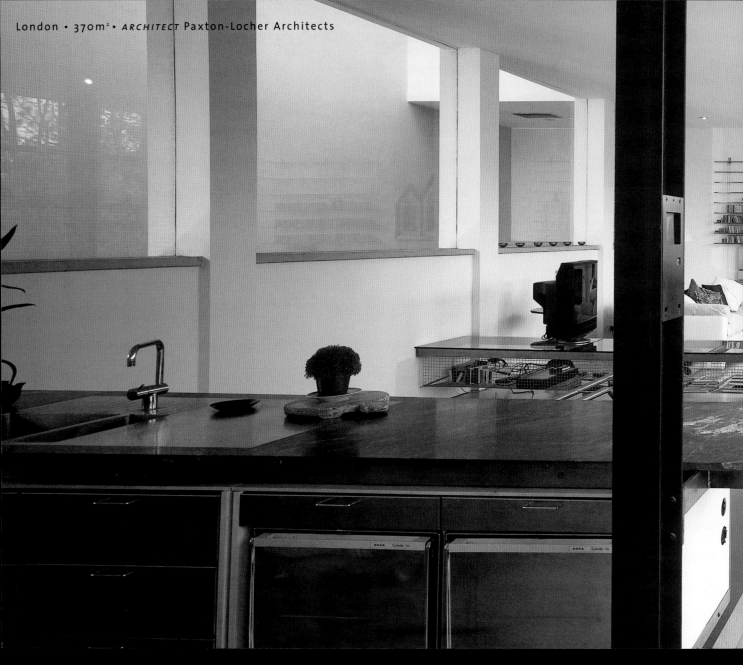

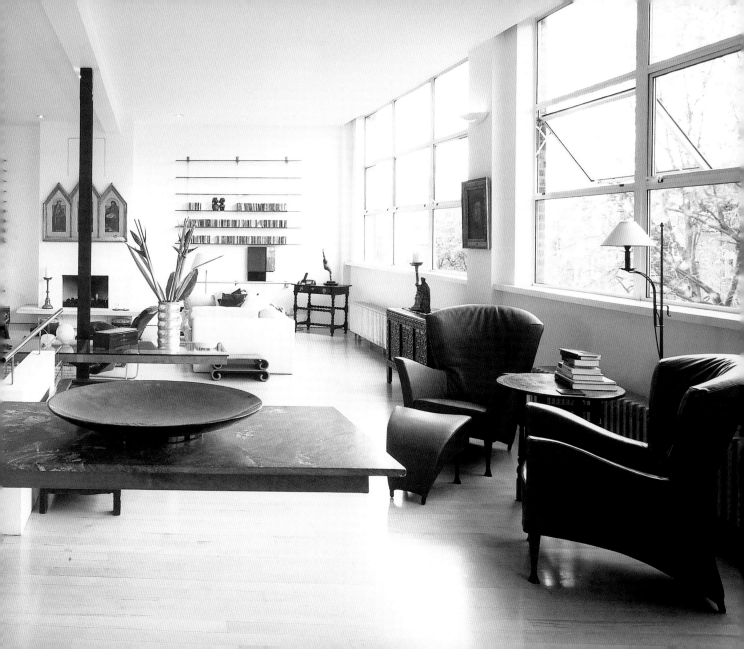

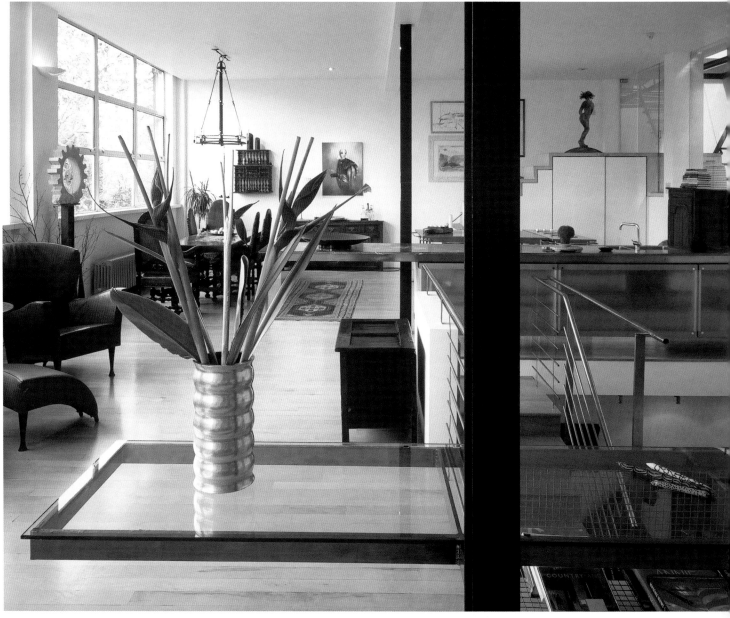

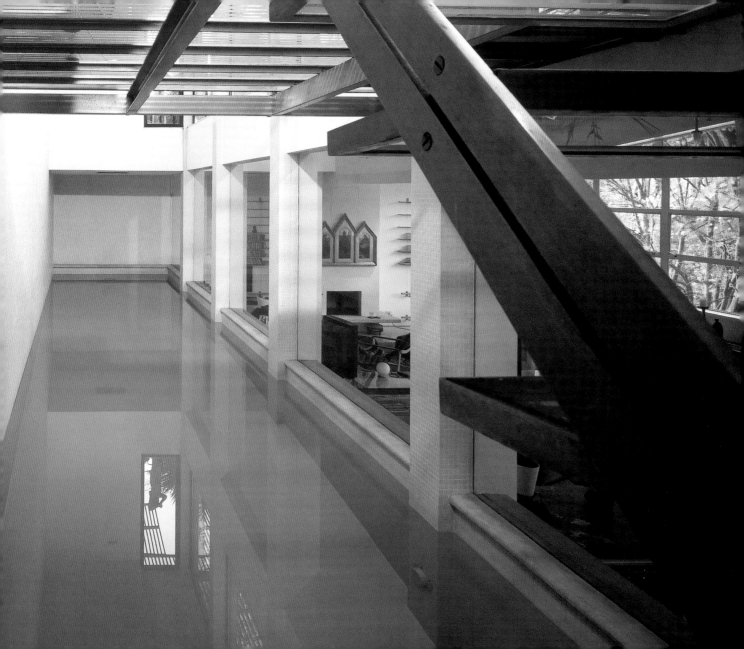

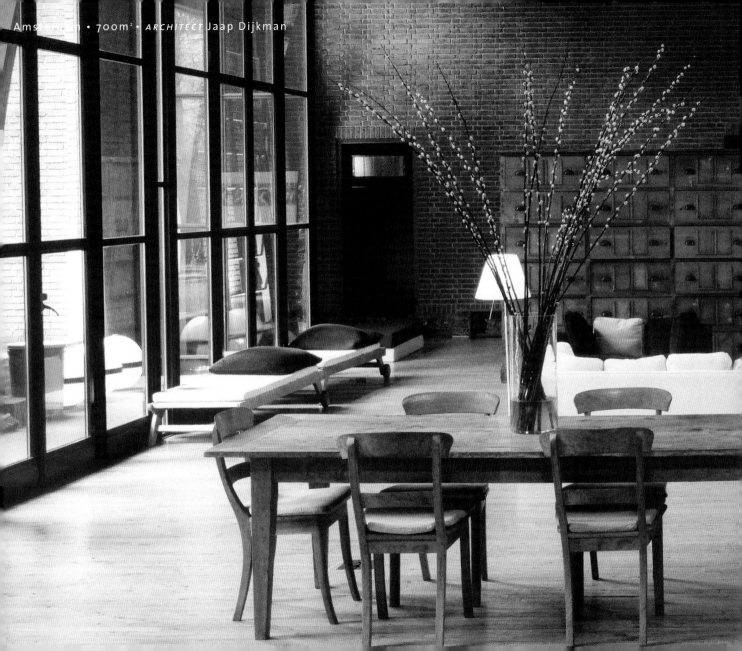

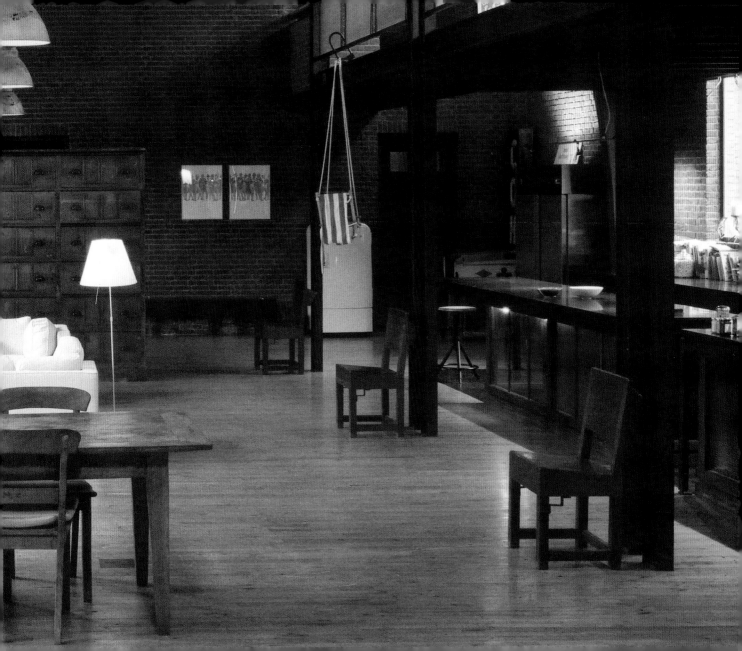

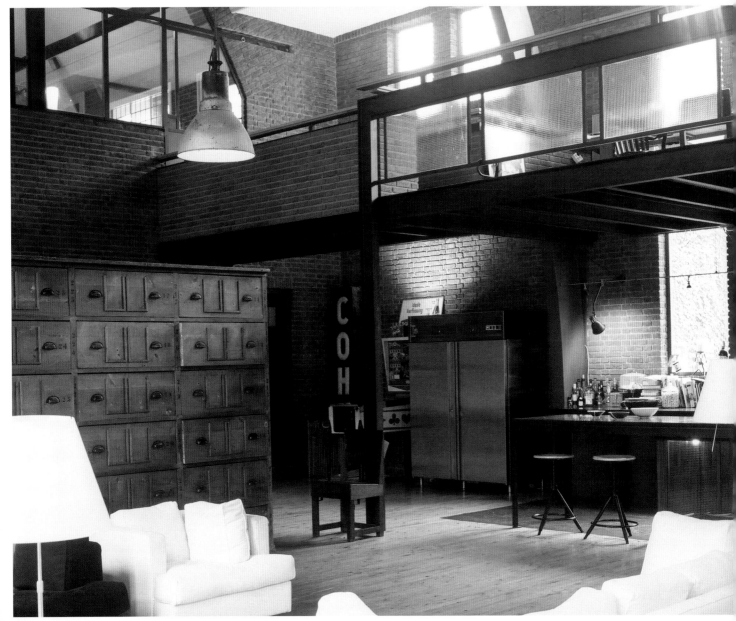

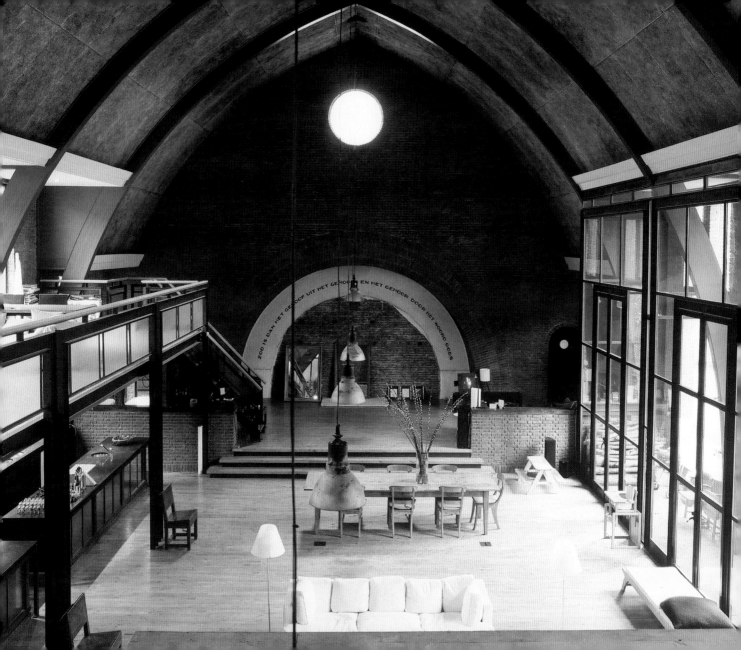

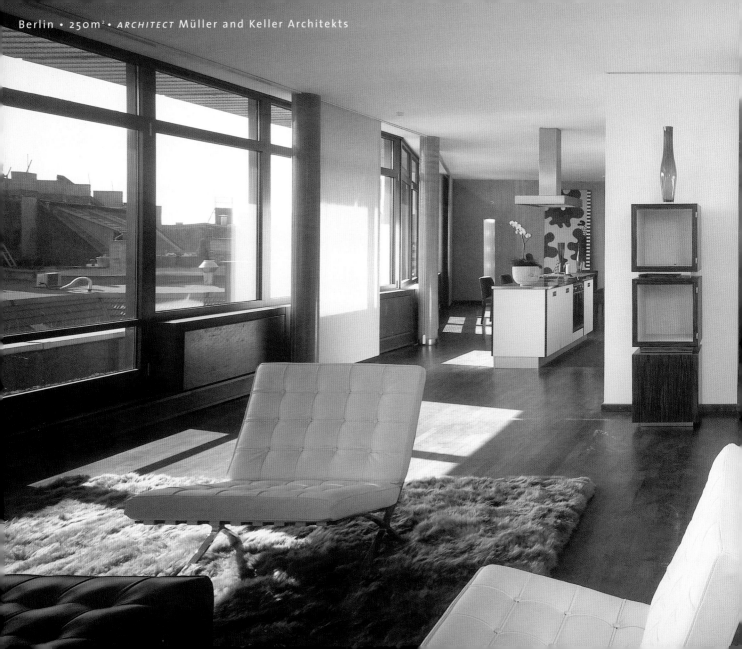

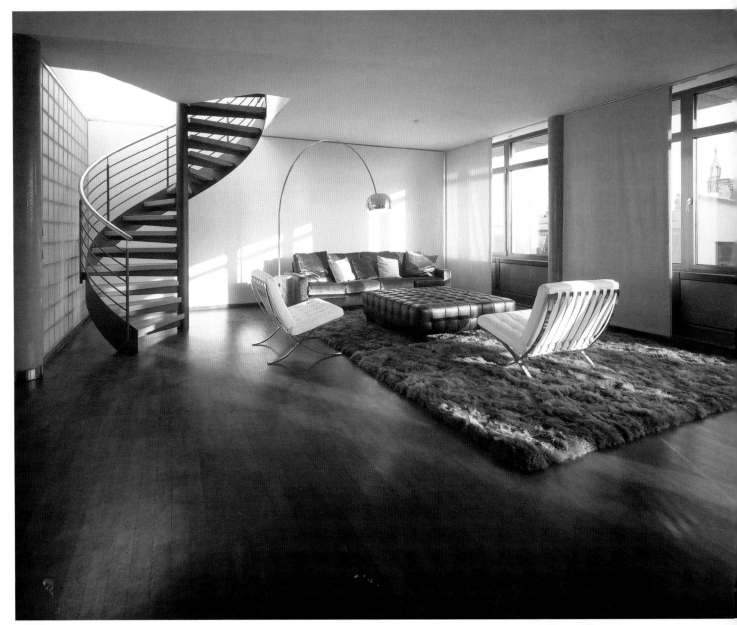

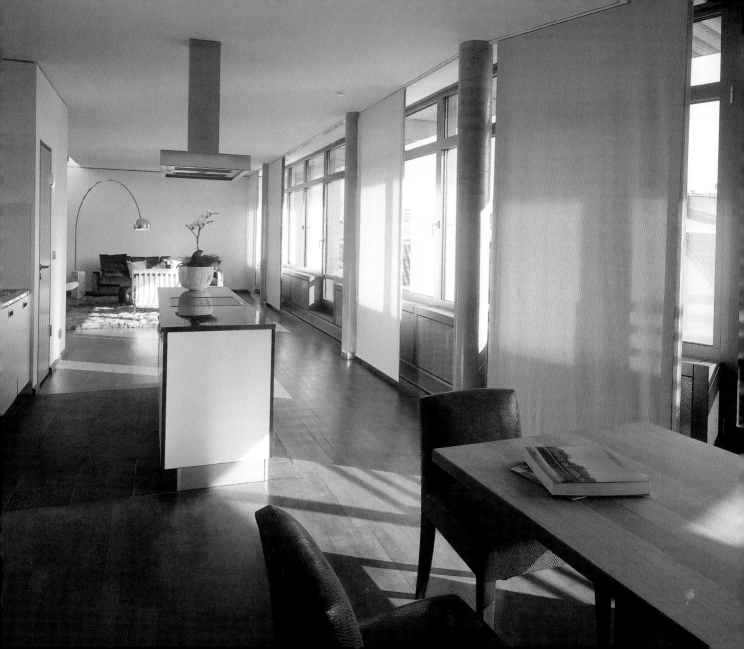

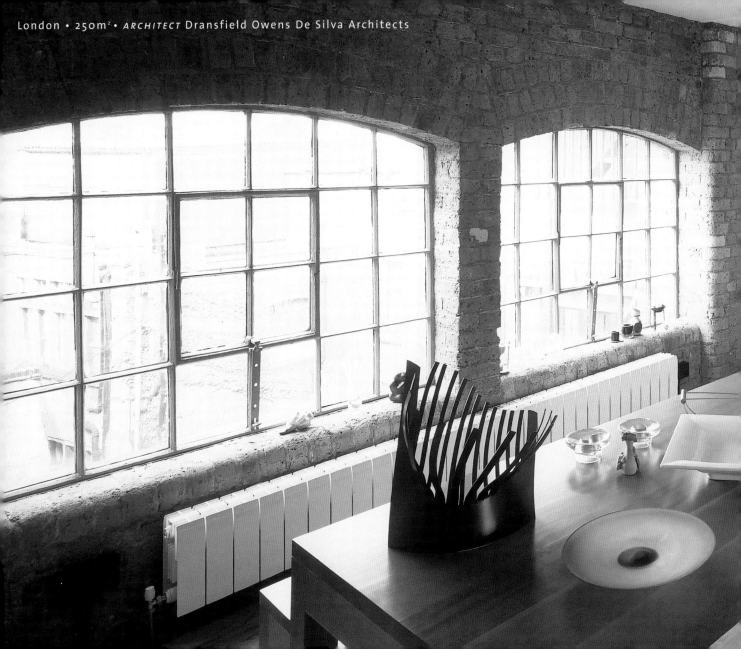

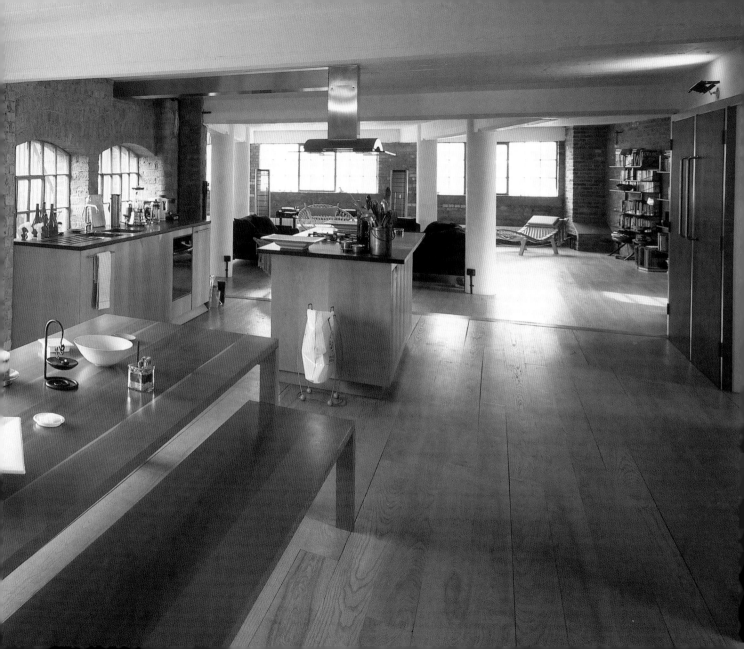

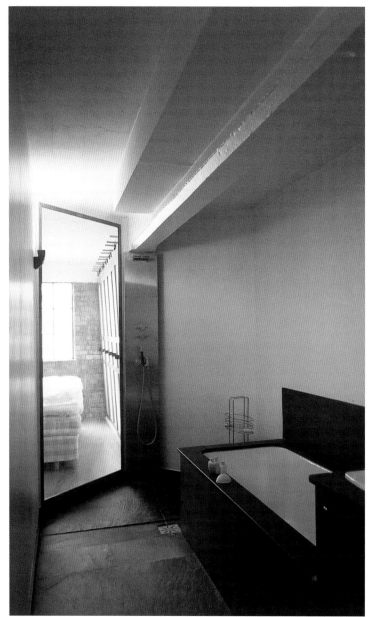
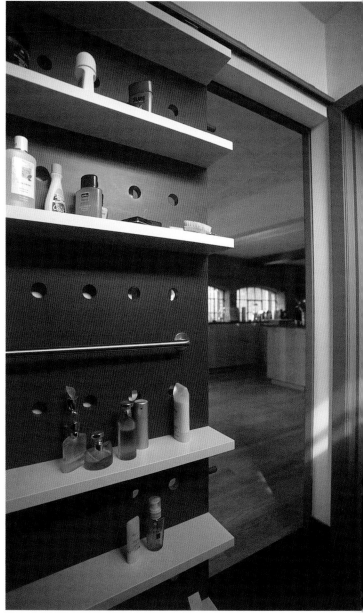

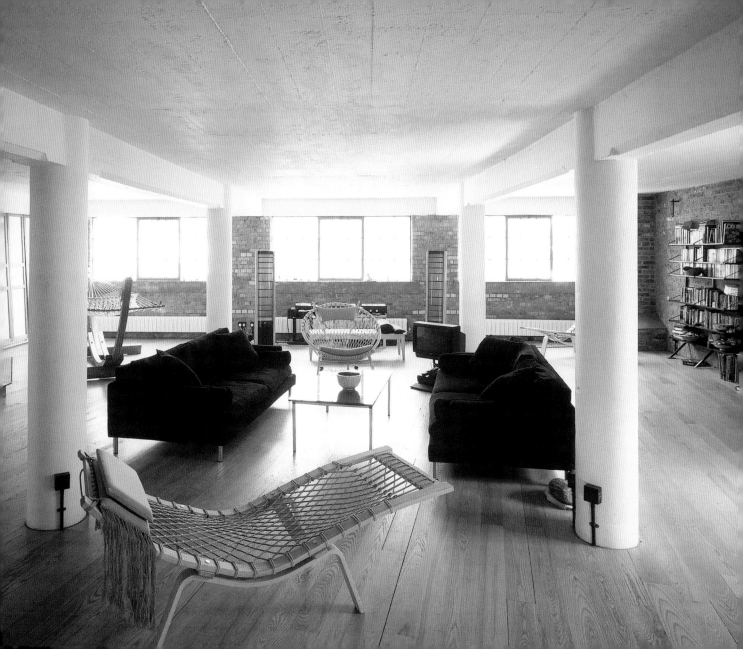

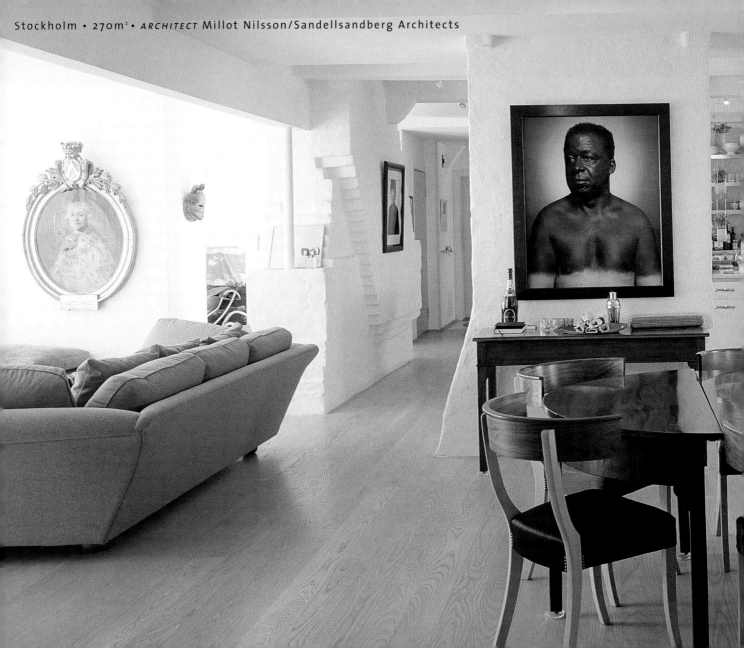

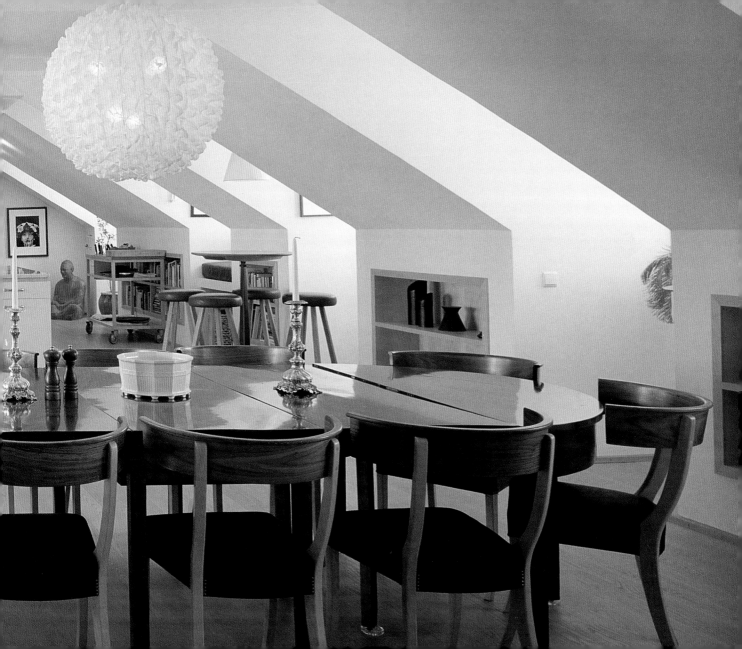

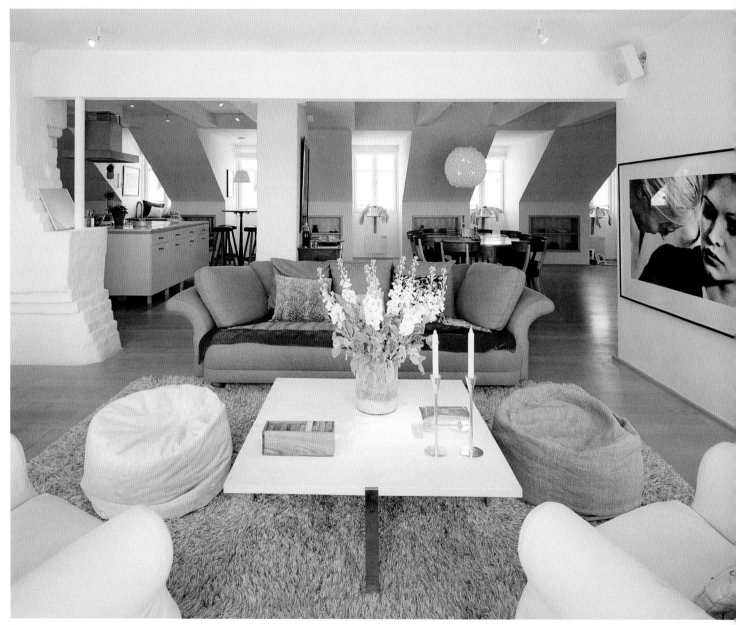

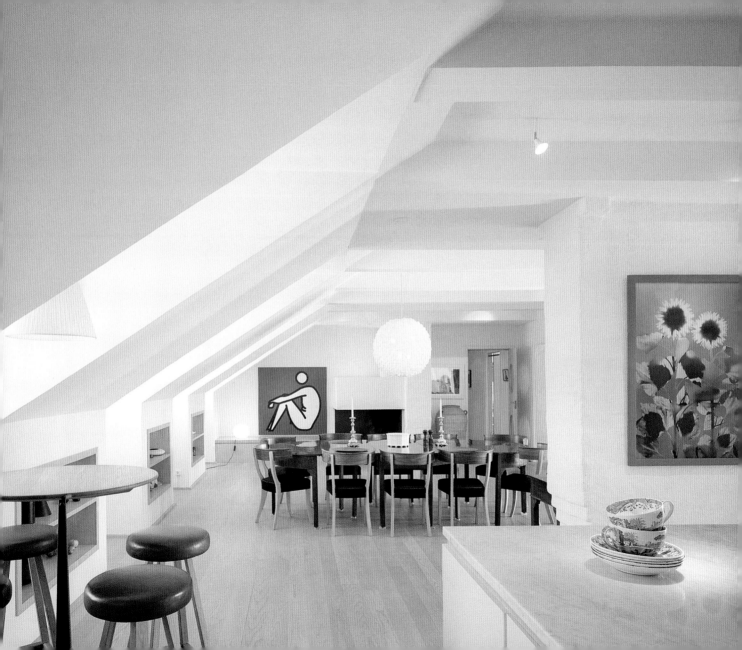

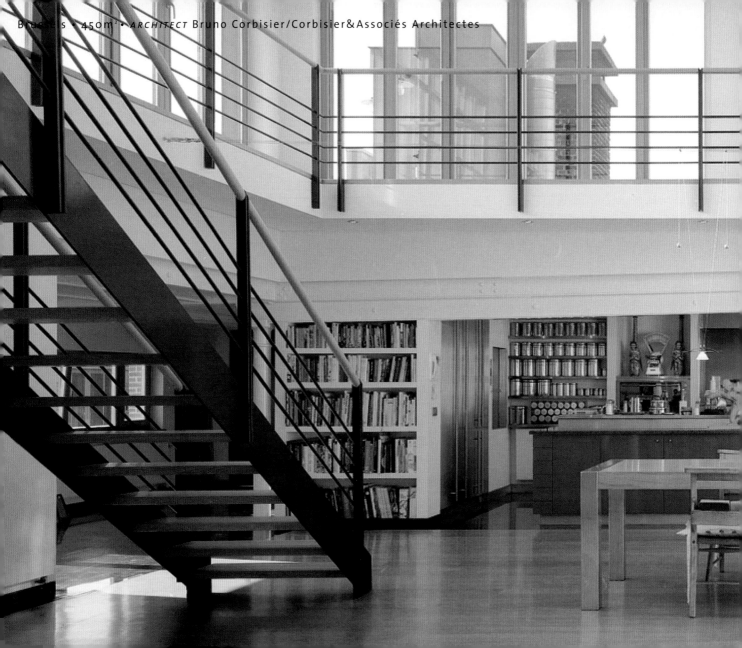

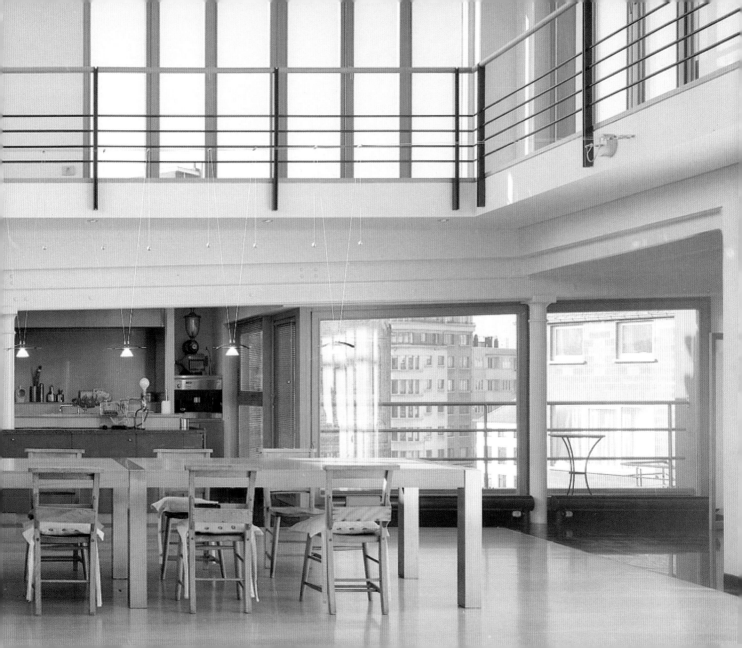

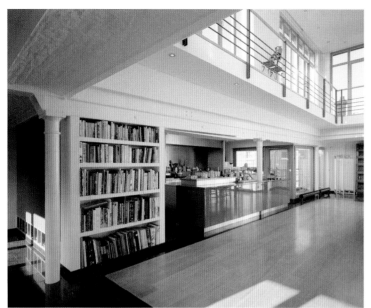
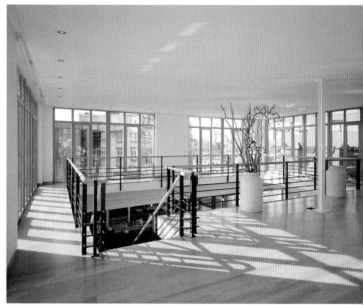
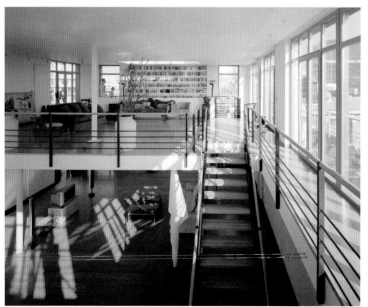
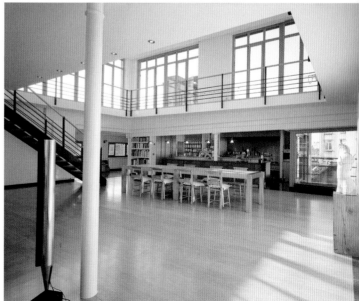

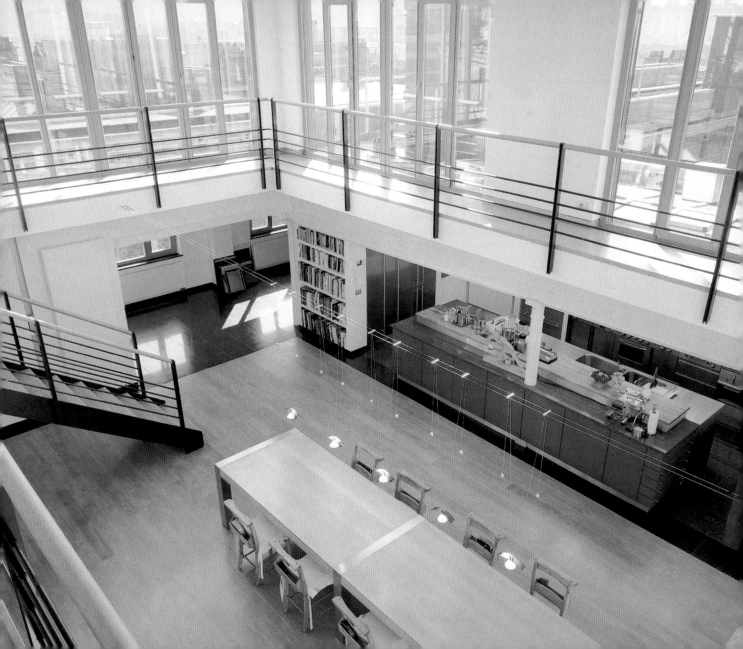

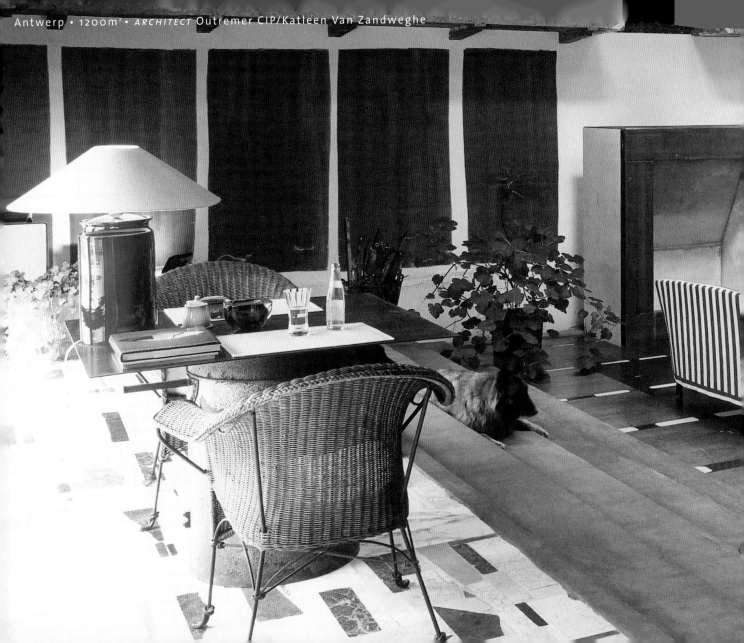

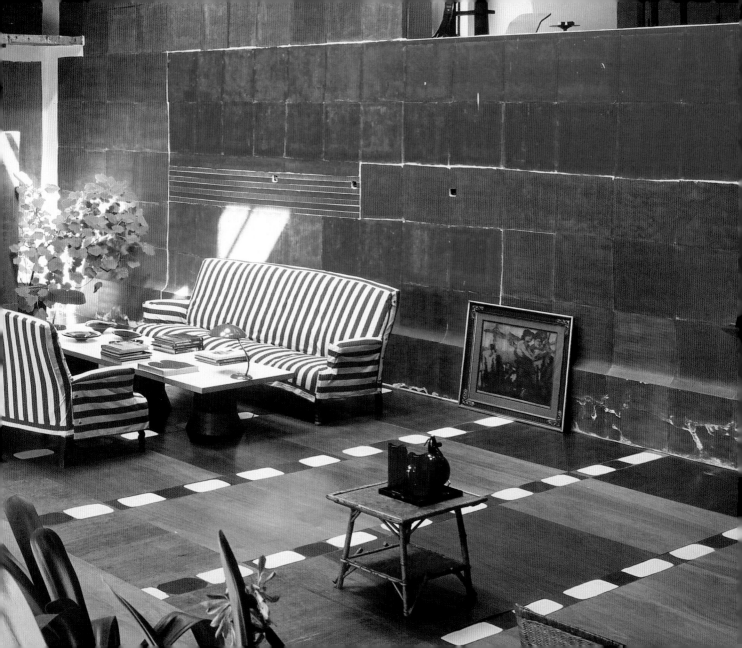

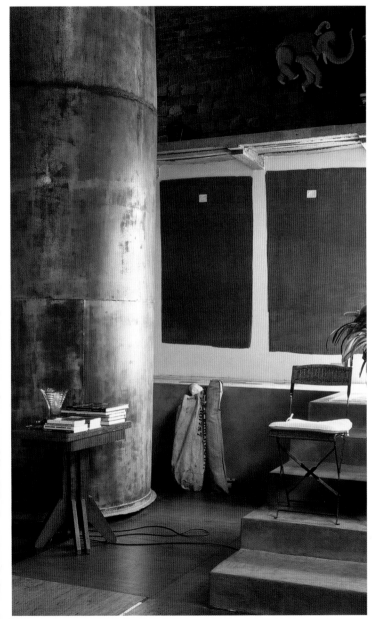
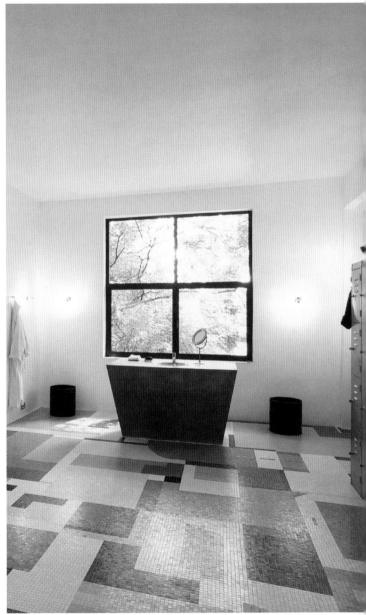

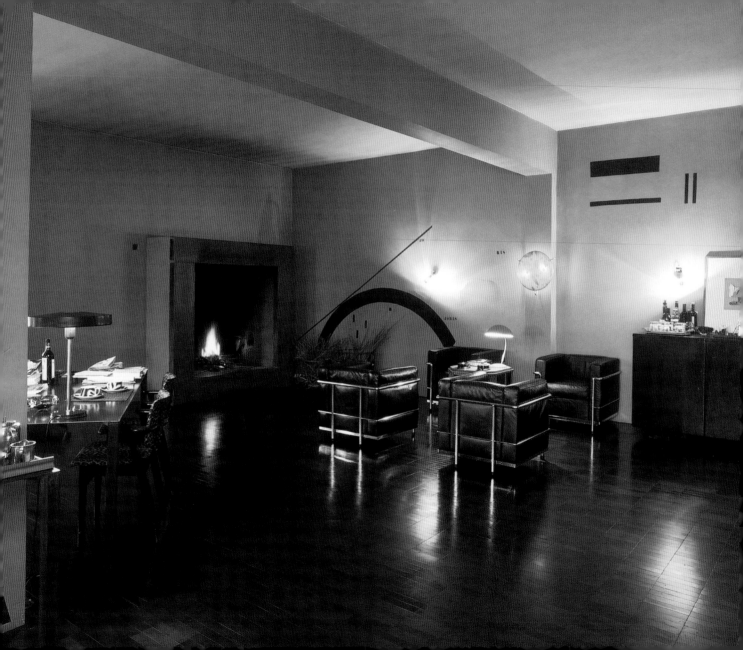

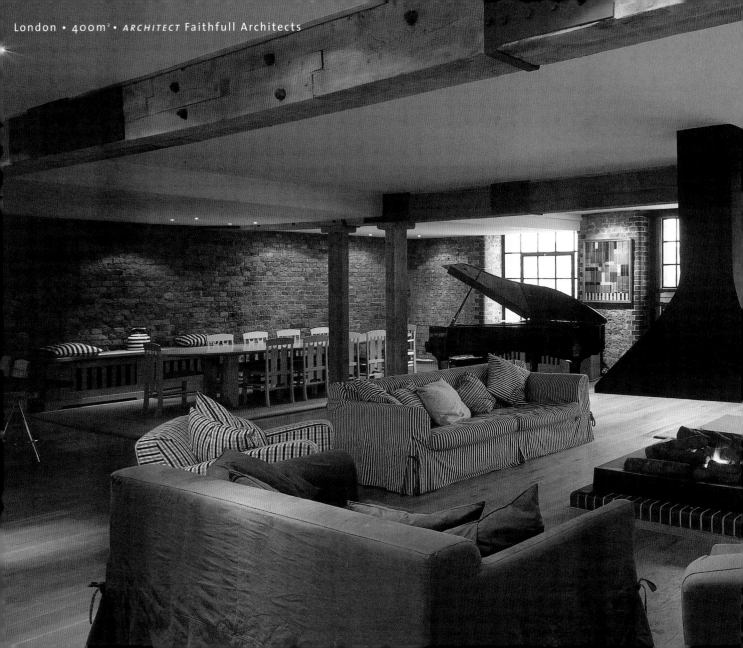

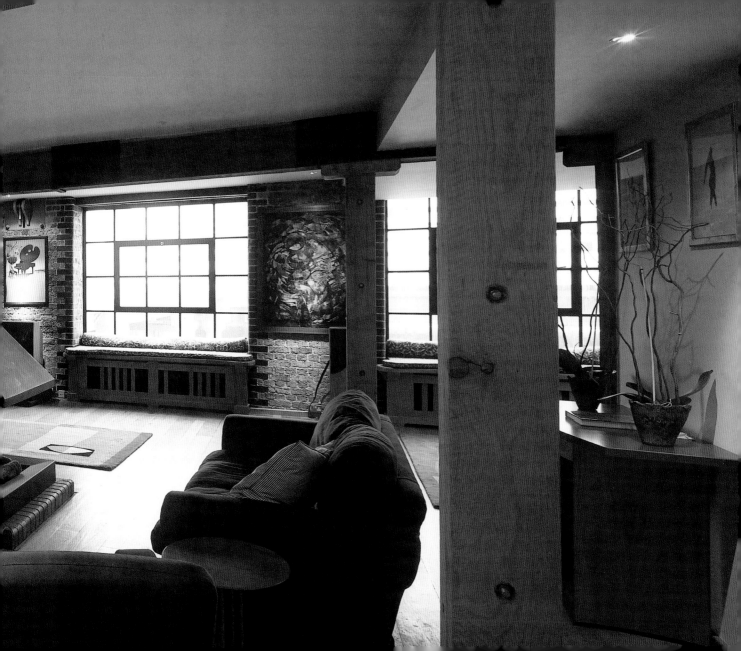

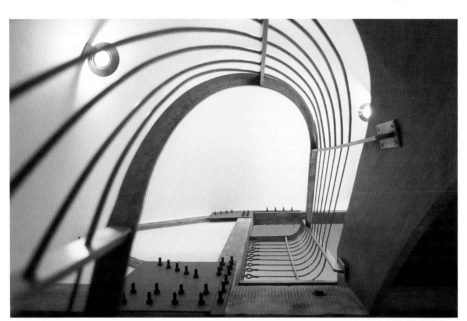

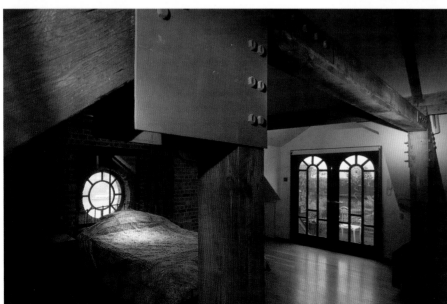

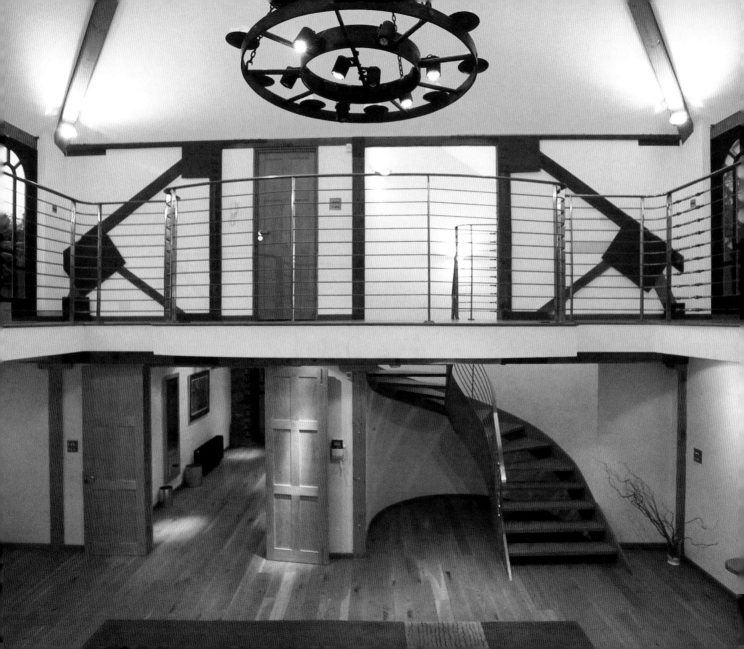

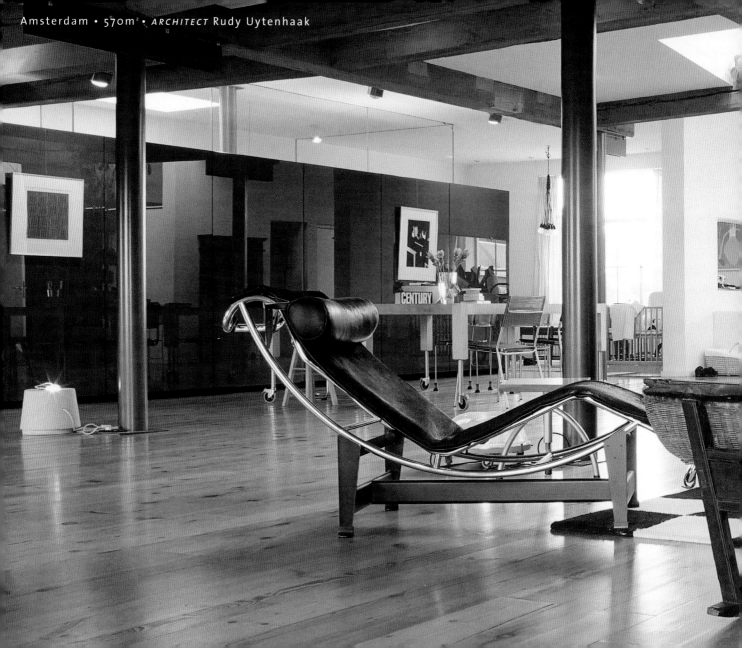

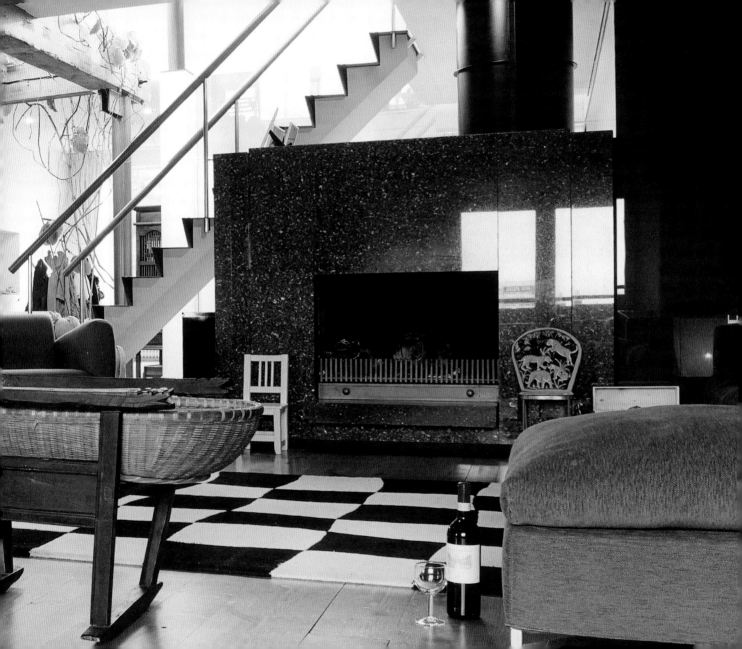

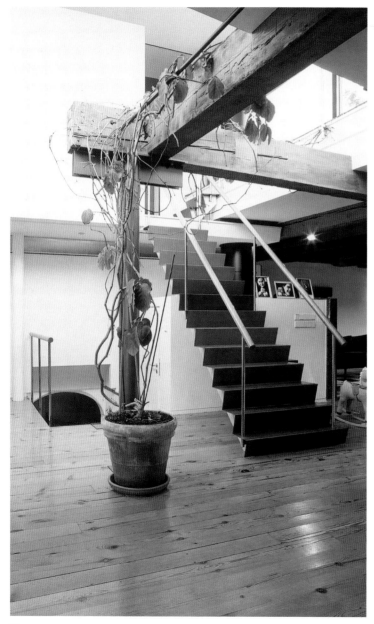
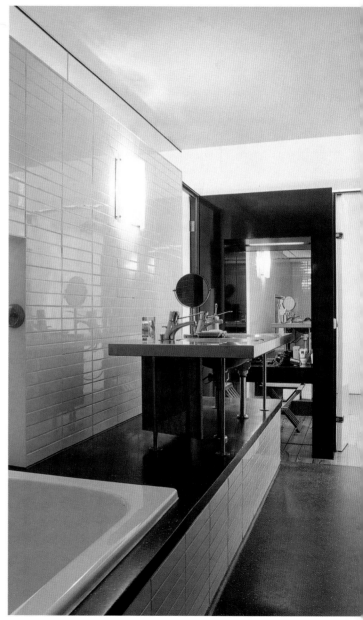

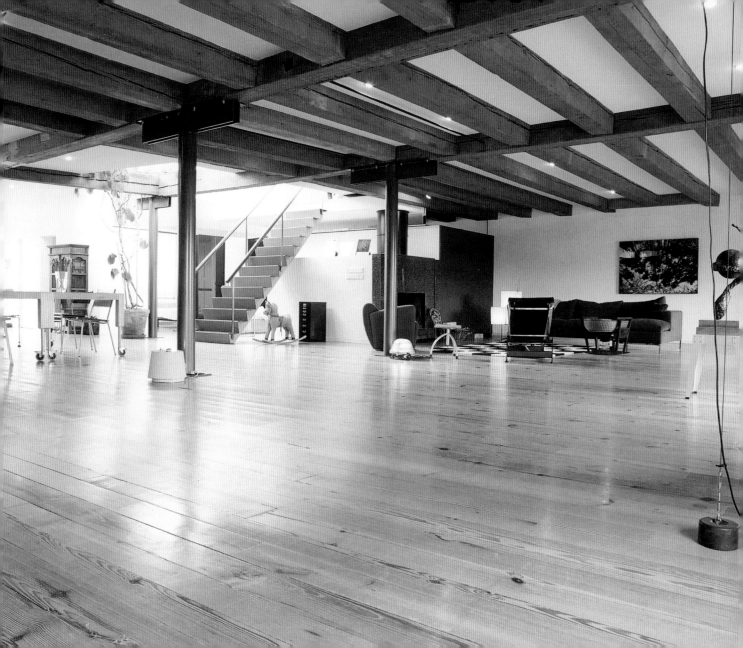

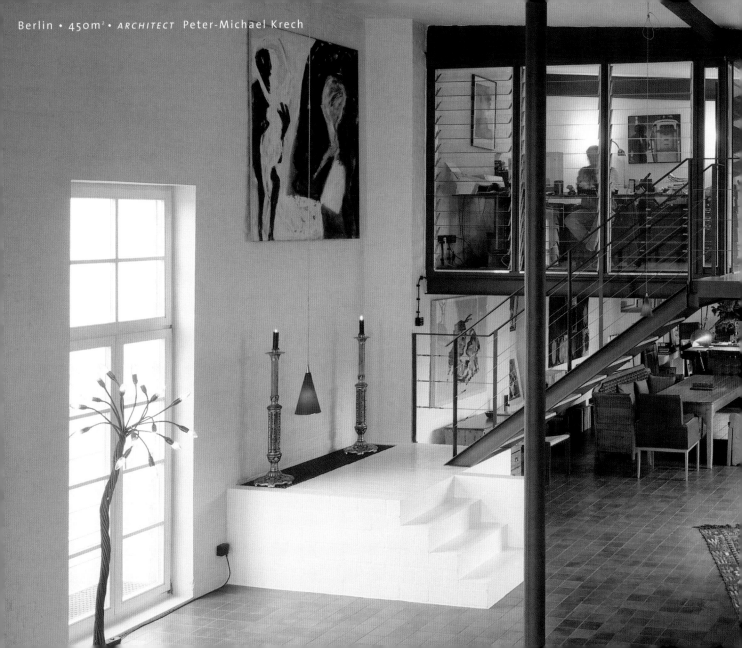

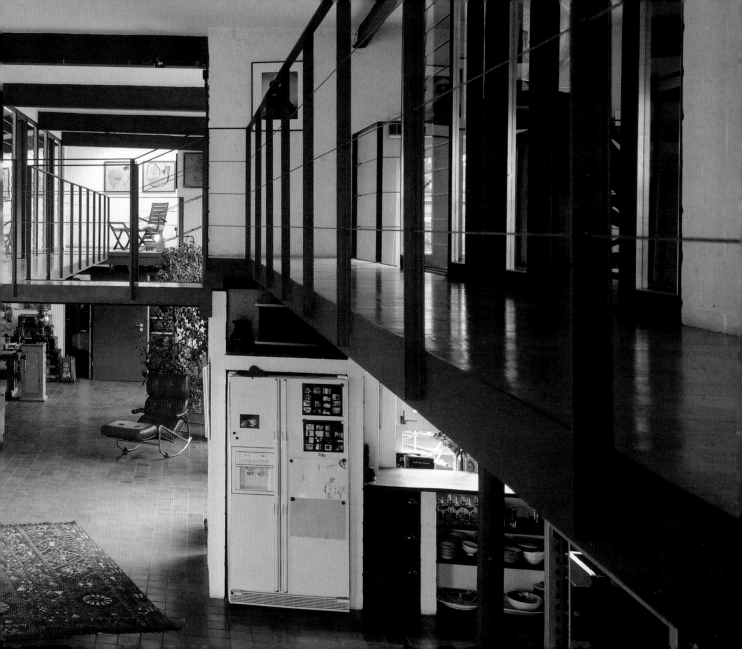

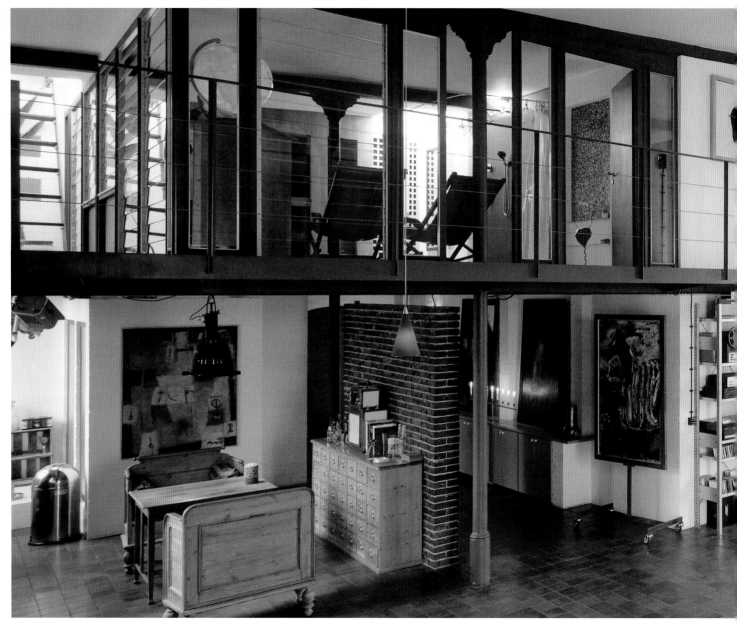

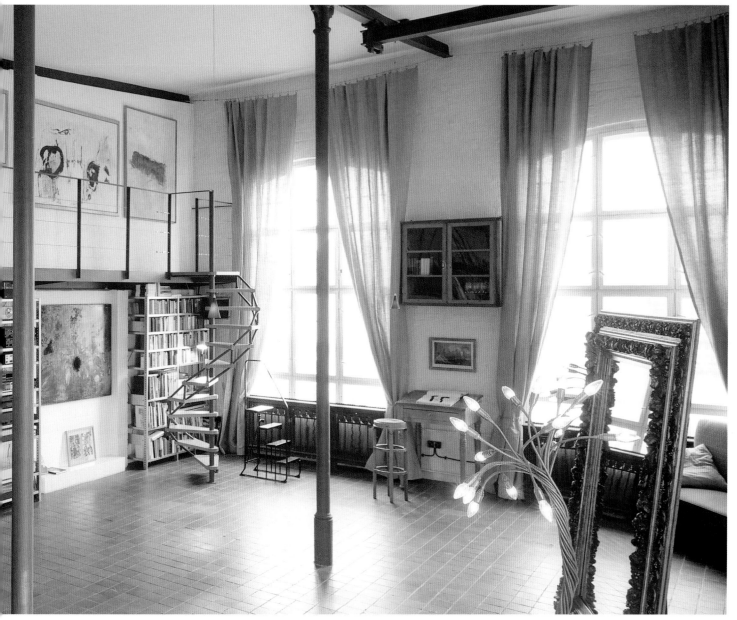

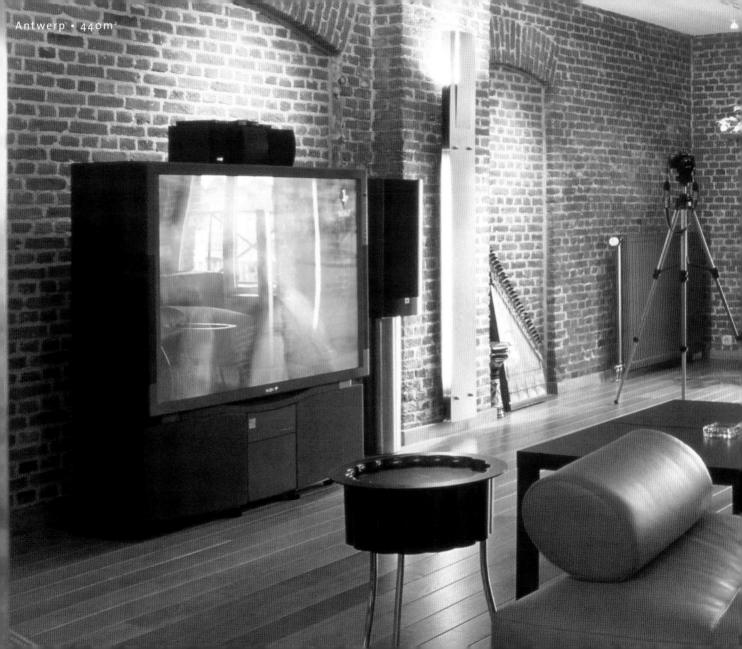

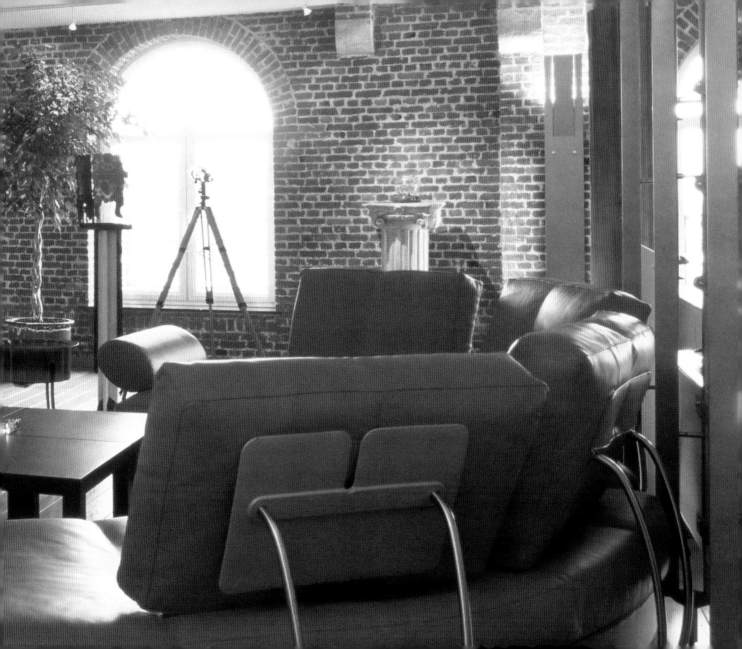

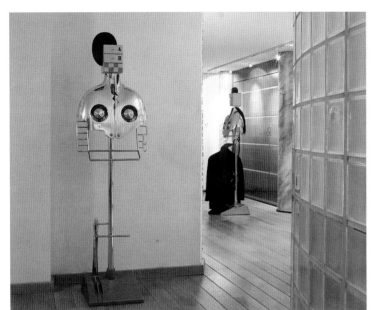
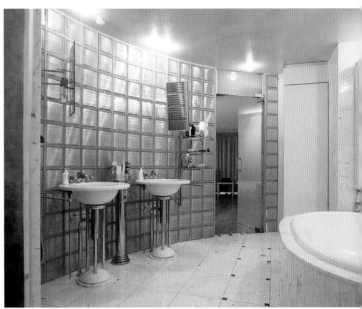
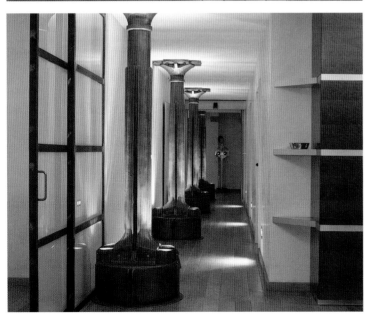
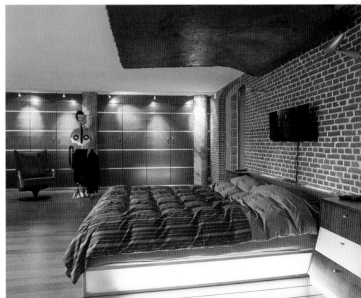

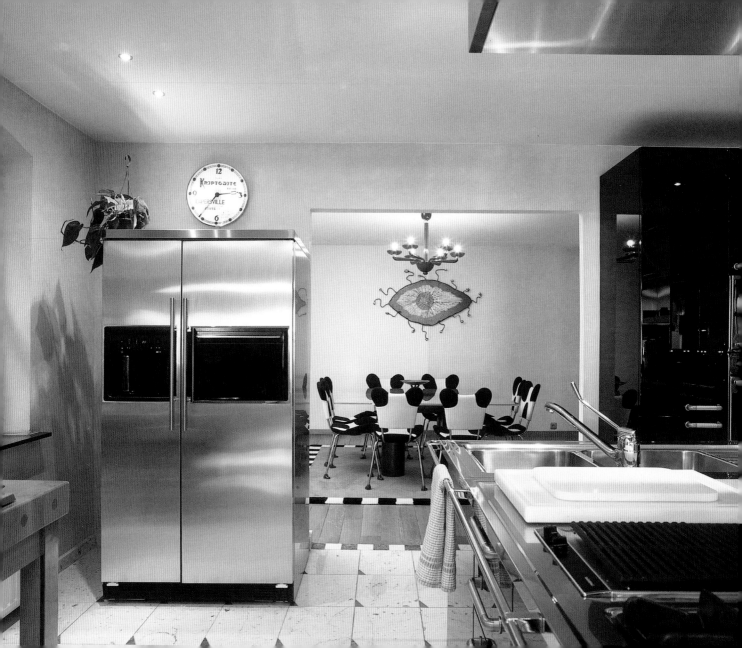

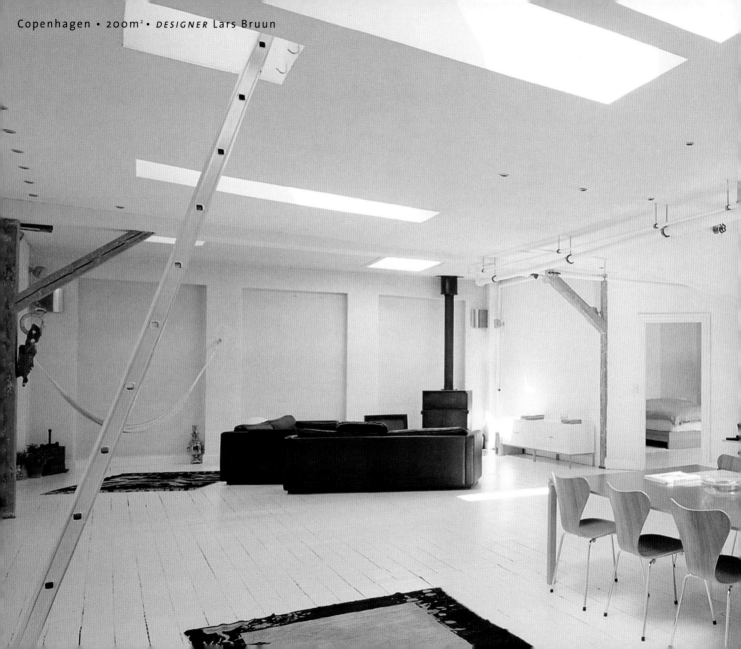

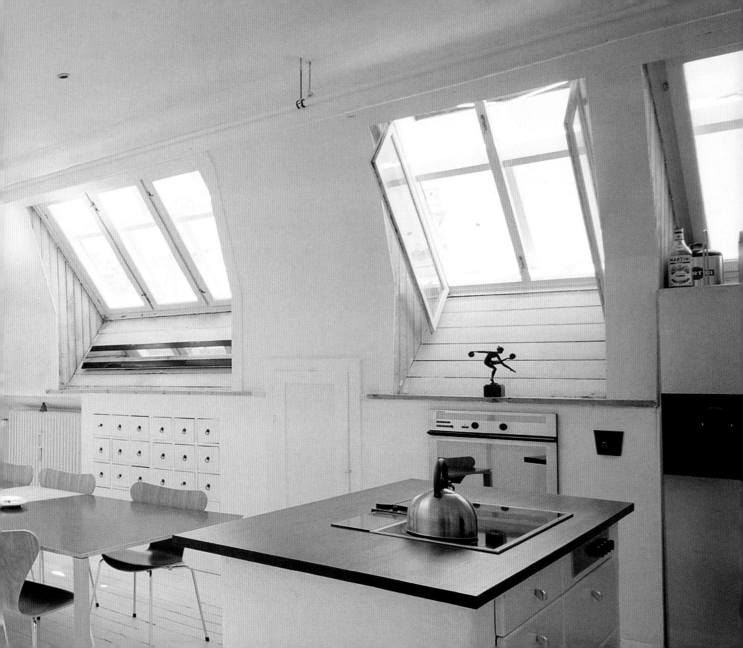

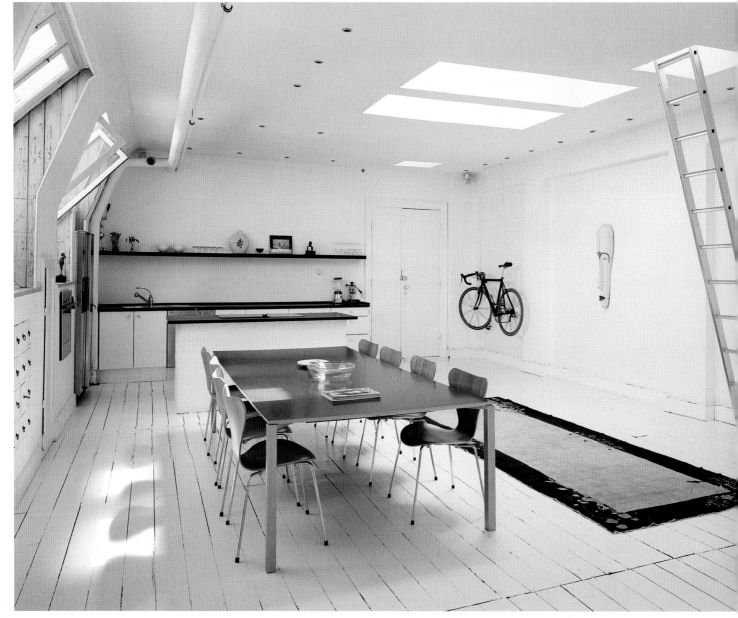

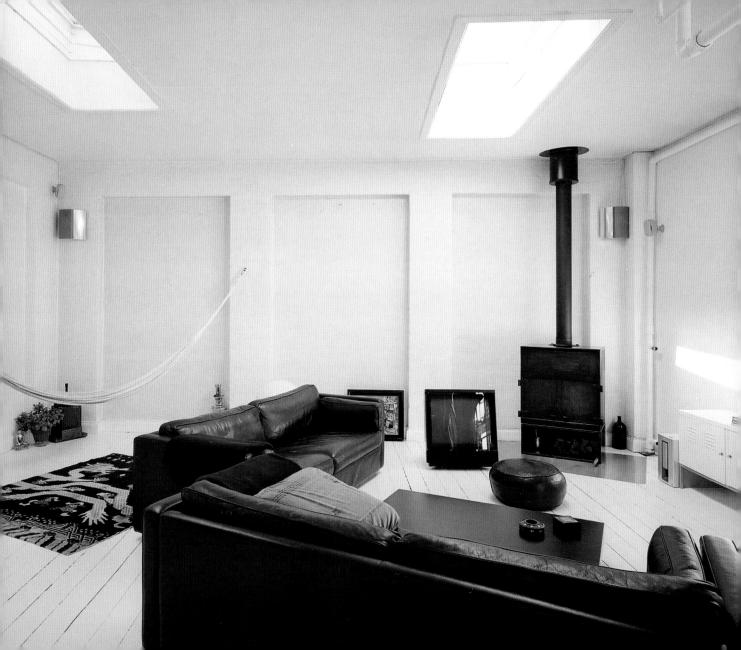

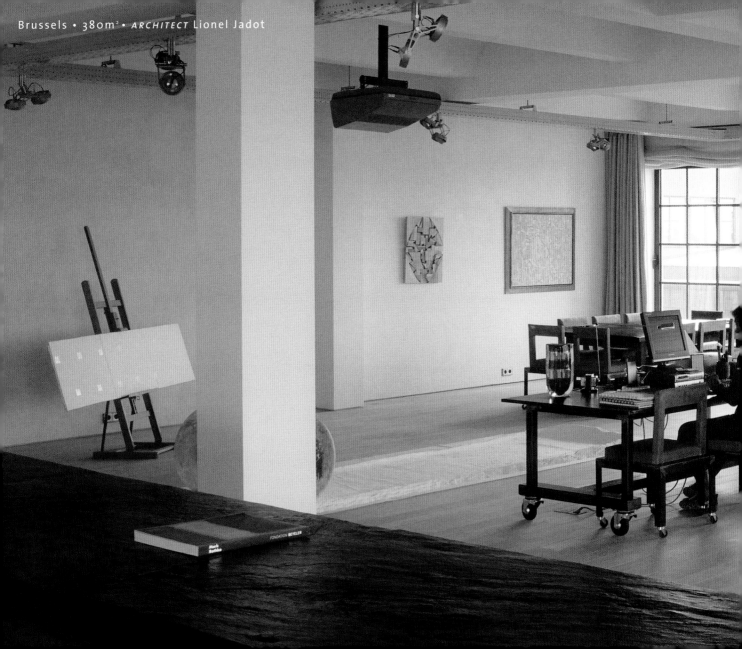

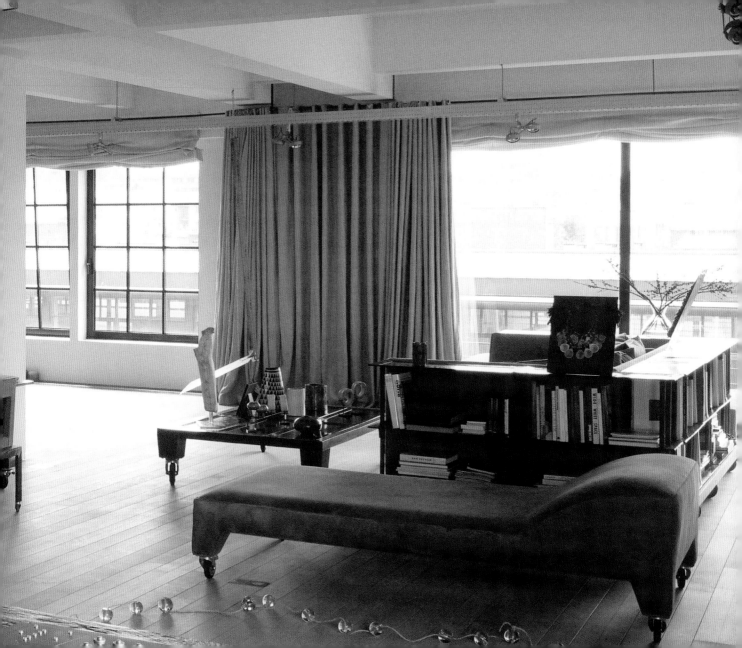

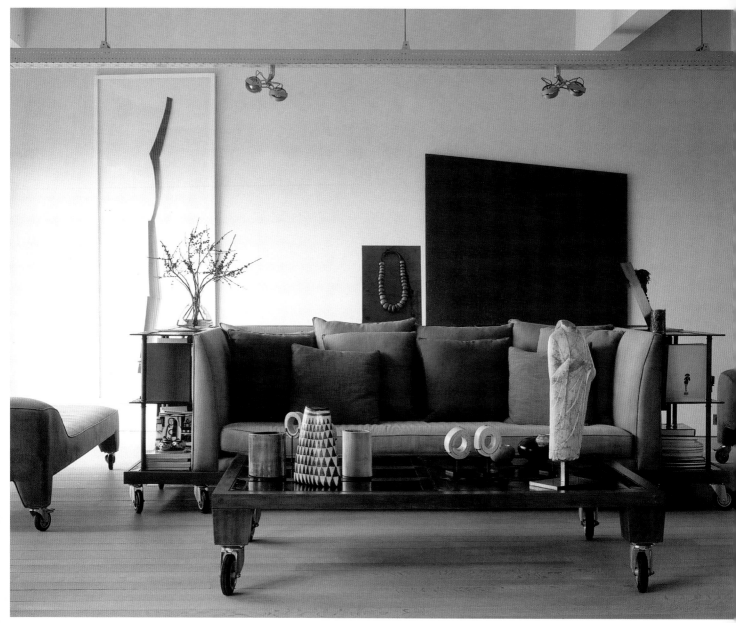

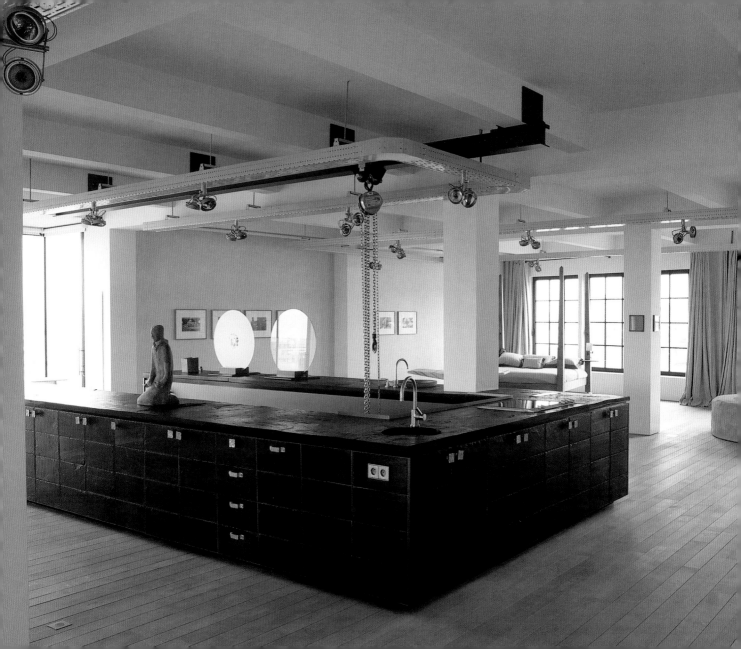

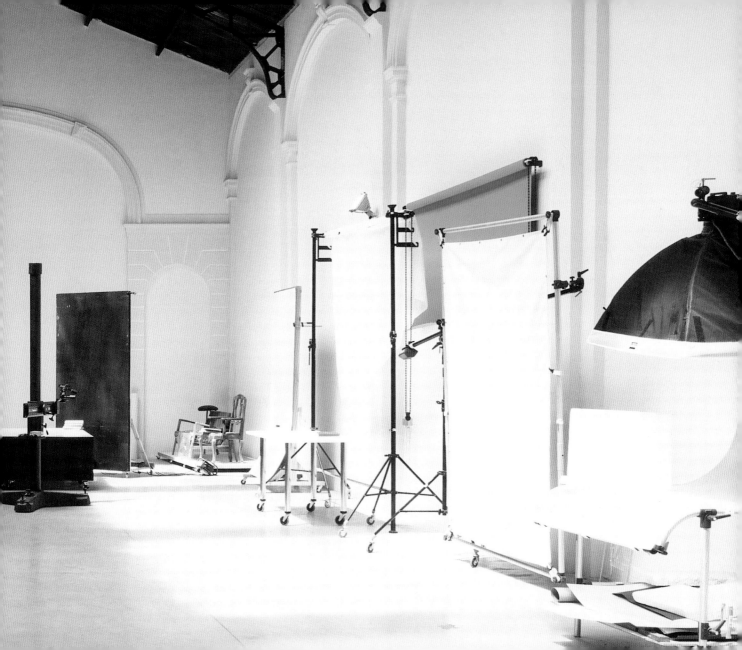

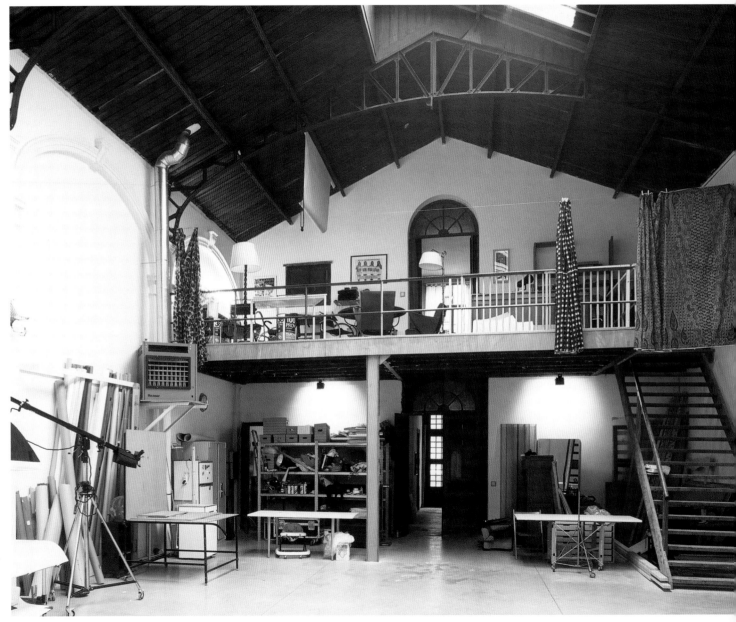

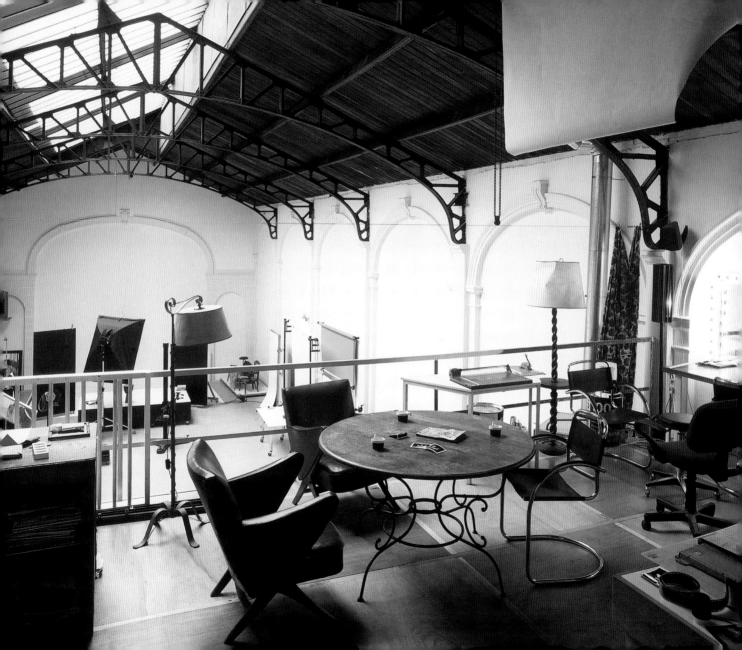

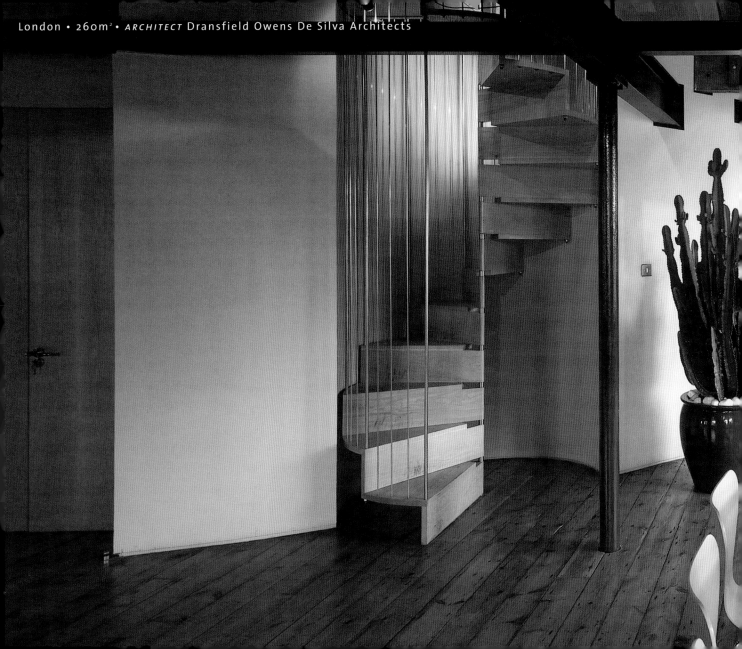

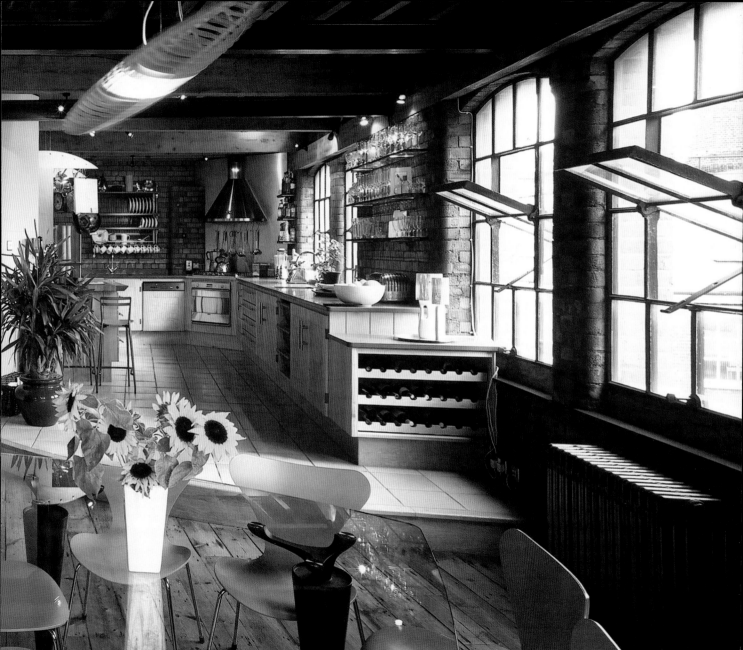

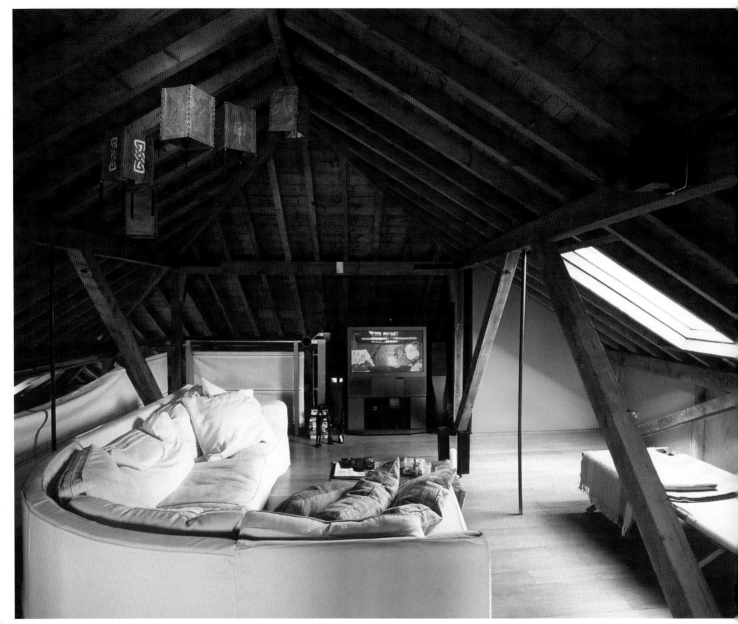

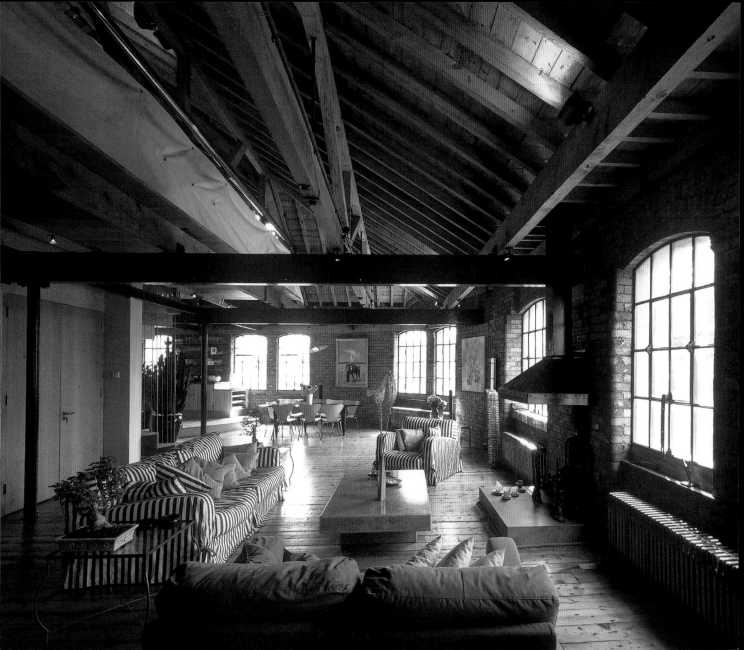

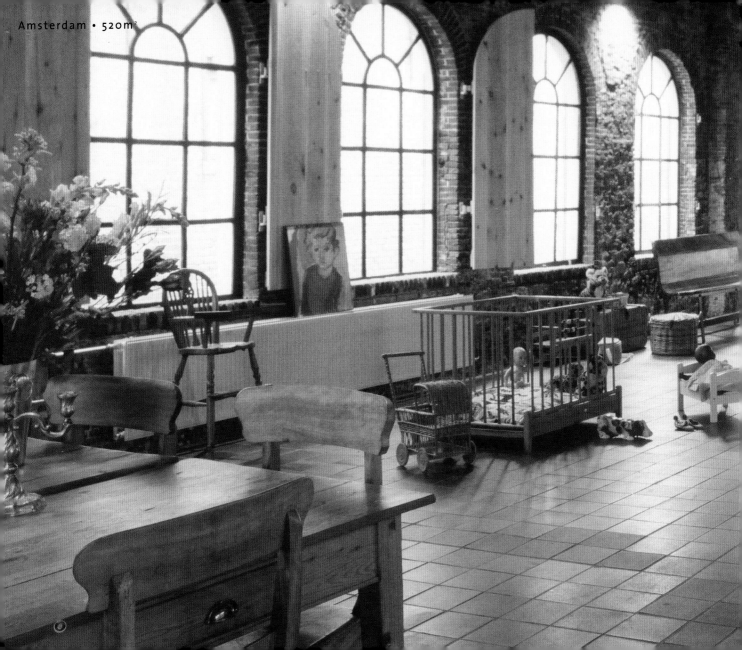

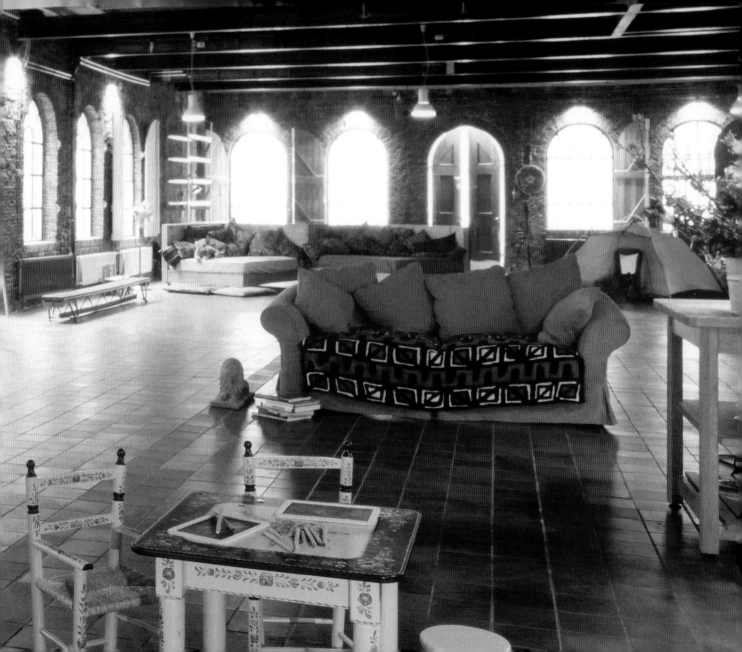

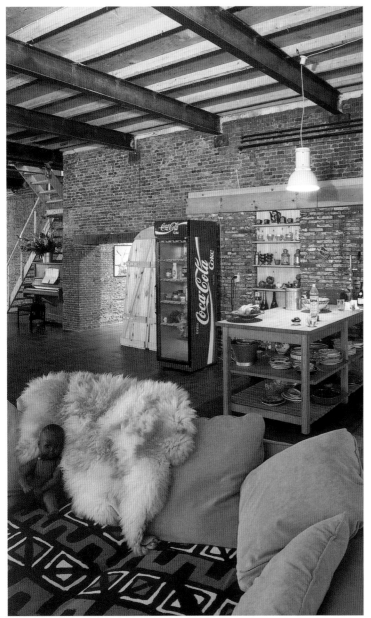
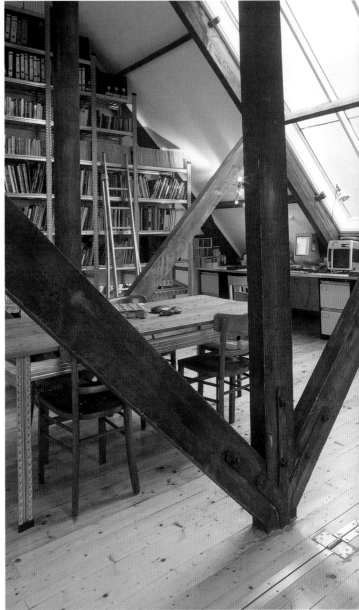

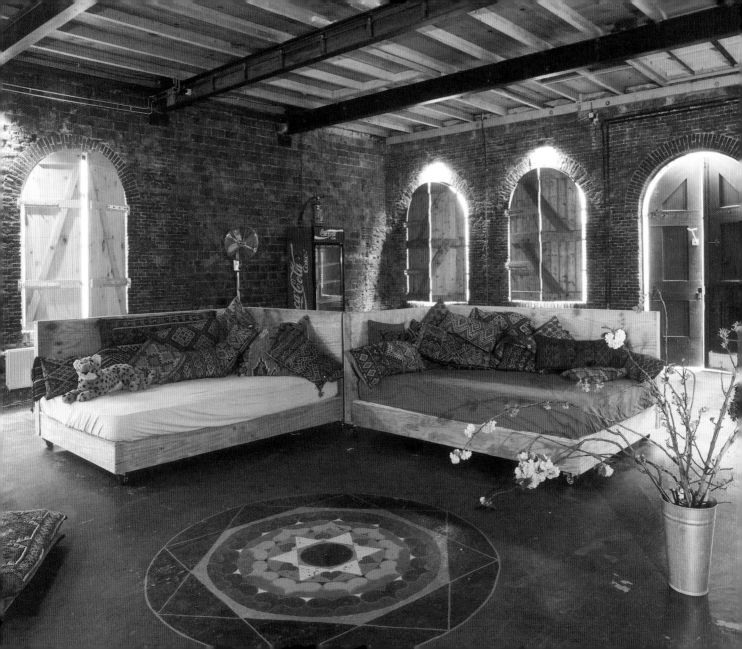

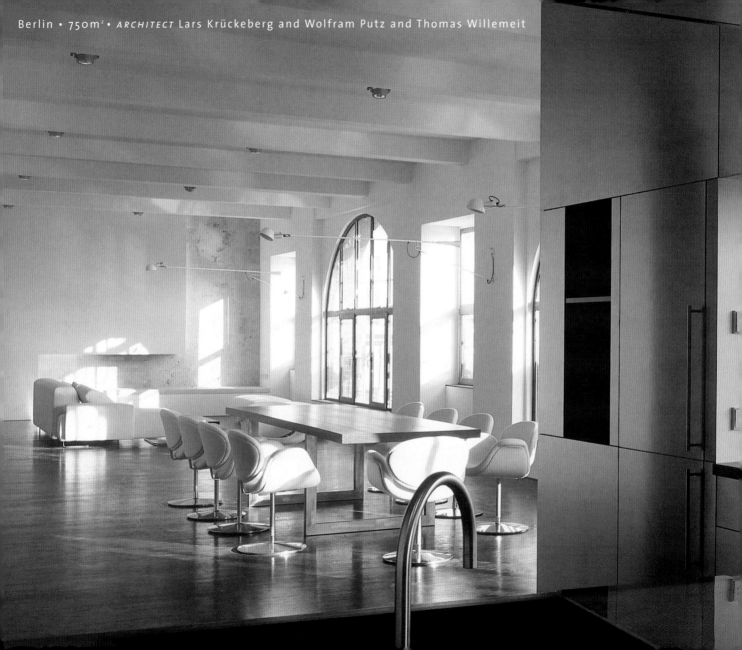

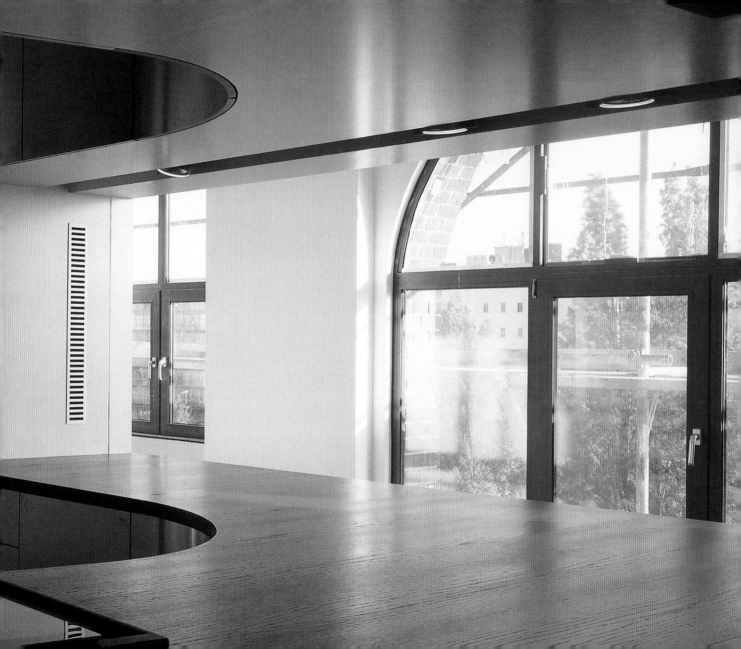

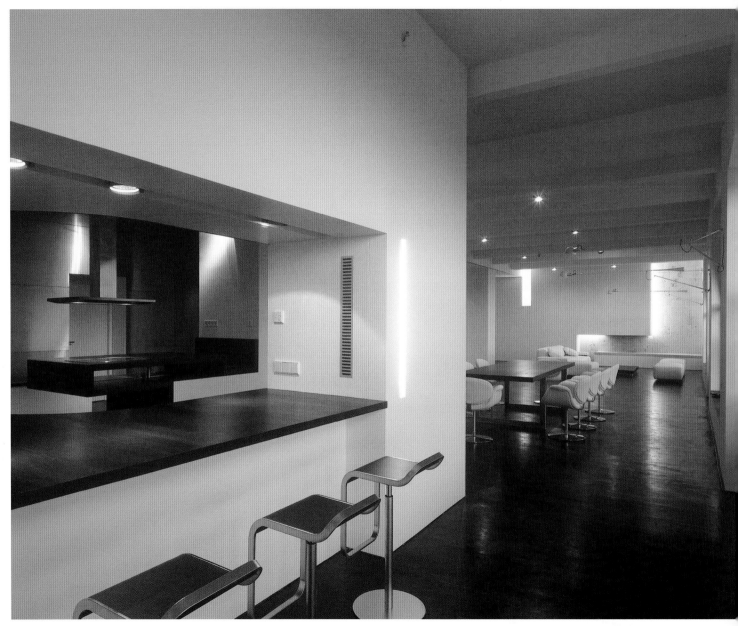

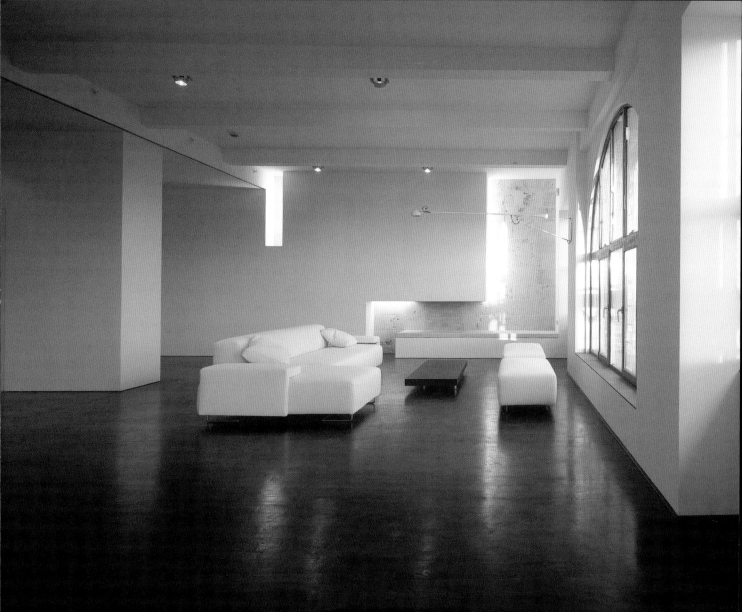

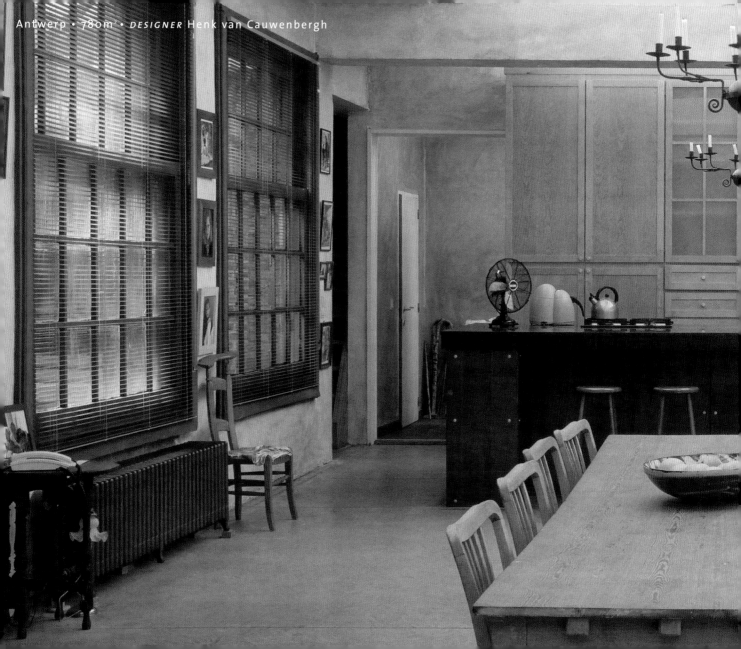

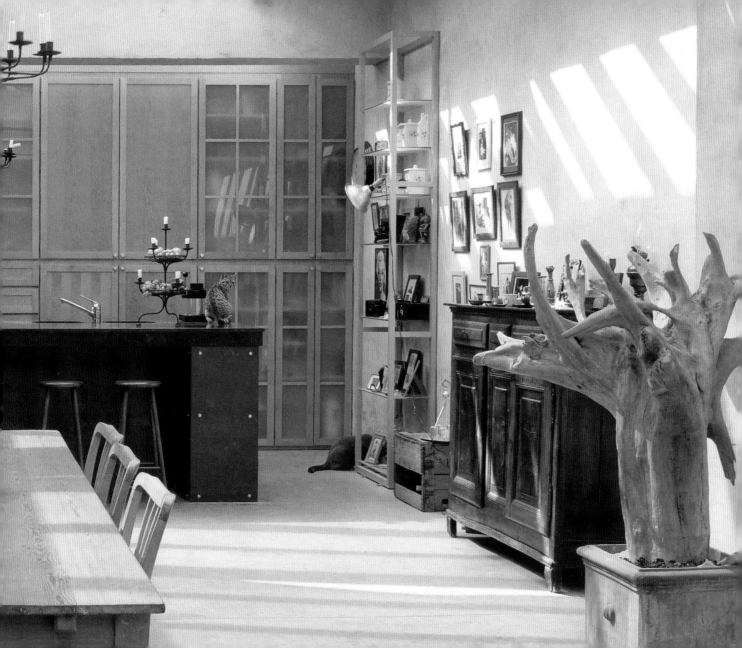

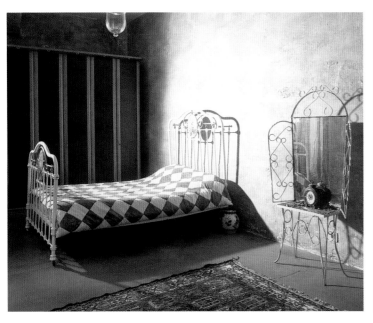
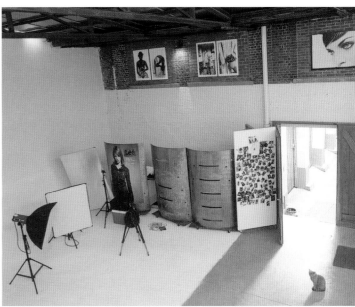

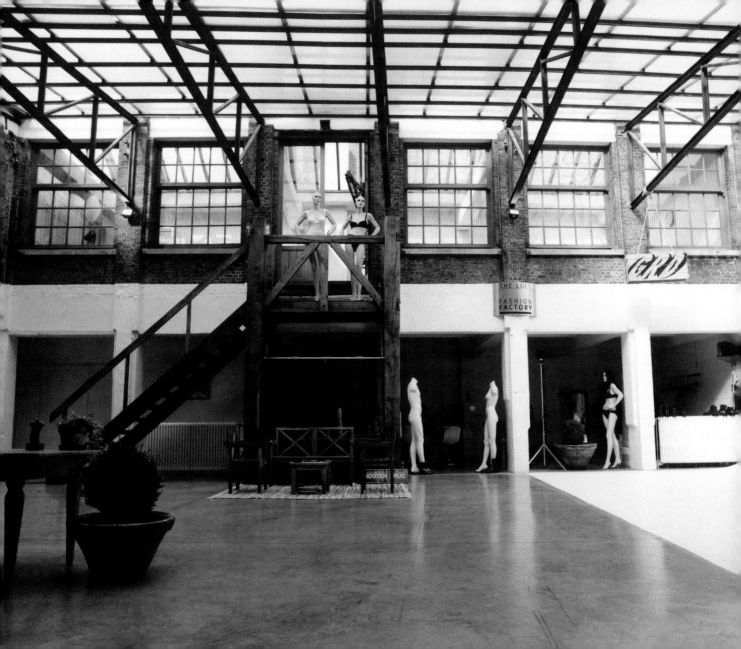

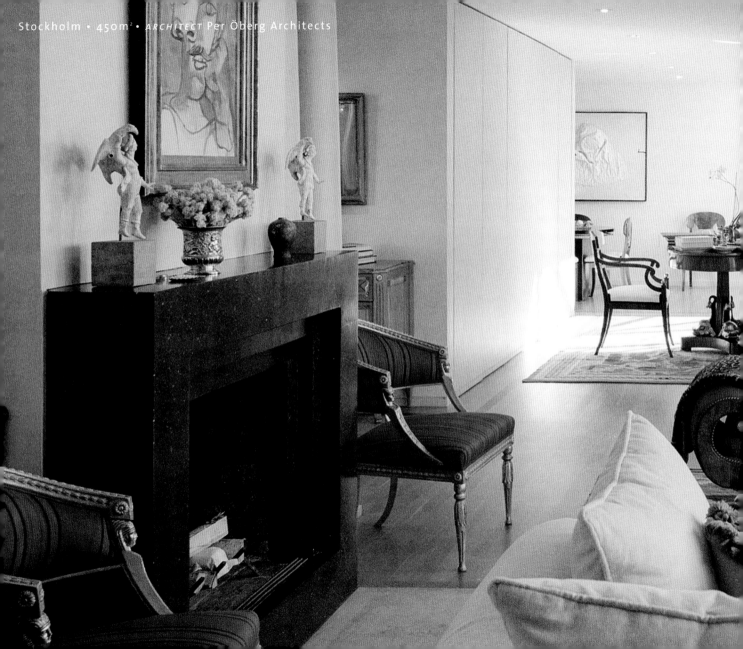

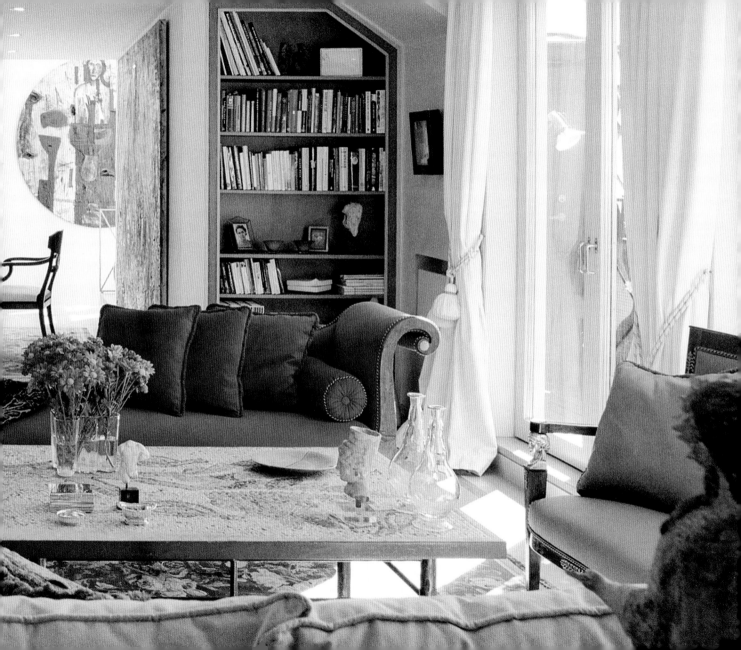

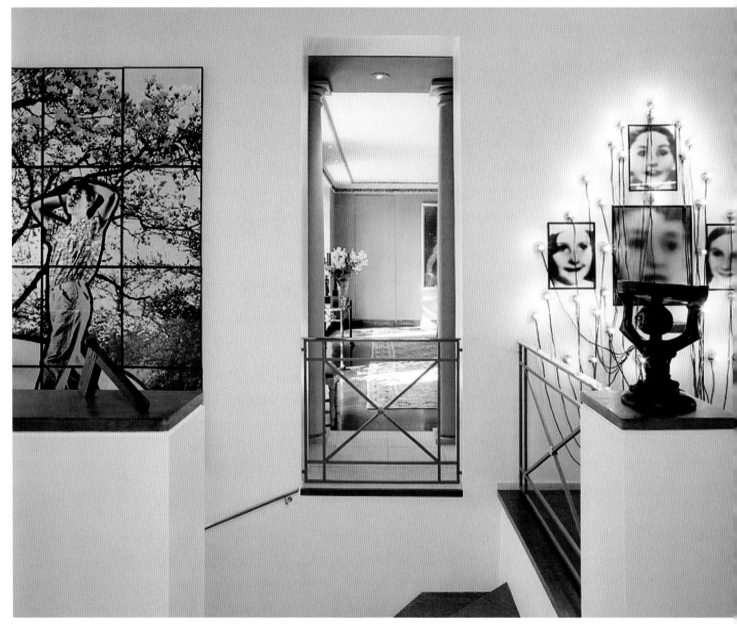

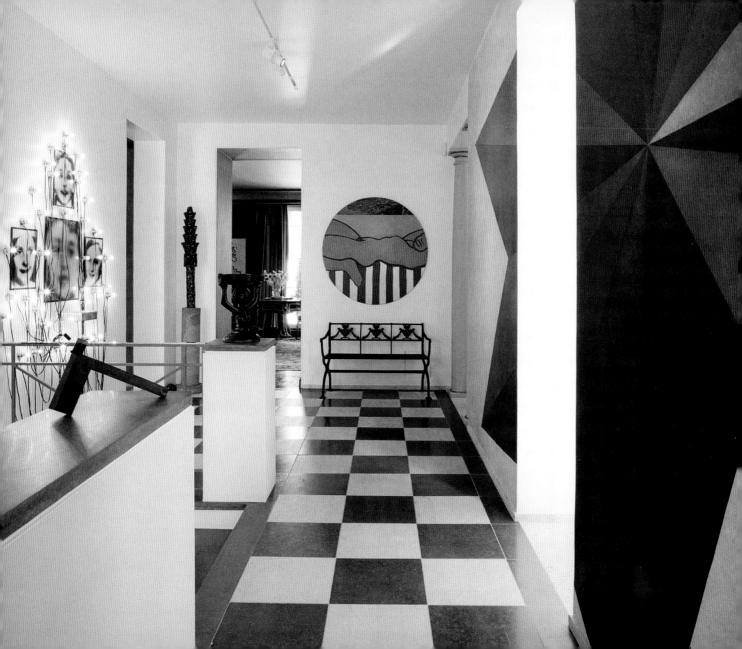

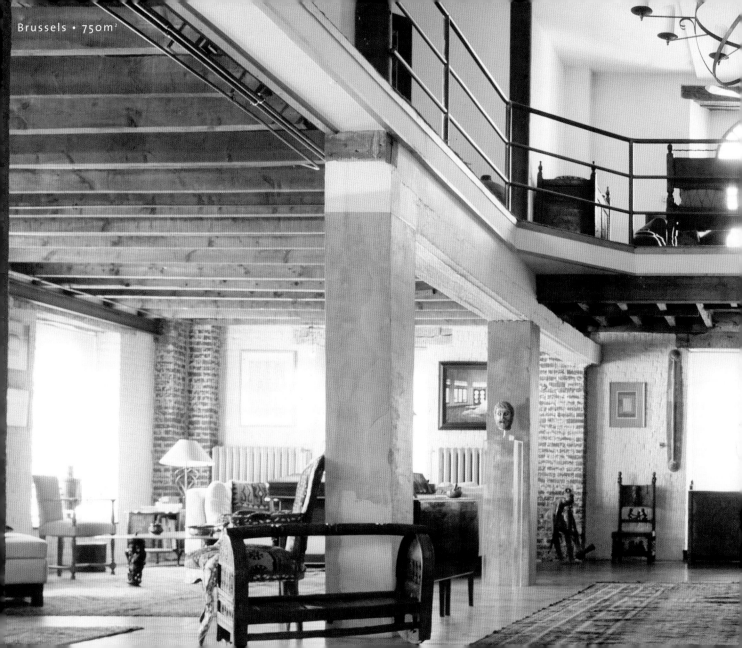

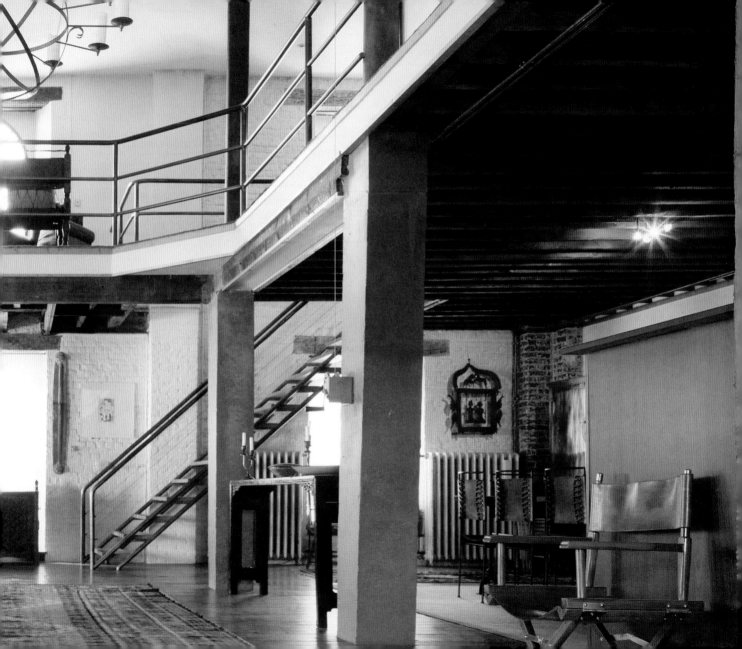

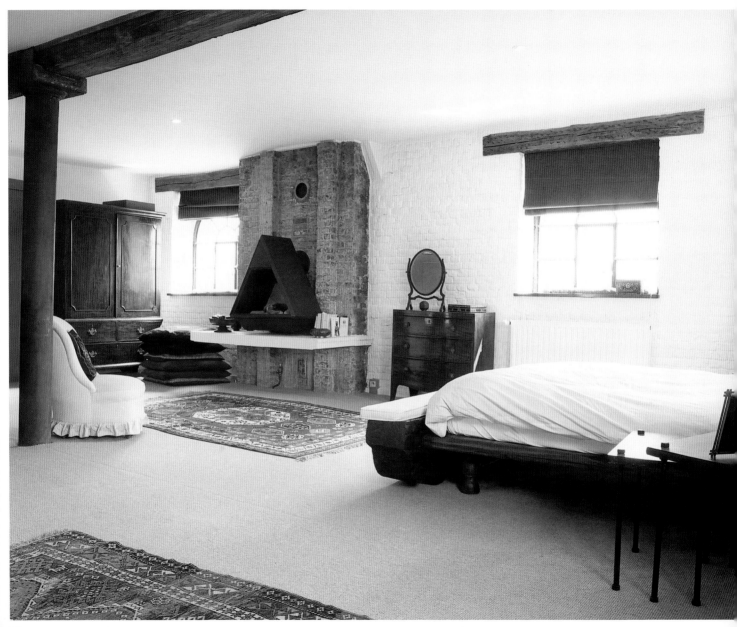

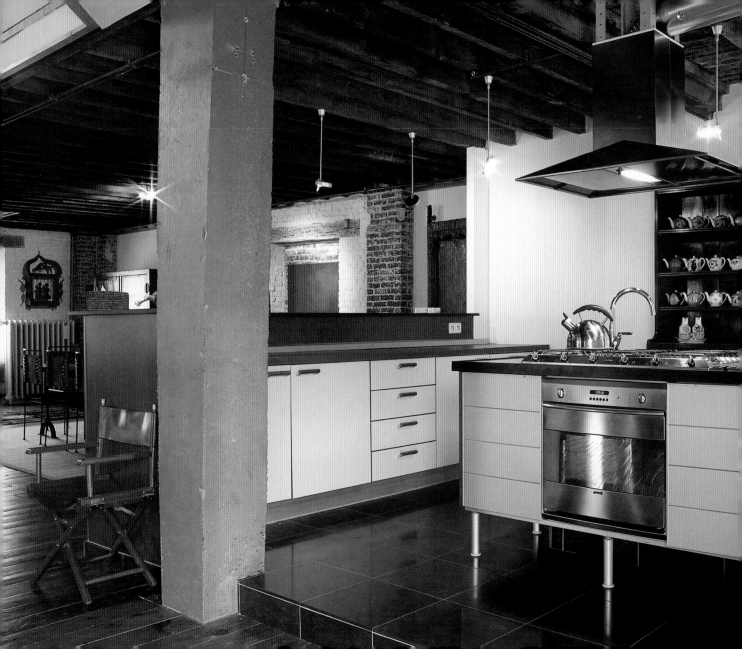

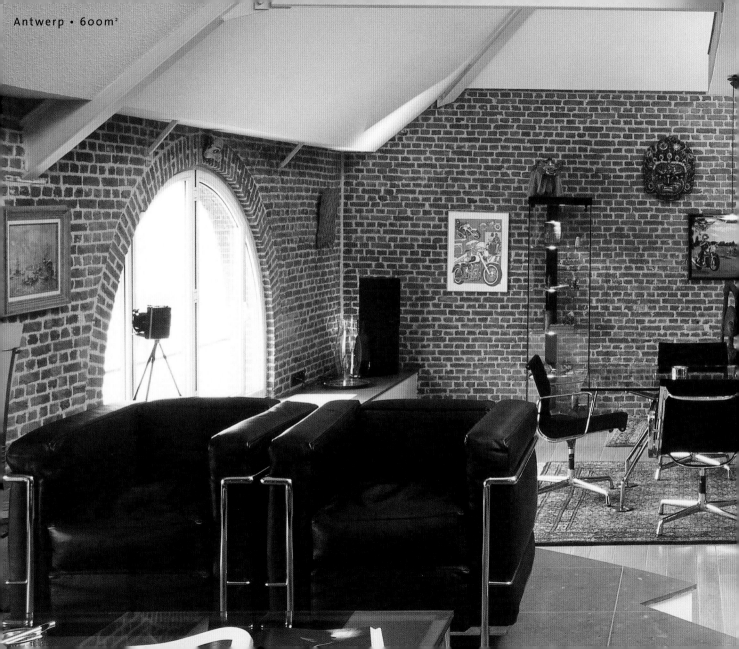

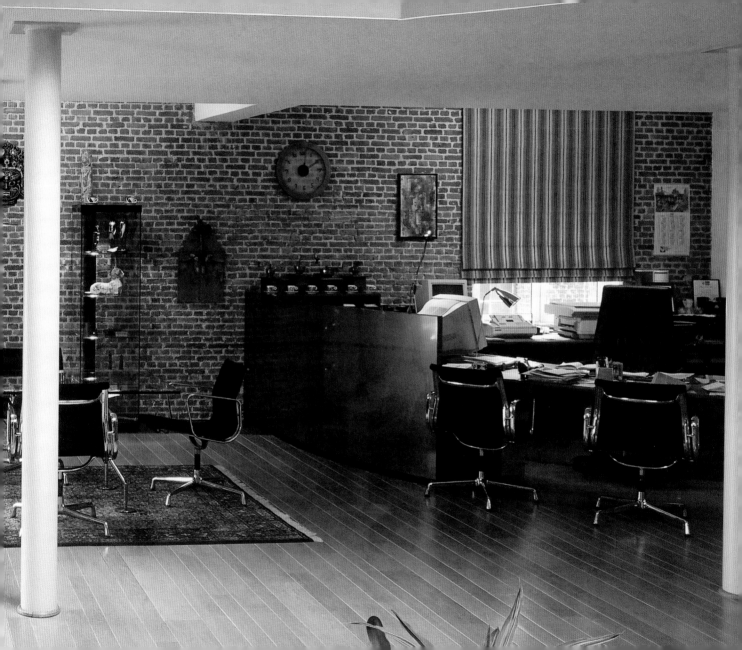

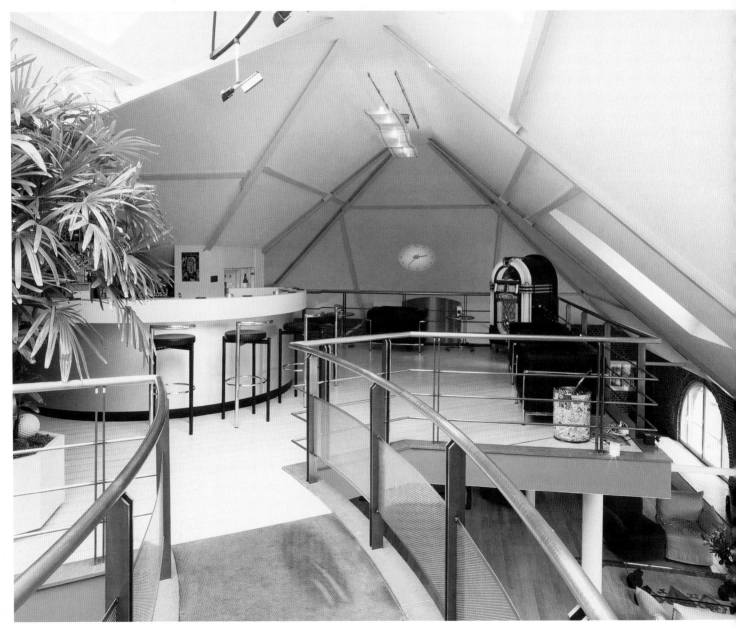

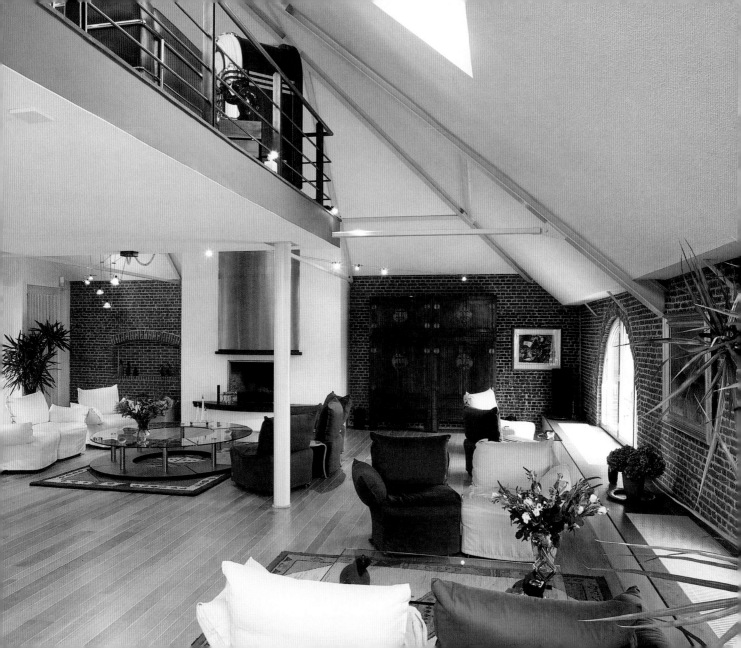

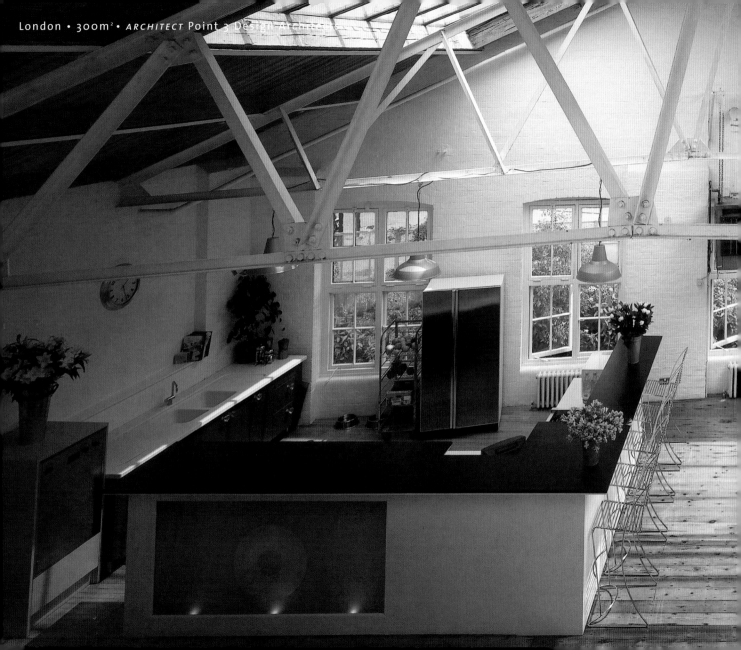

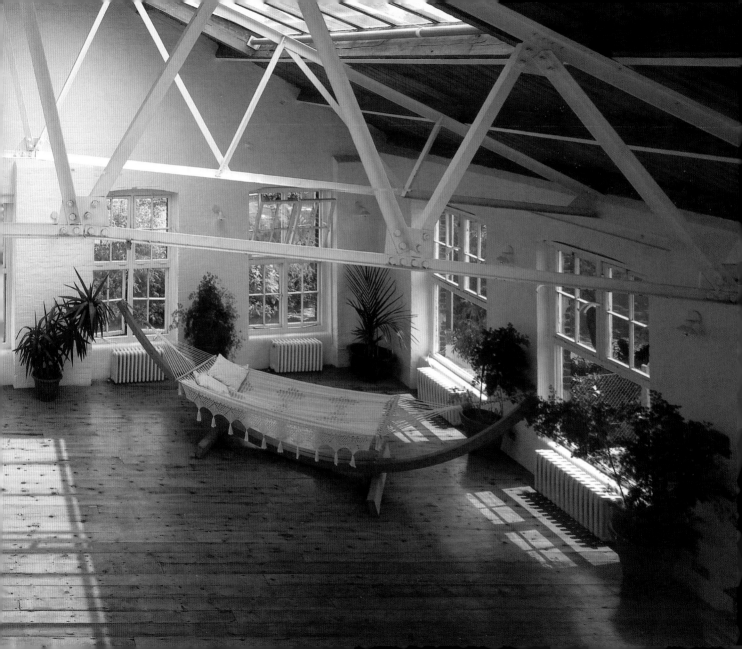

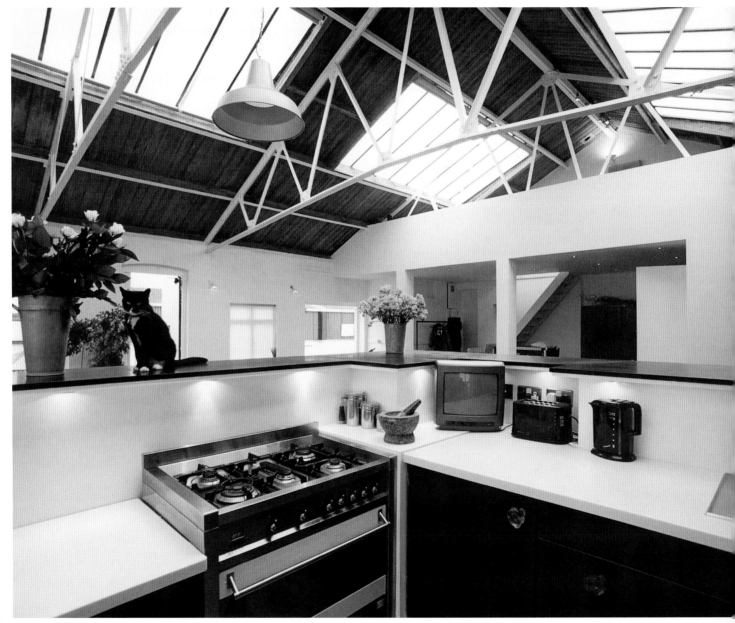

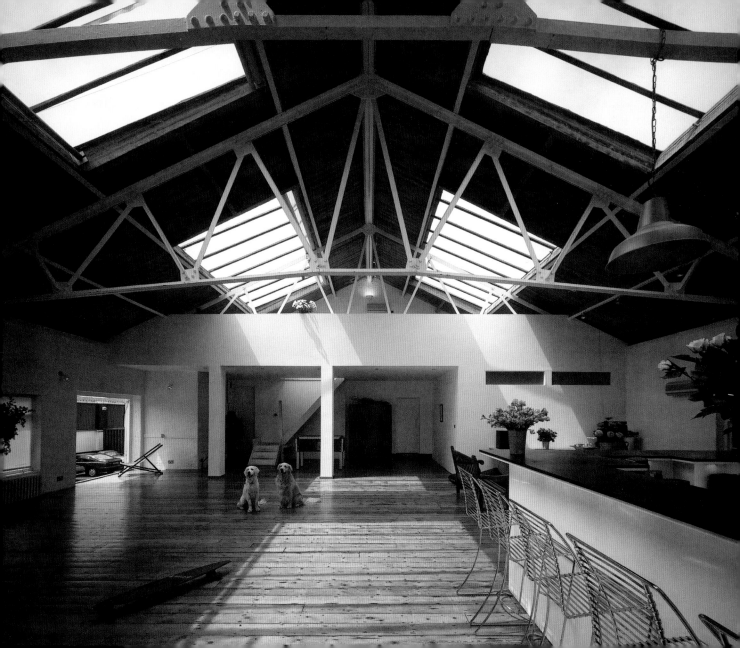

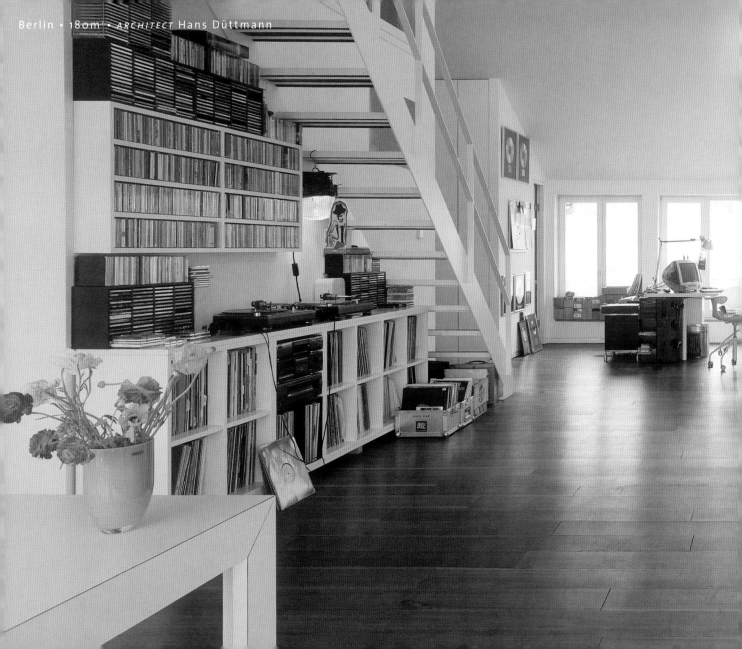

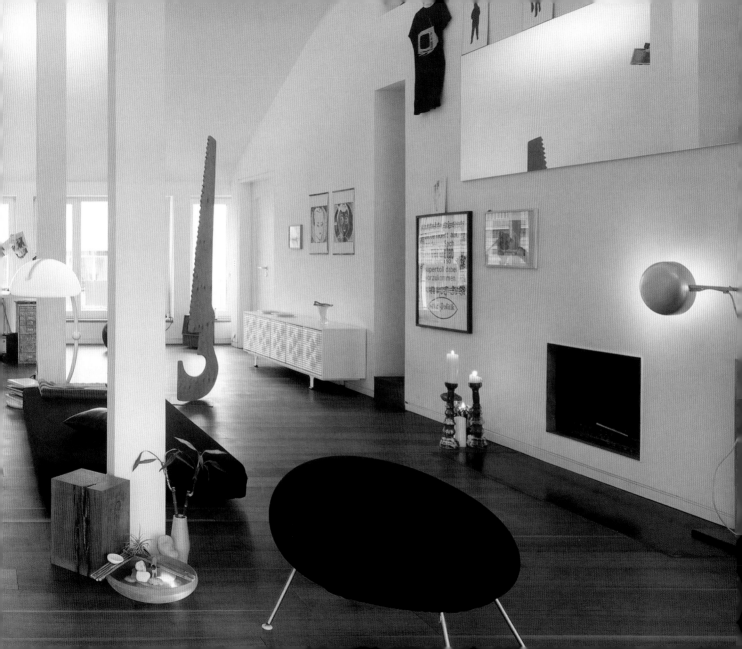

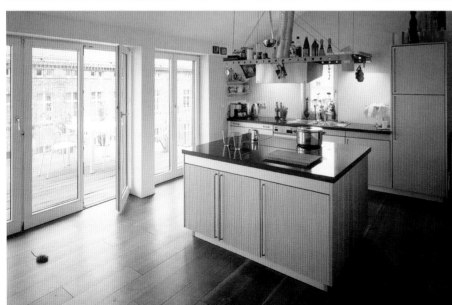

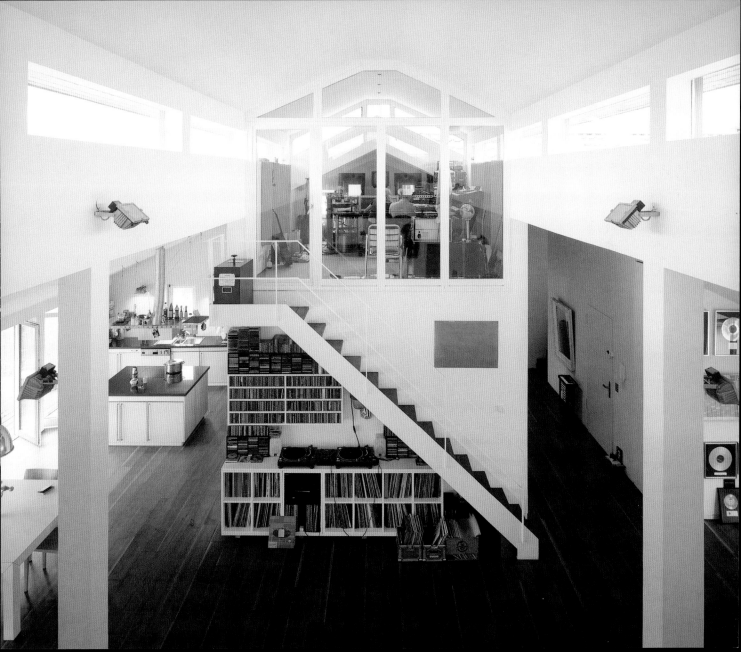

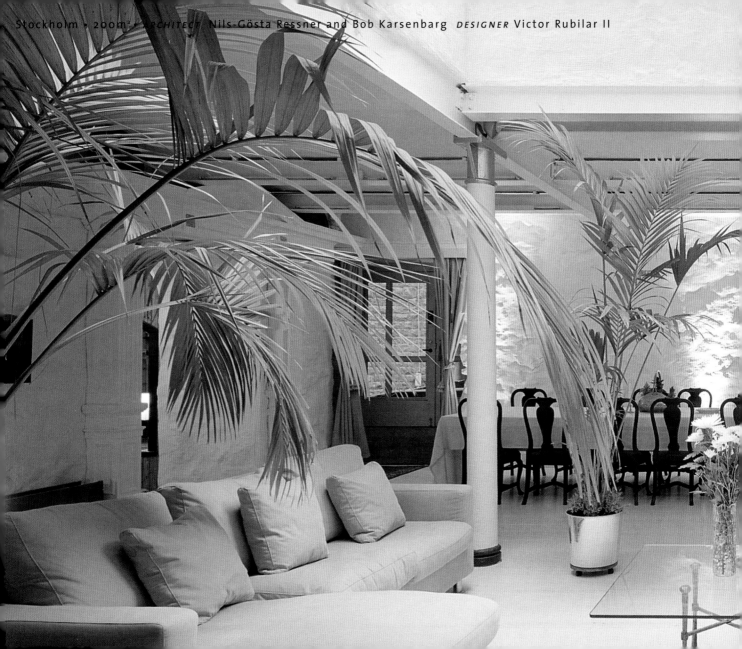

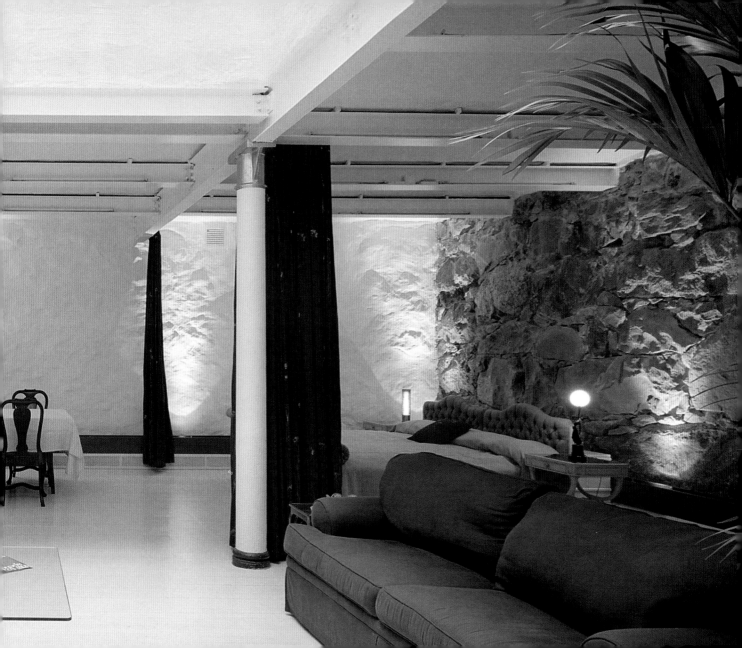

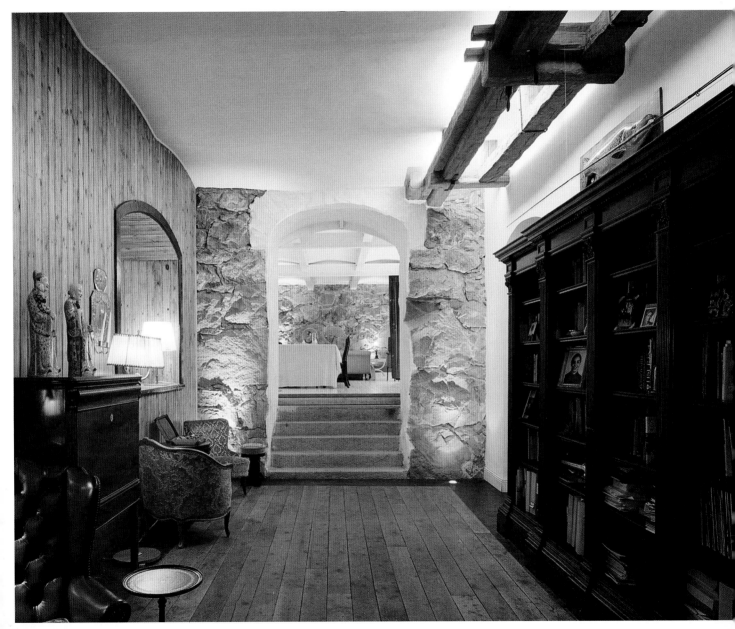

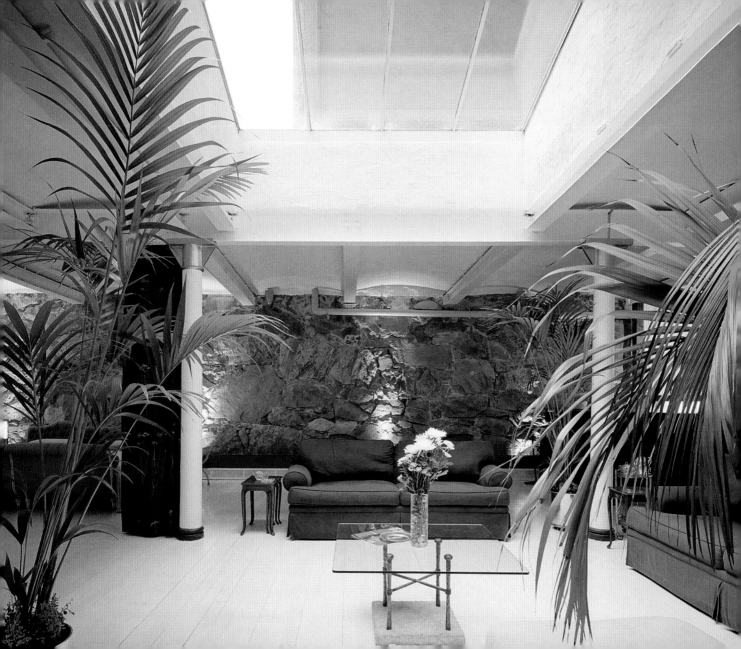

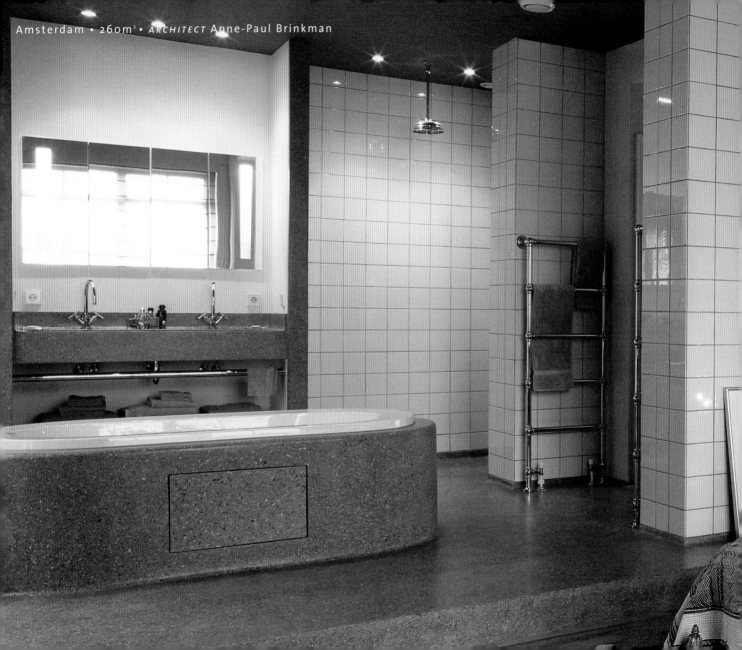

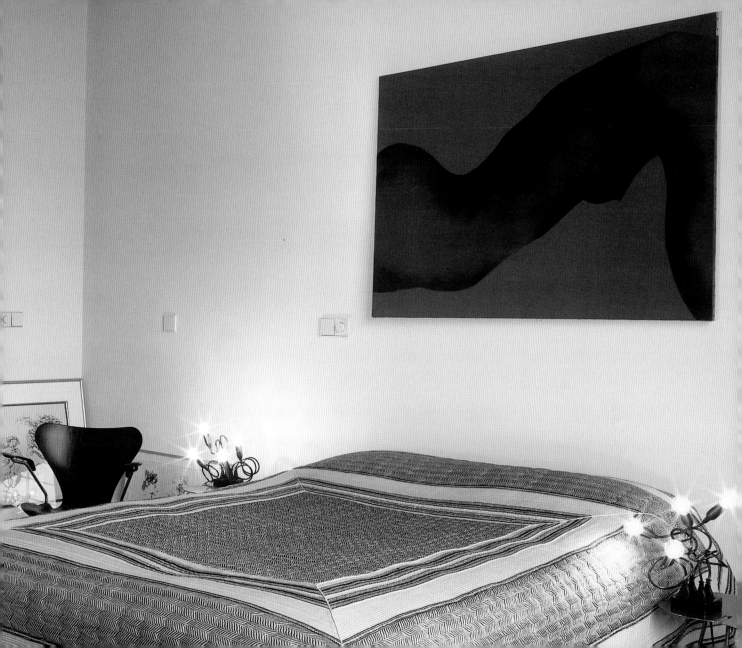

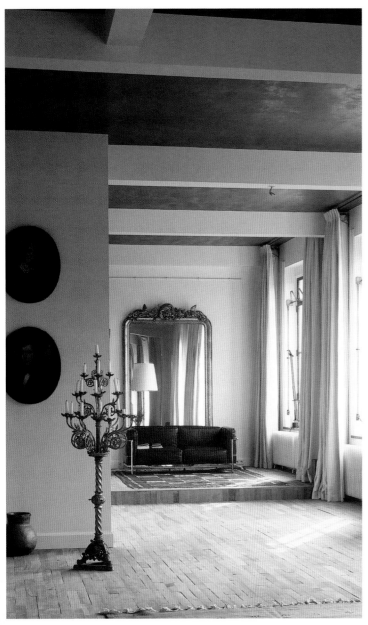
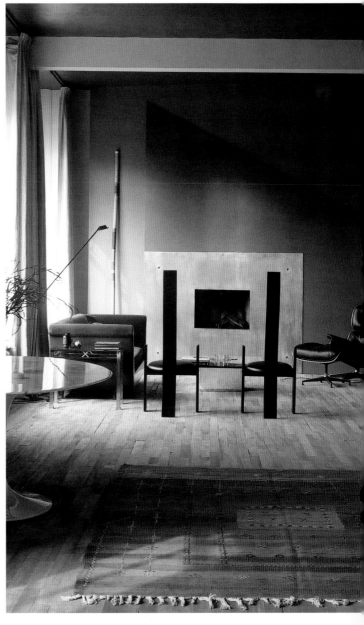

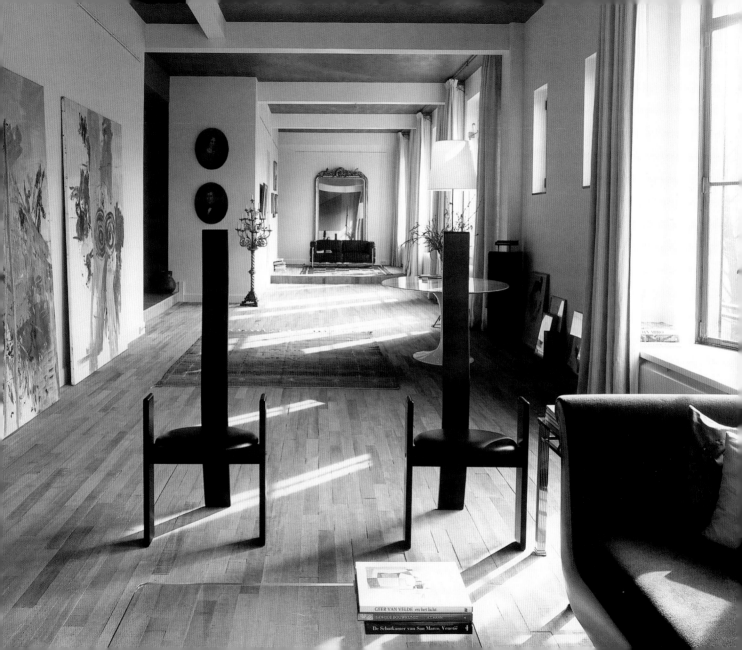

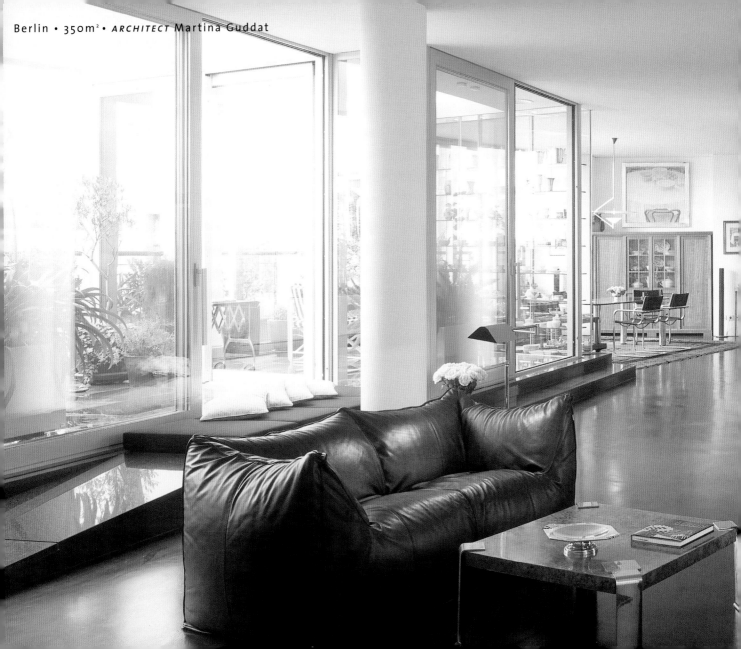

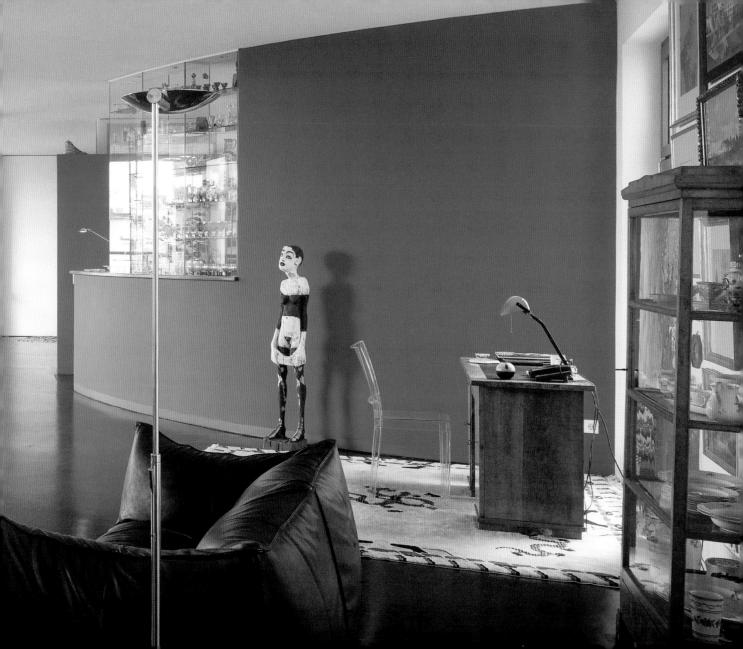

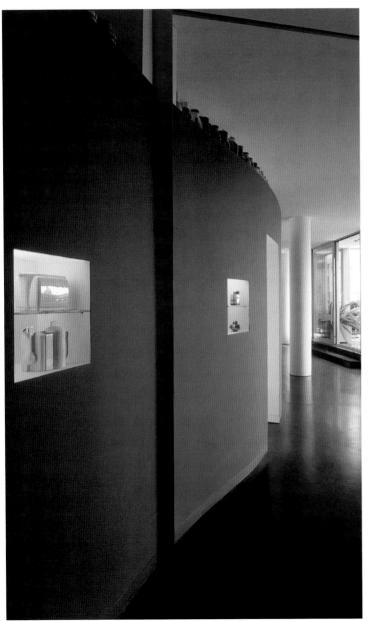
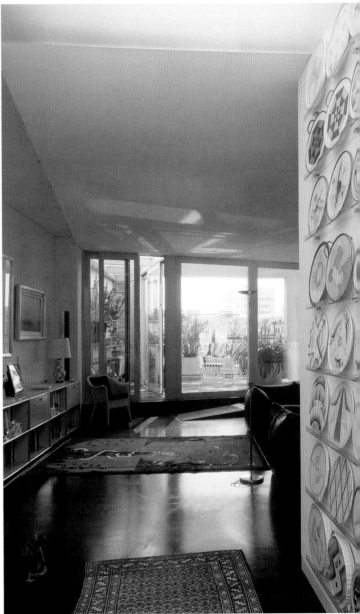

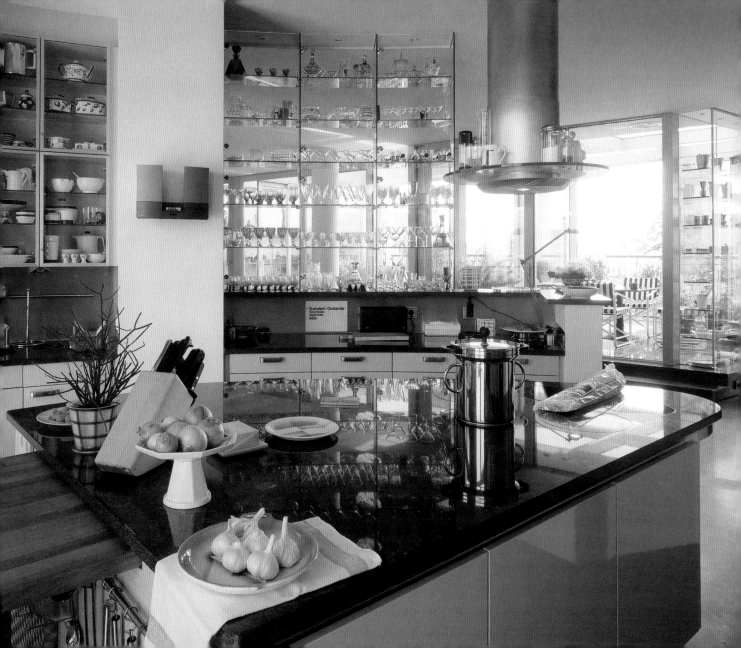

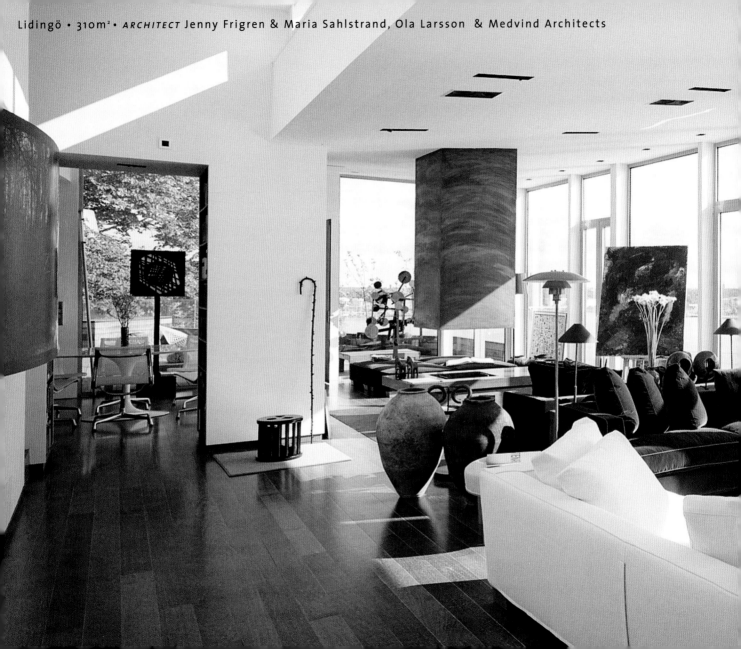

Lidingö • 310m² • *ARCHITECT* Jenny Frigren & Maria Sahlstrand, Ola Larsson & Medvind Architects

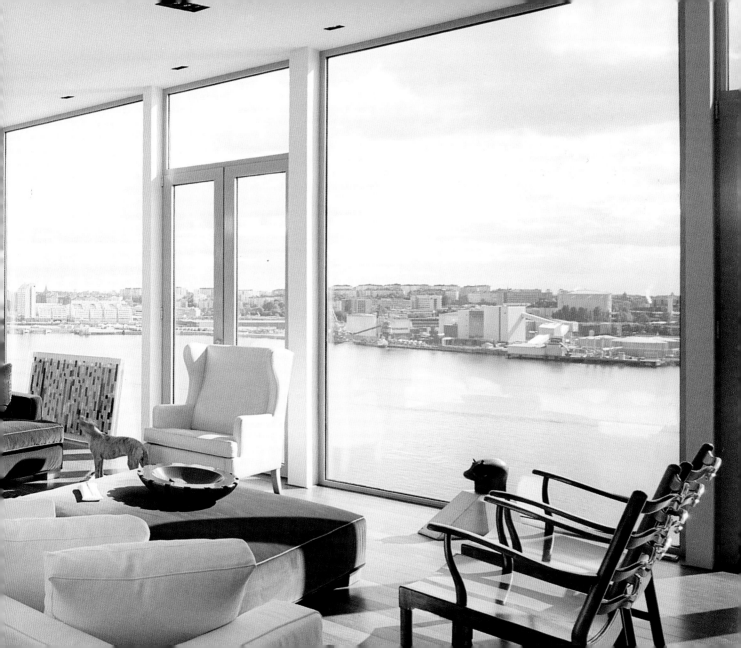

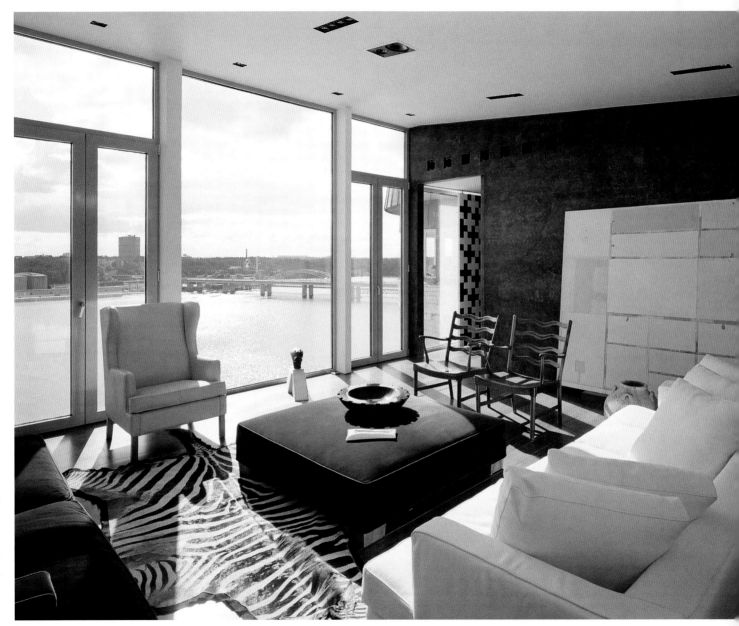

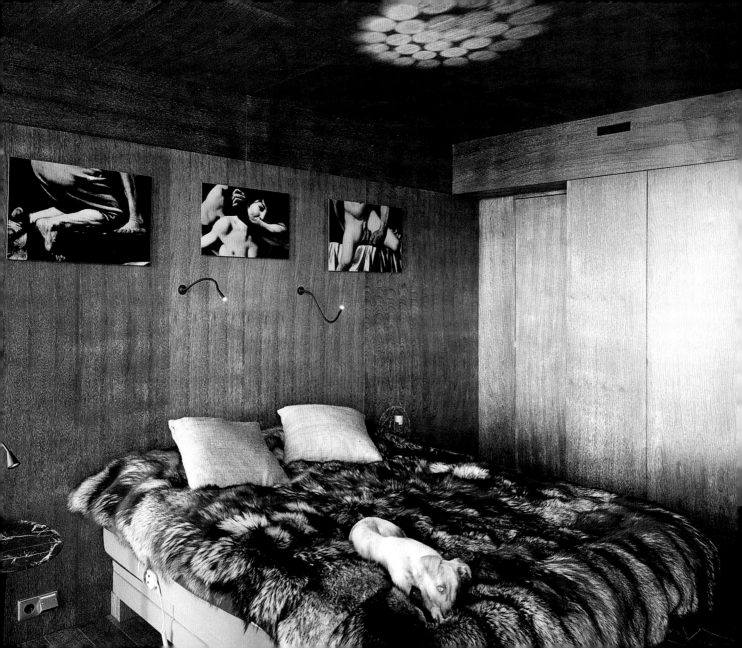

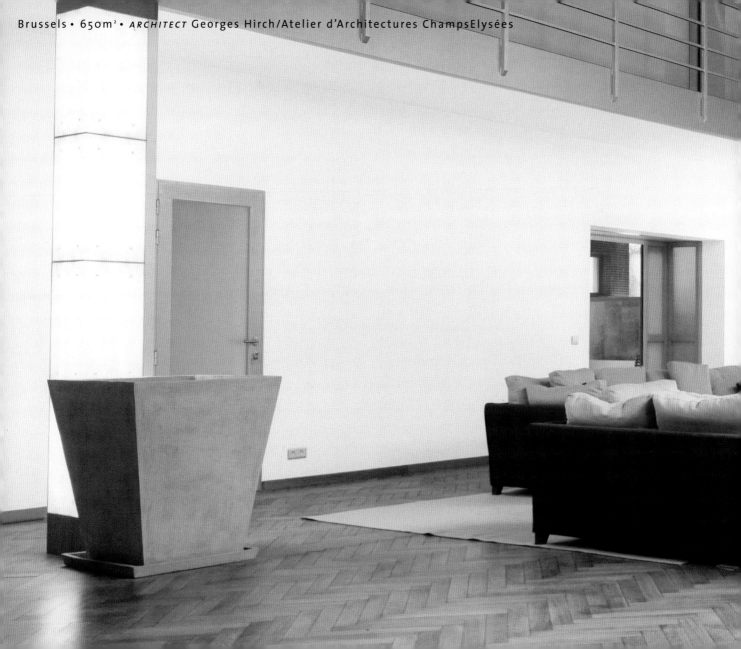

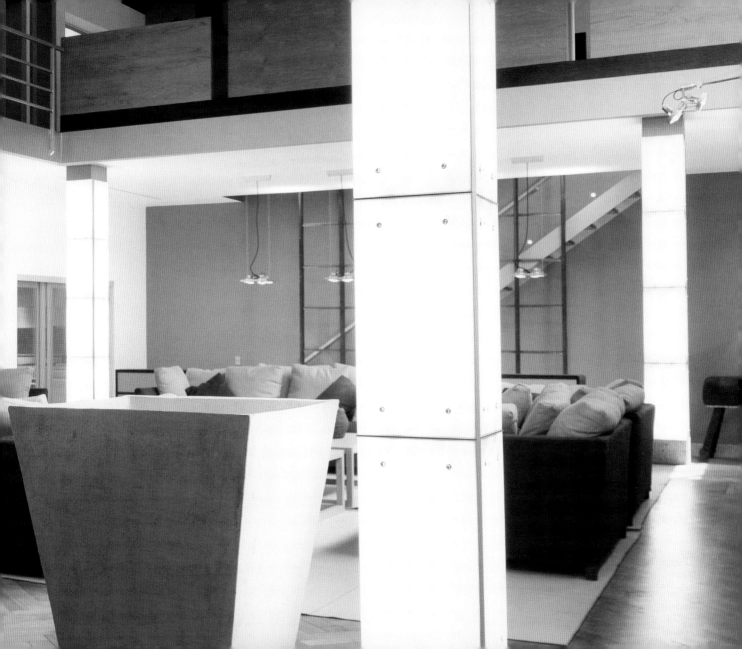

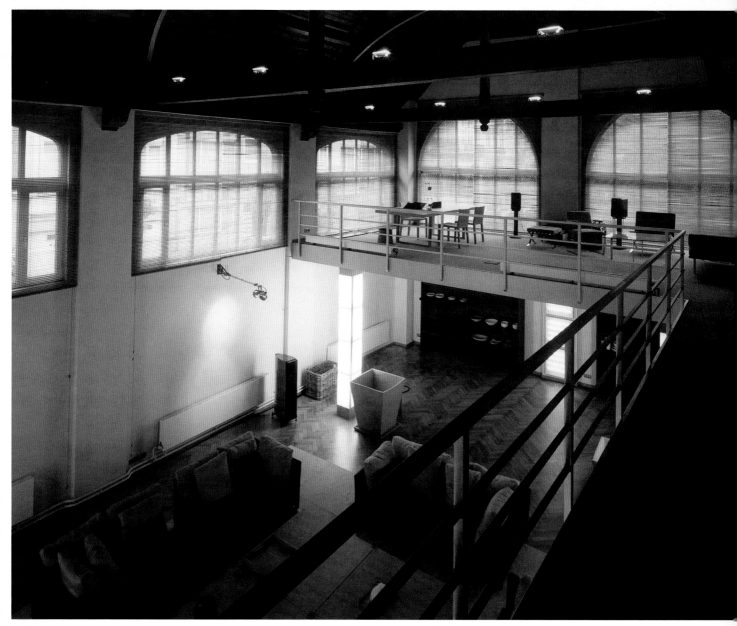

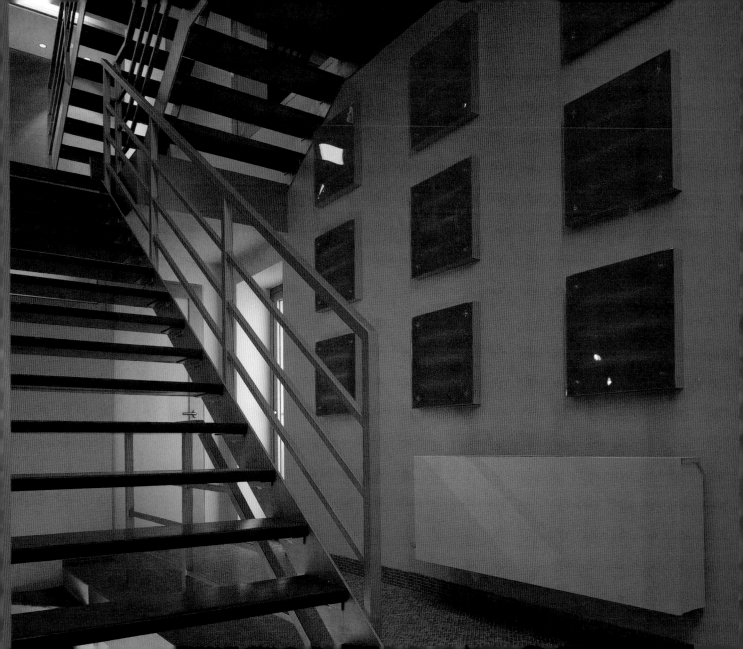

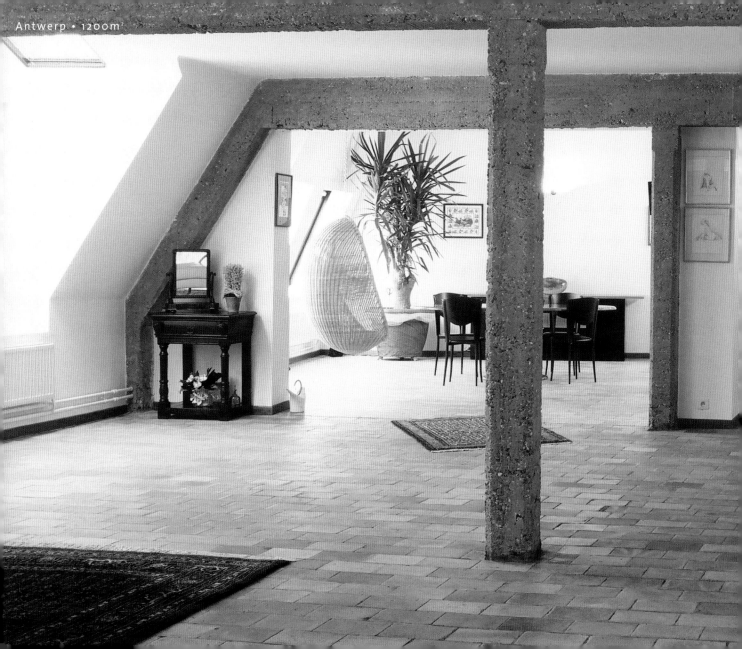

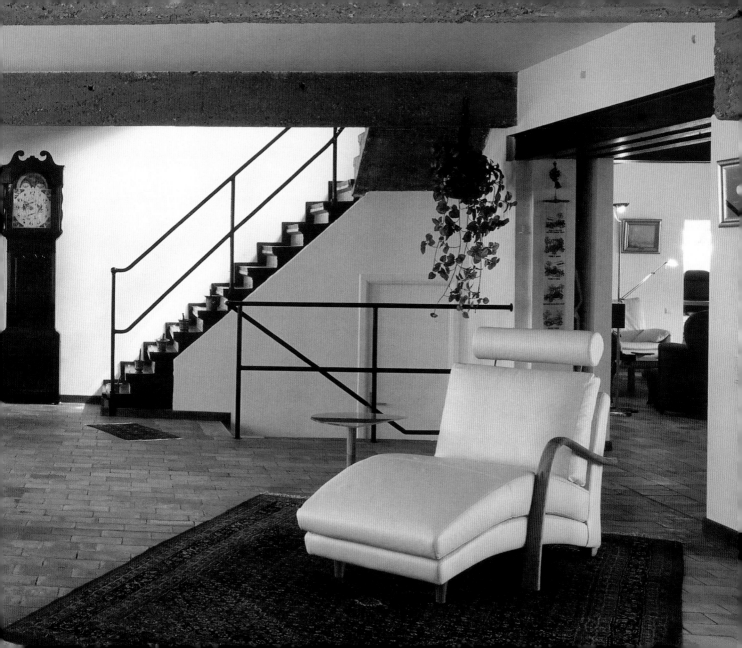

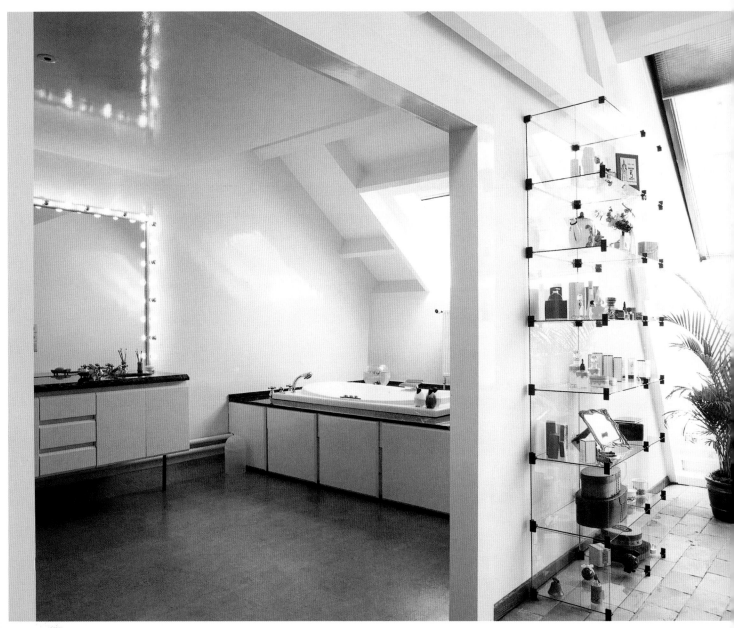

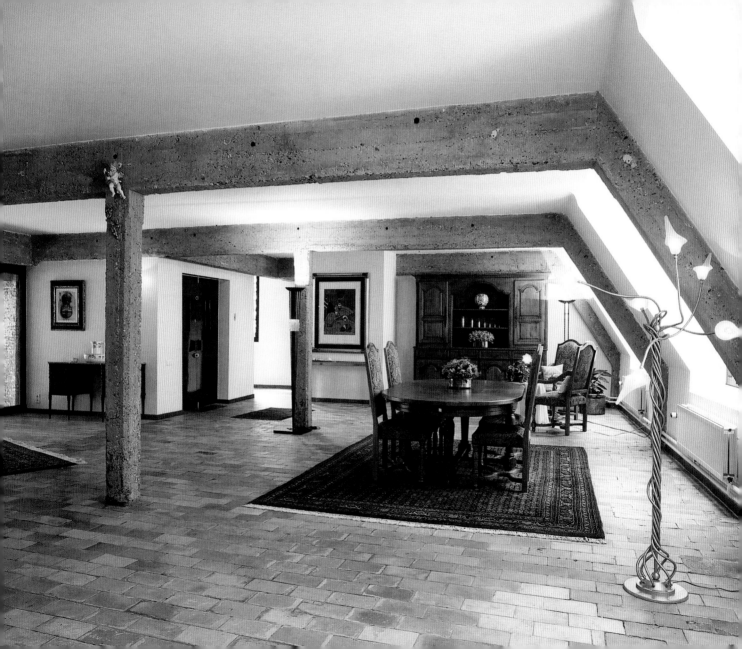

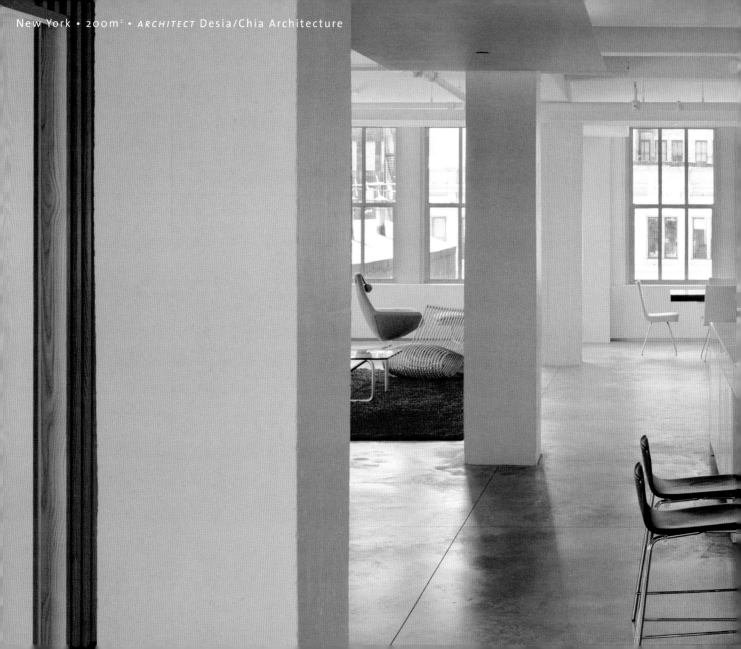

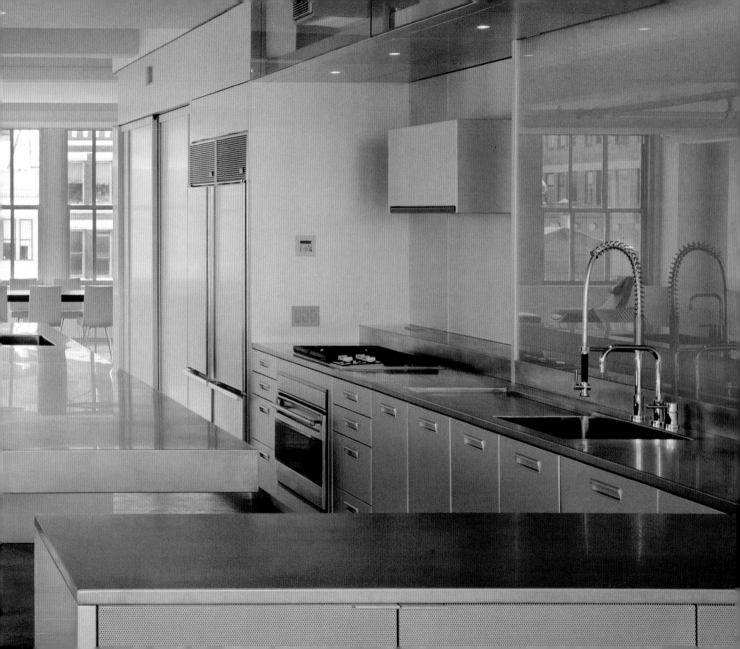

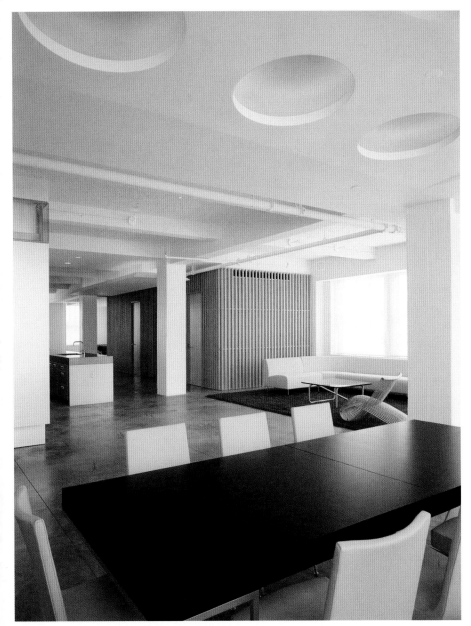

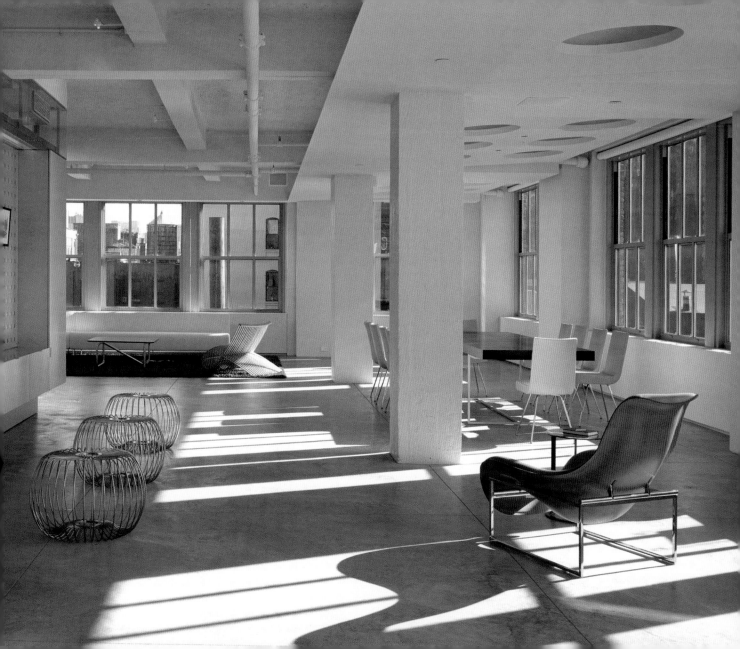

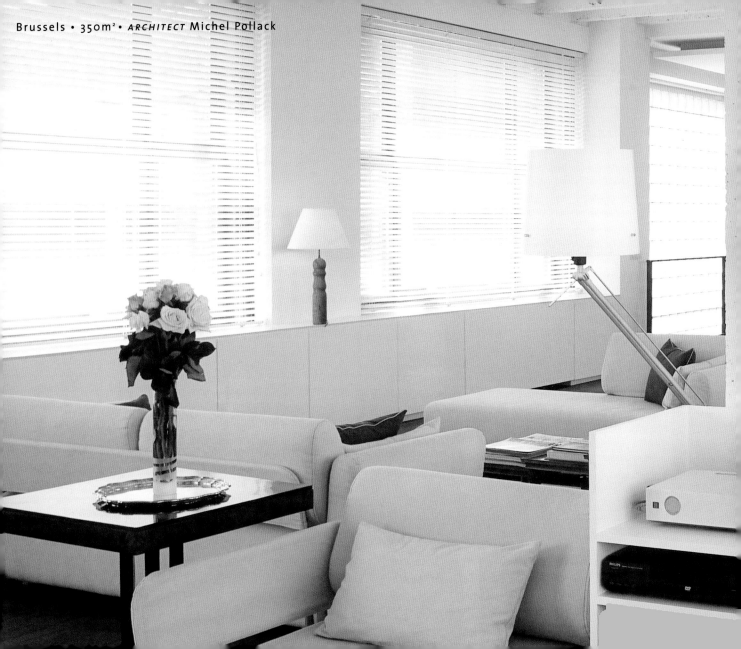

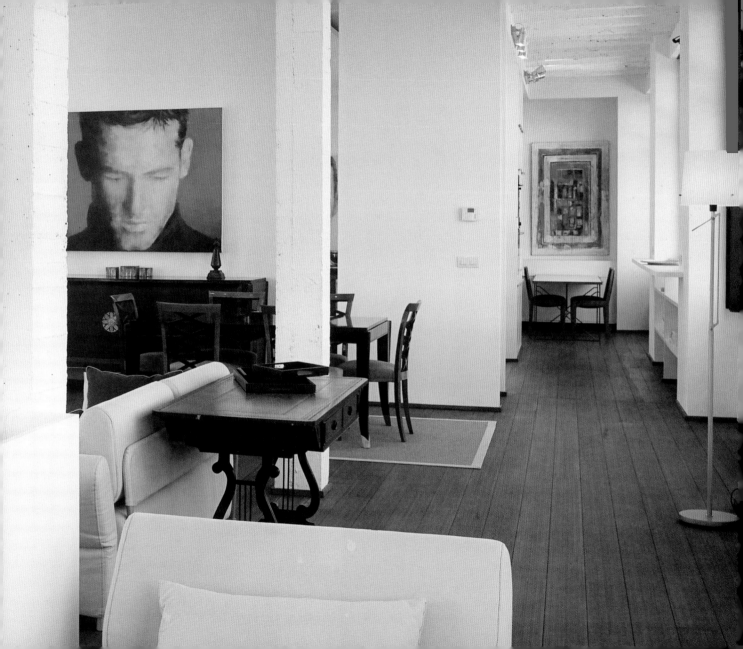

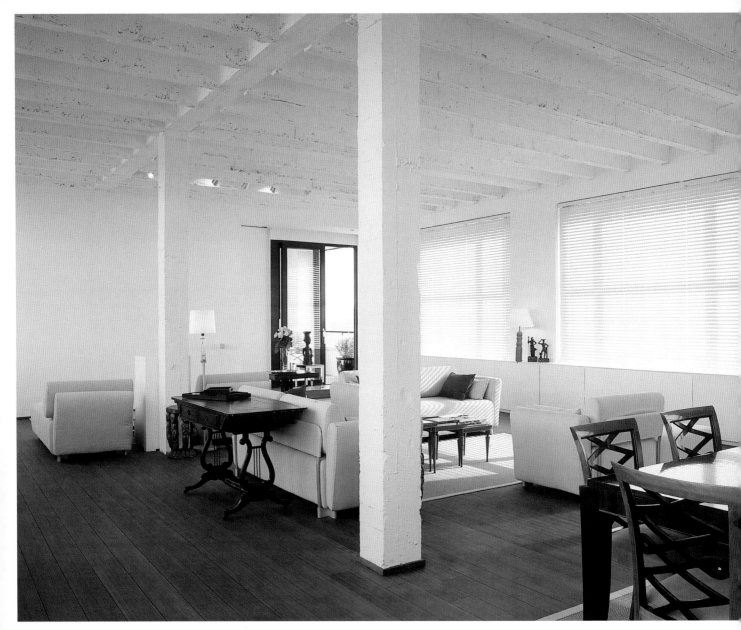

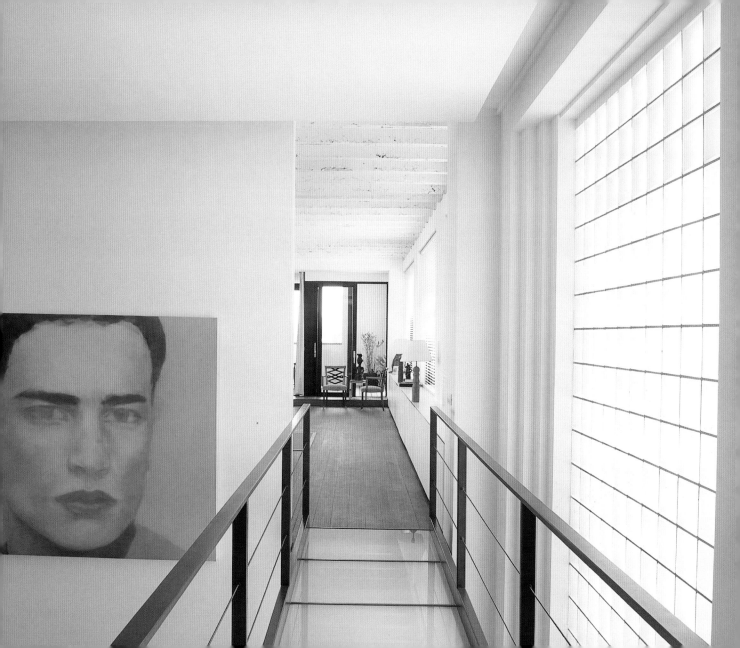

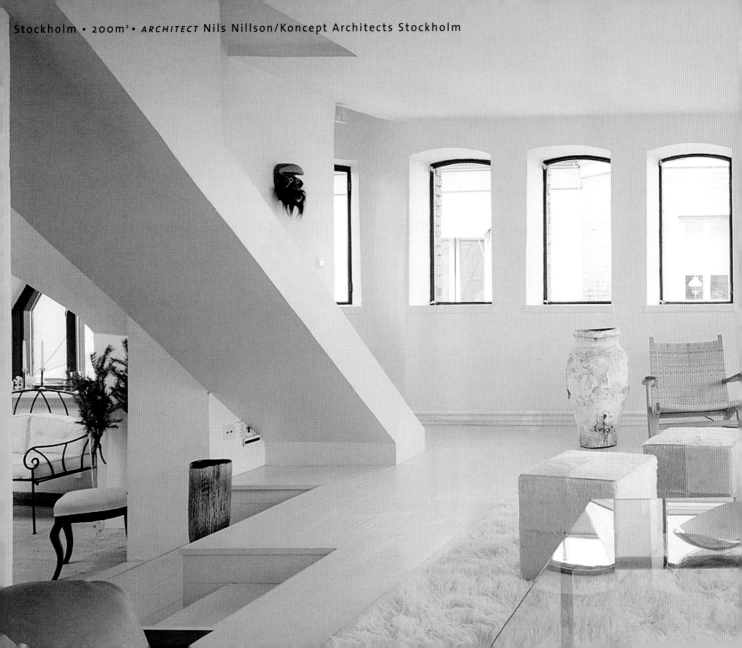

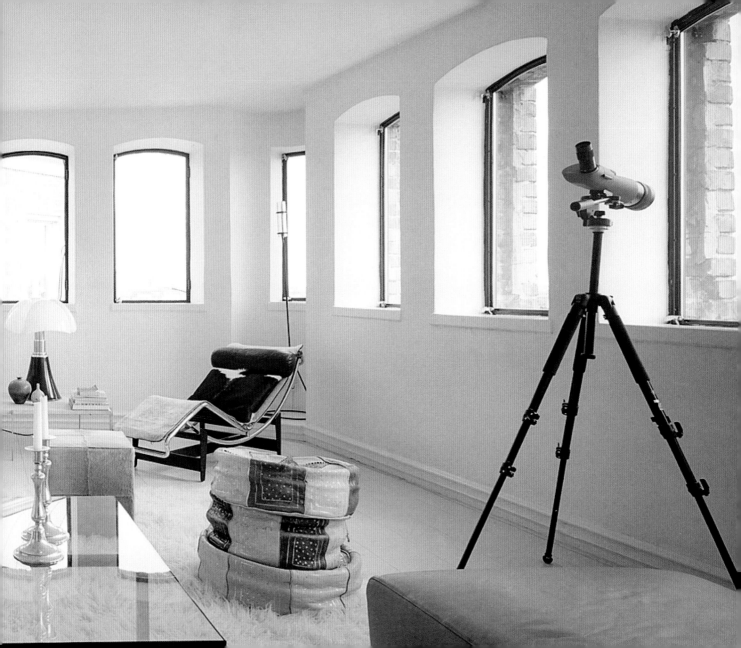

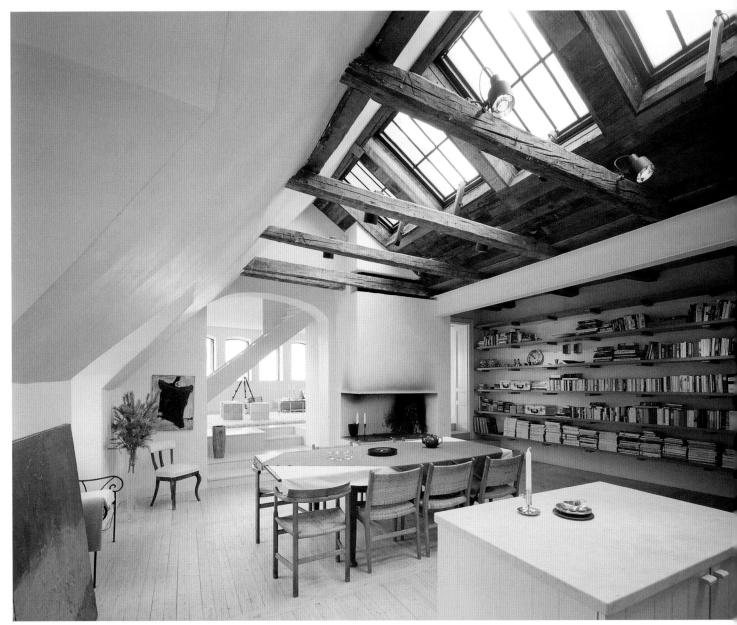

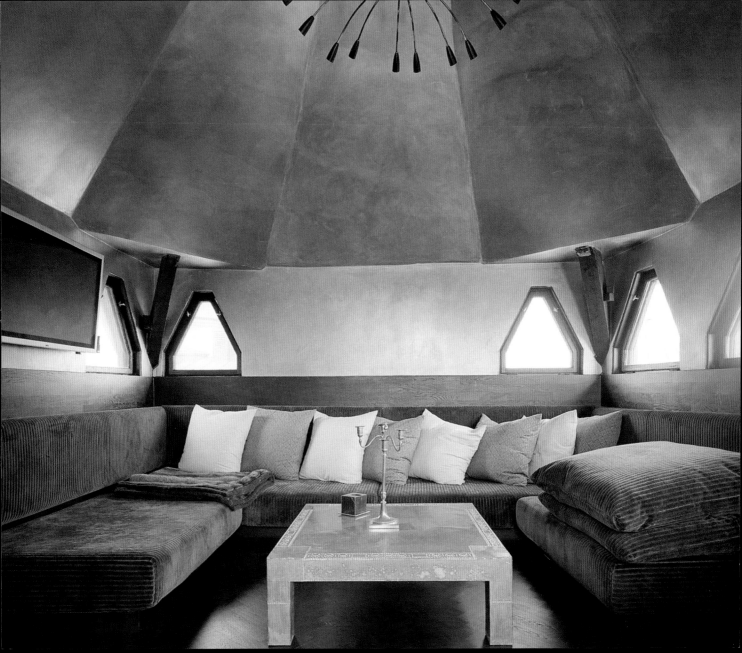

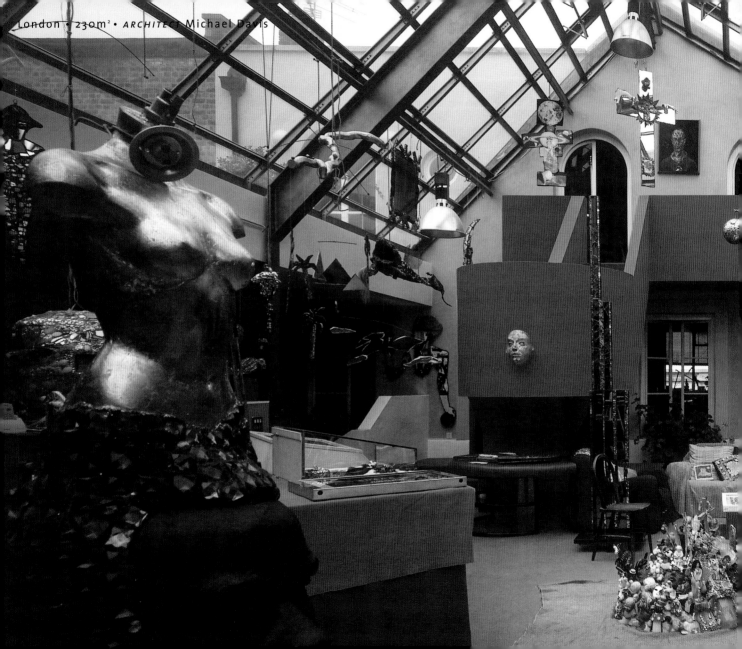

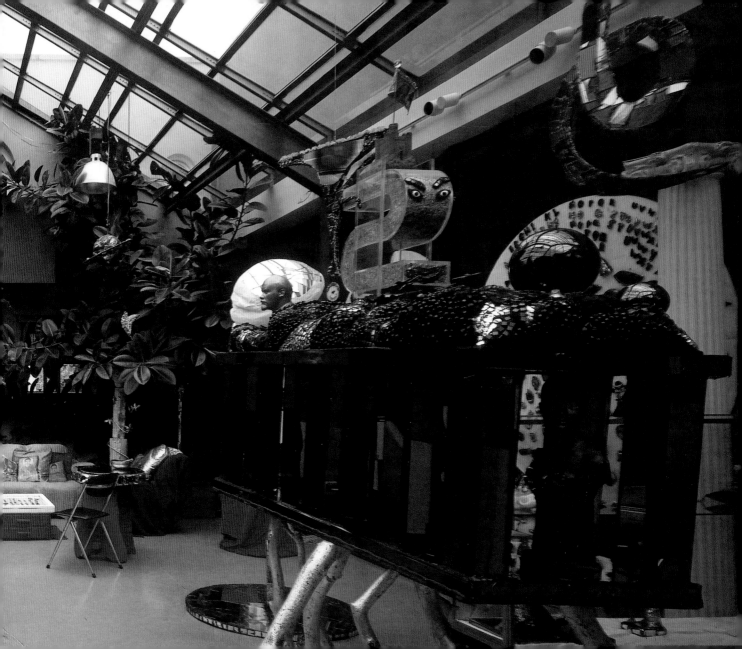

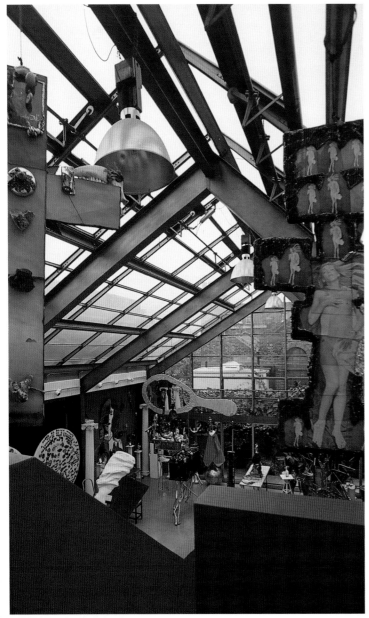
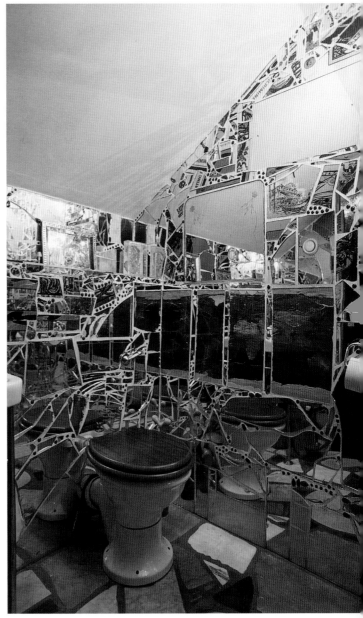

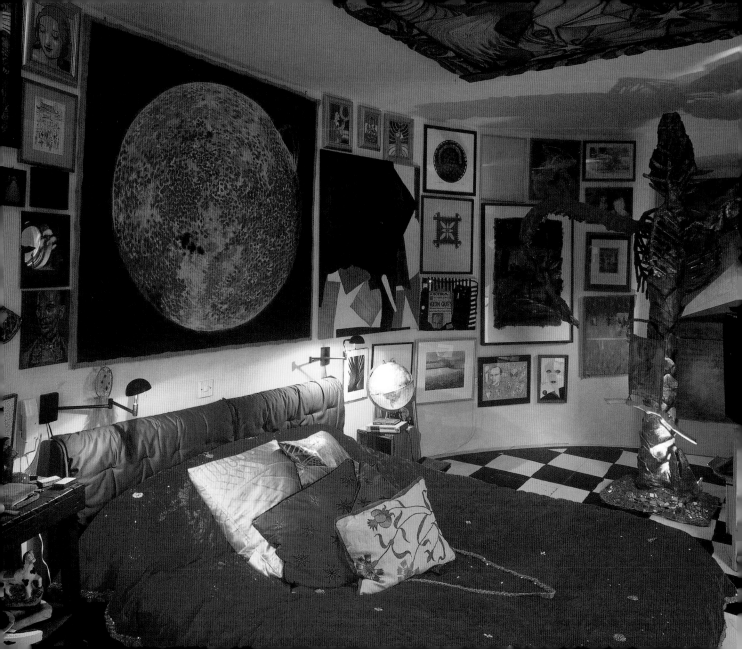

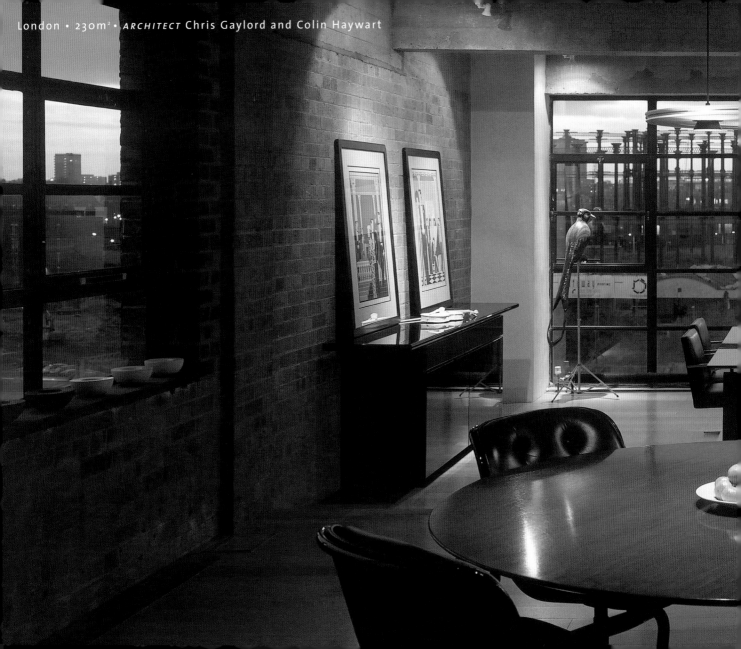

London • 230m² • *ARCHITECT* Chris Gaylord and Colin Haywart

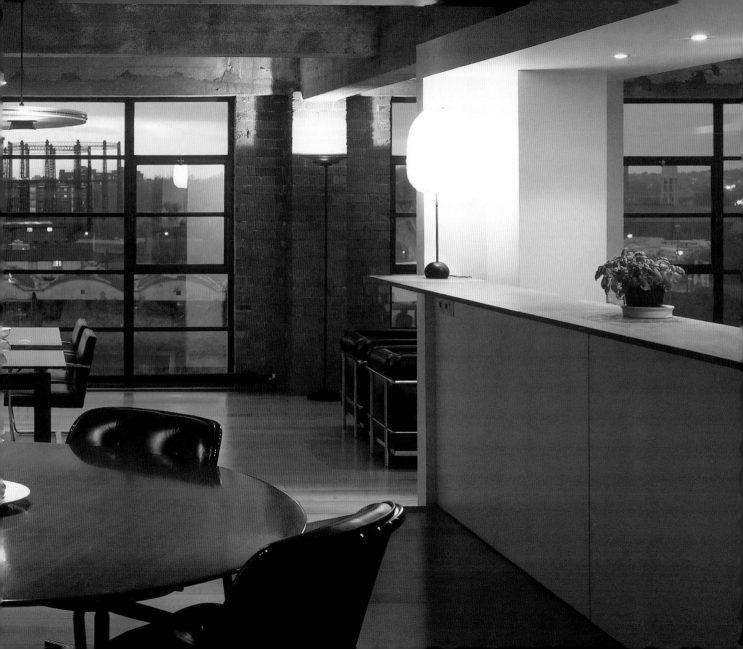

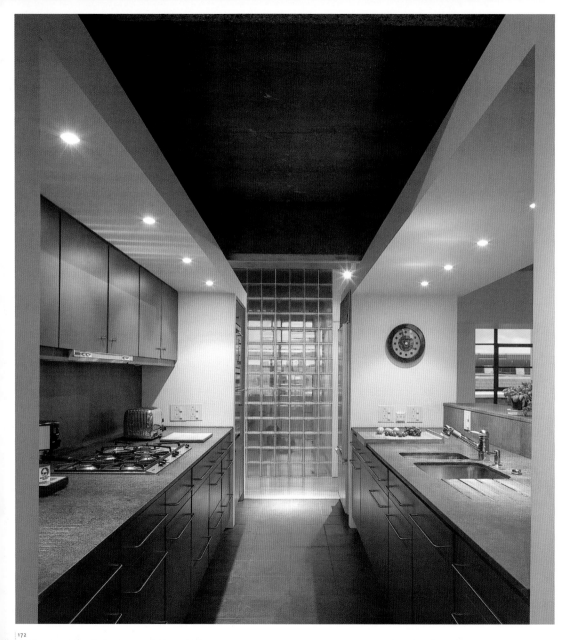

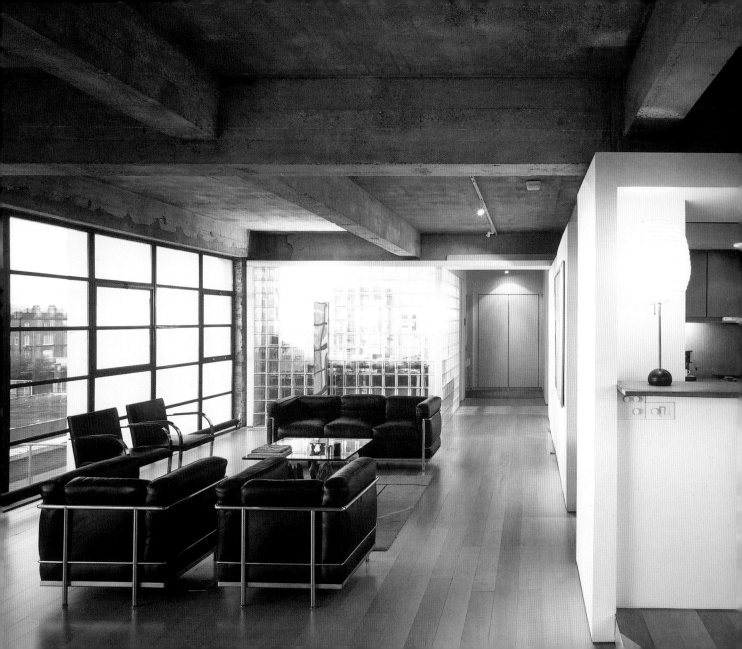

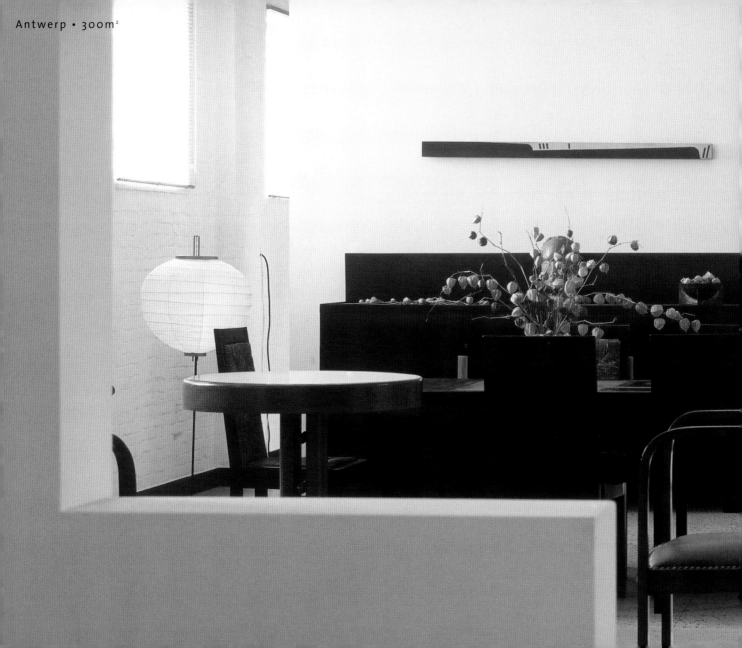

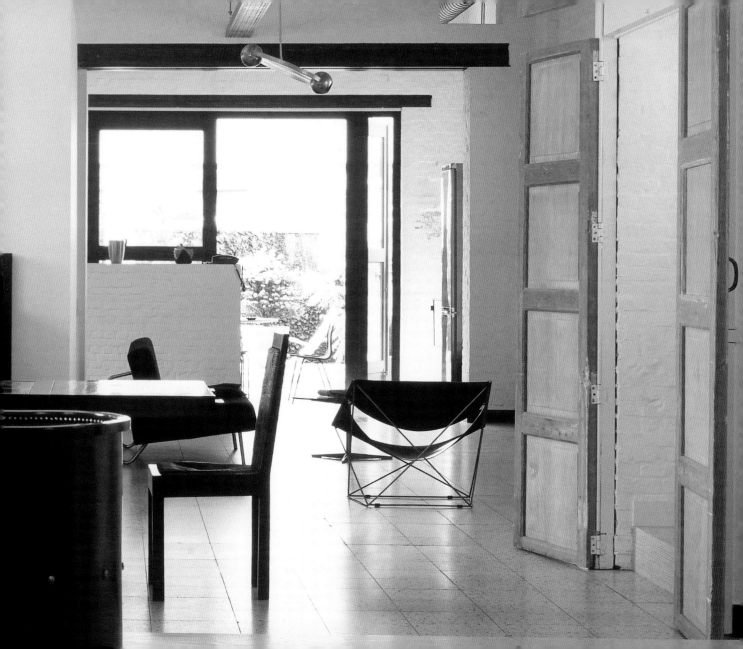

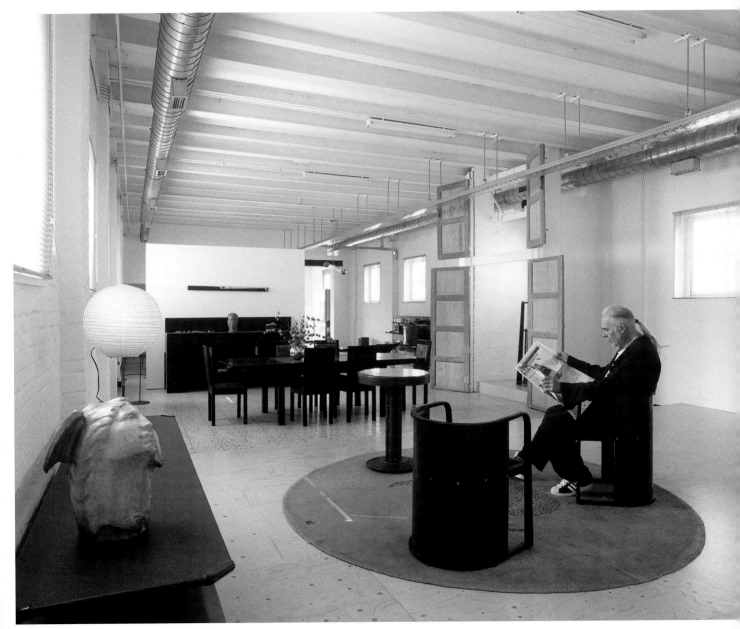

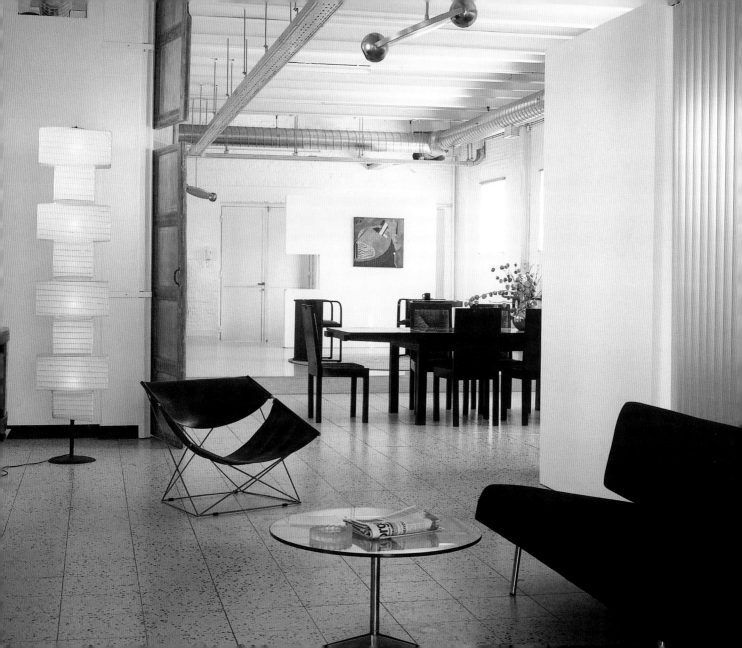

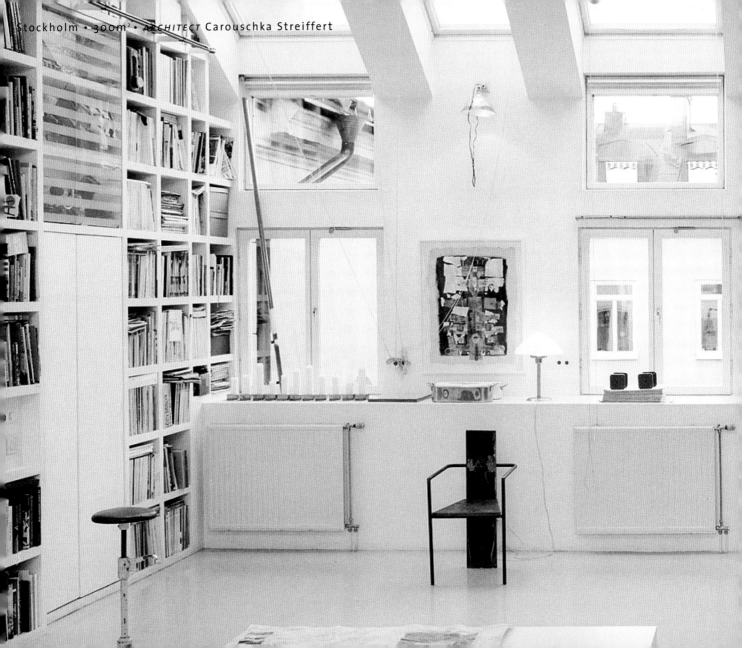

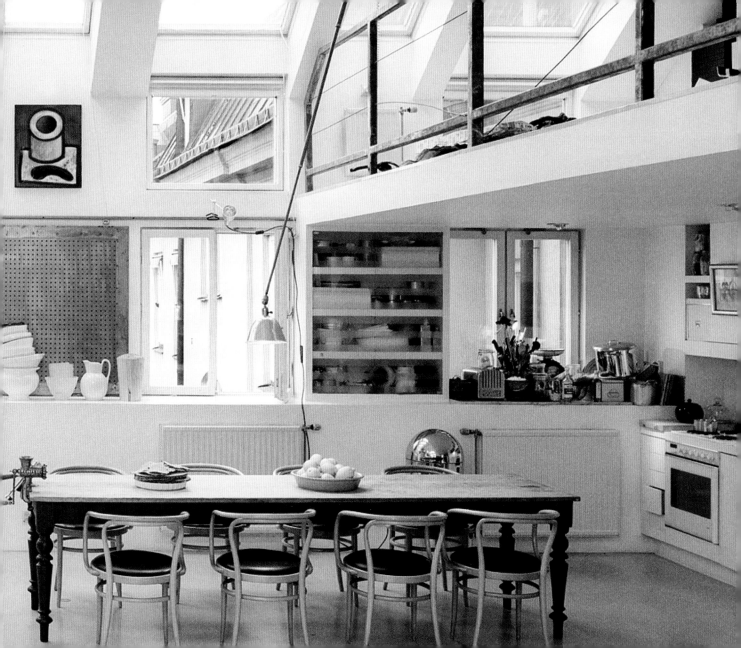

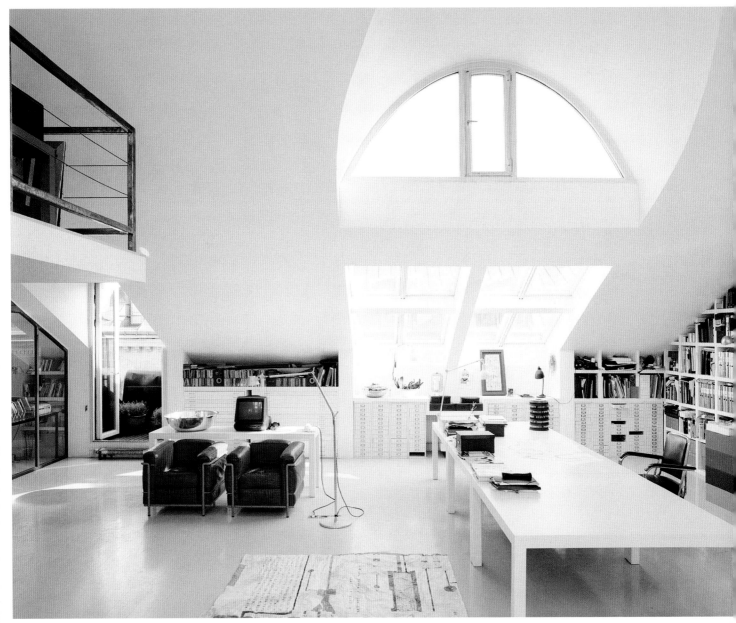

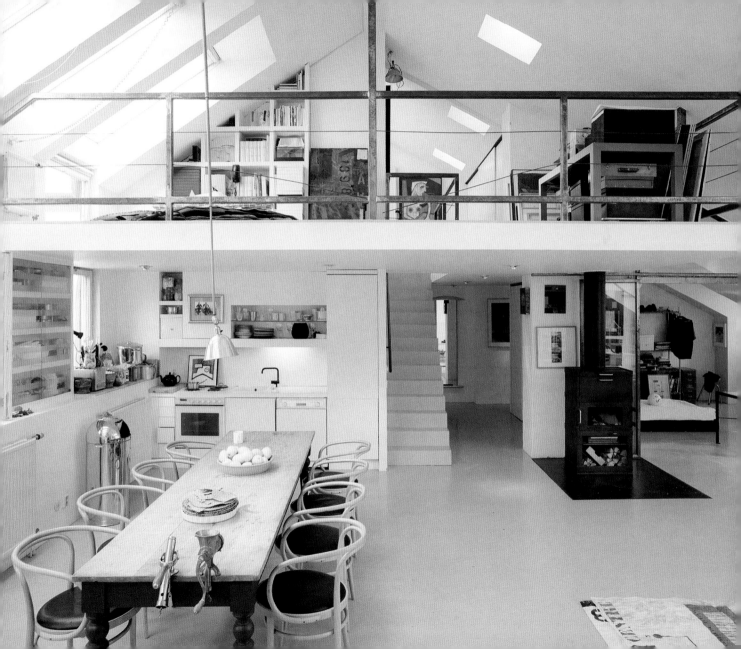

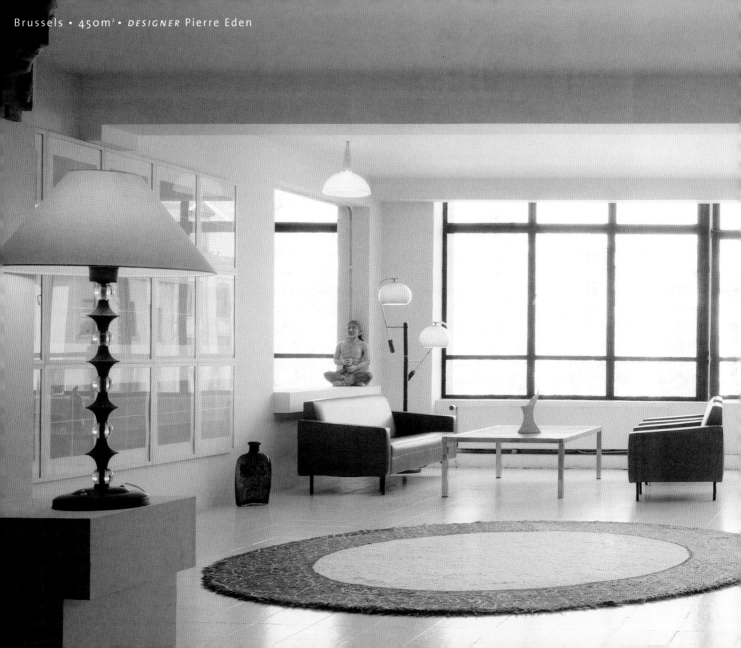

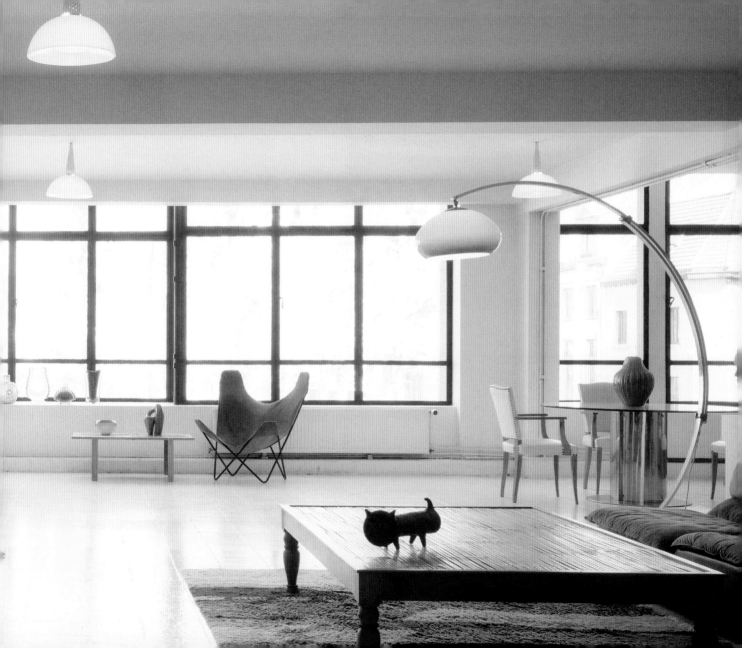

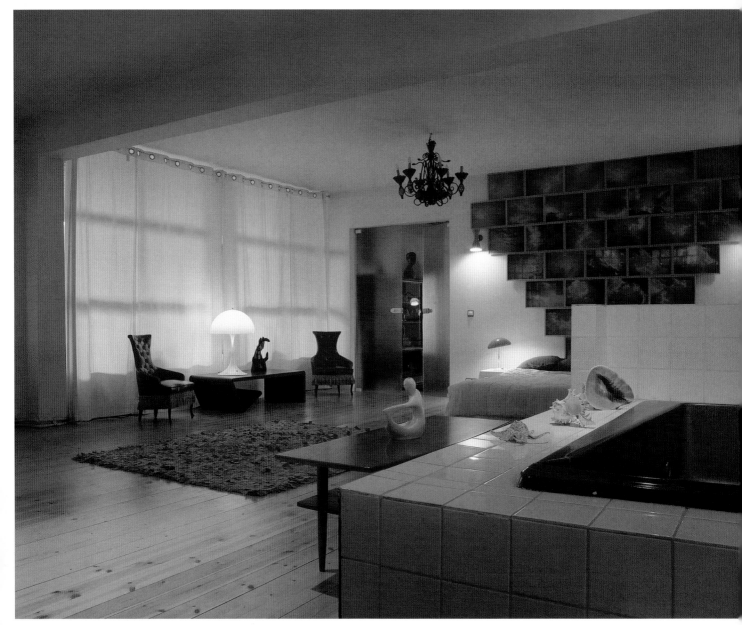

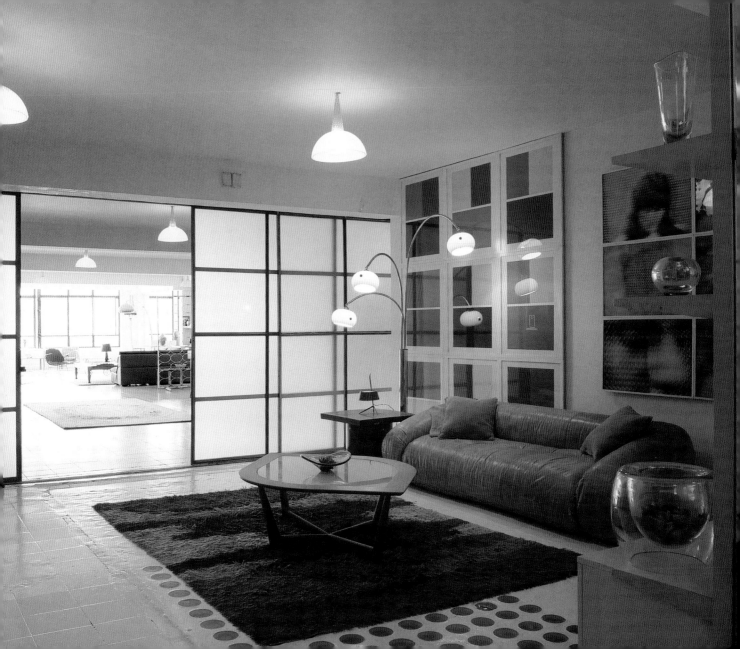

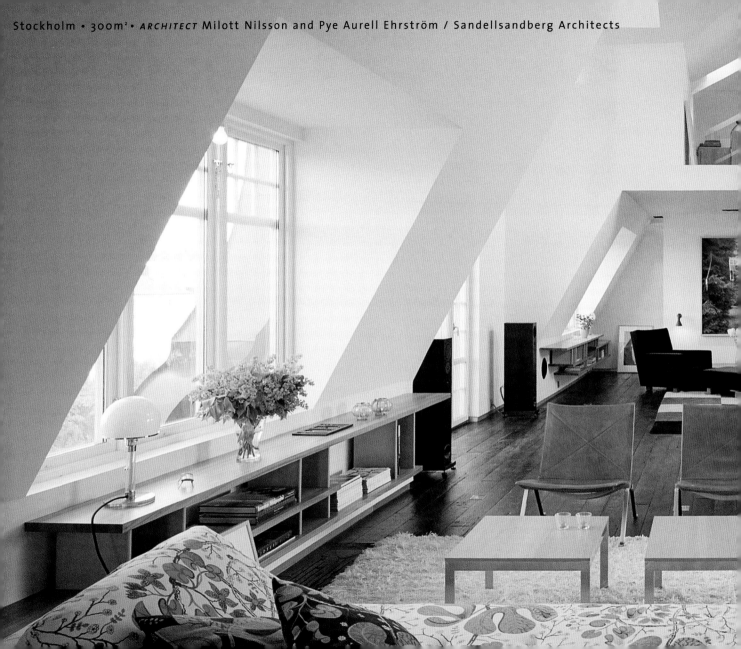

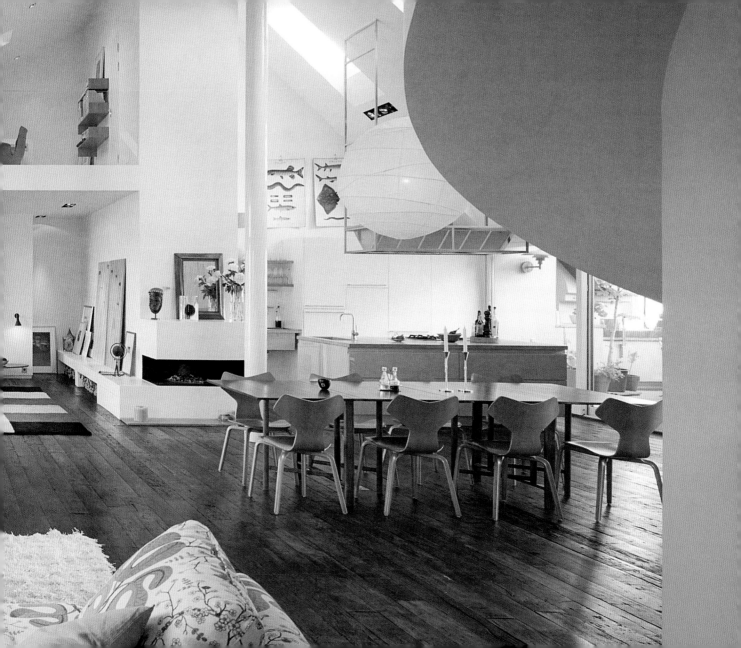

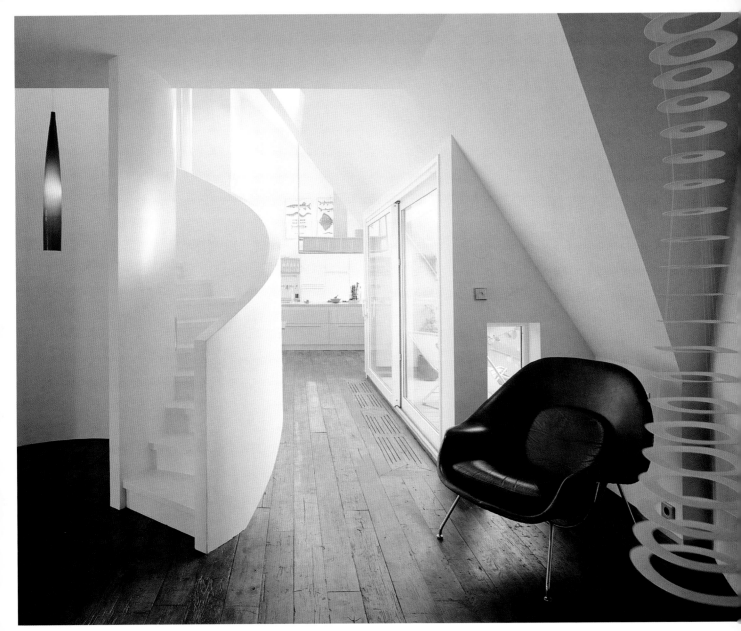

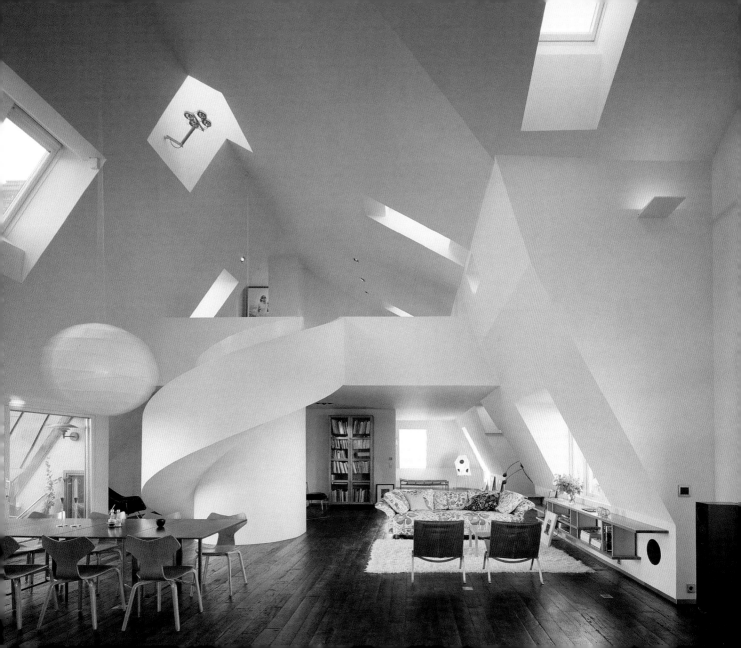

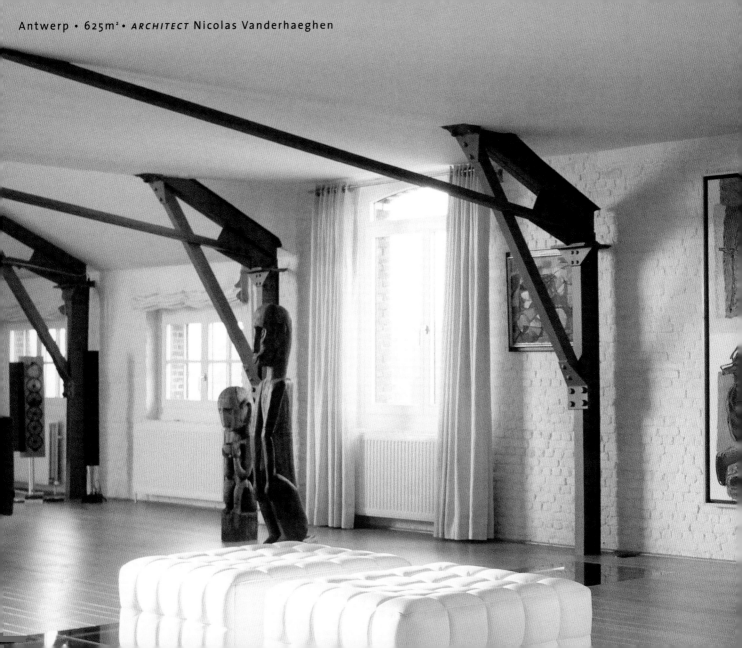

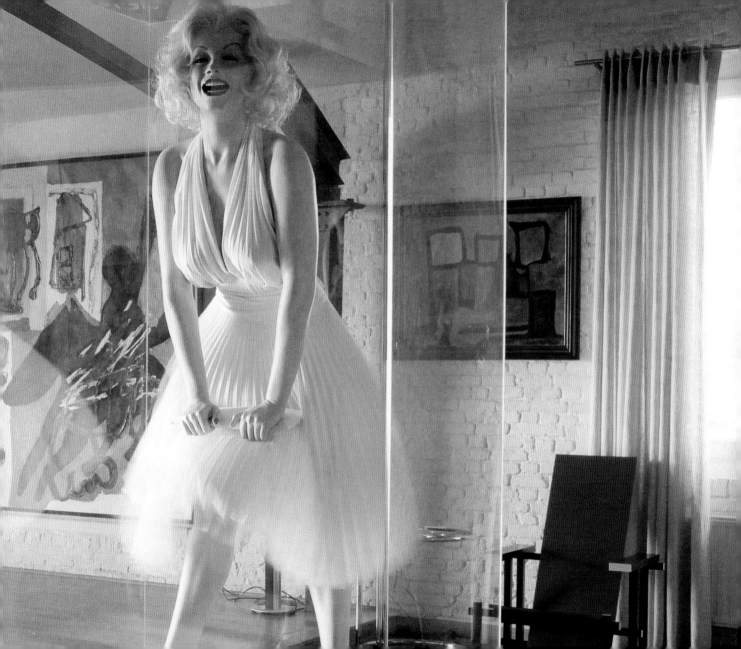

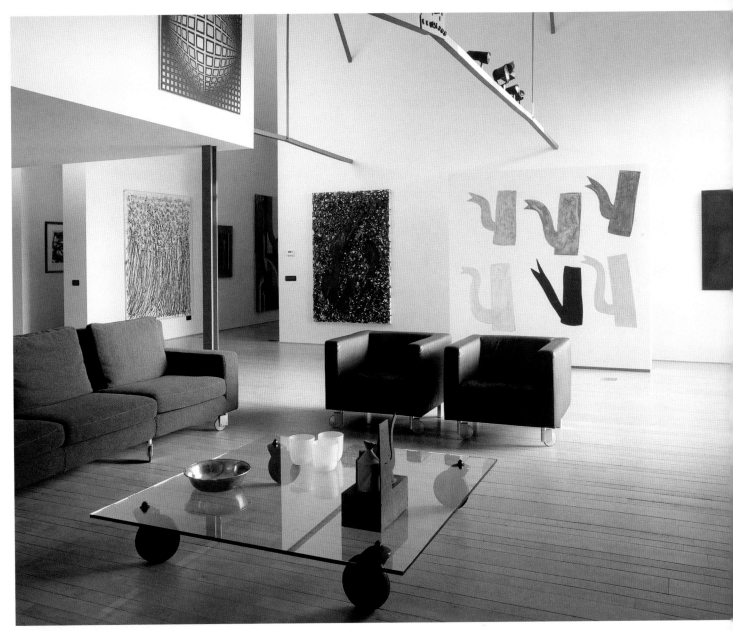

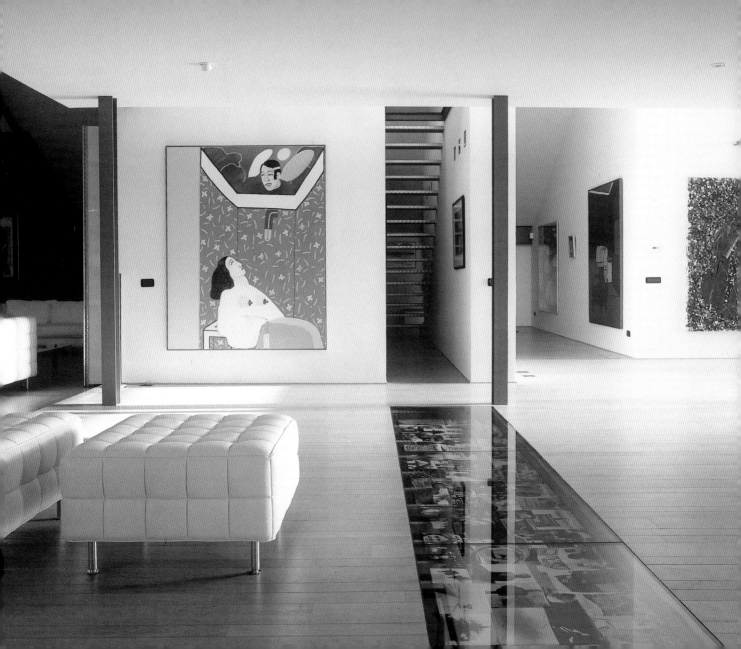

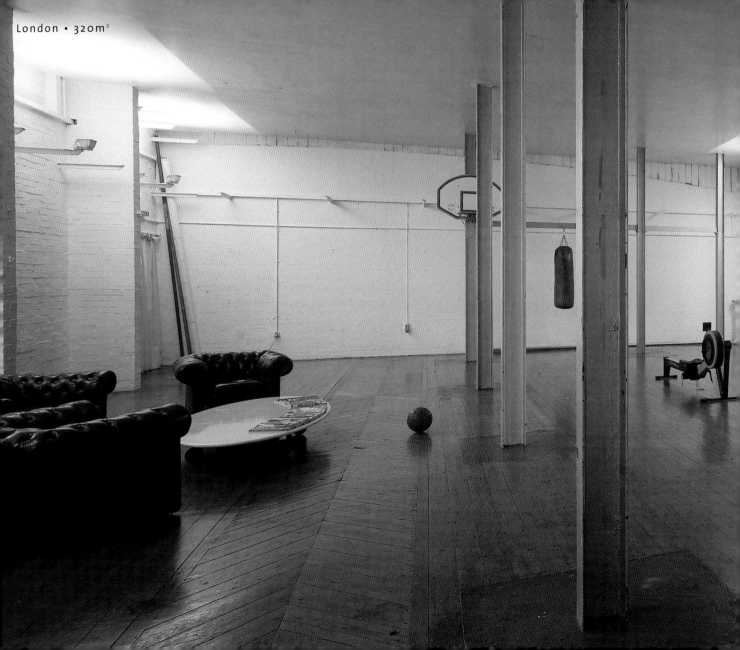
London · 320m²

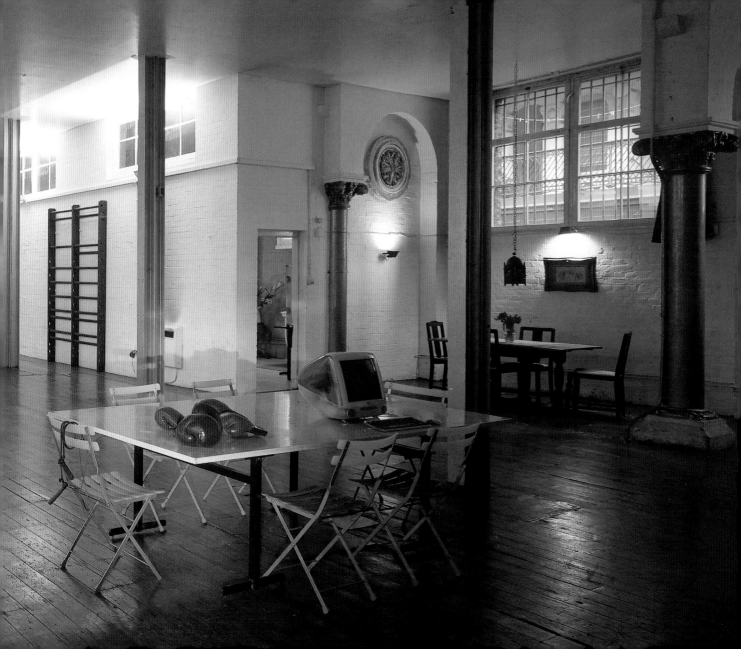

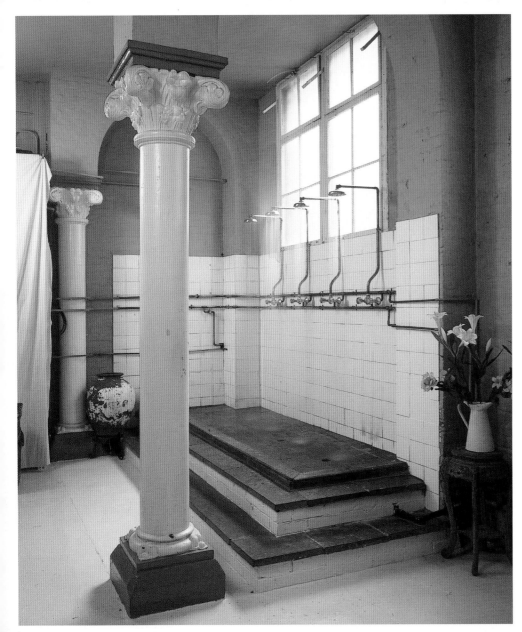

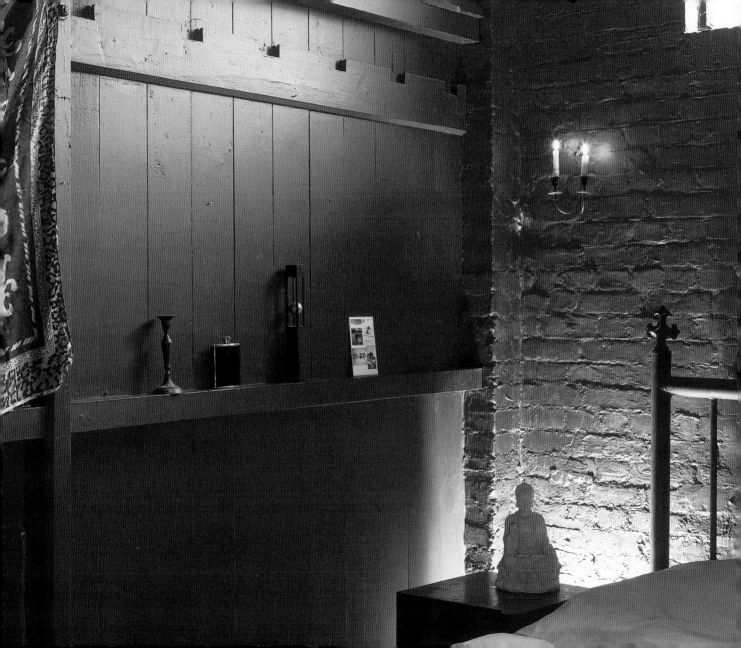

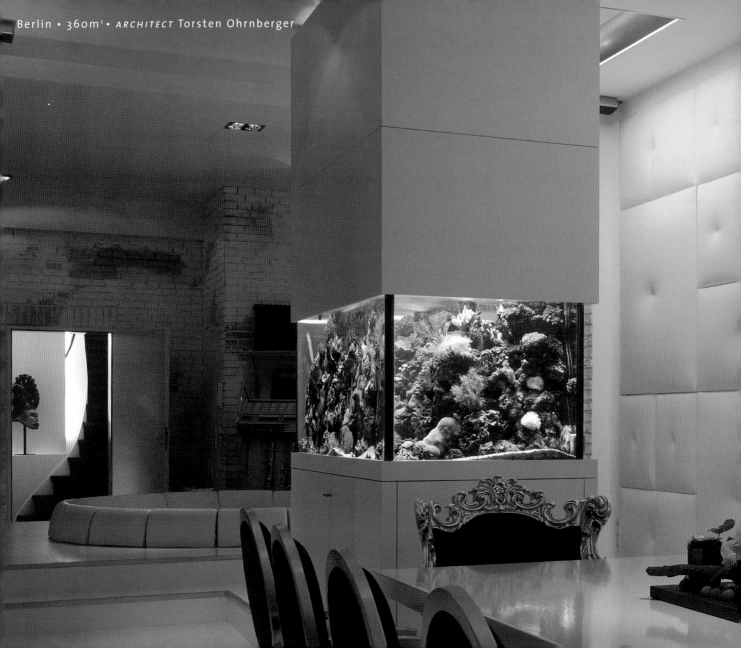

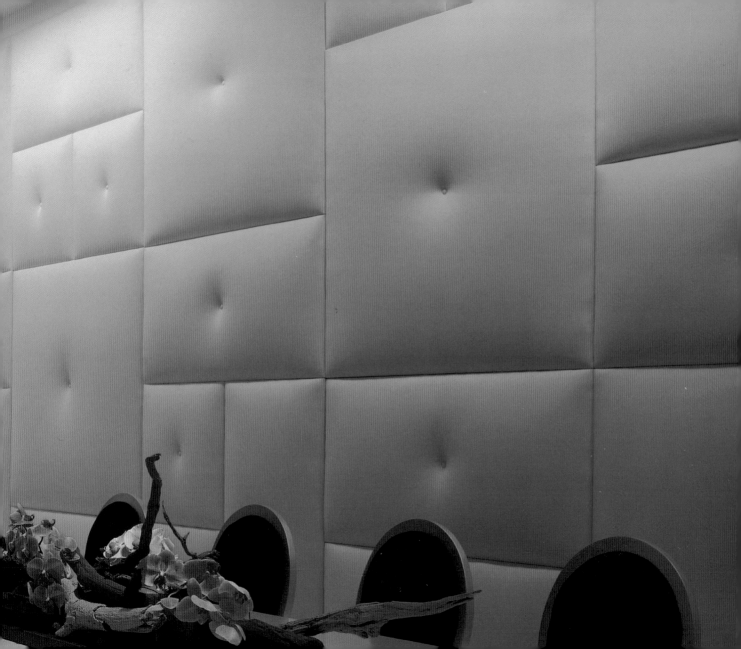

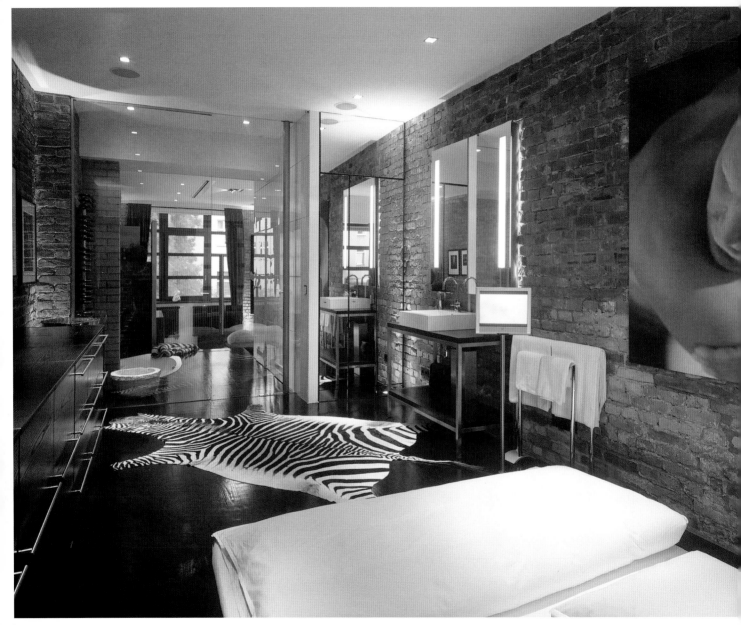

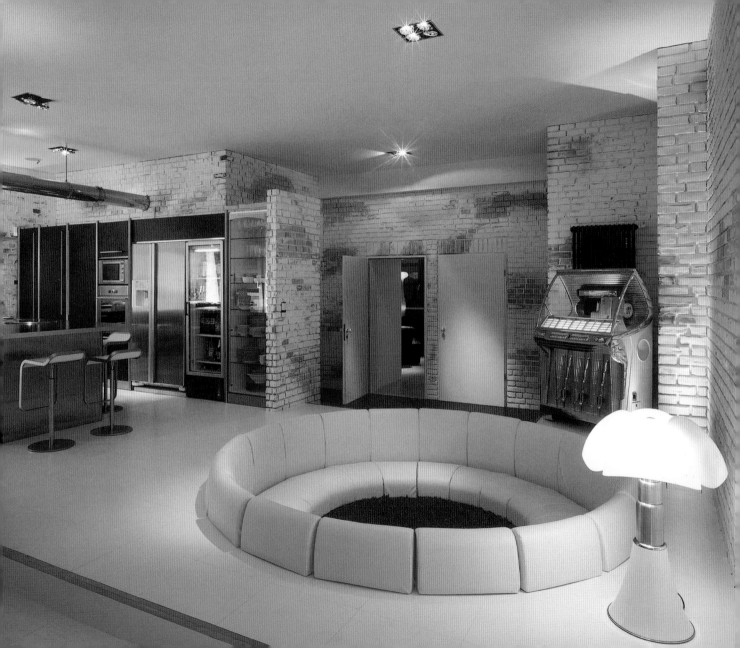

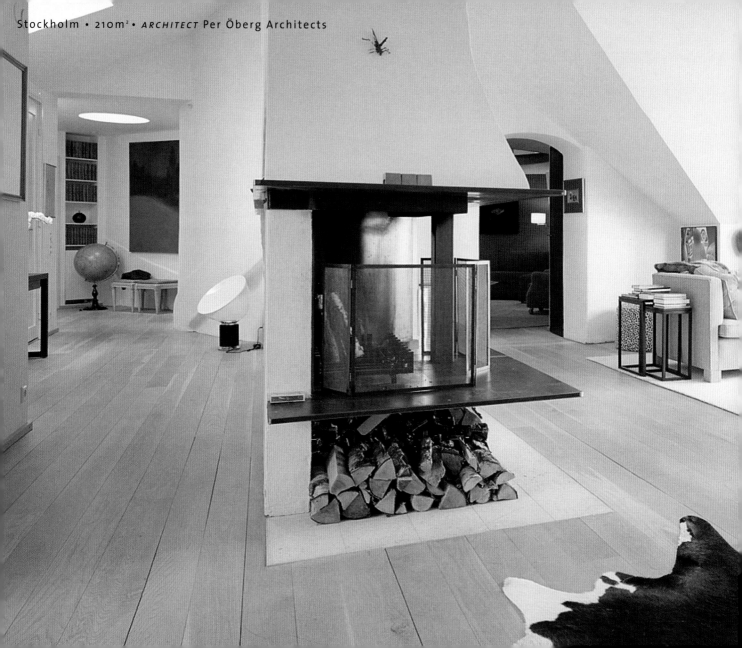

Stockholm • 210m² • *ARCHITECT* Per Öberg Architects

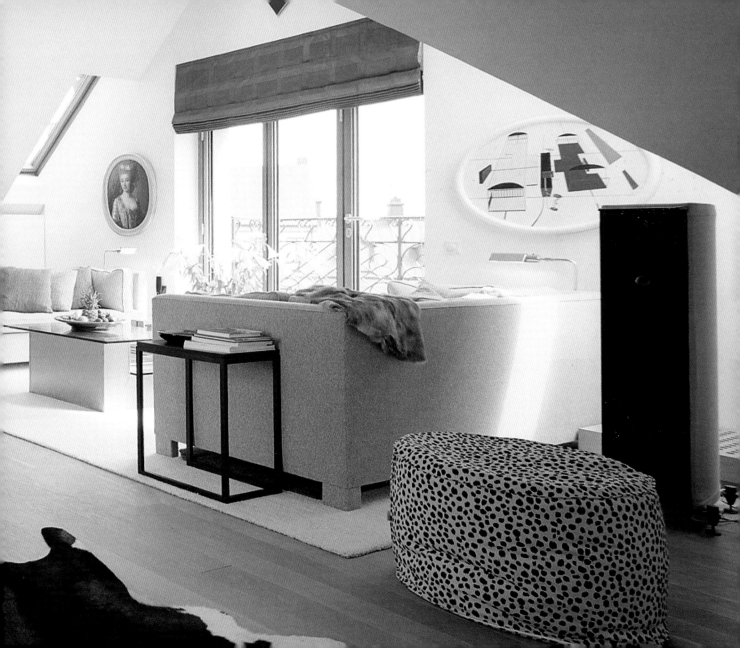

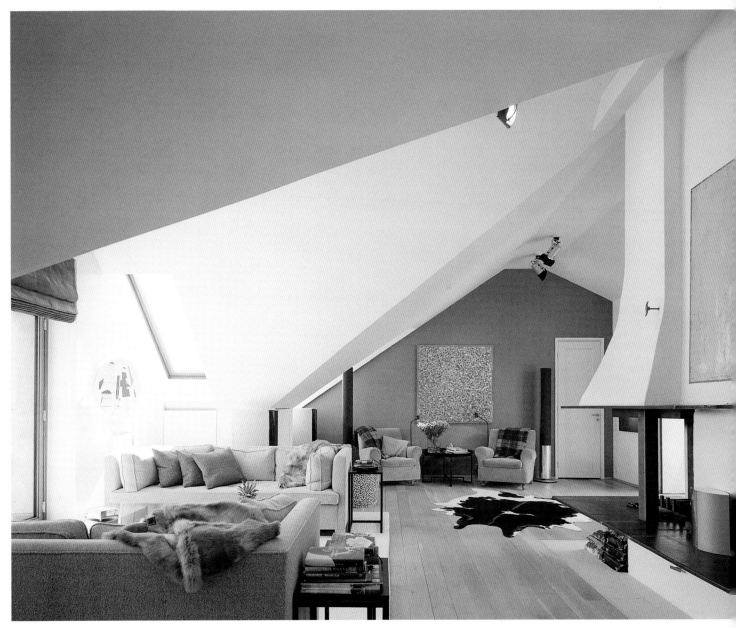

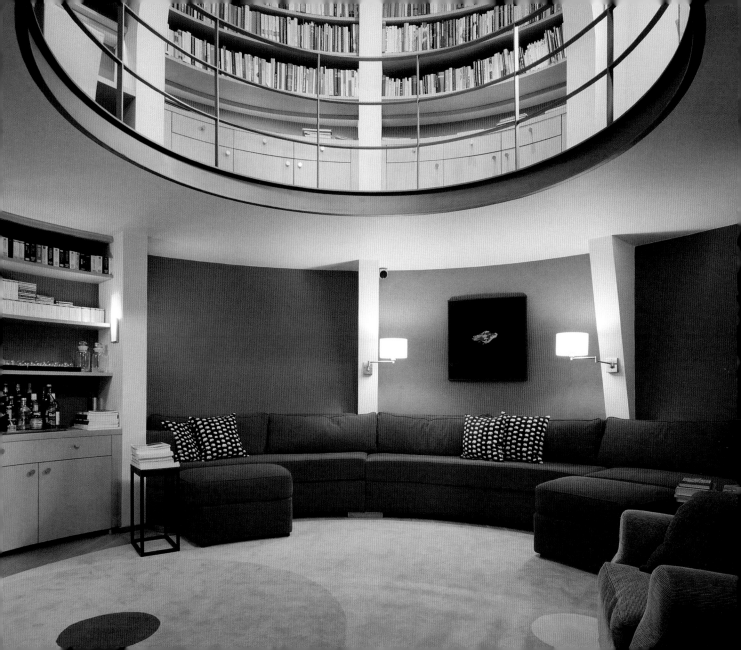

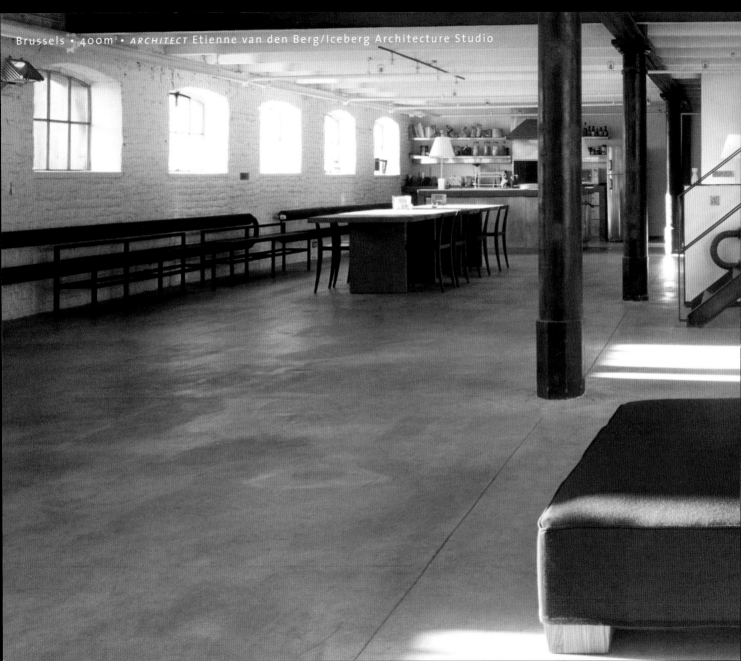

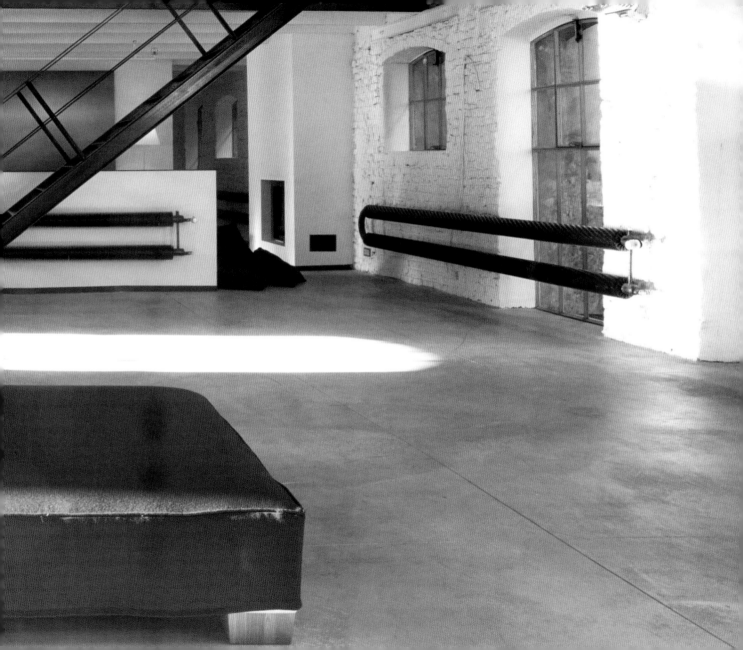

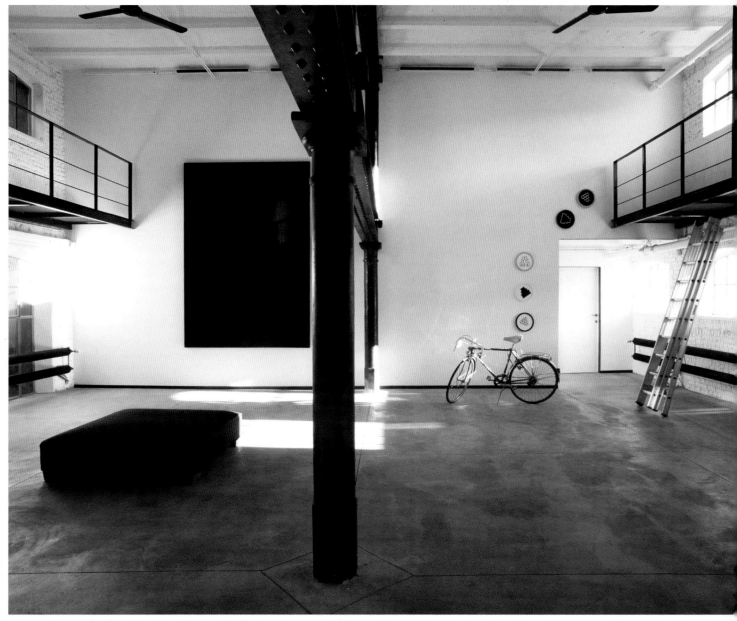

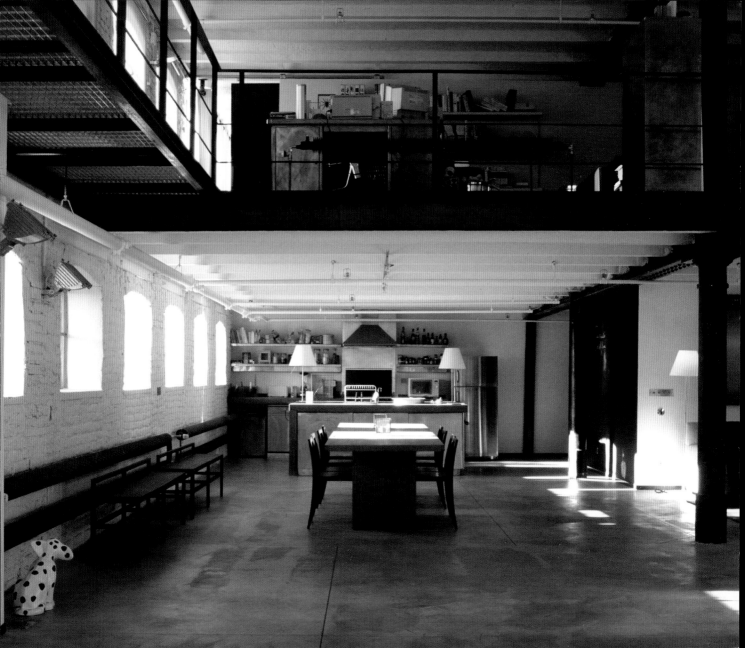

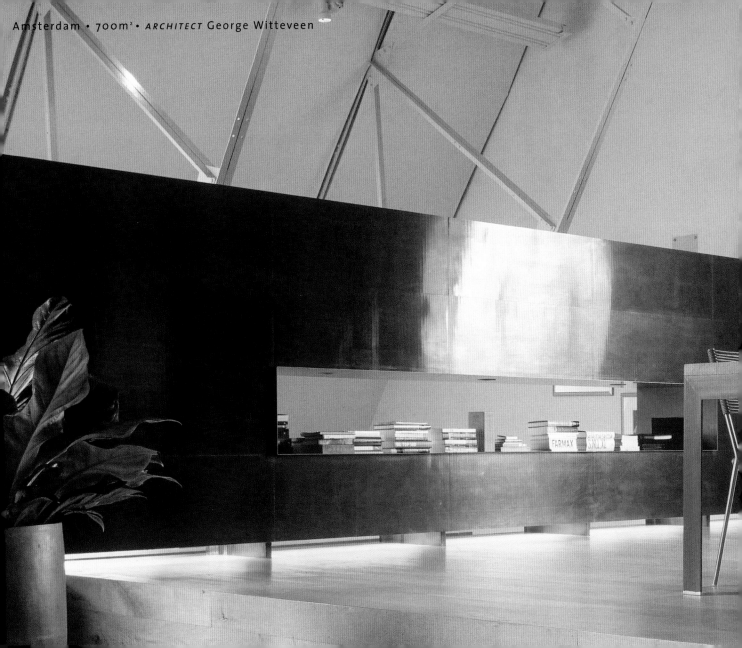

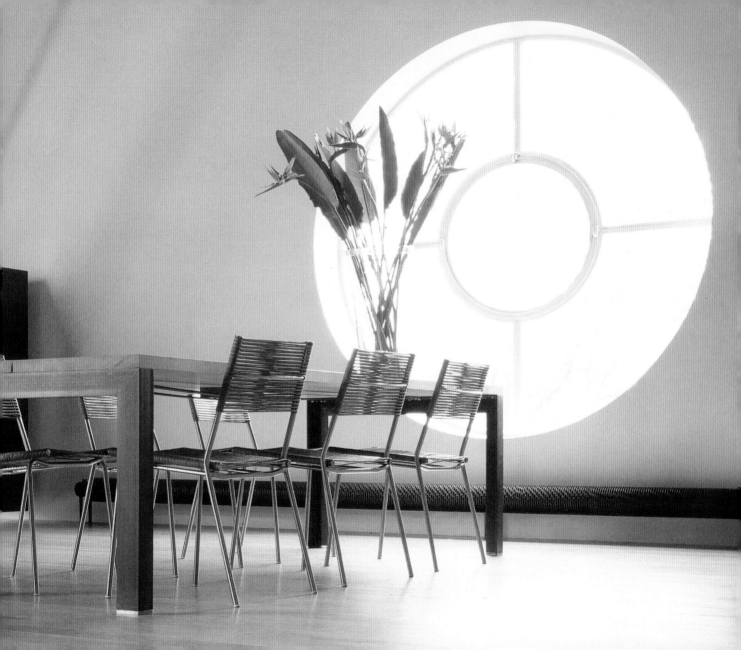

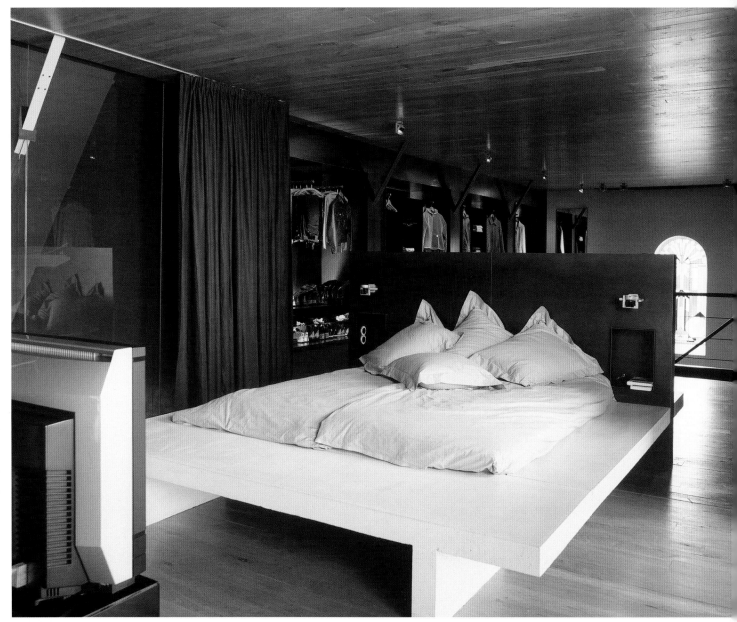

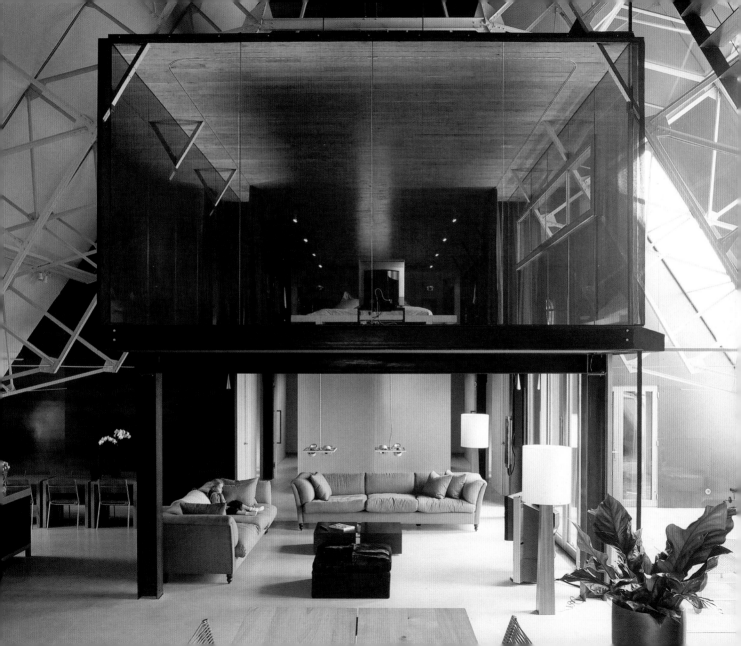

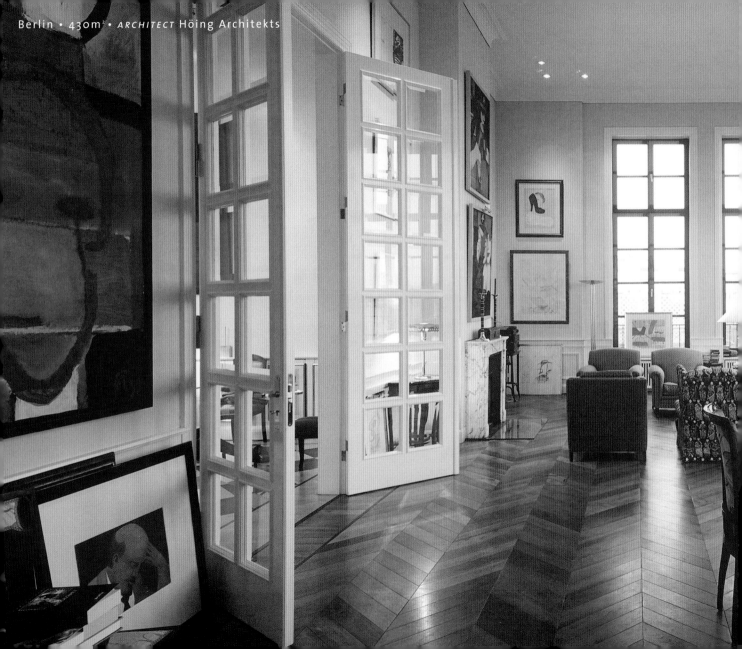

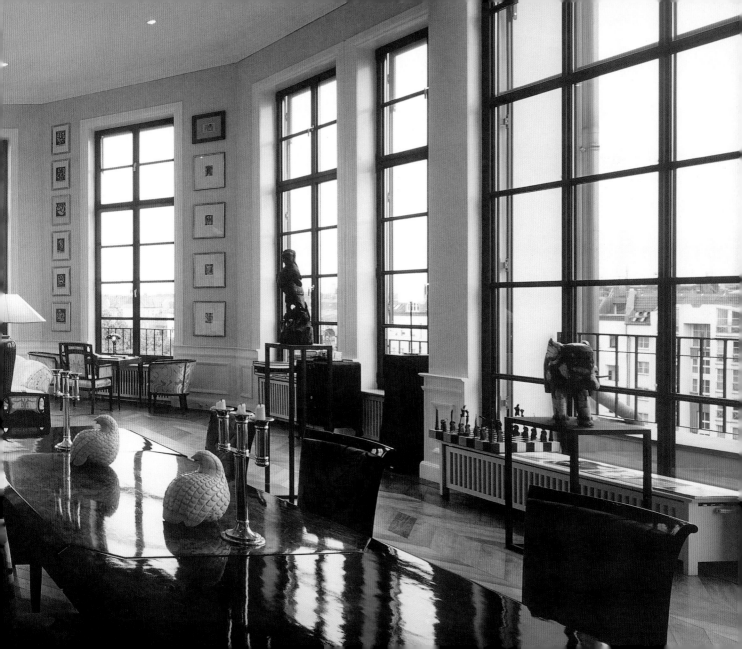

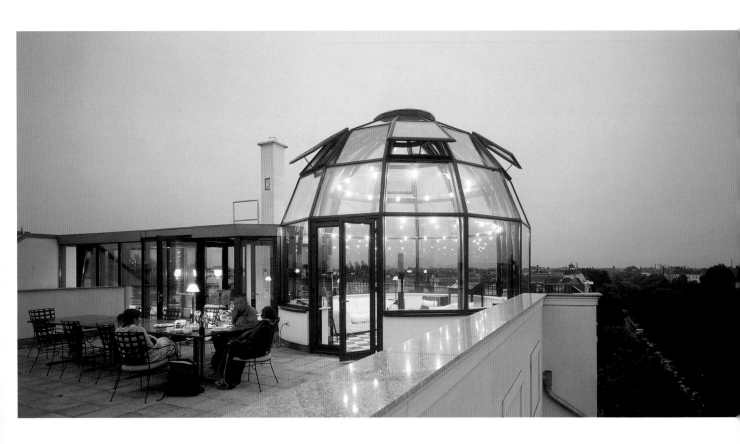

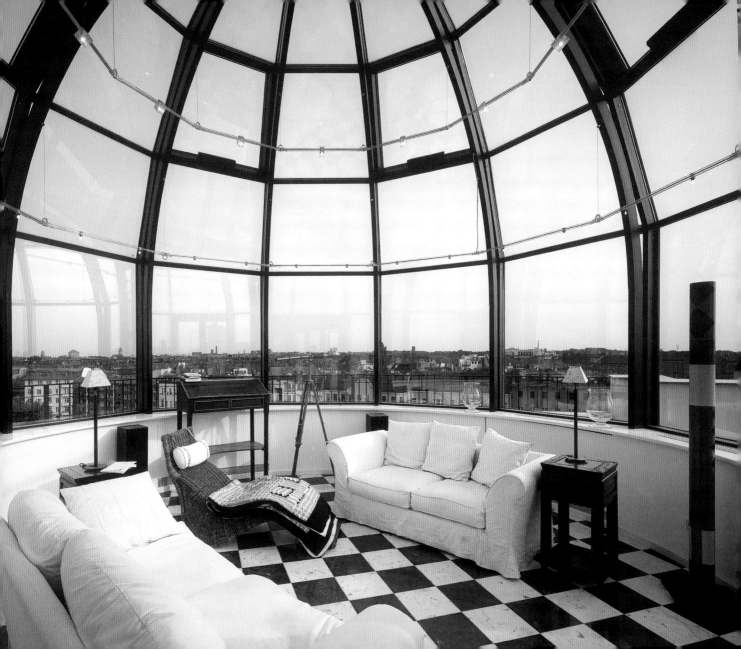

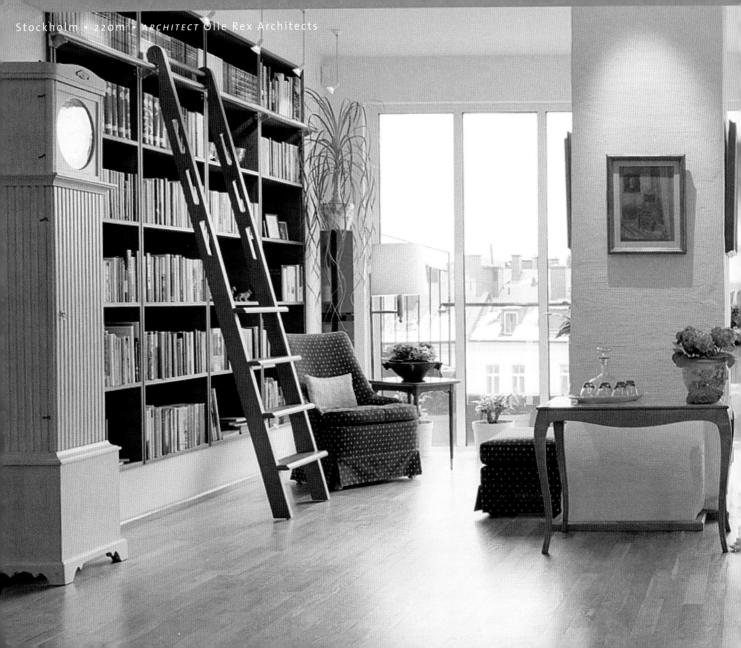

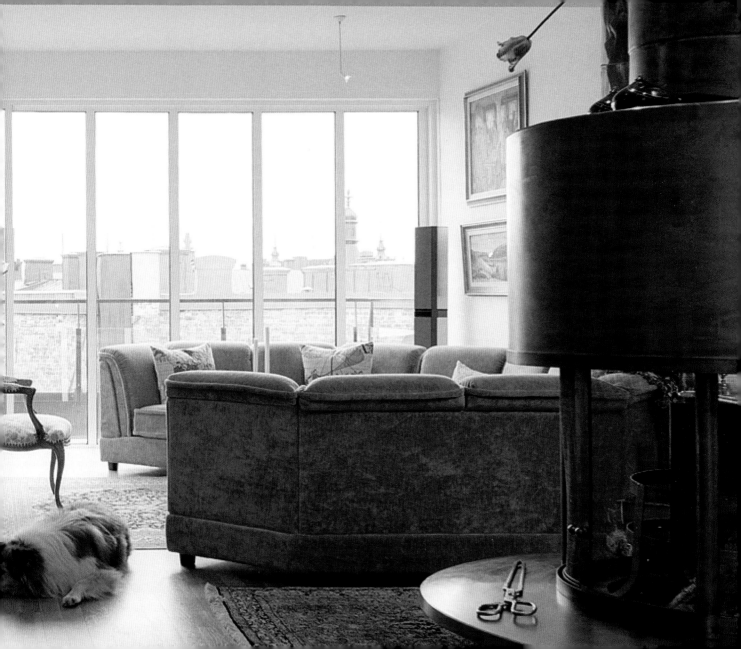

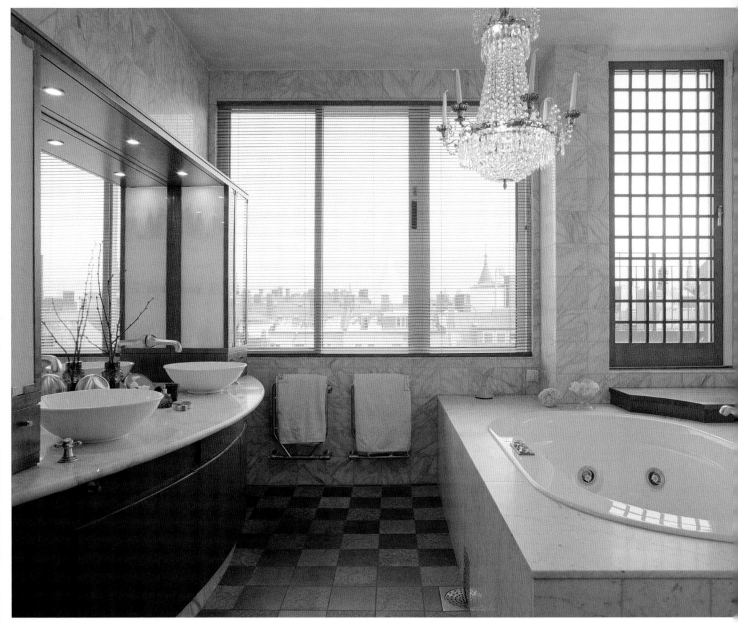

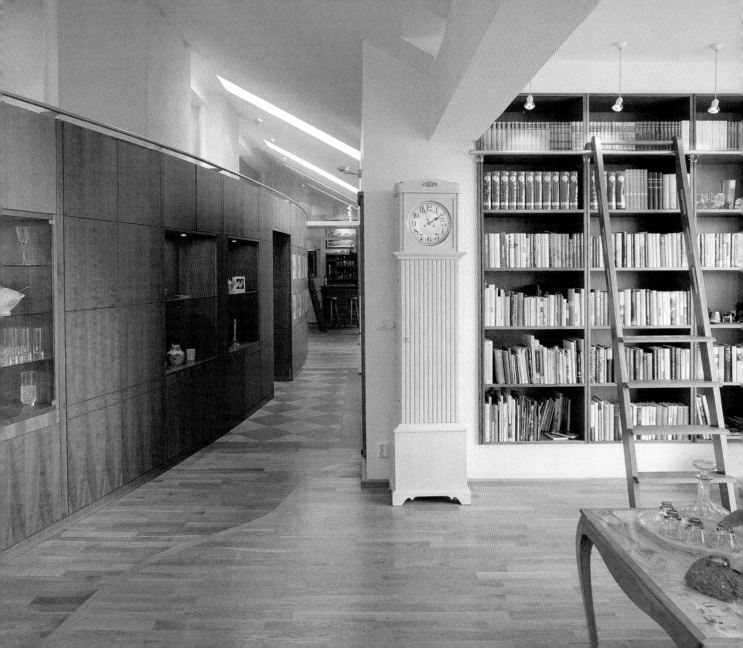

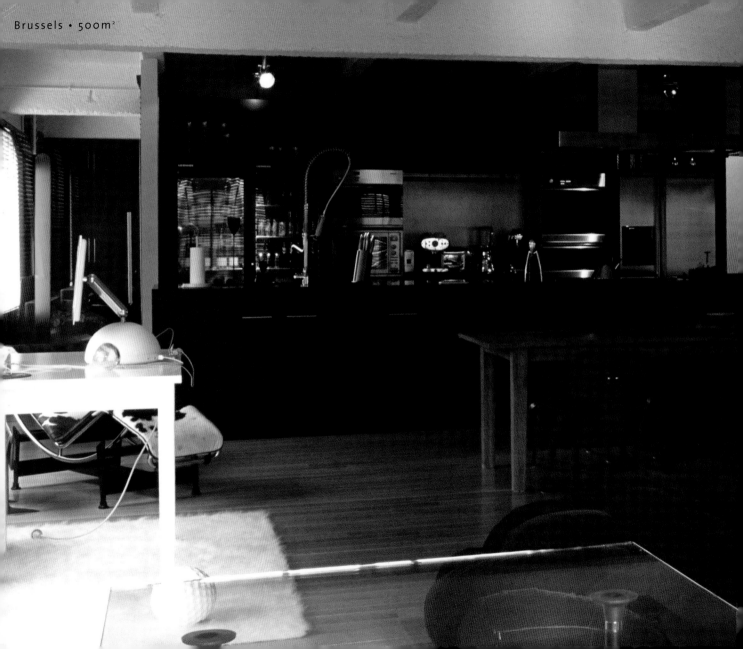

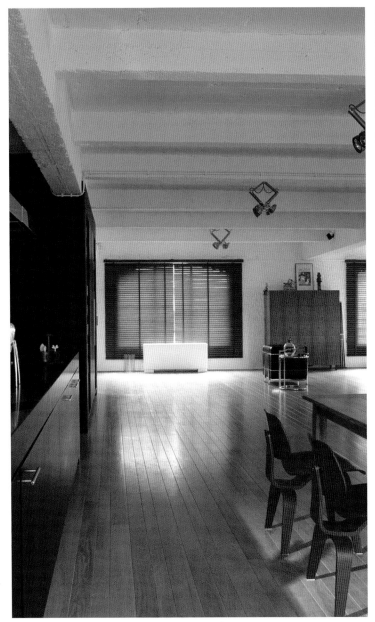
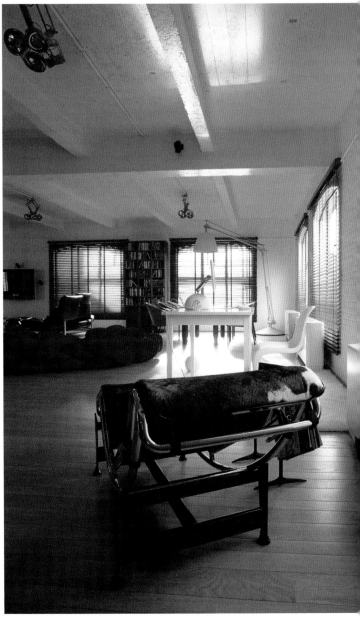

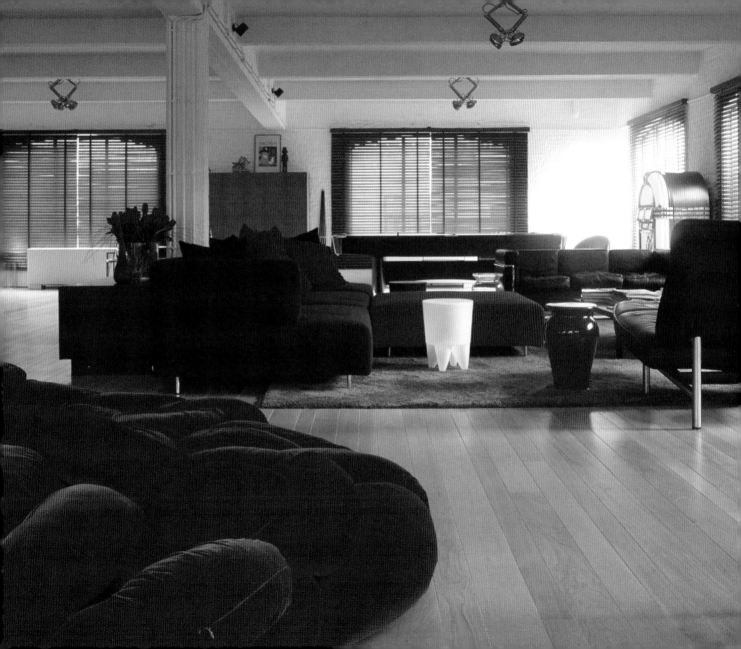

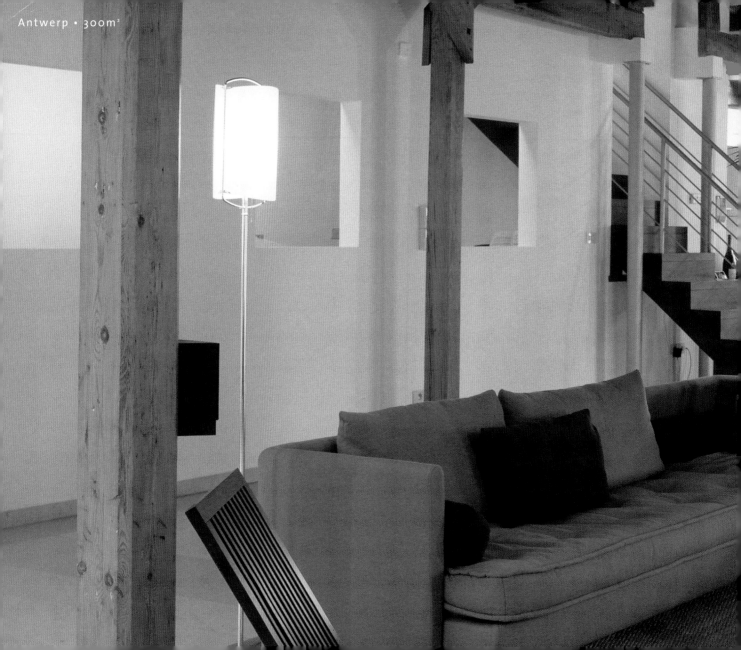

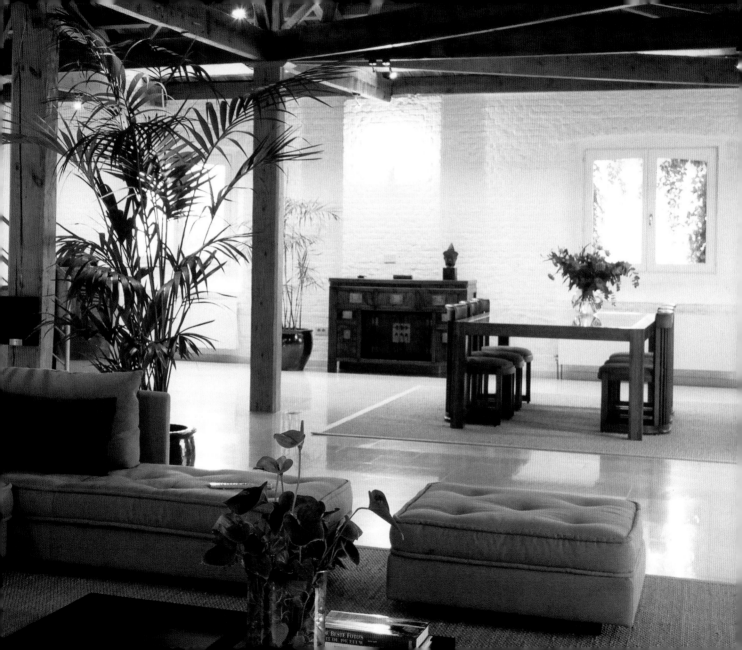

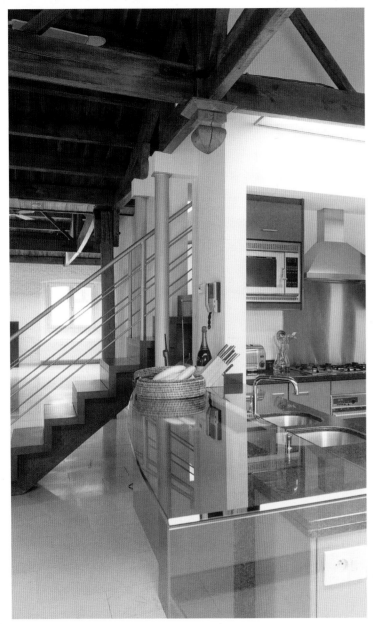
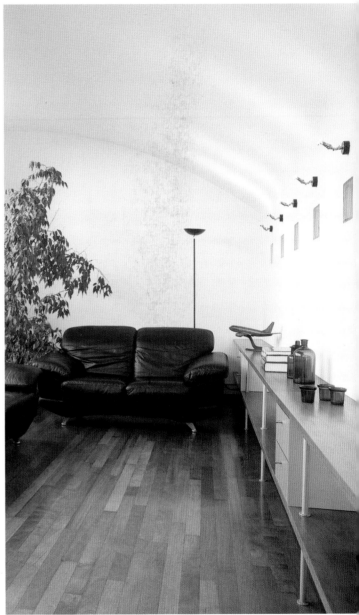

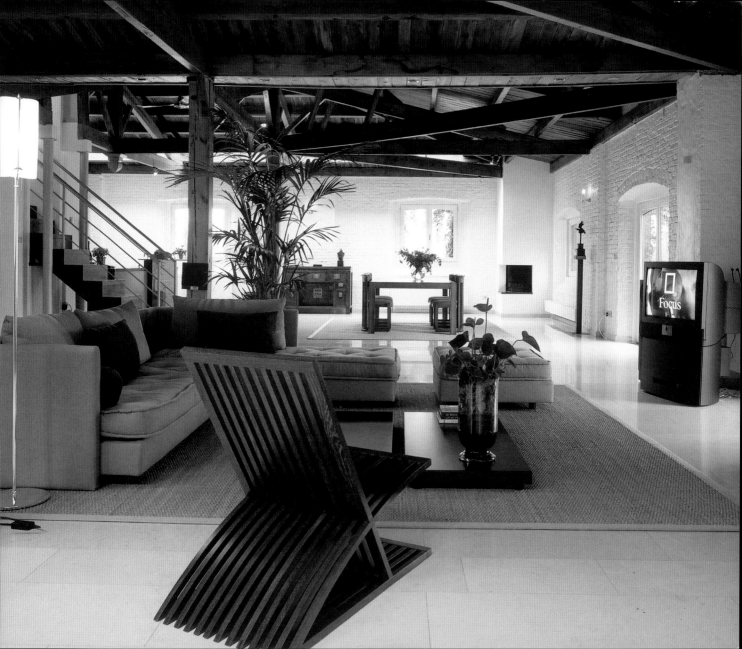

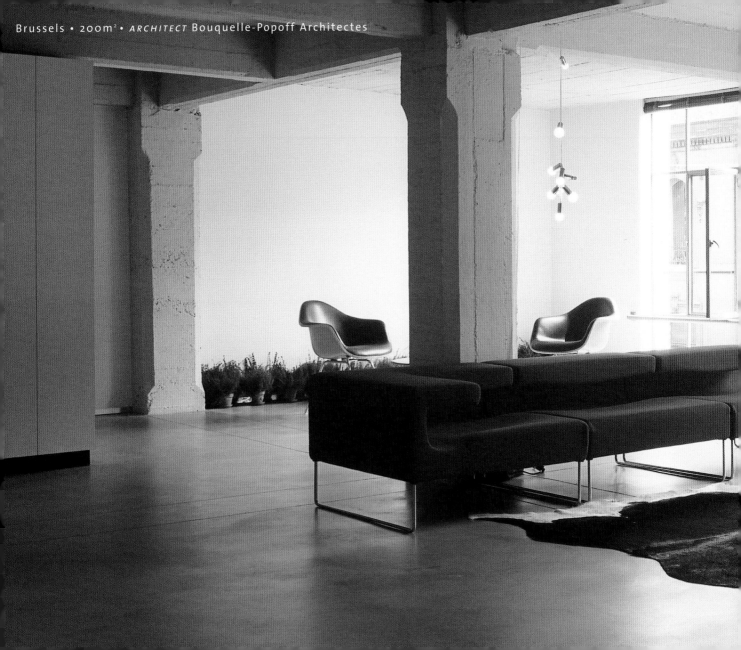

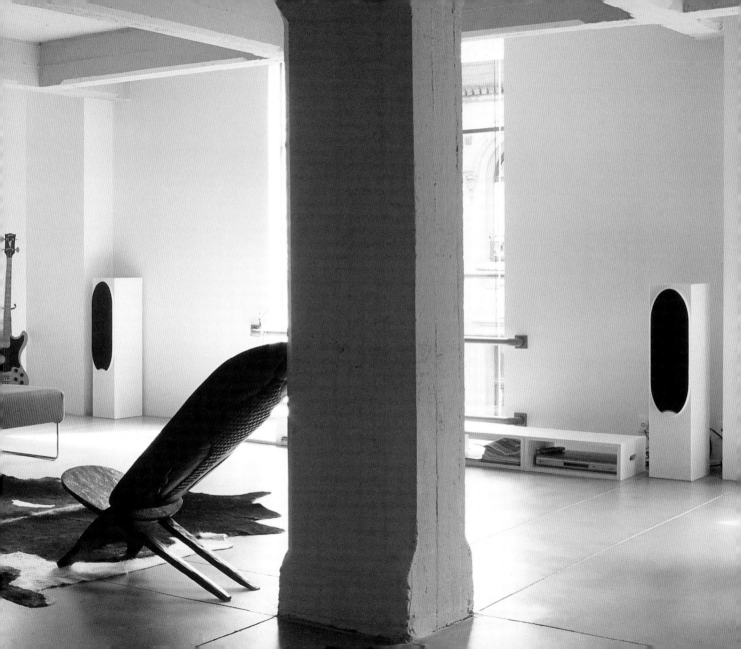

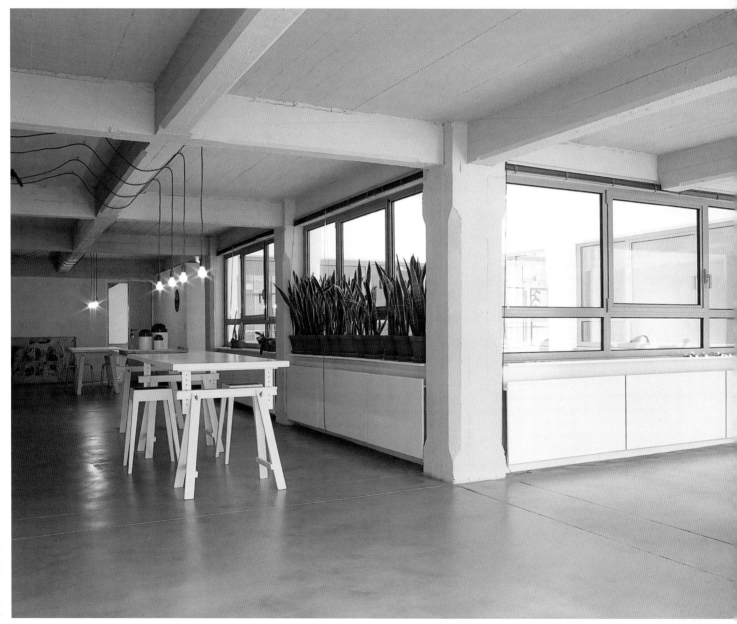

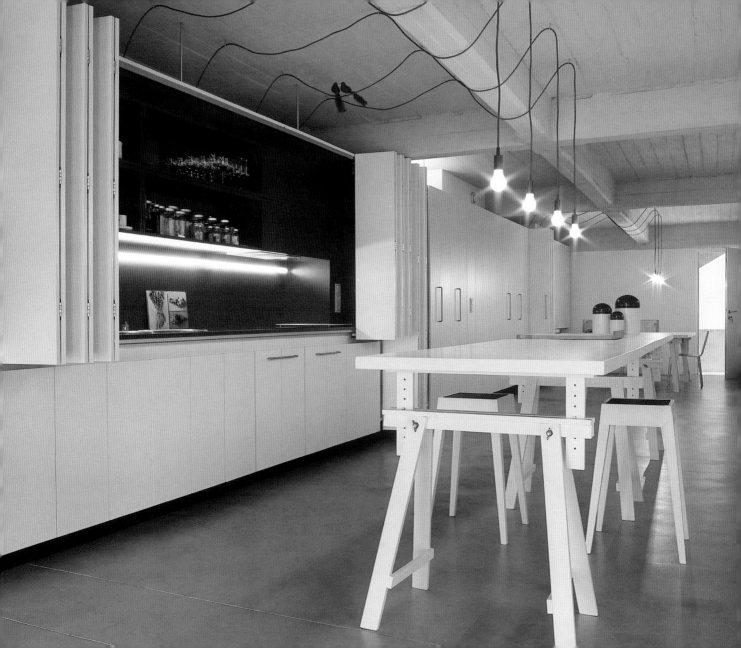

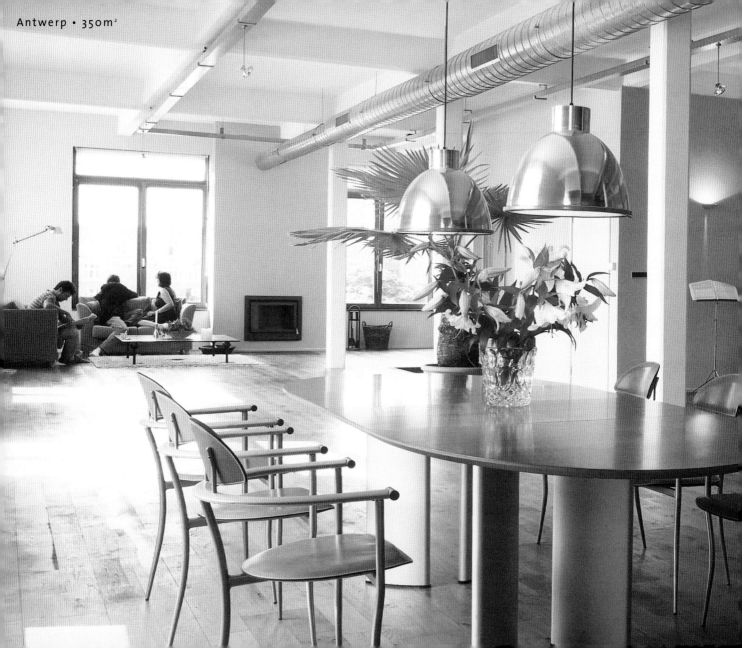

Antwerp • 350m²

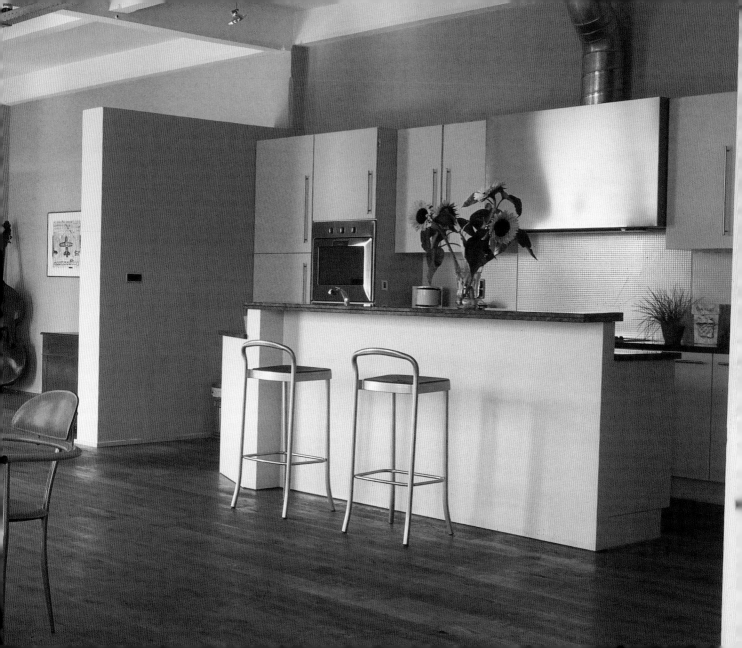

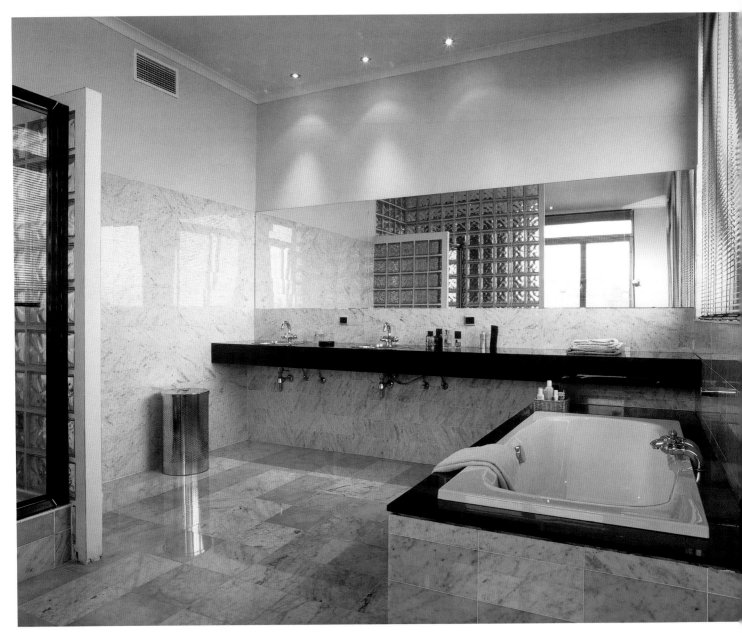

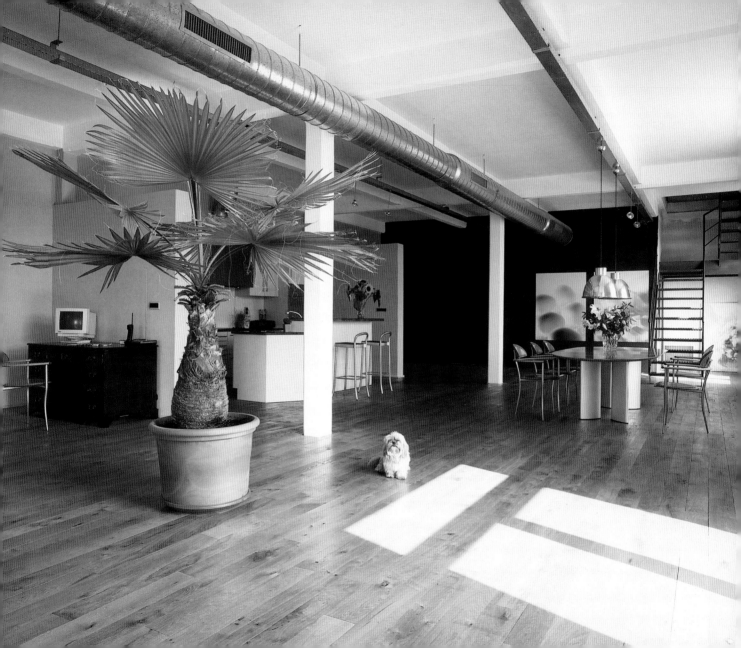

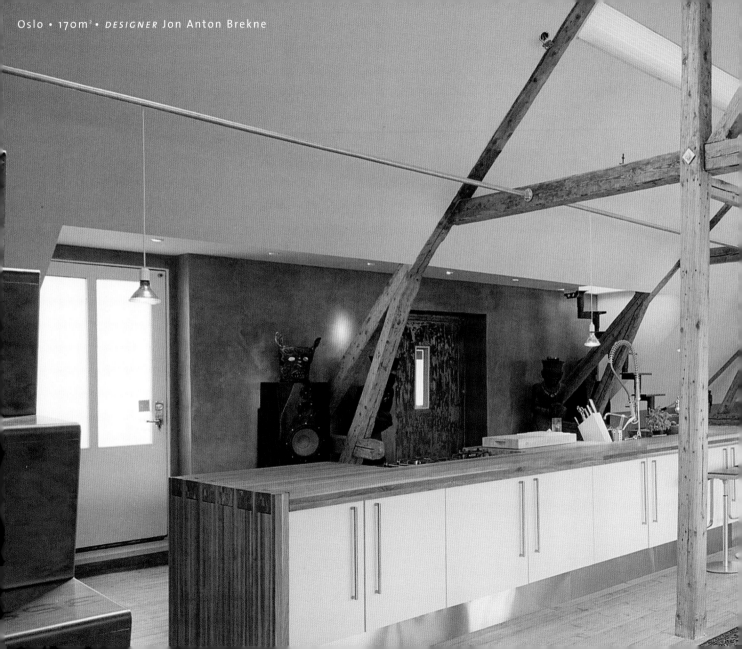

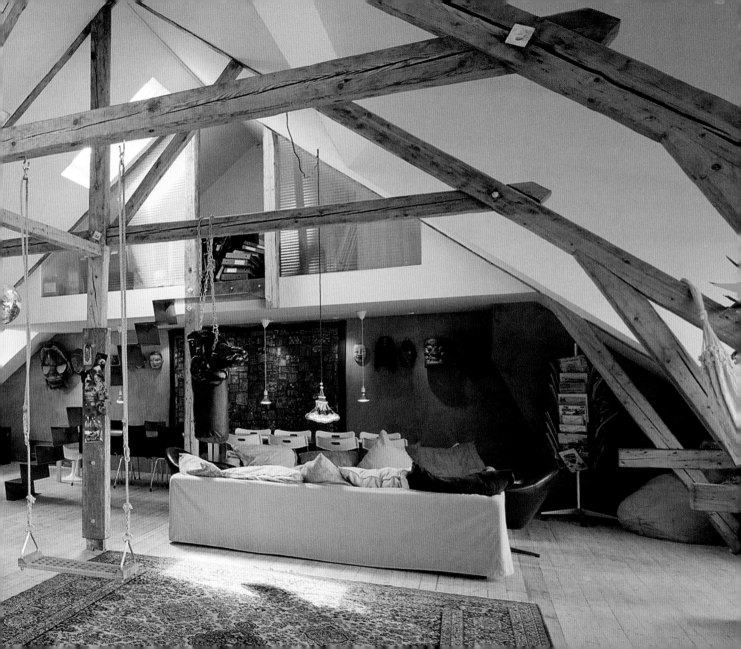

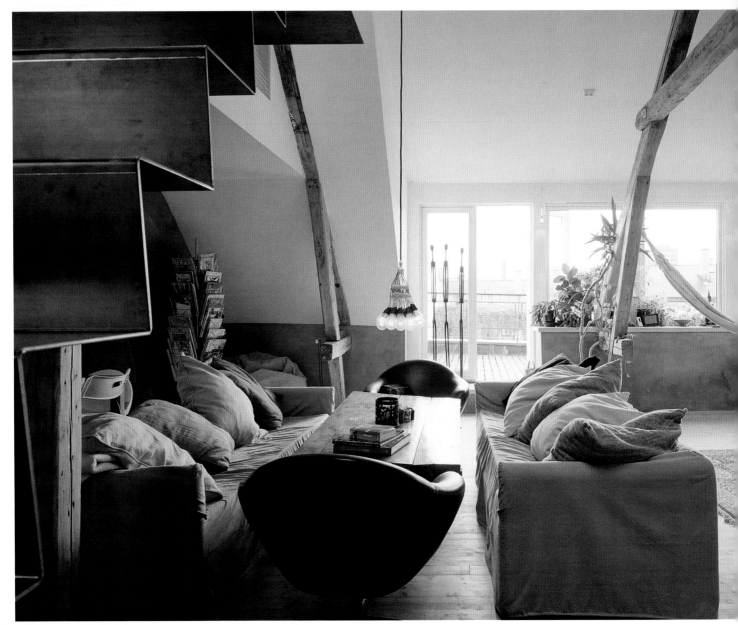

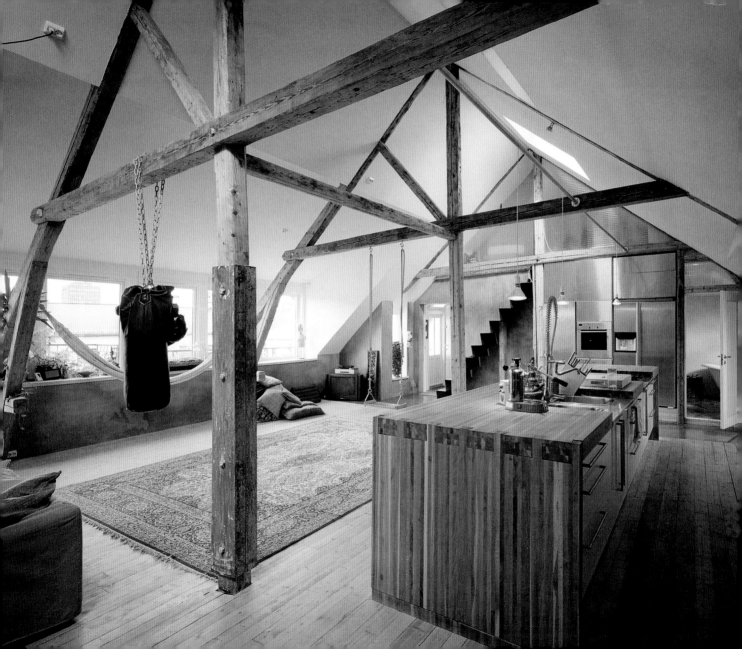

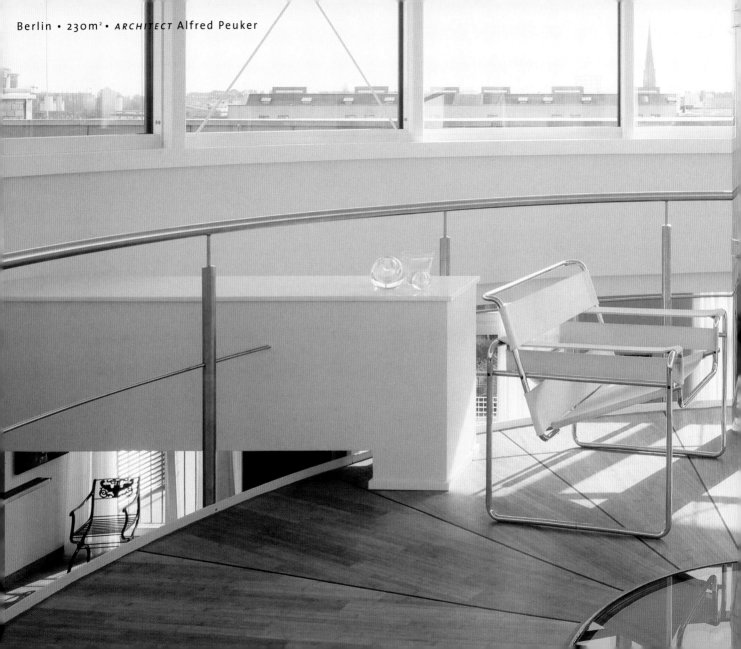

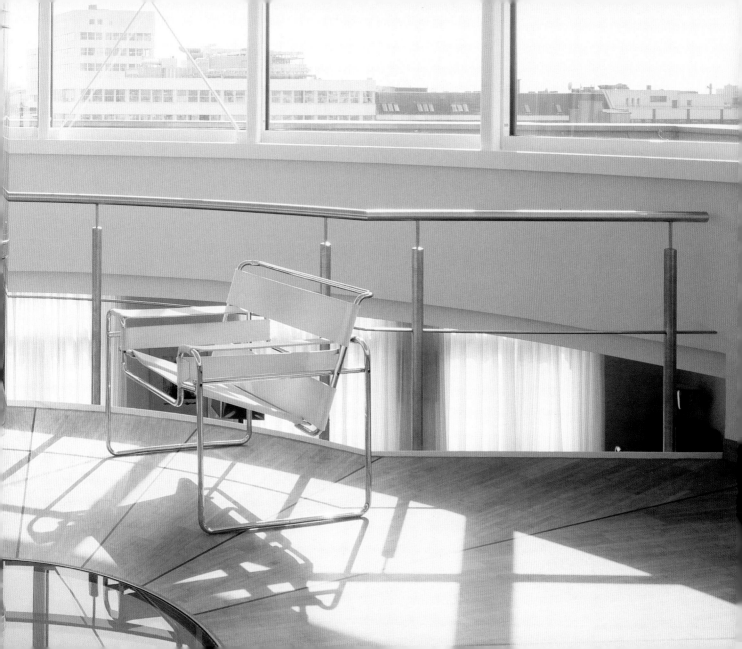

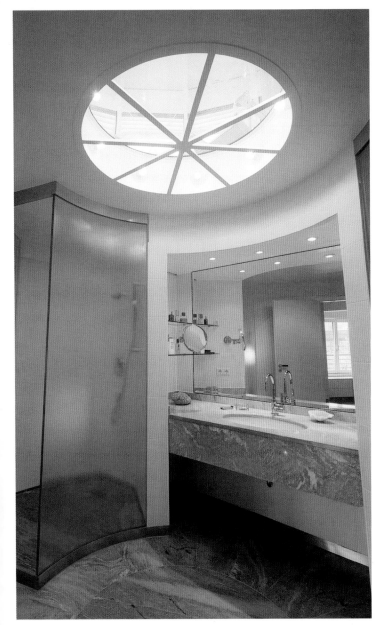

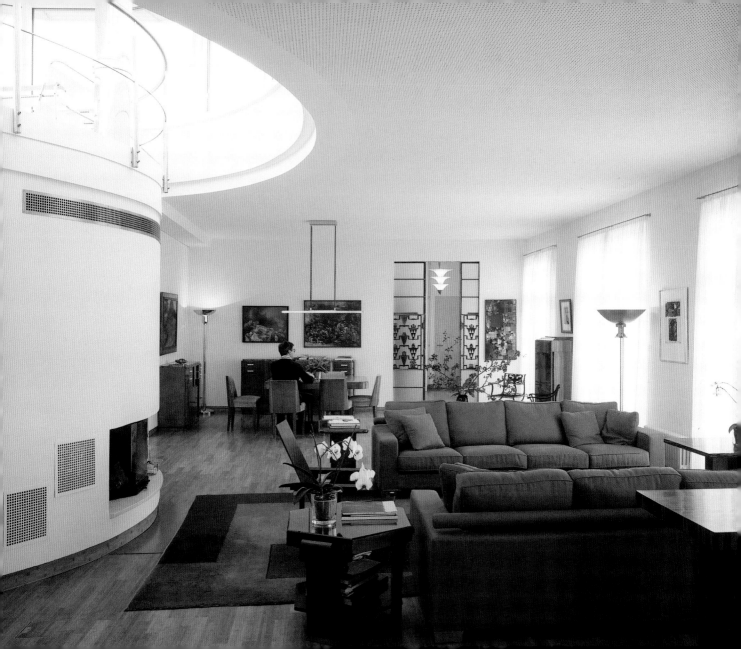

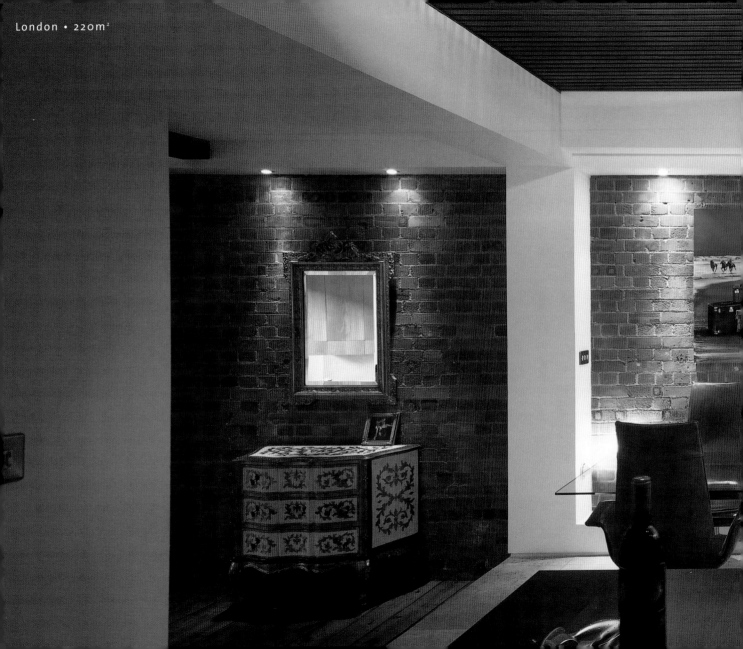

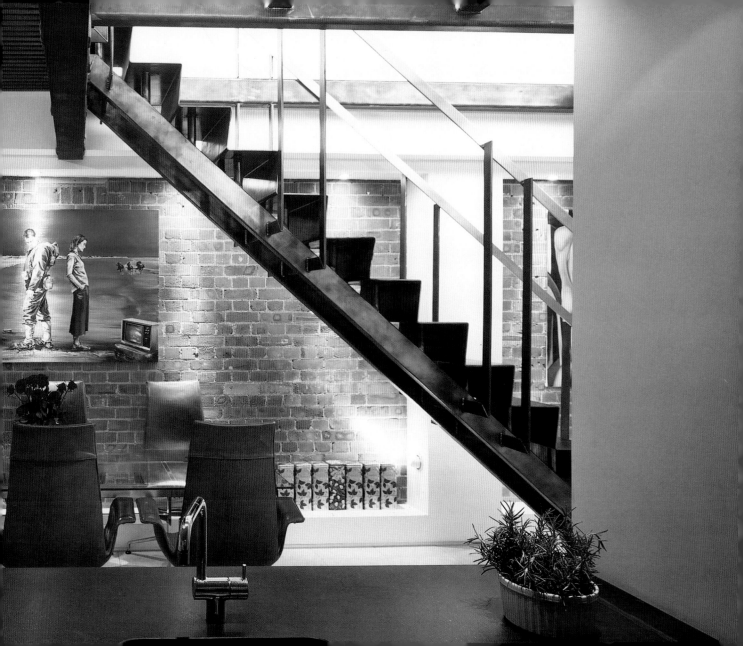

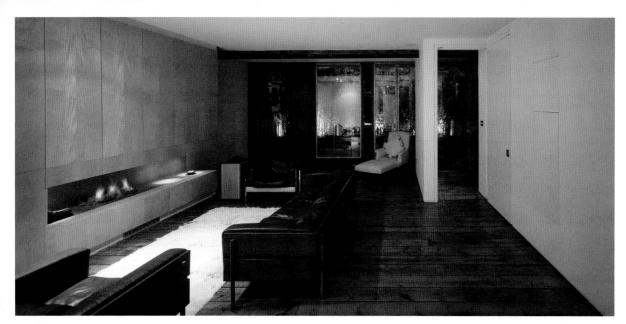

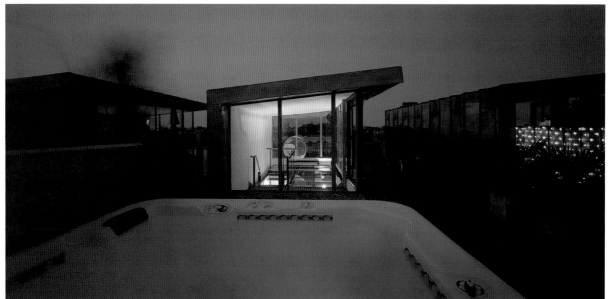

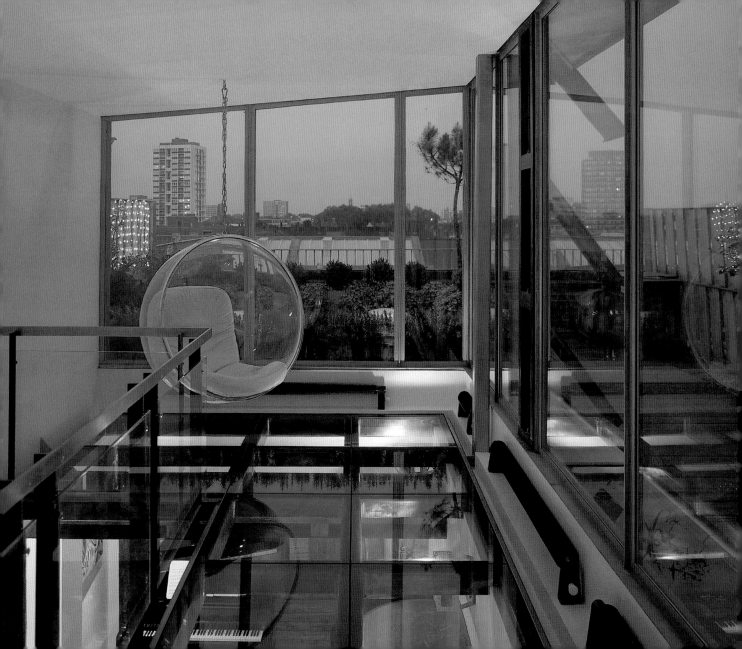

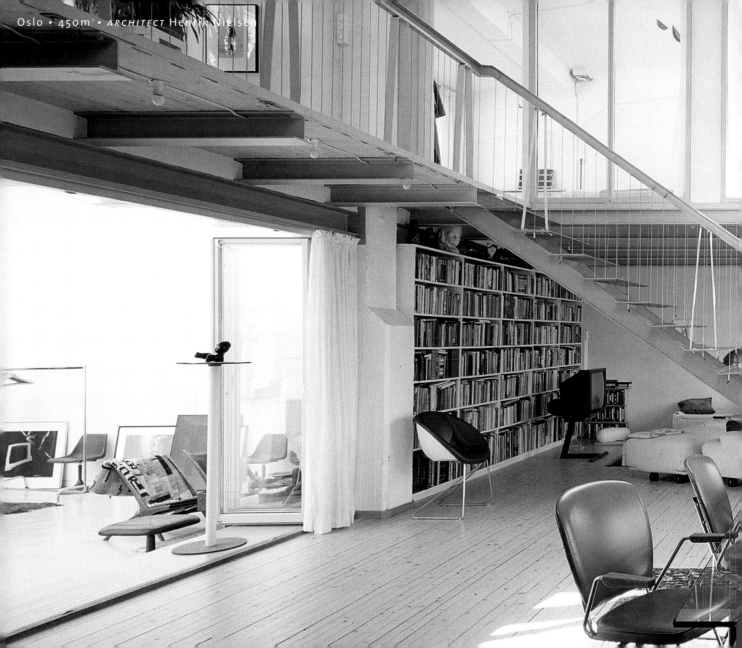

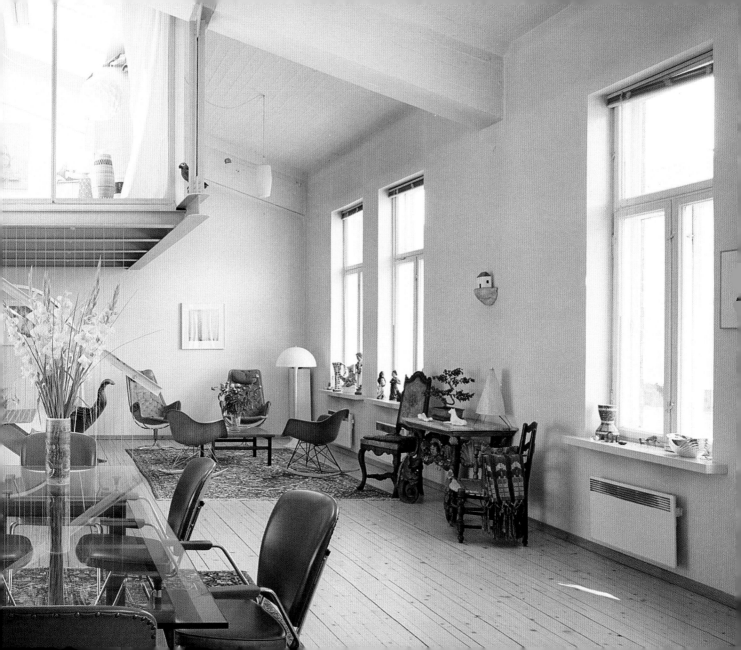

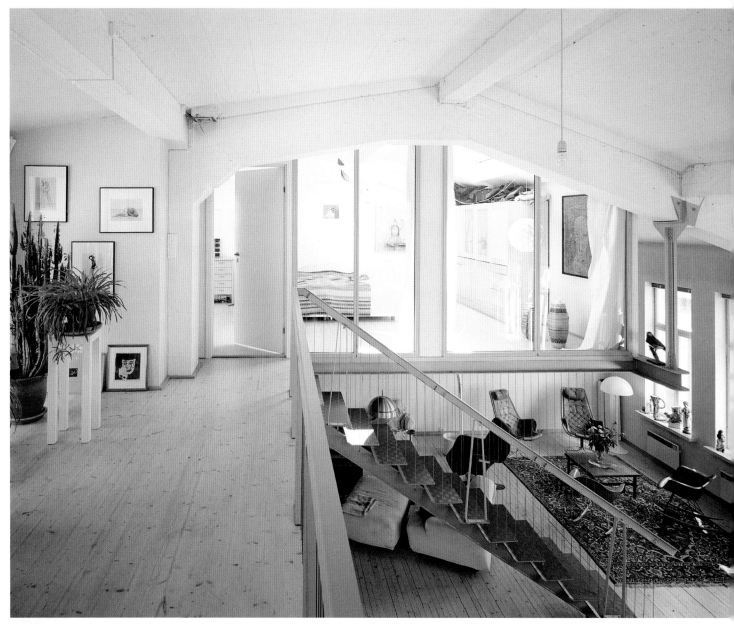

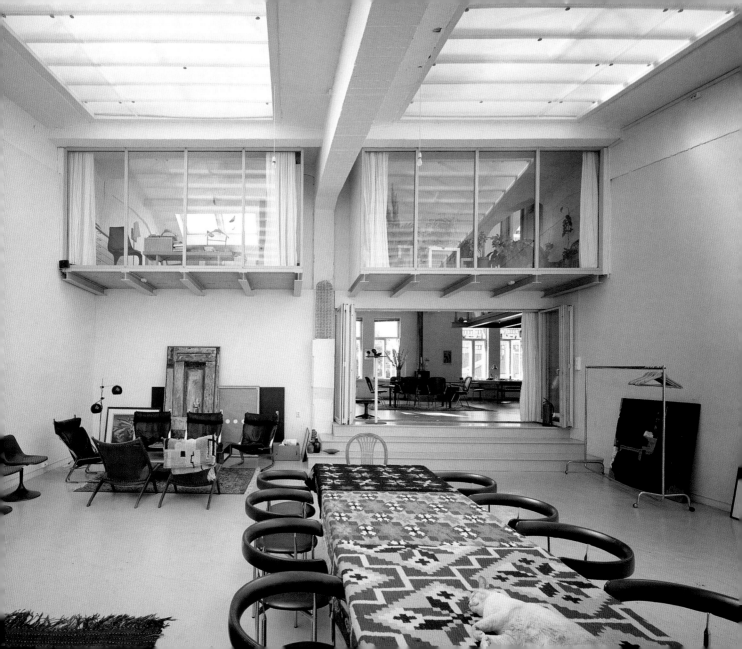

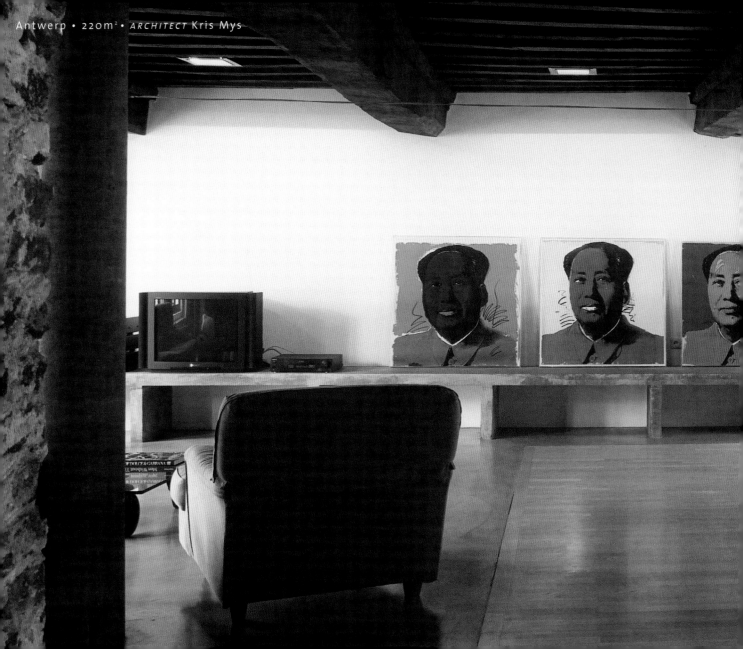

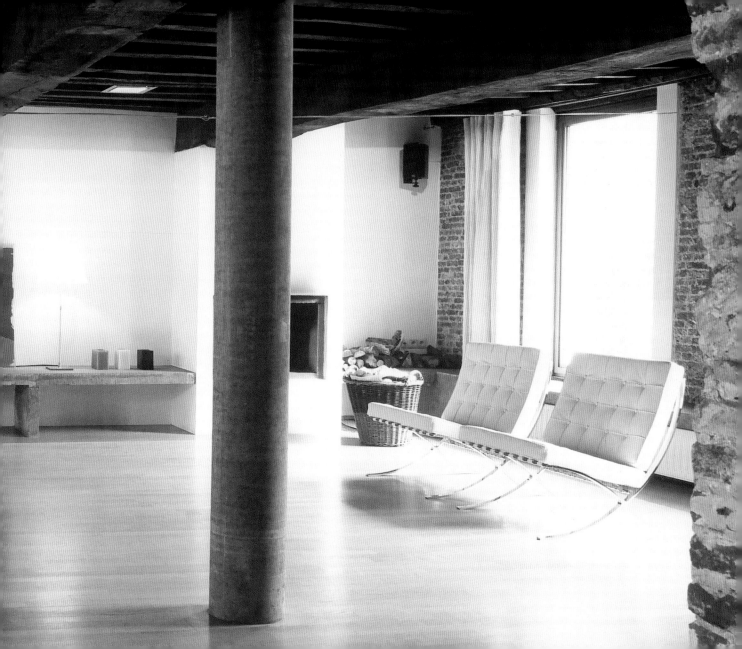

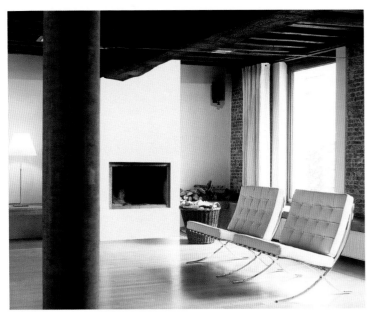
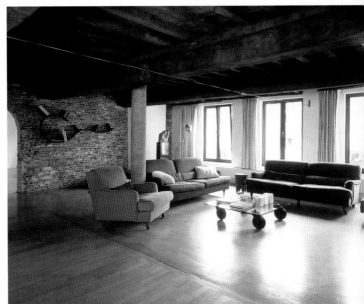
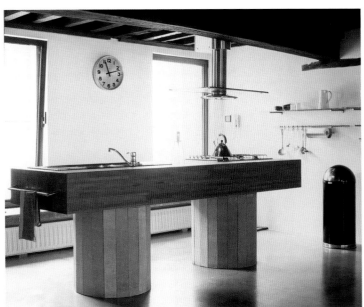
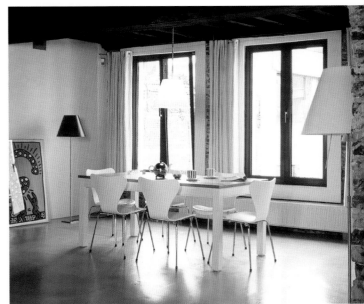

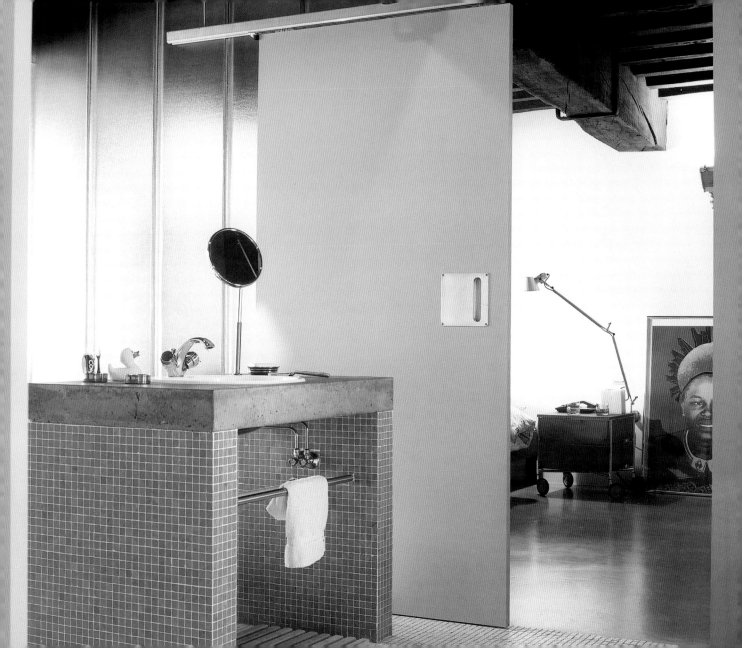

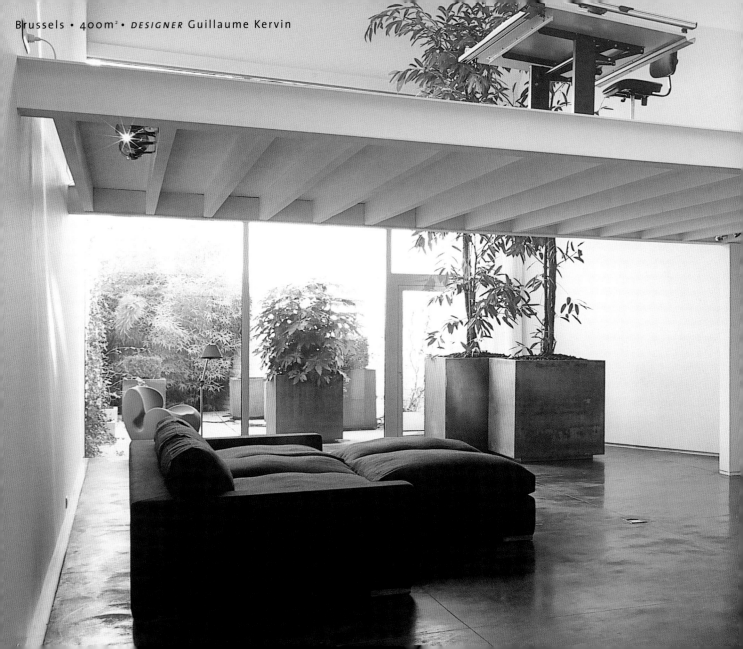

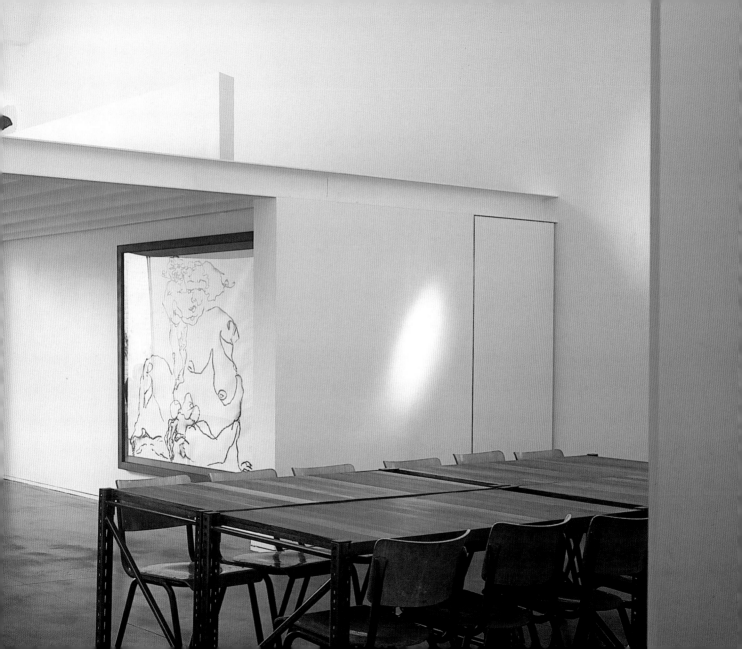

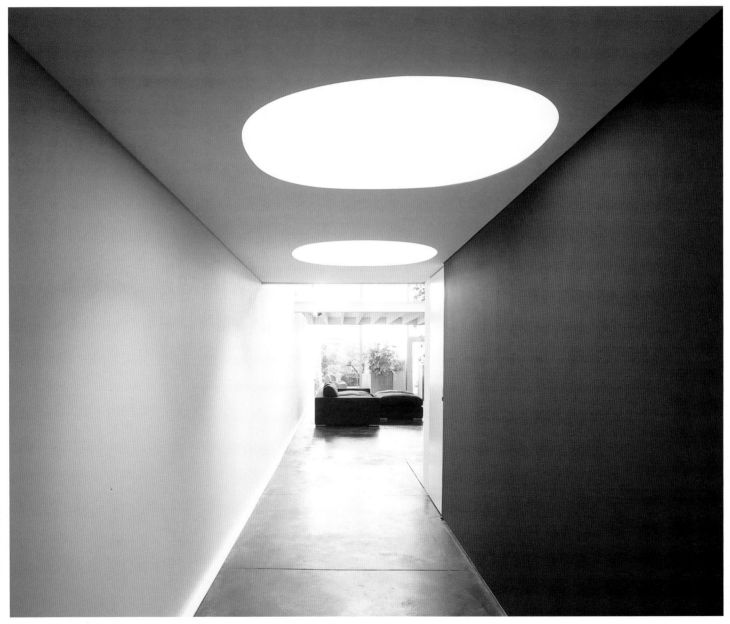

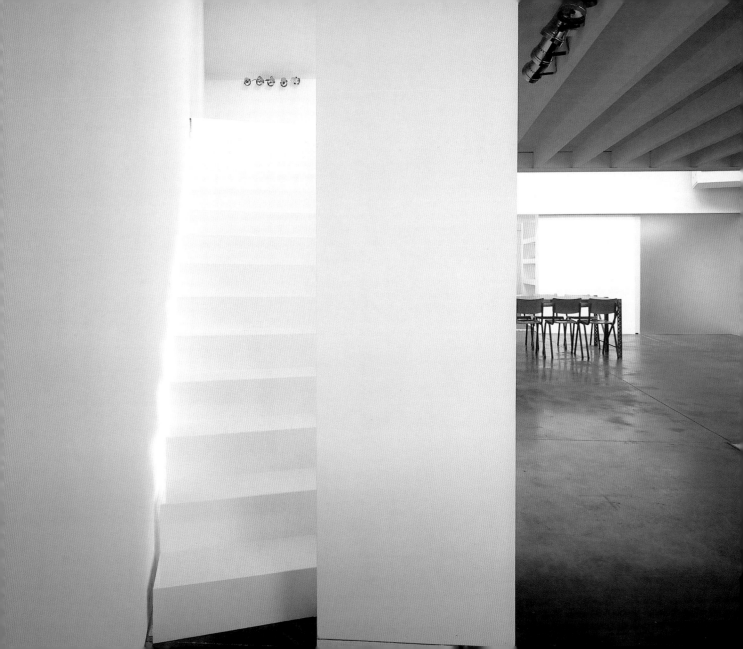

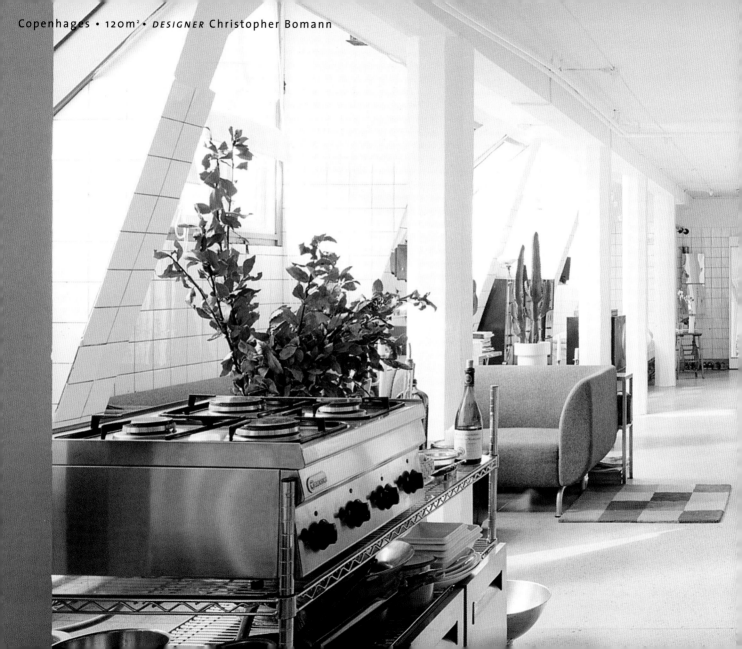

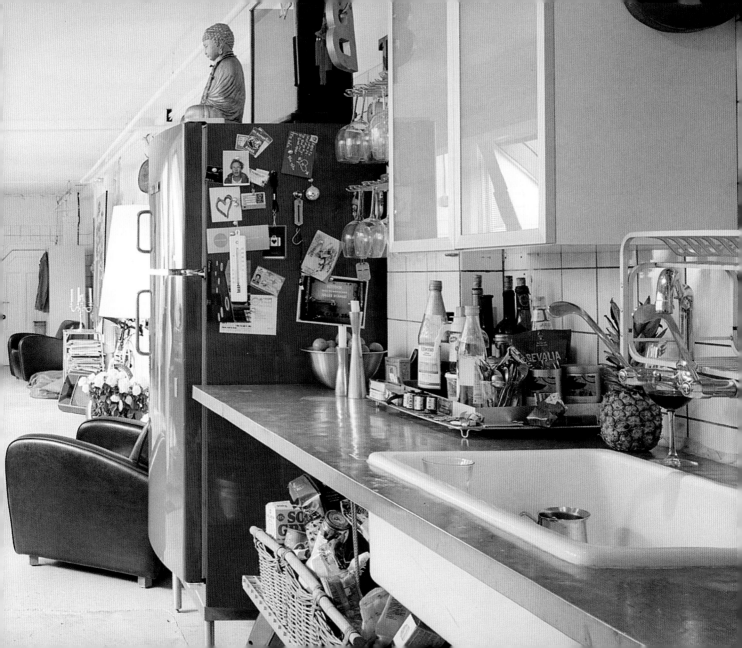

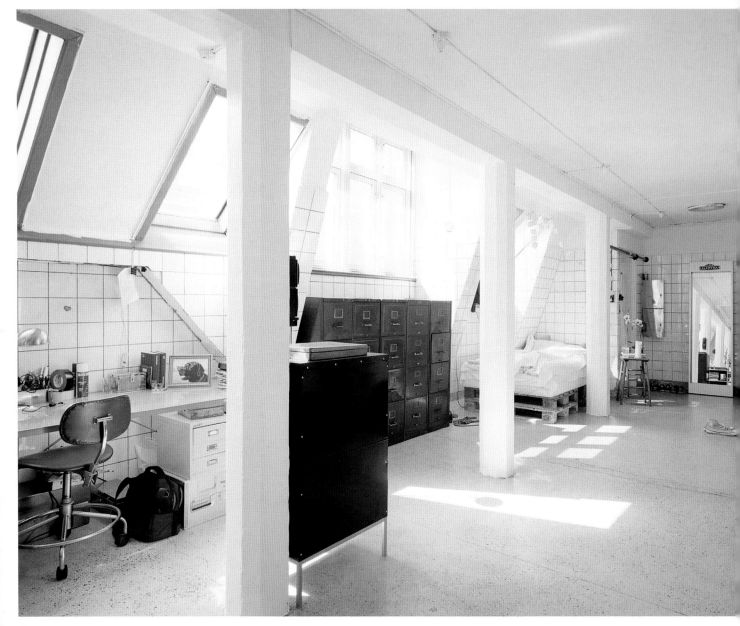

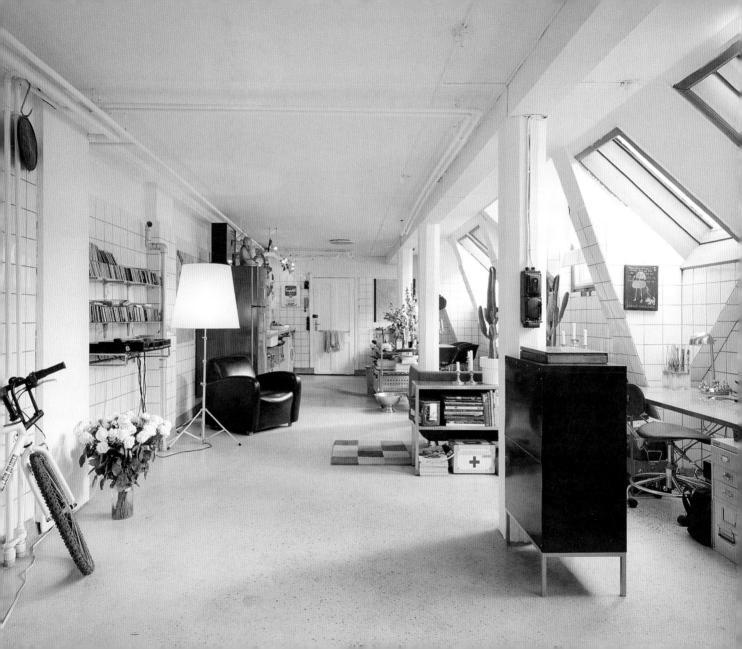

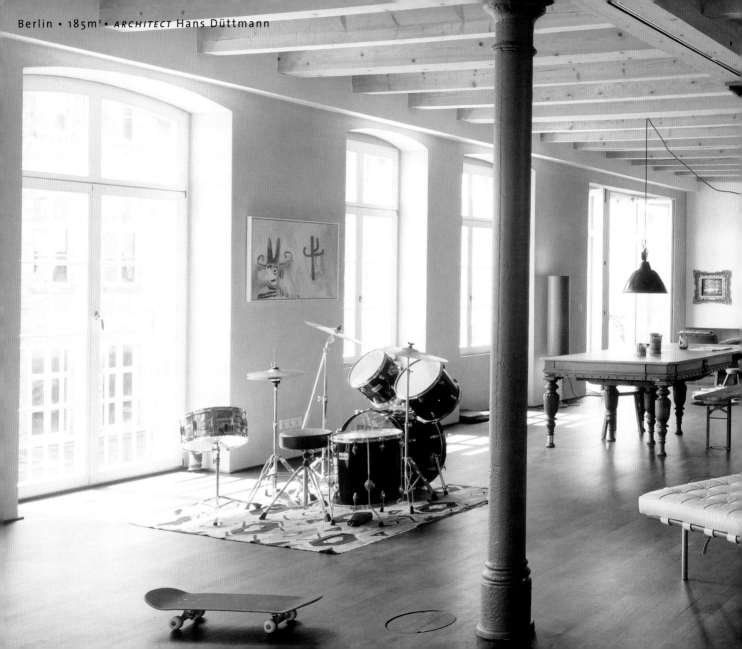

Berlin • 185m² • *ARCHITECT* Hans Düttmann

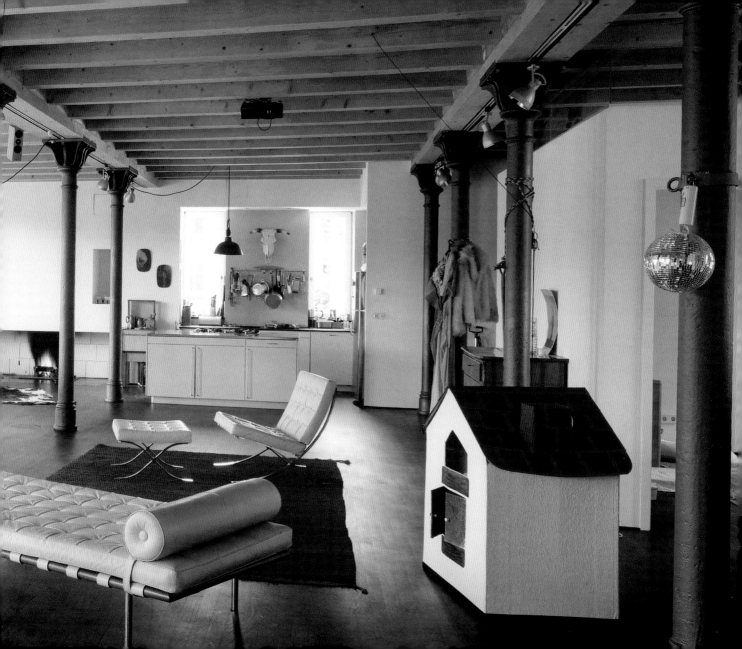

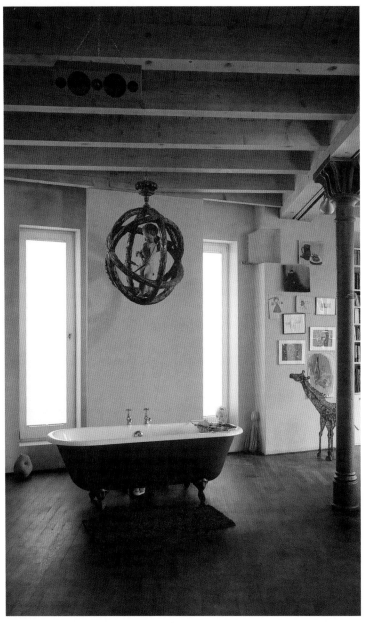
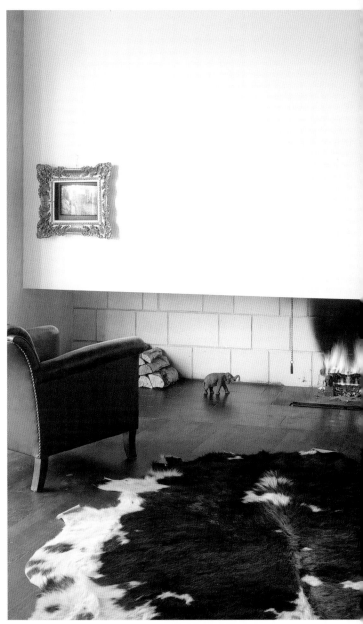

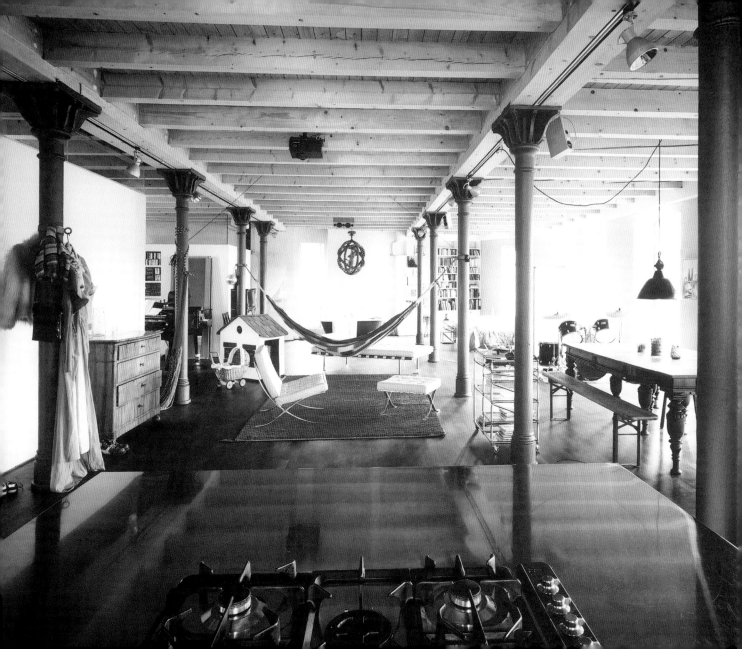

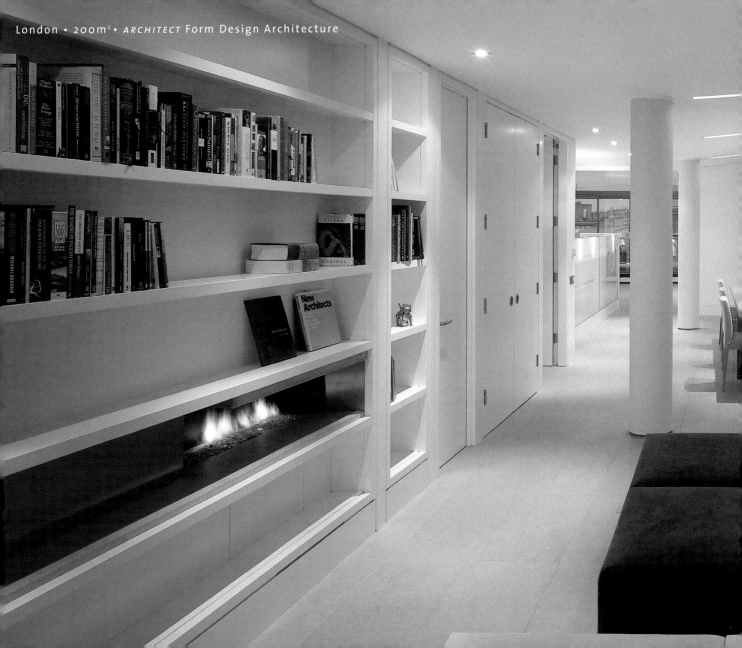

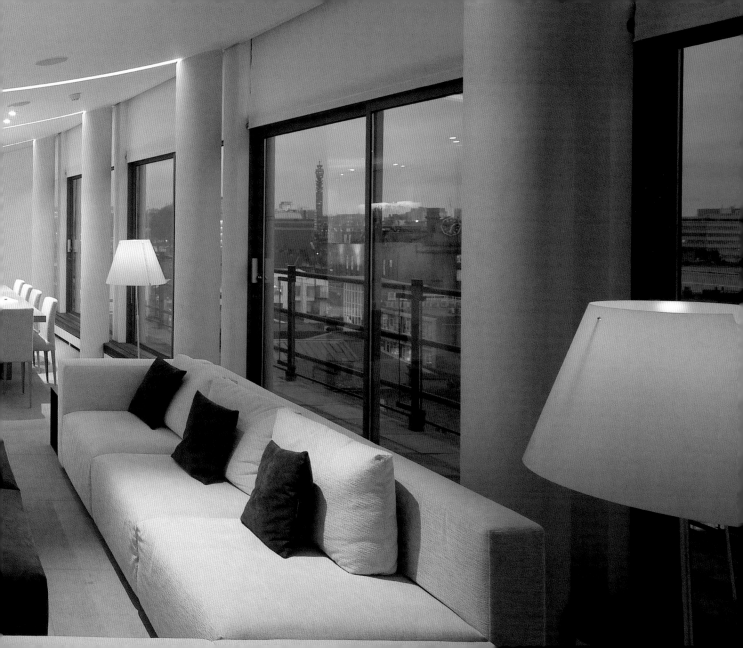

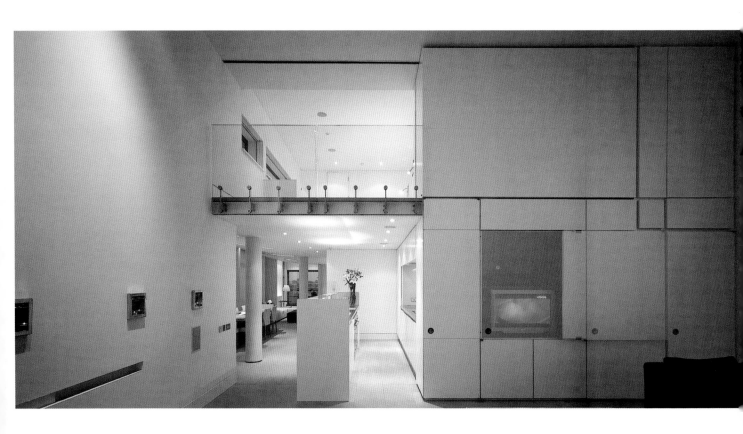

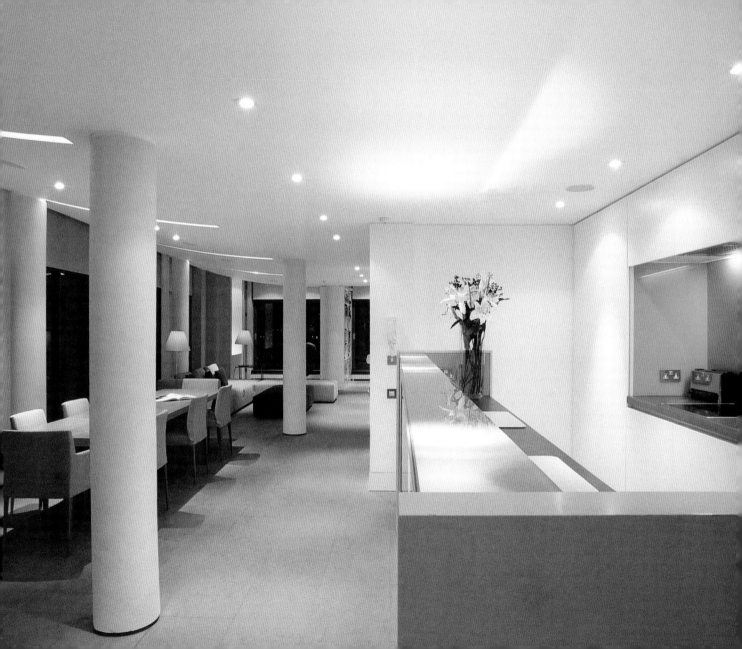

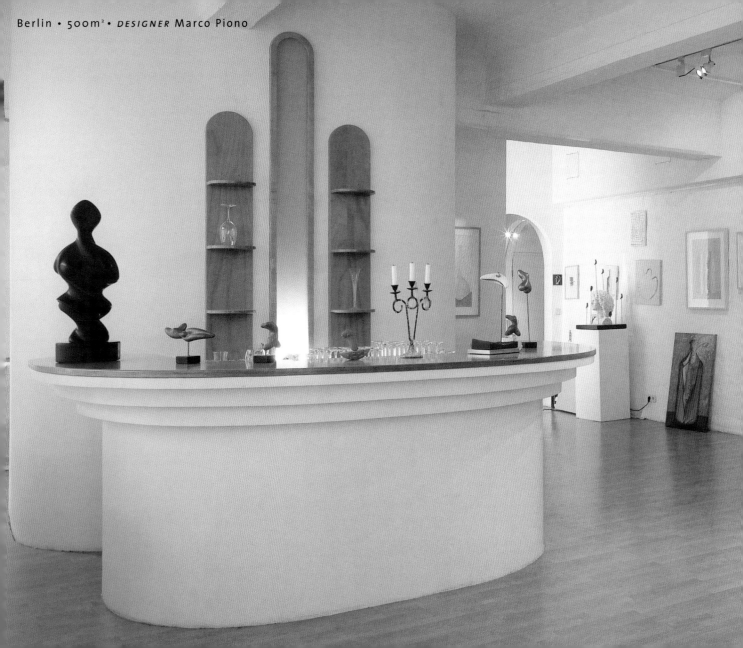

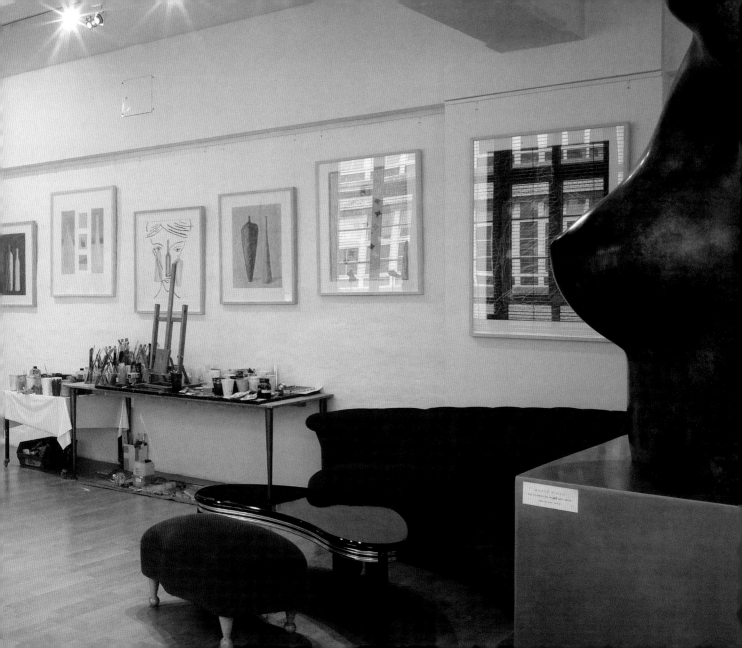

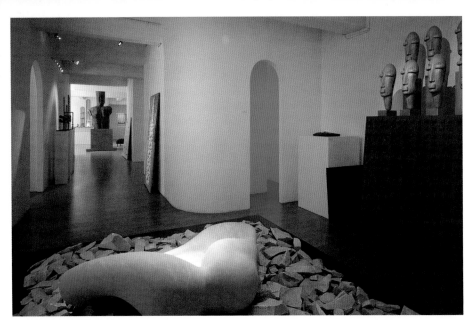

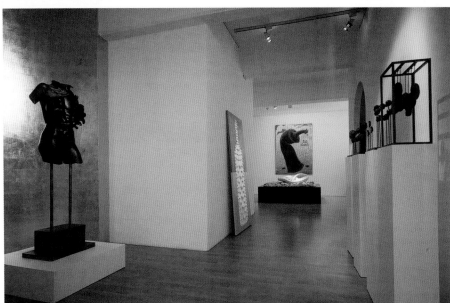

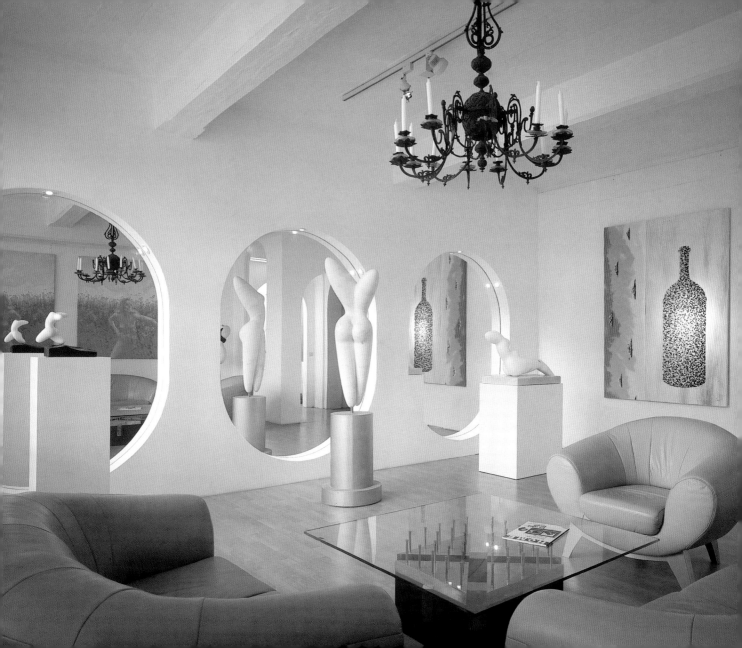

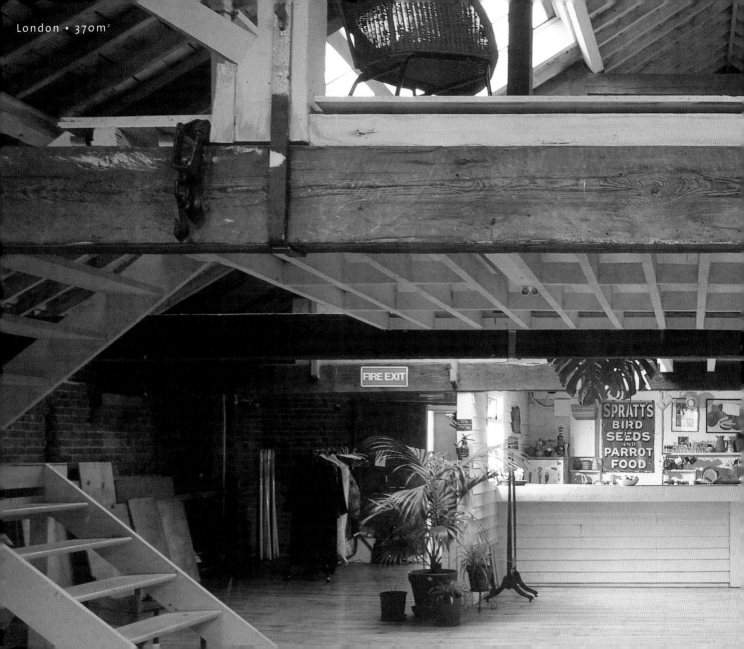

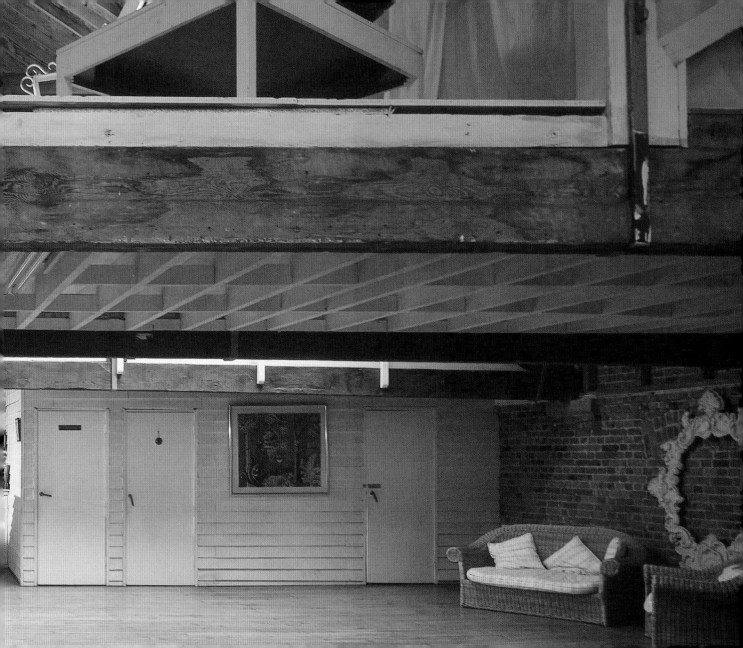

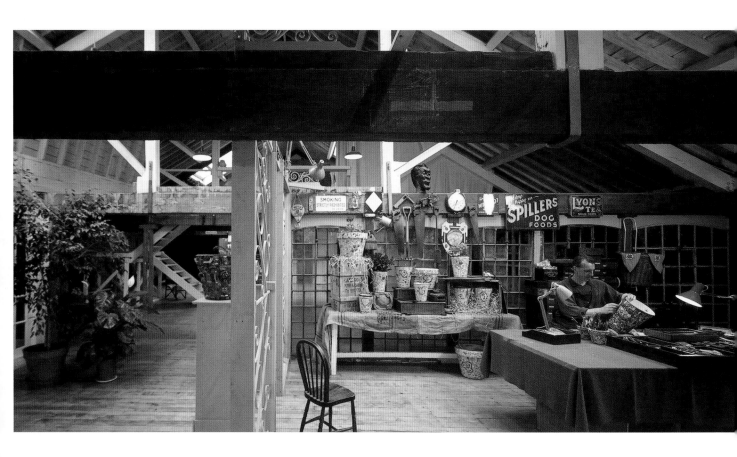

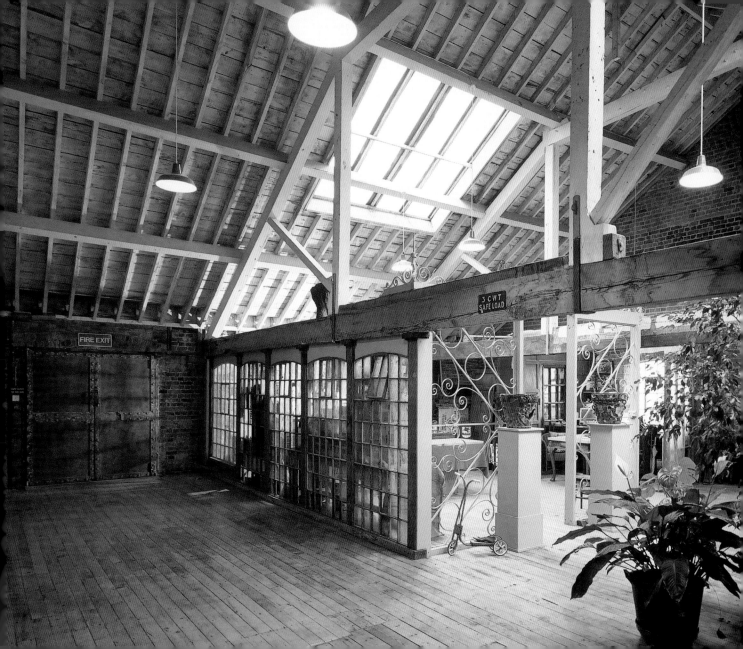

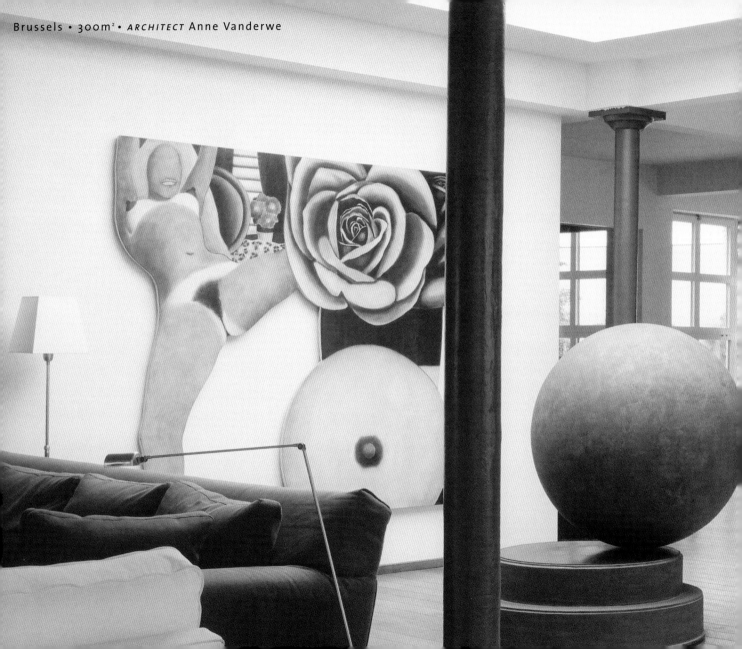

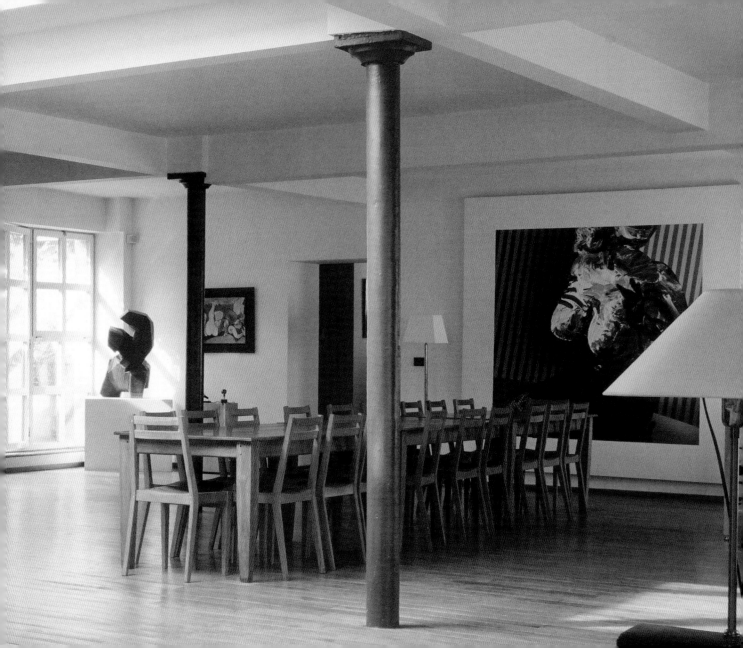

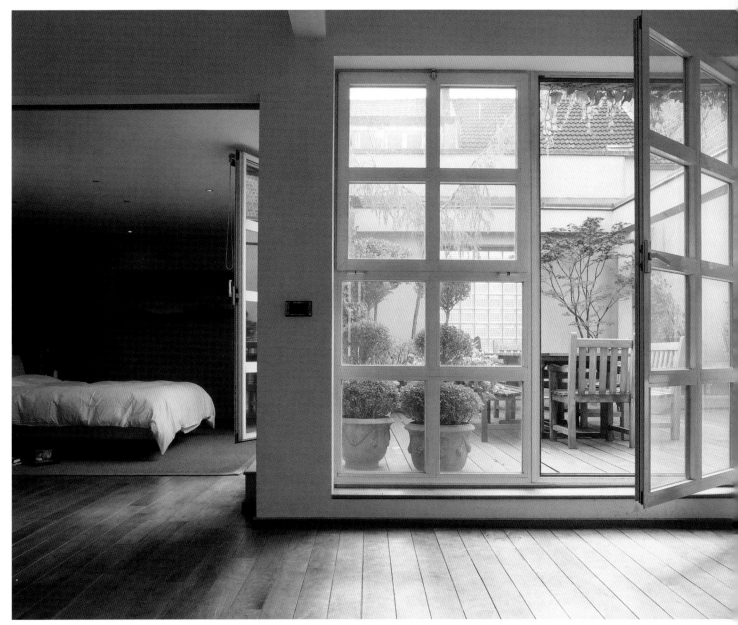

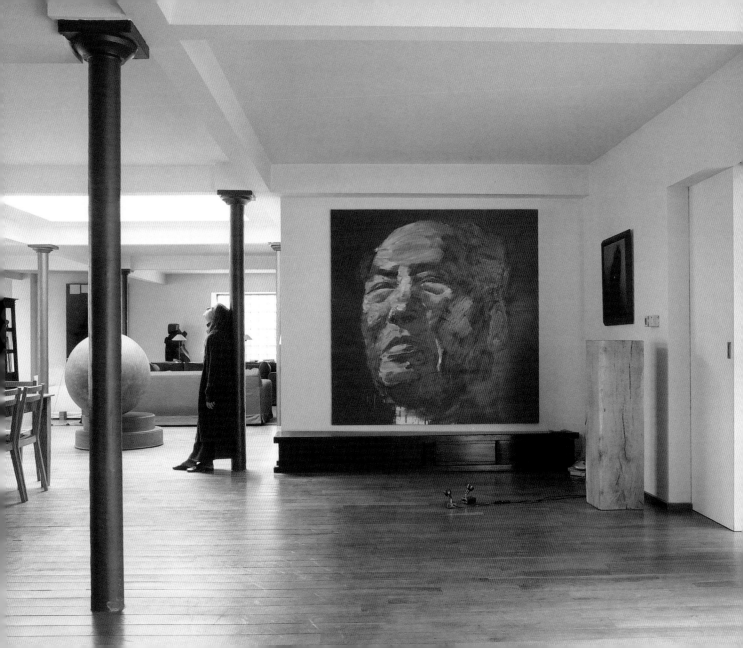

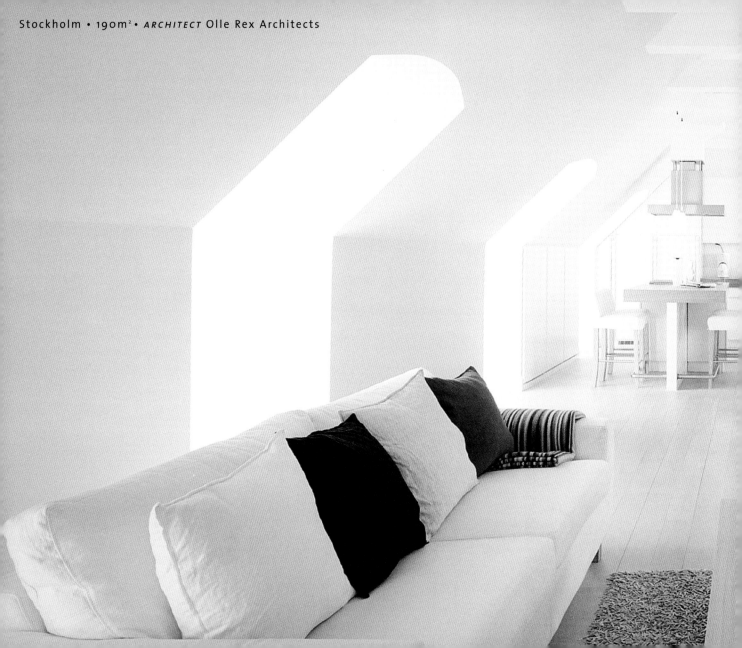

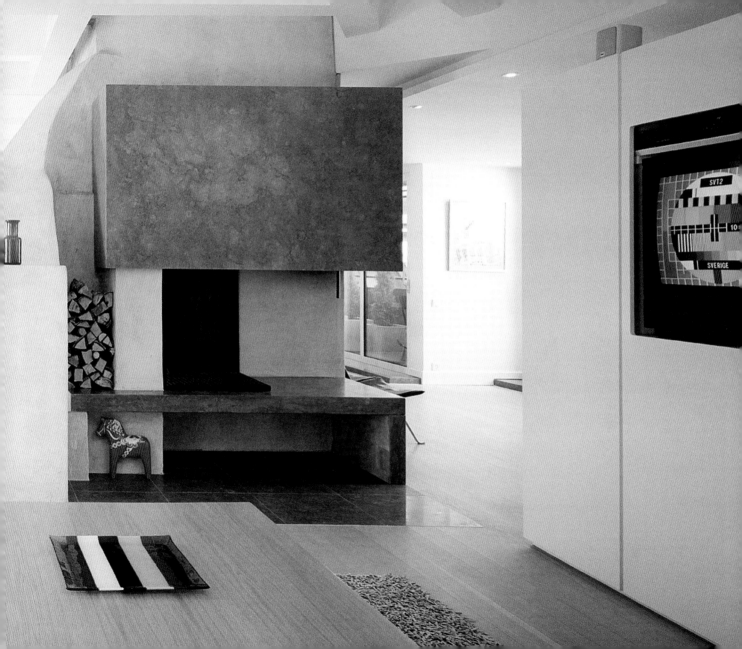

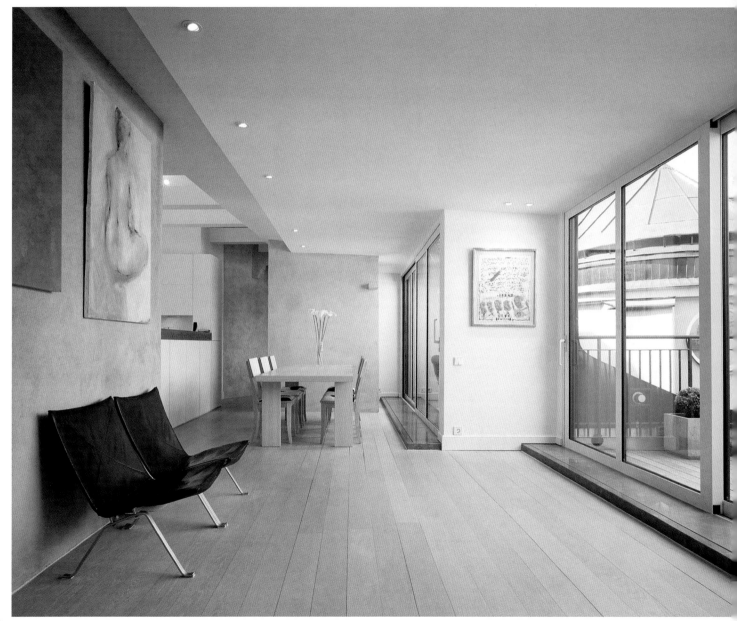

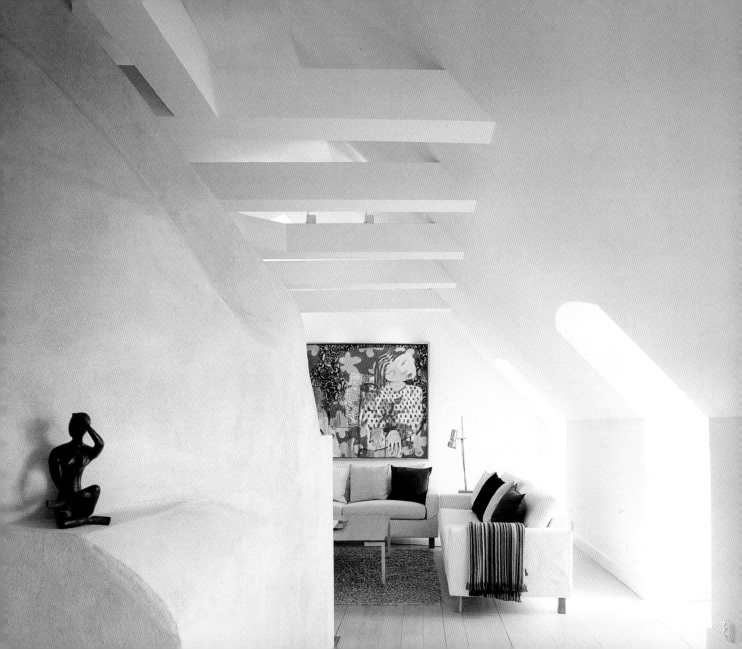

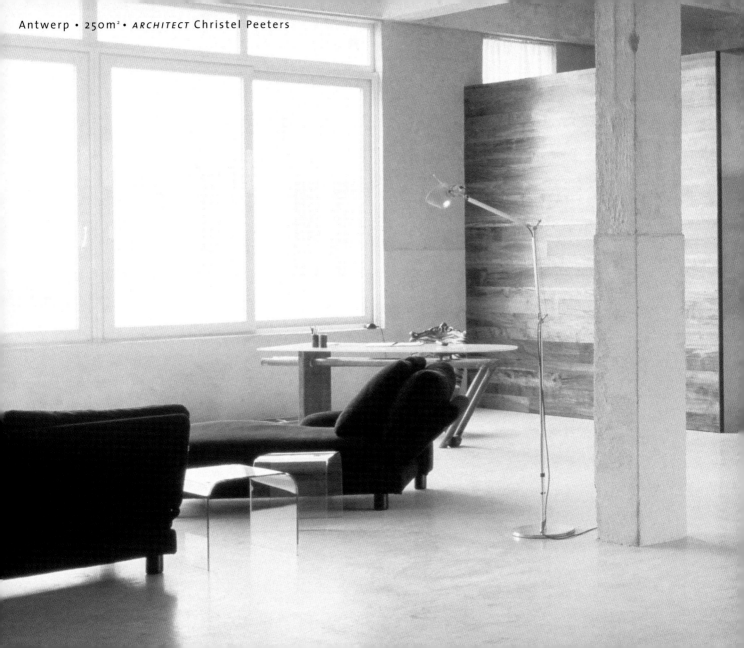

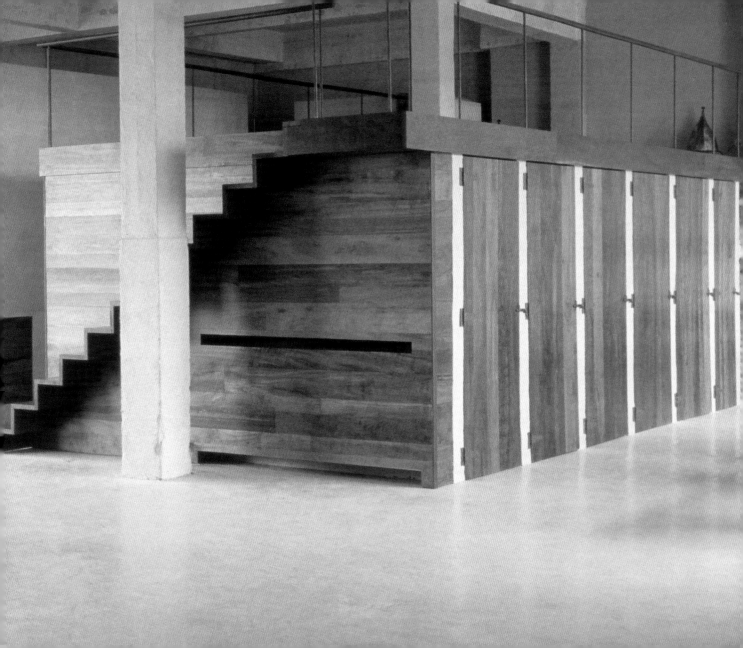

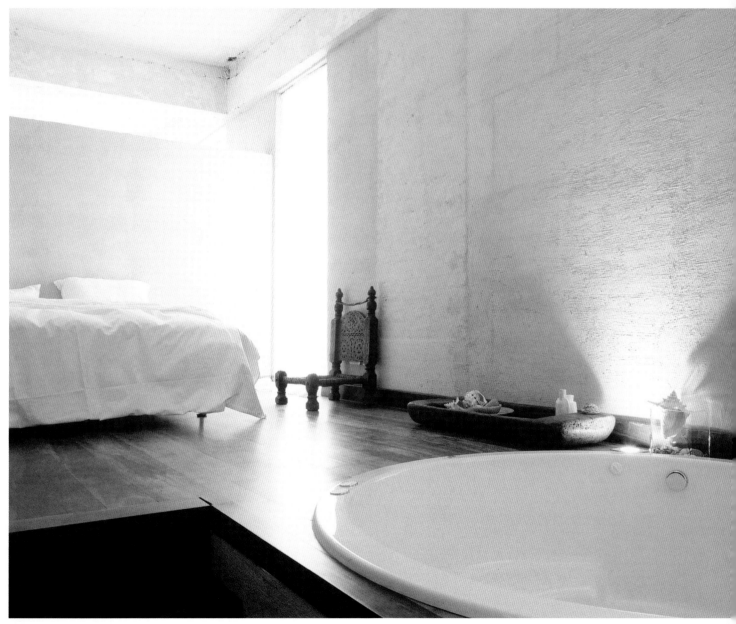

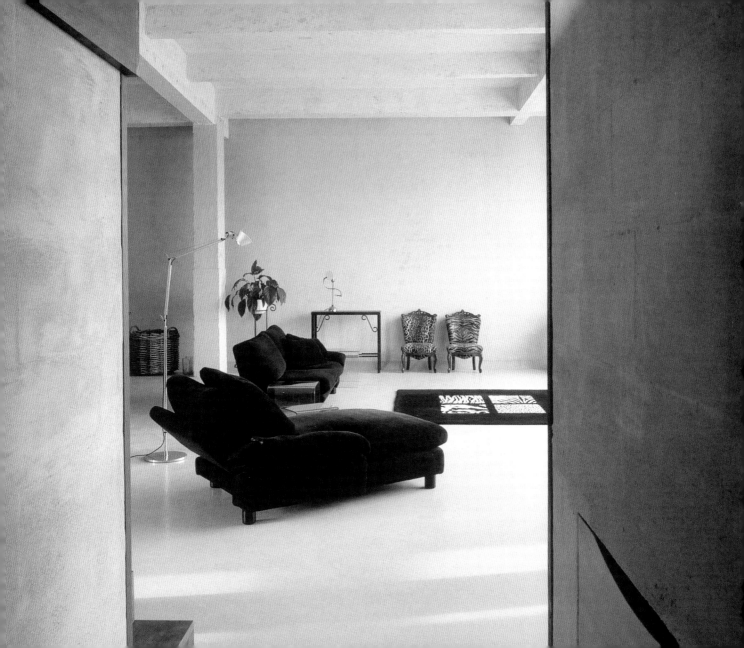

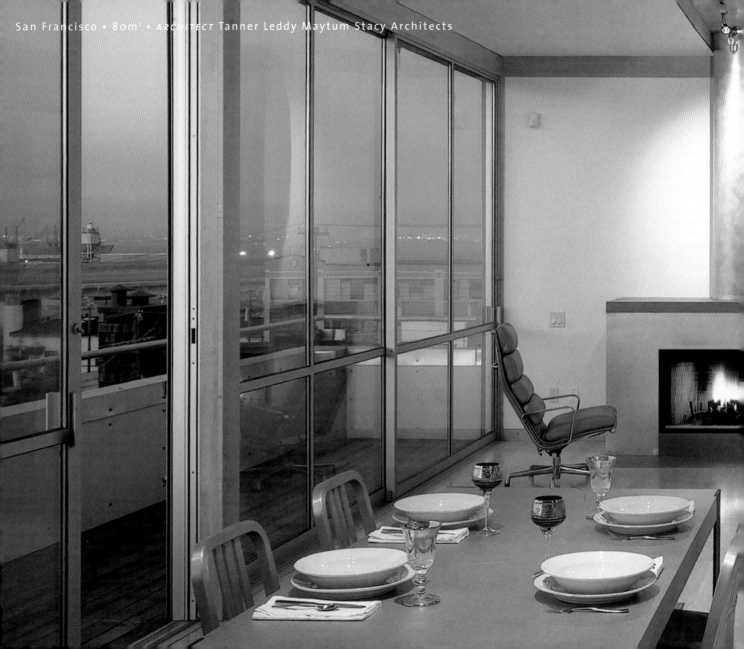

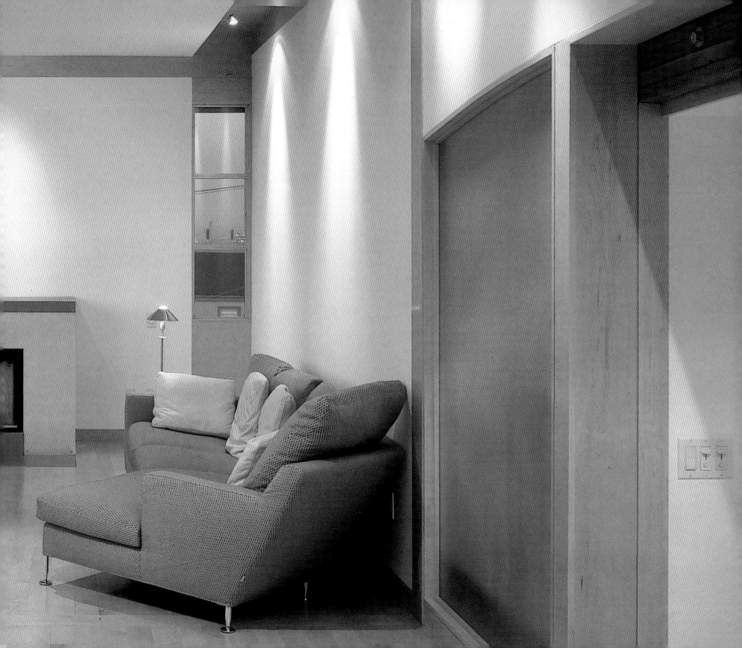

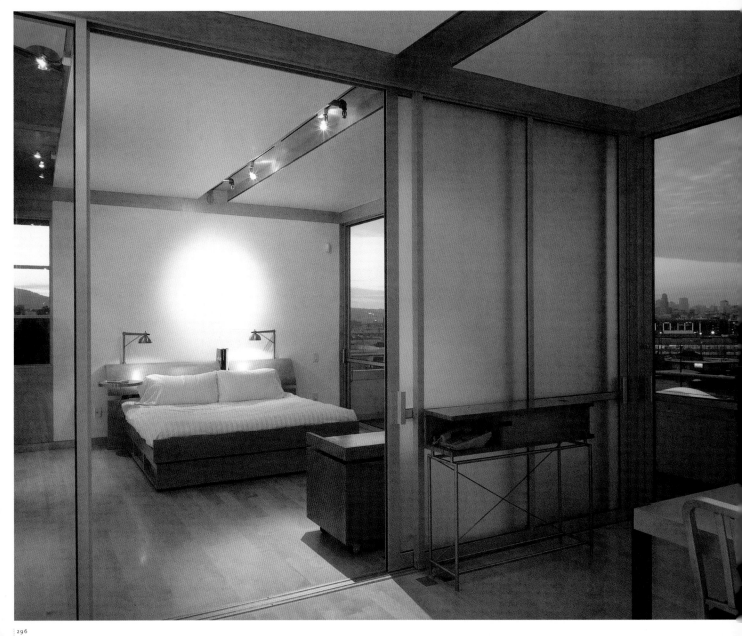

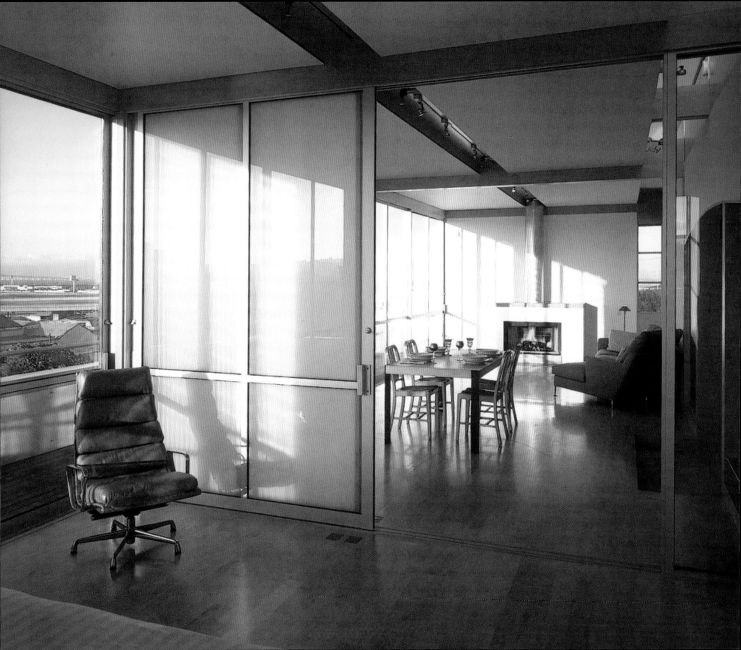

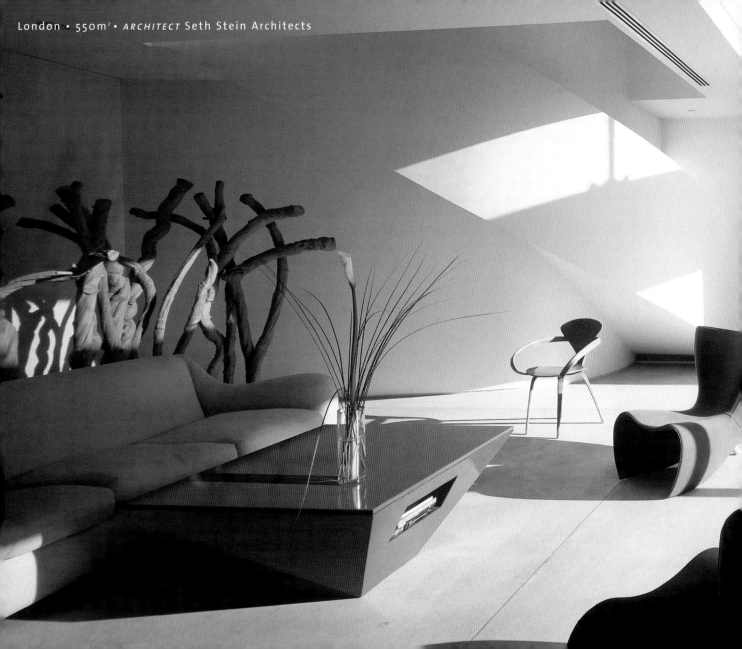

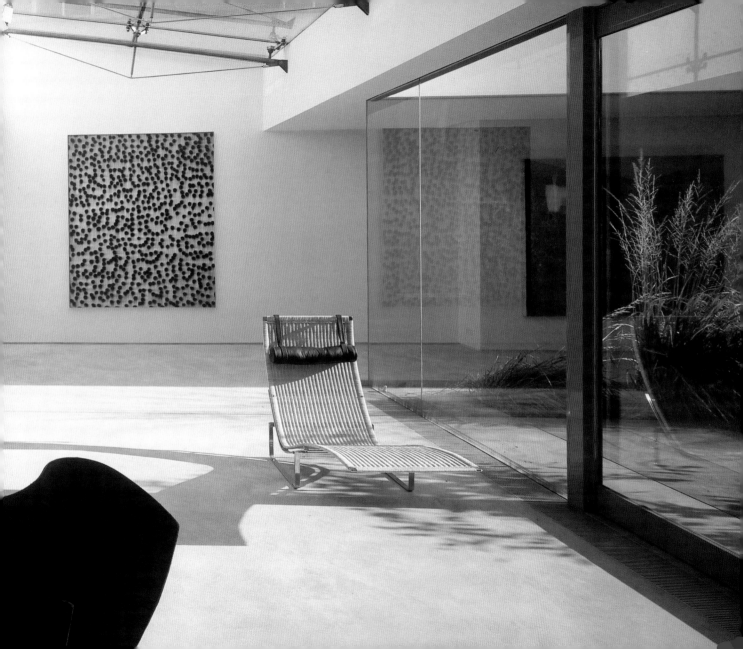

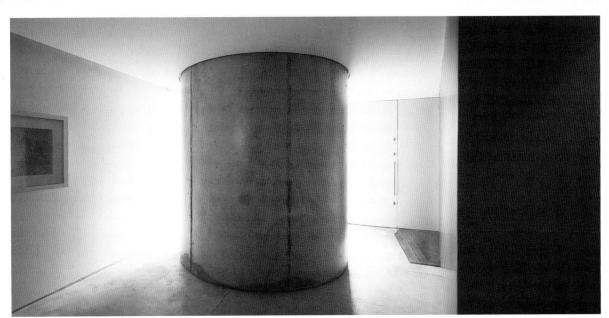

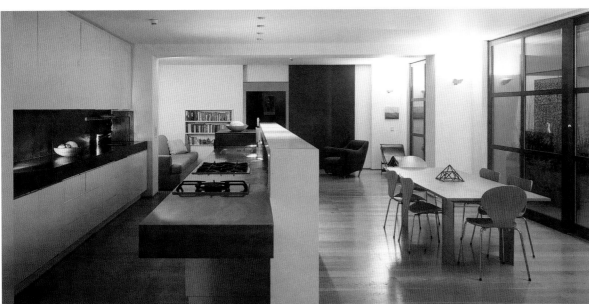

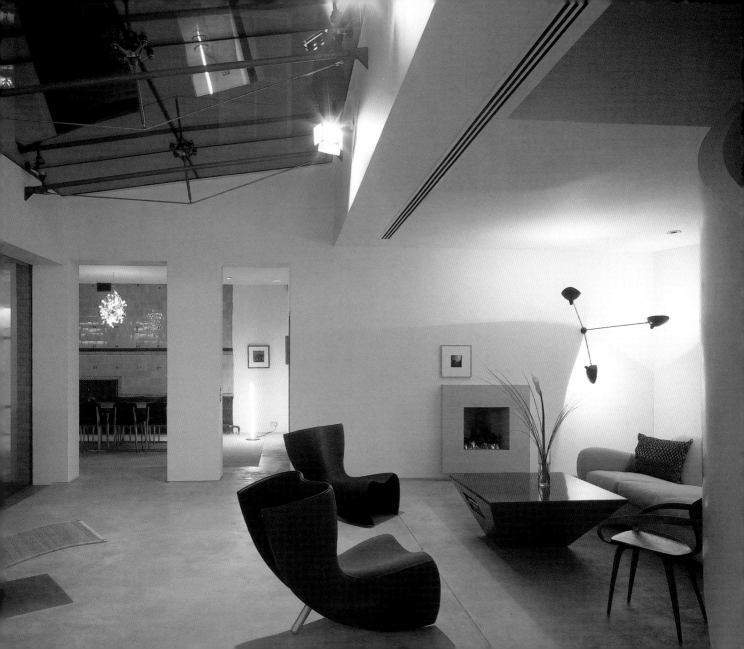

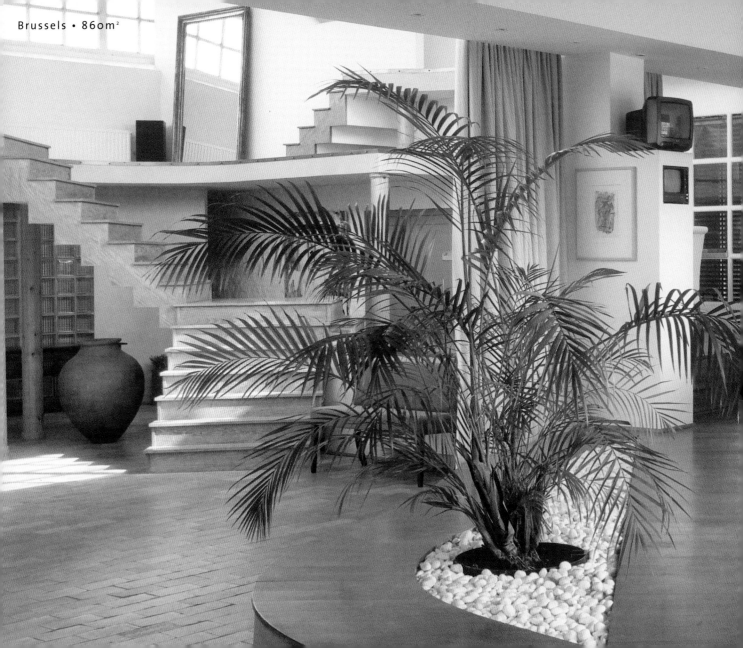

Brussels • 86om²

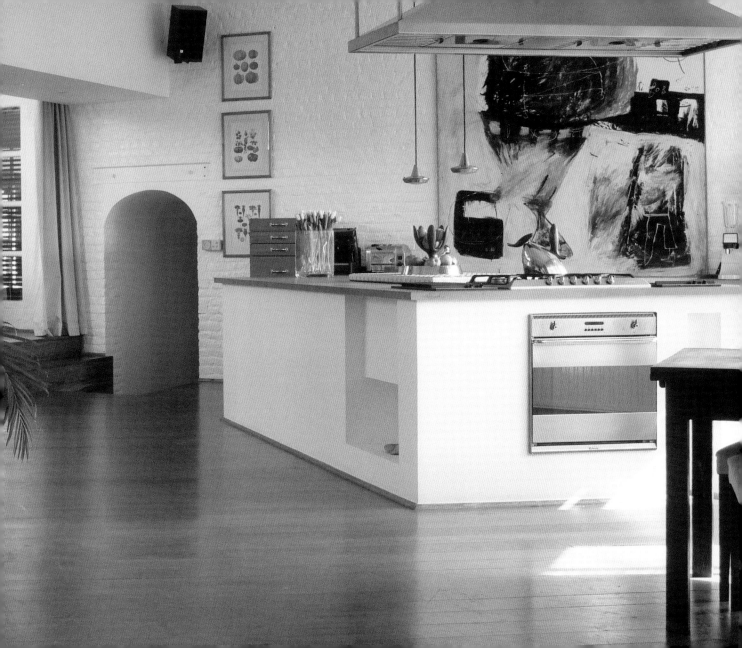

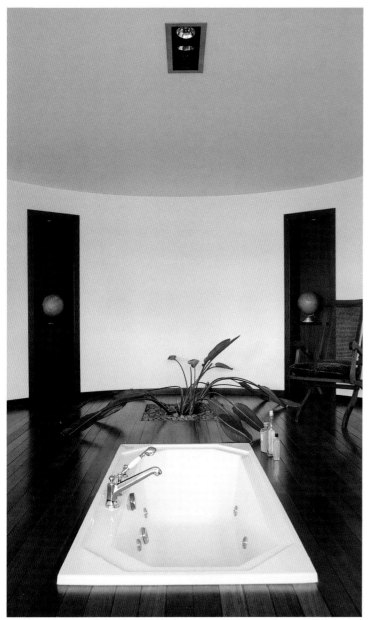
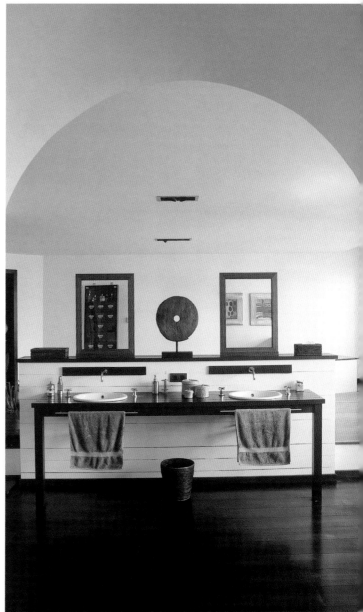

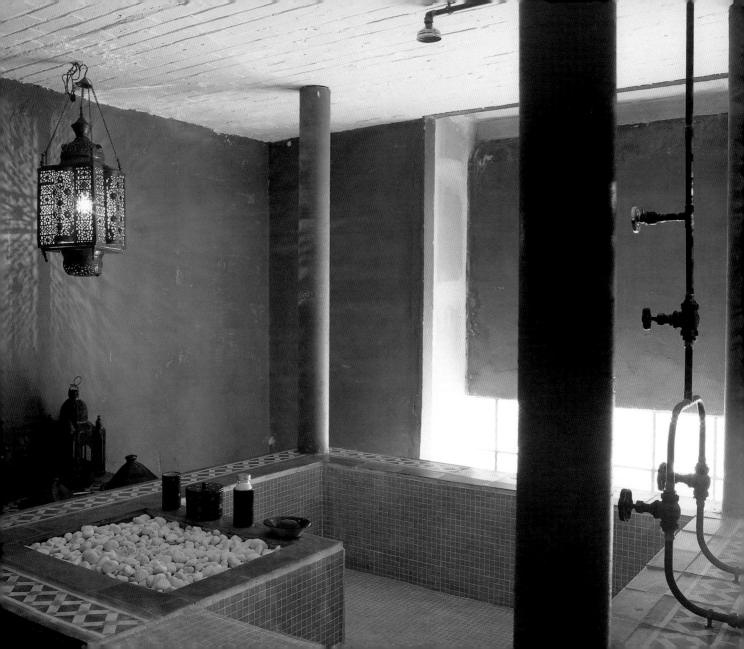

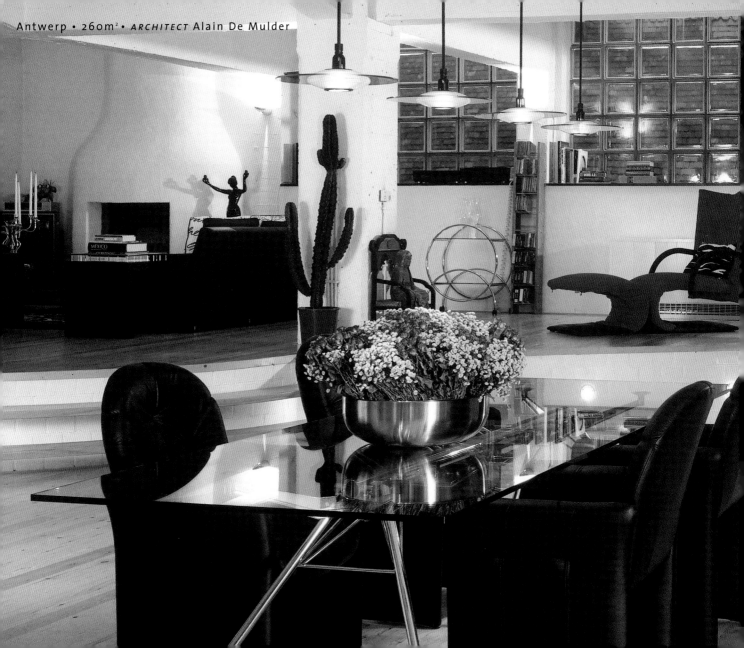

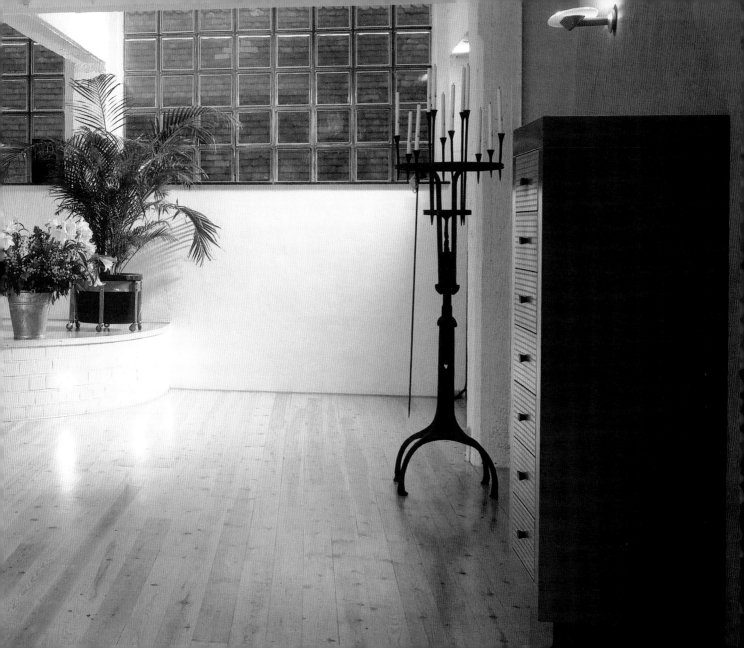

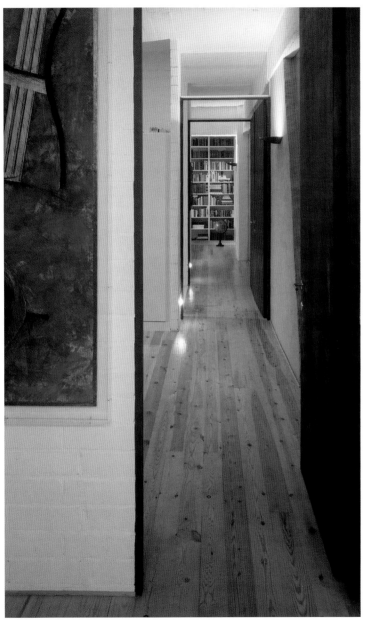
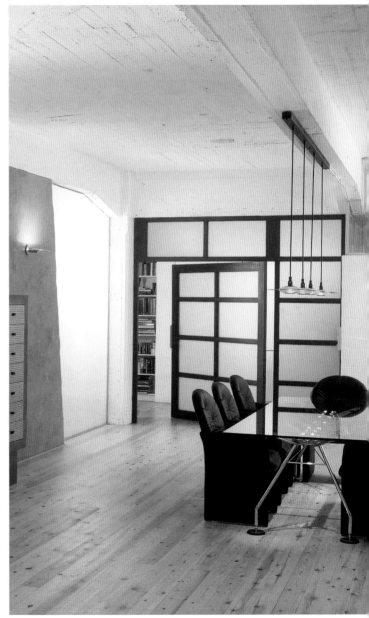

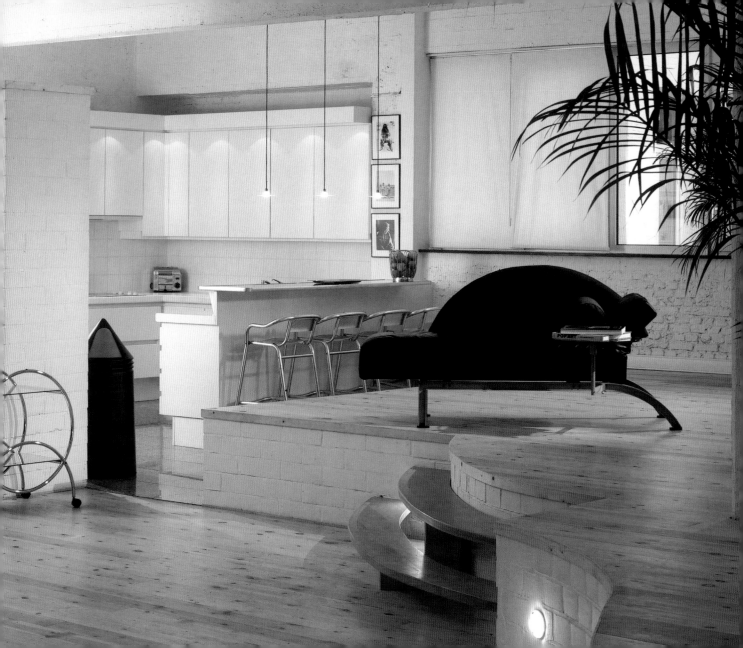

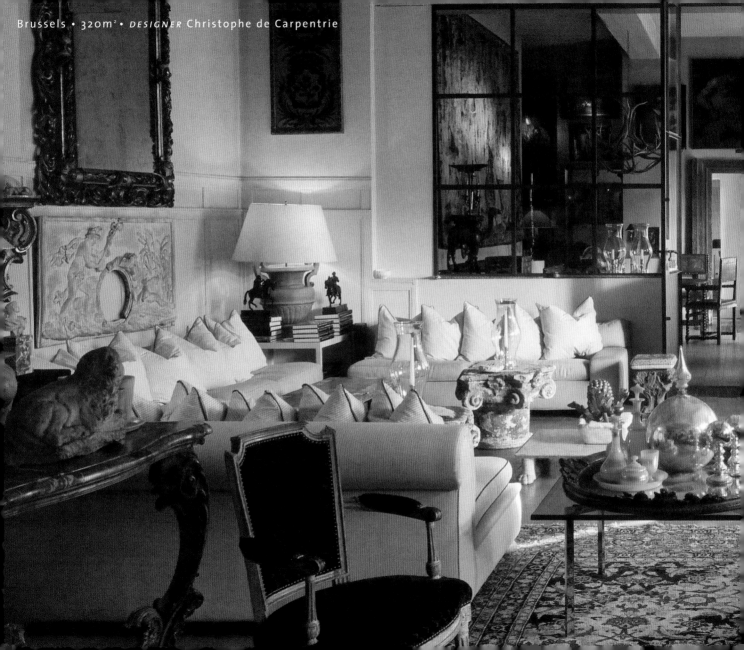

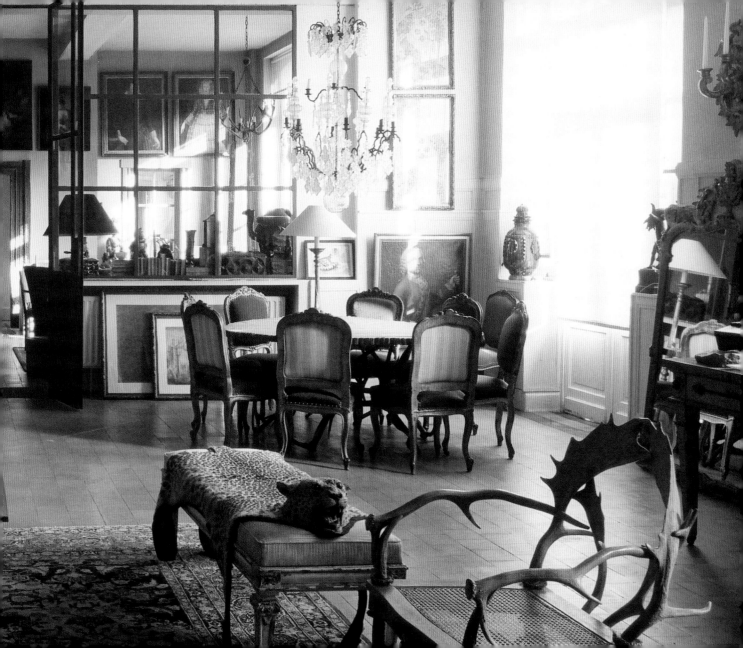

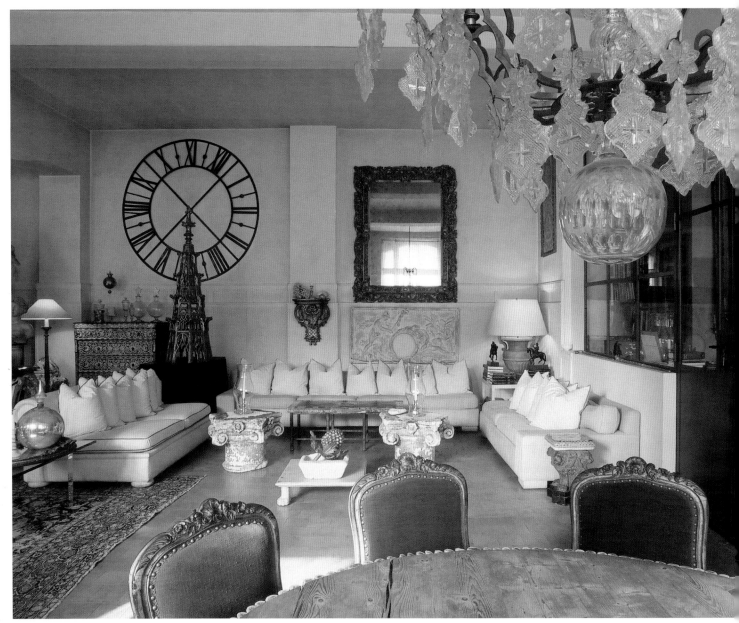

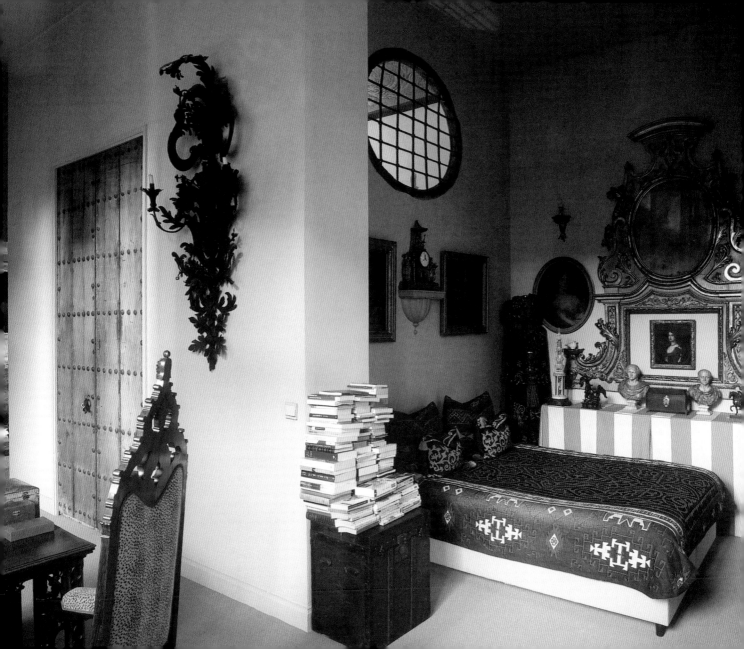

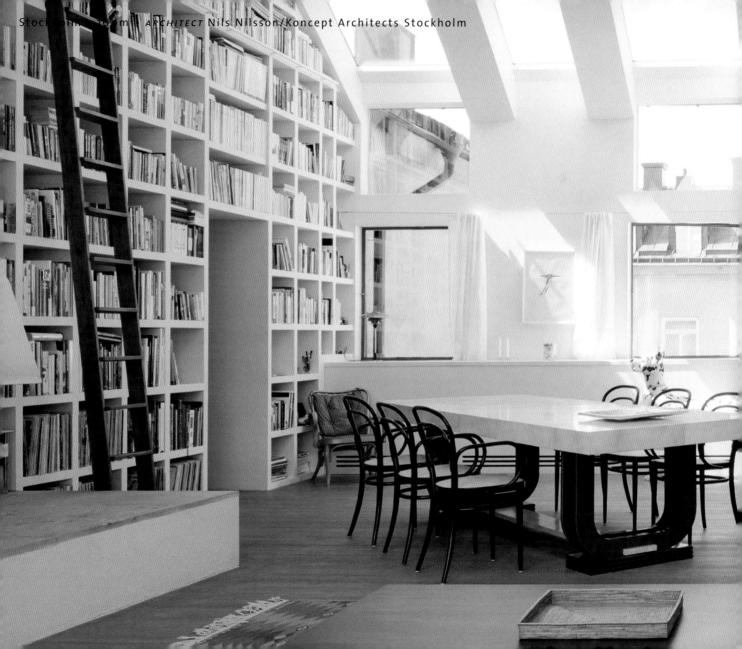

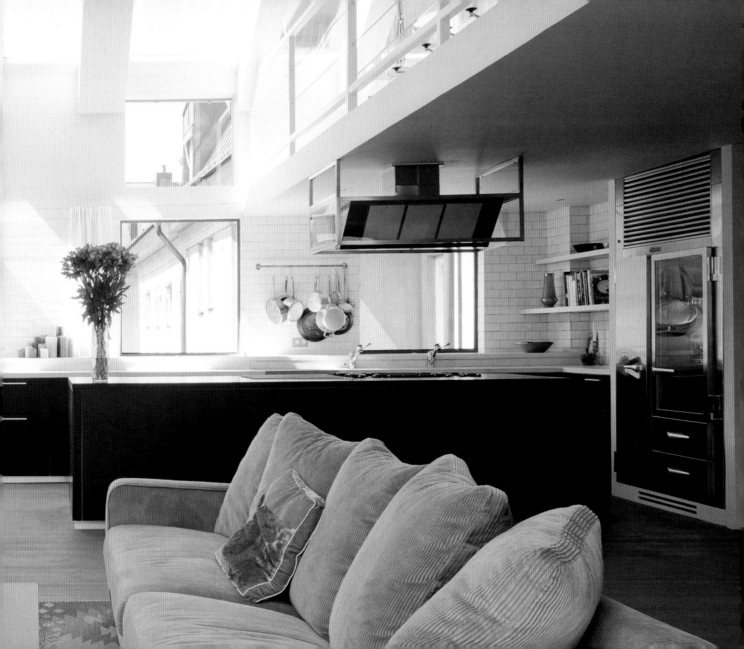

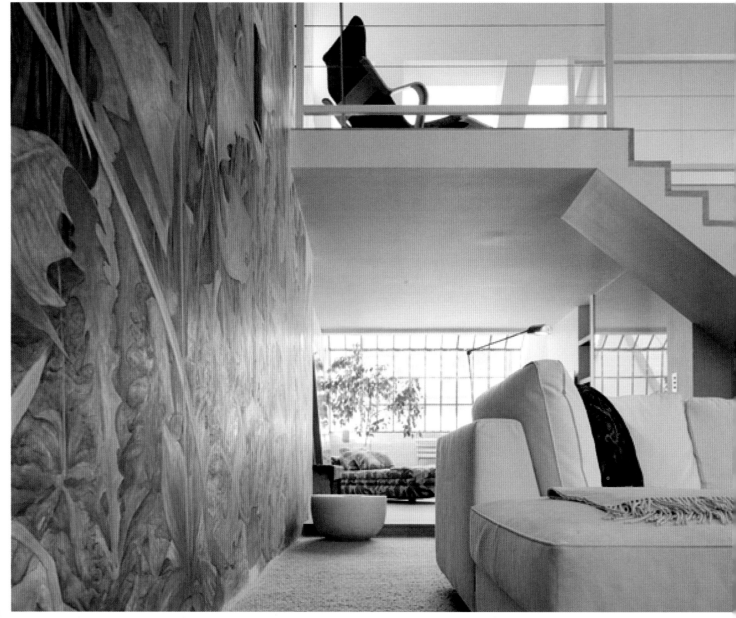

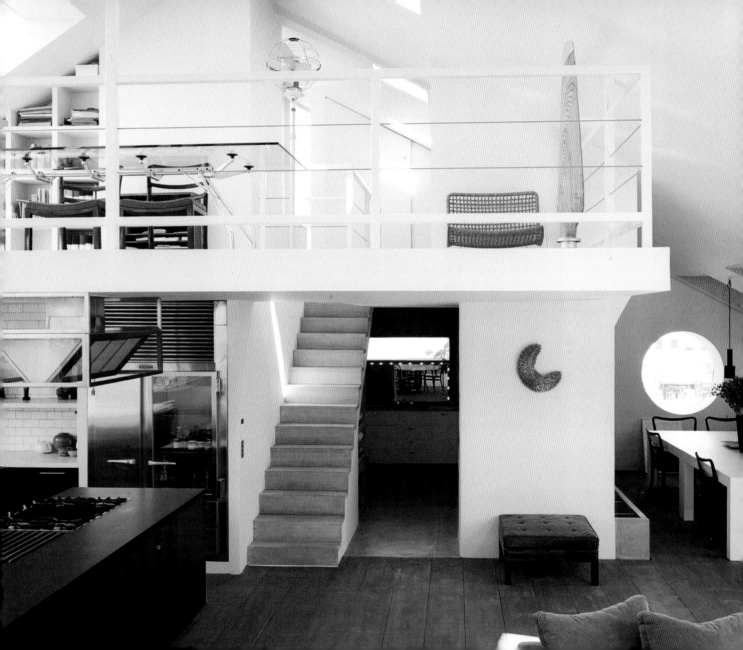

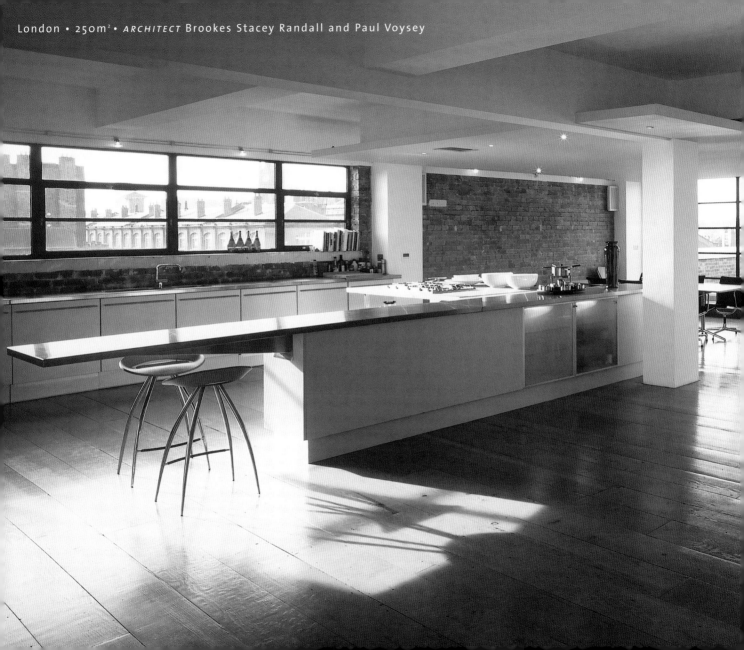

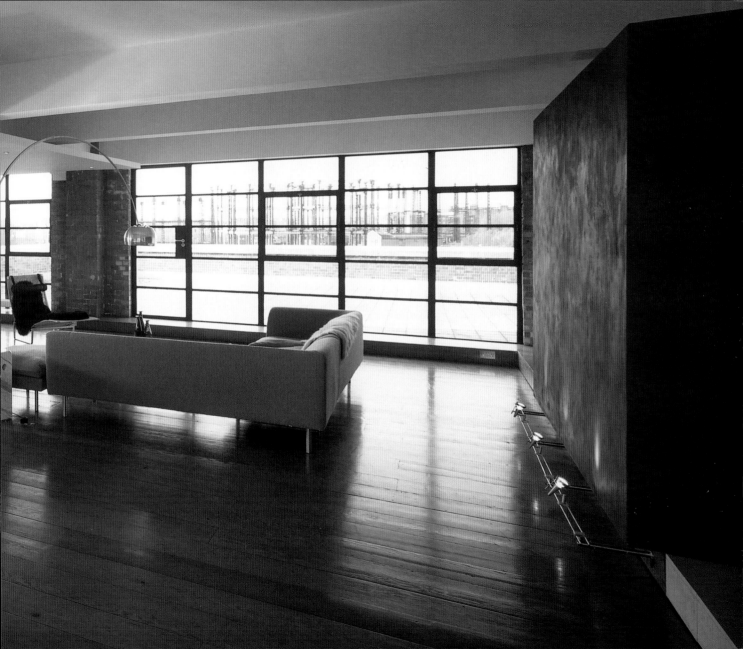

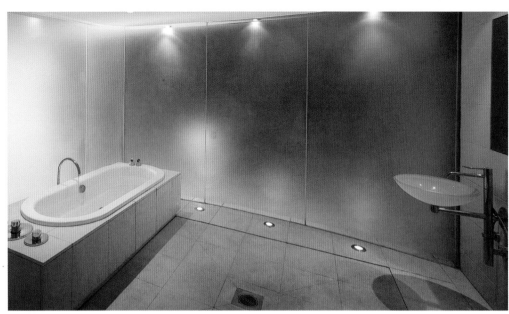

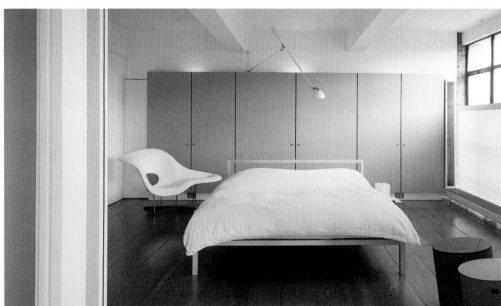

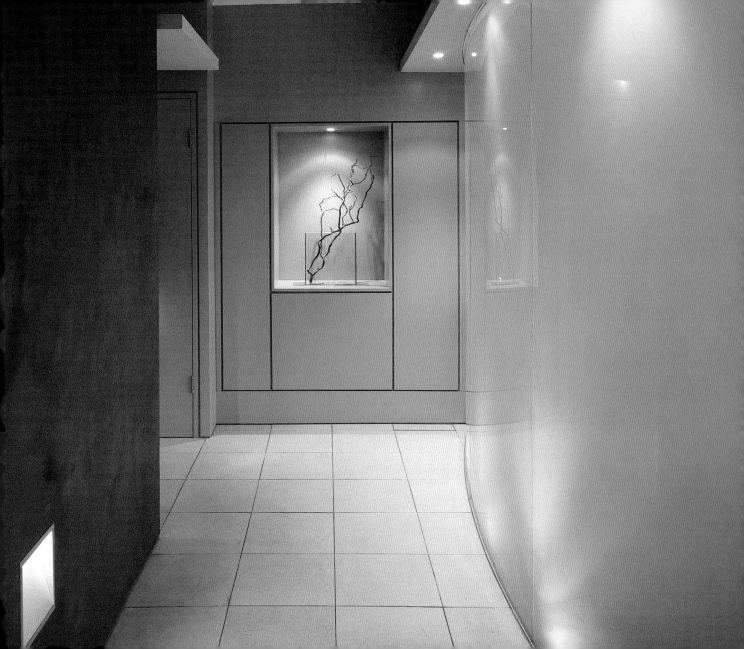

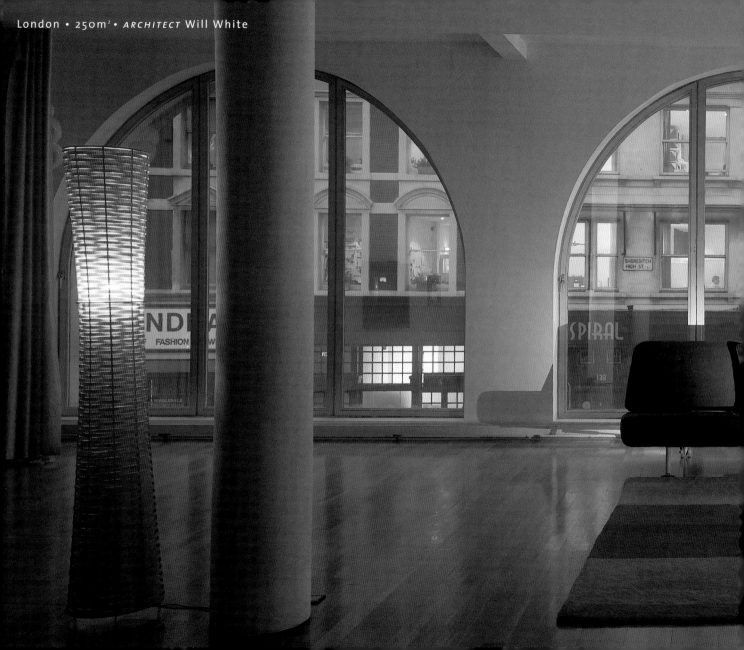

London • 250m² • *ARCHITECT* Will White

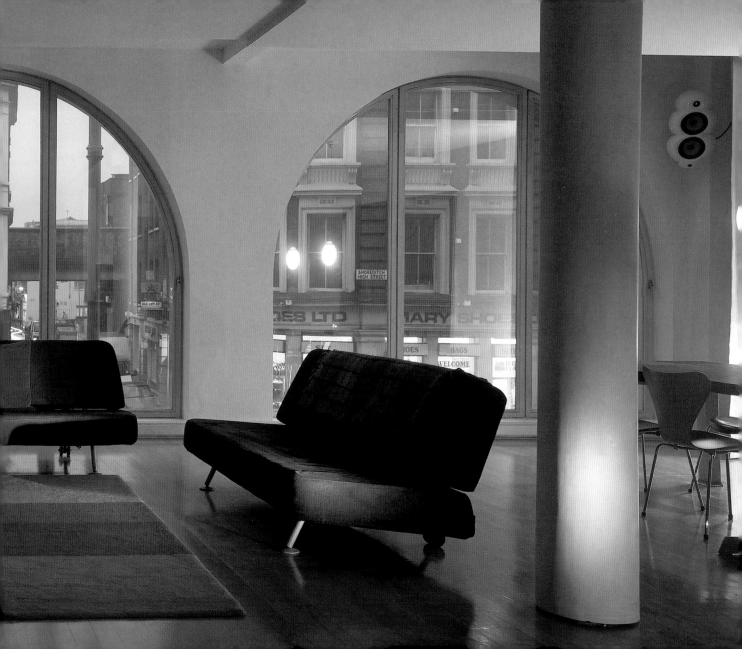

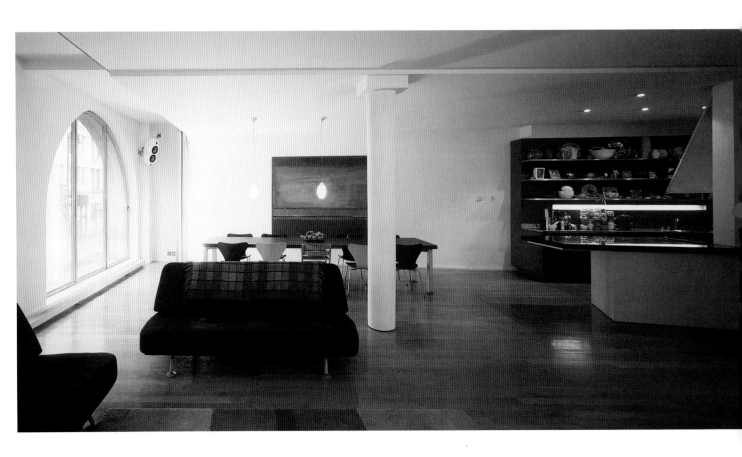

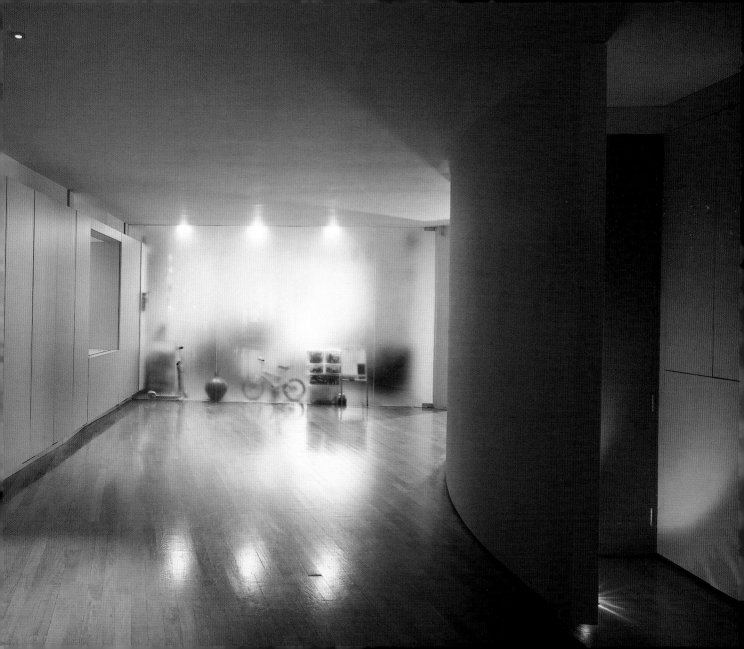

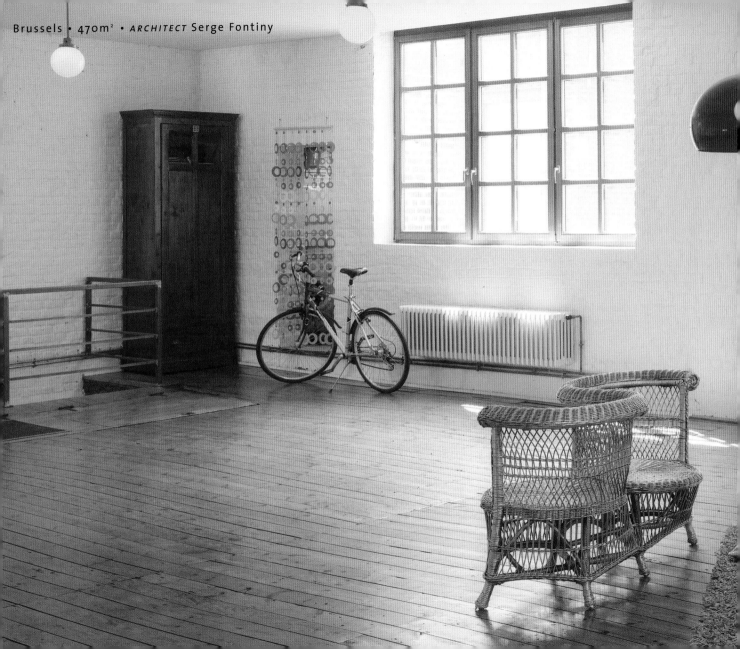

Brussels • 470m² • *ARCHITECT* Serge Fontiny

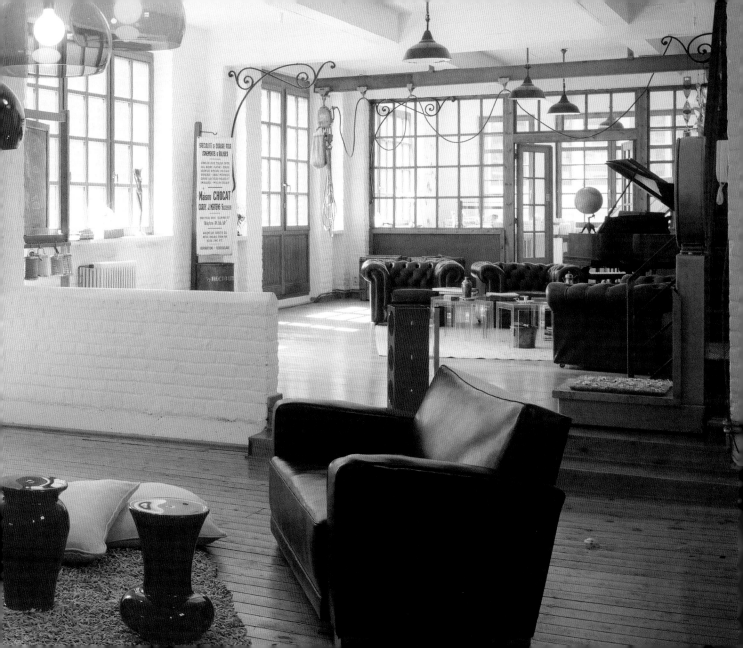

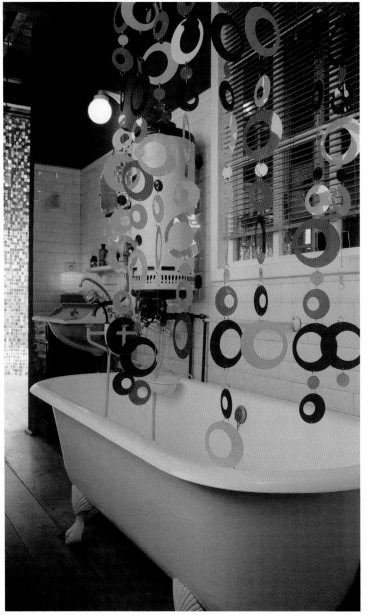
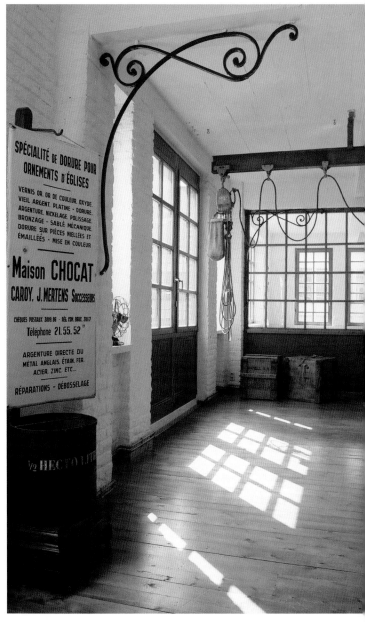

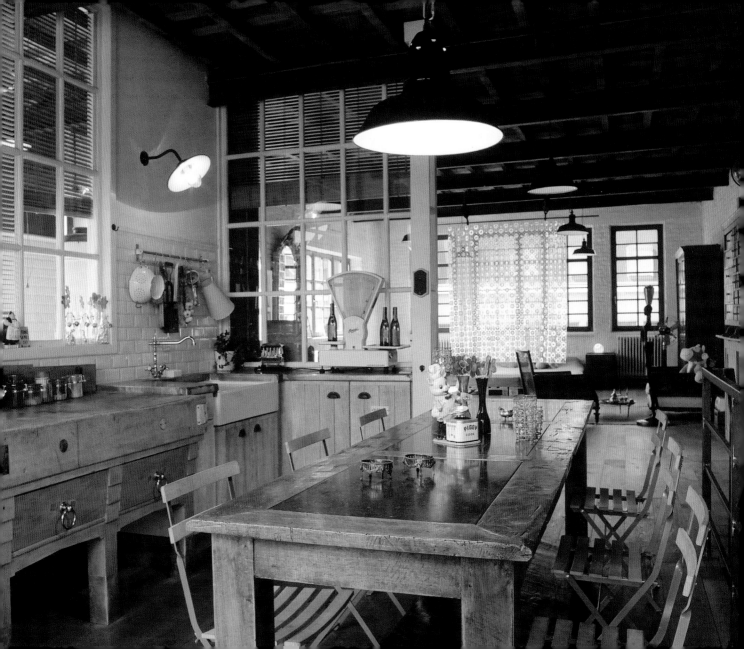

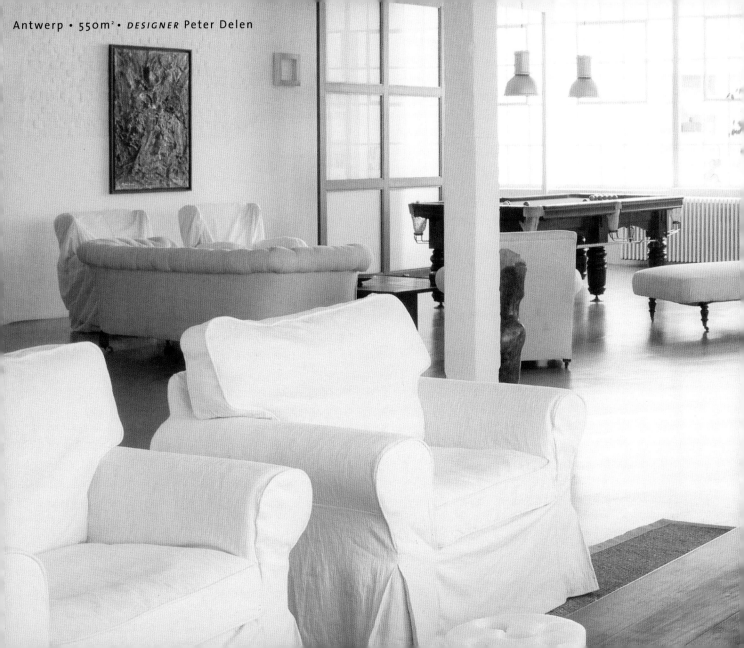

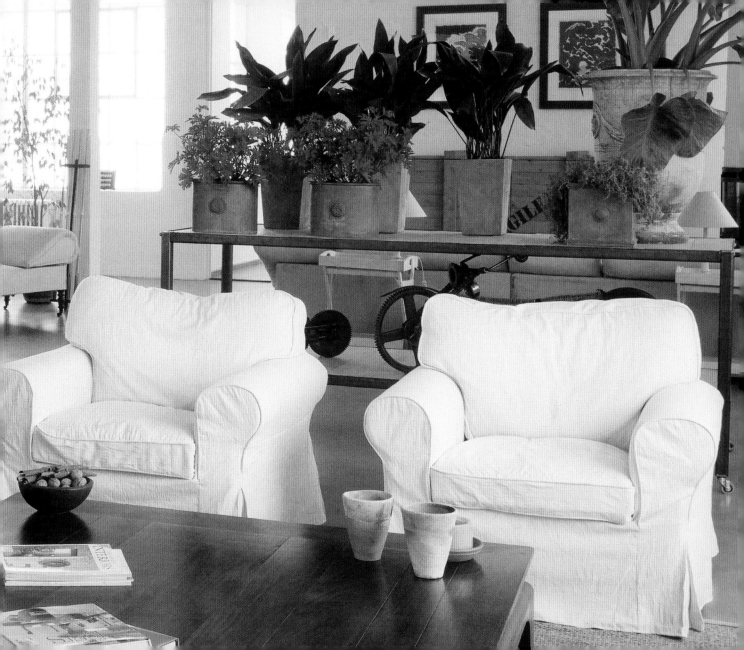

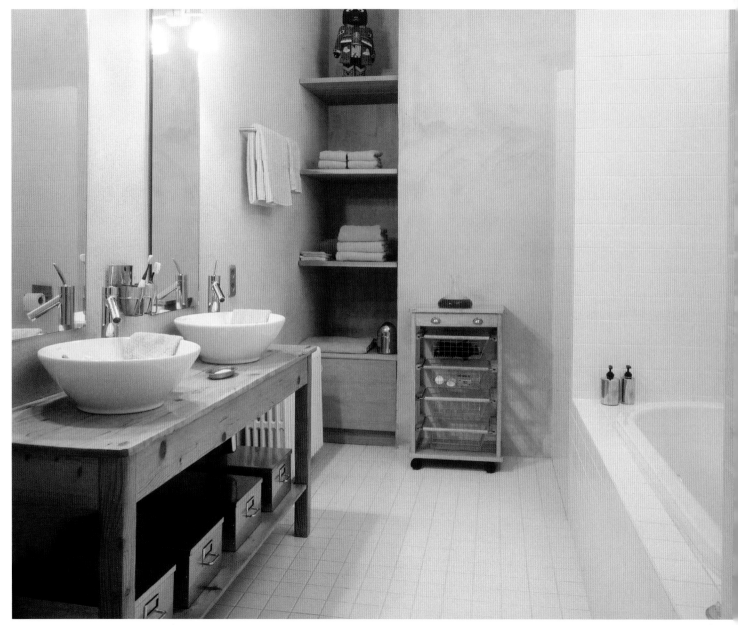

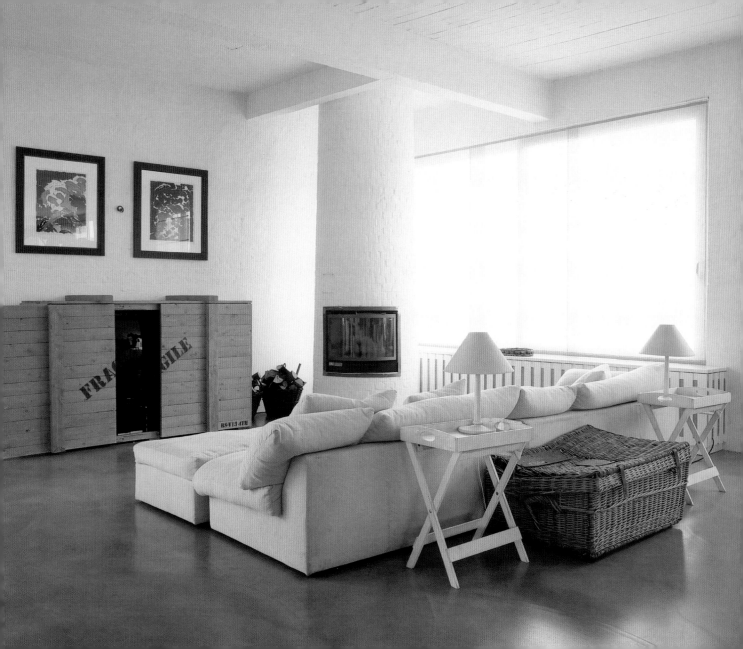

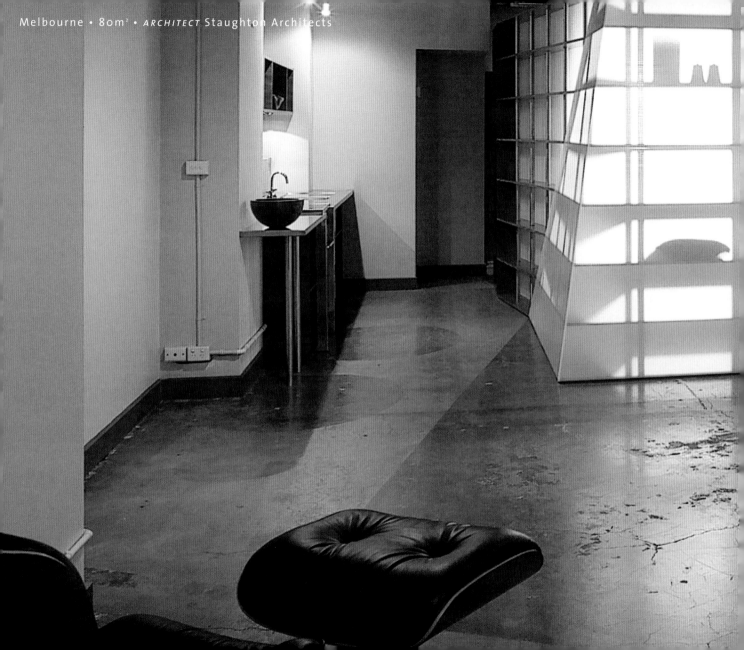

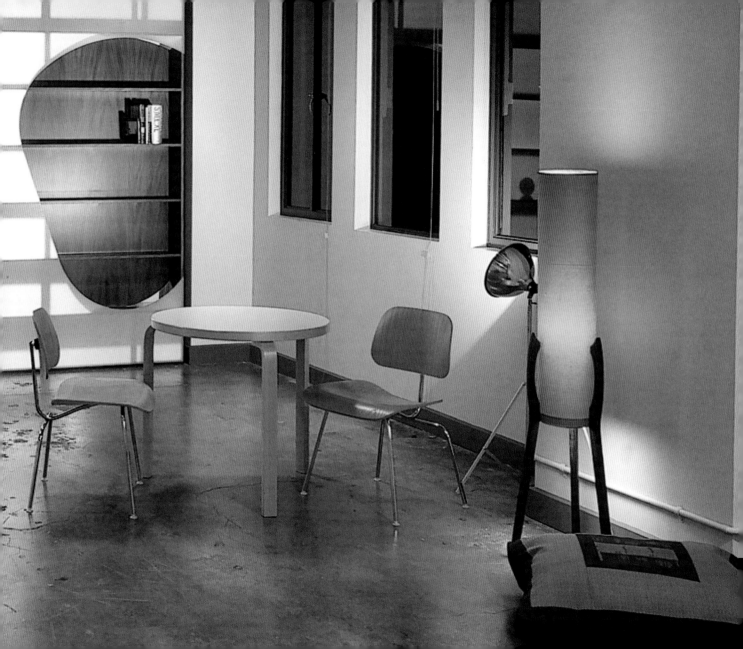

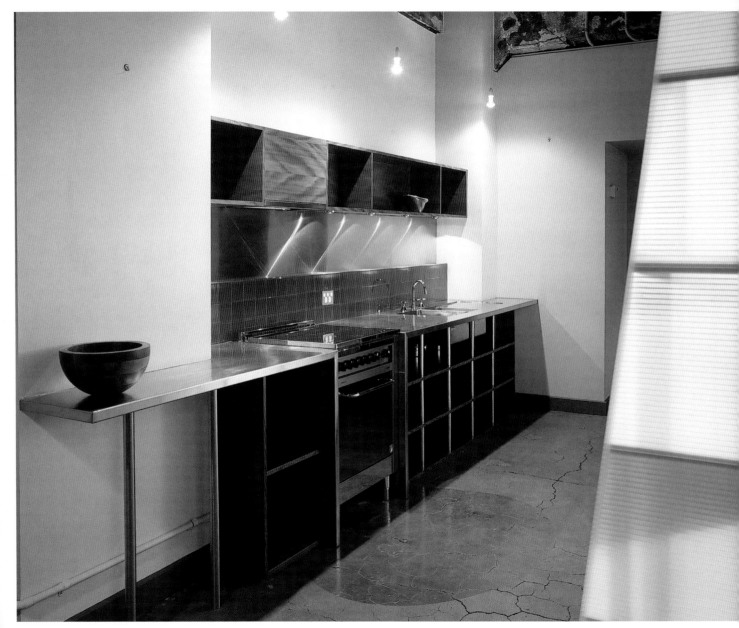

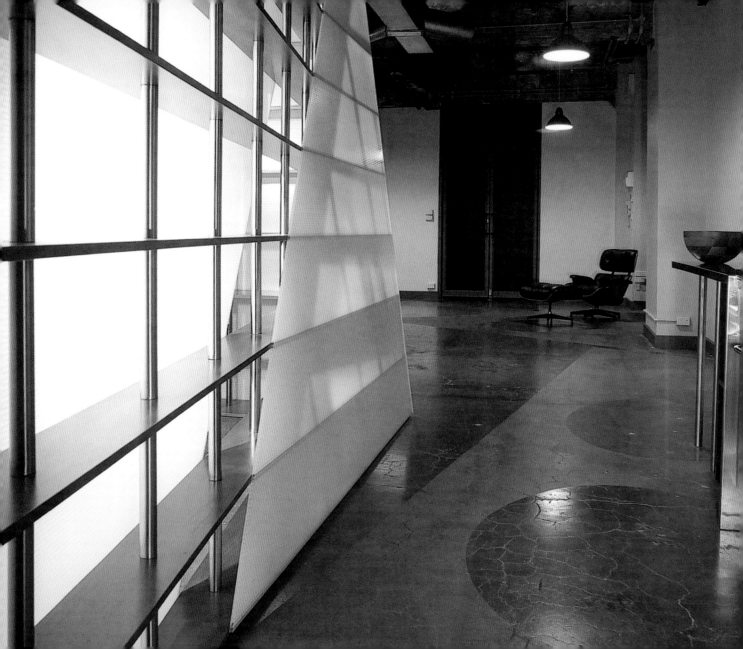

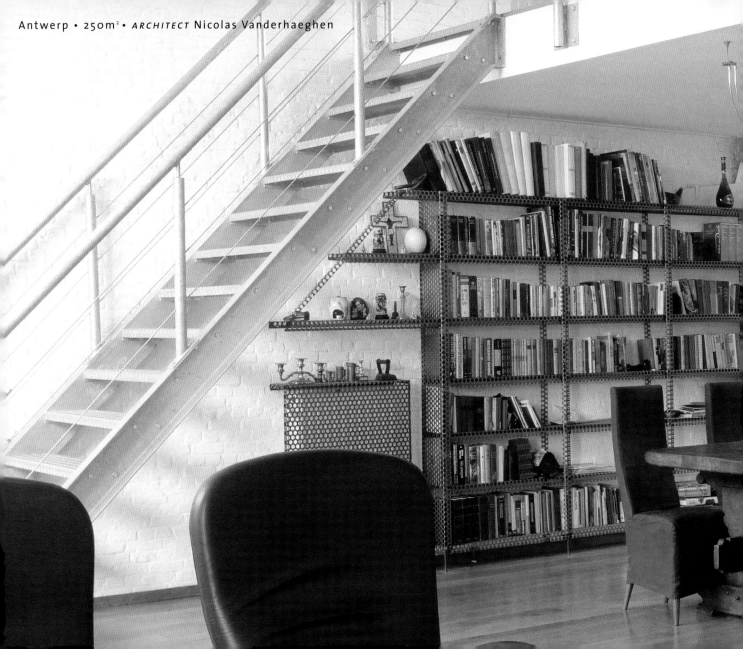

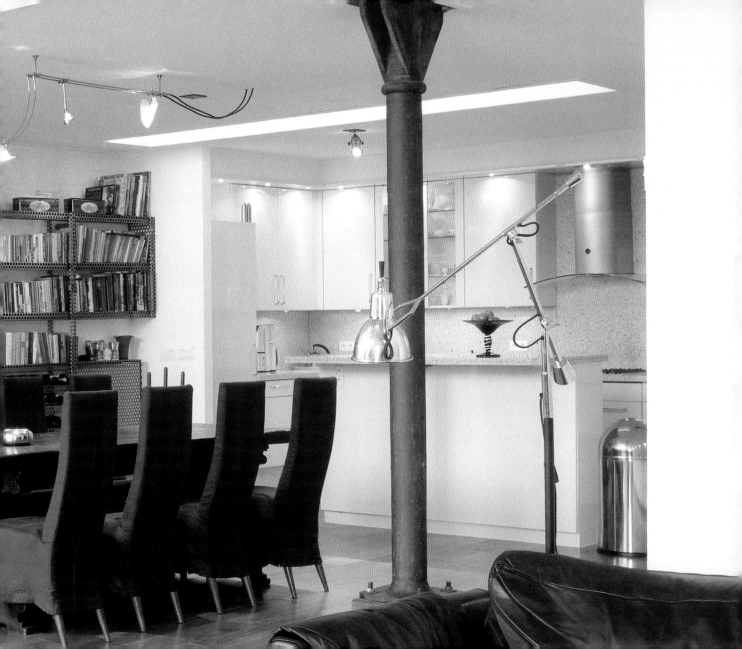

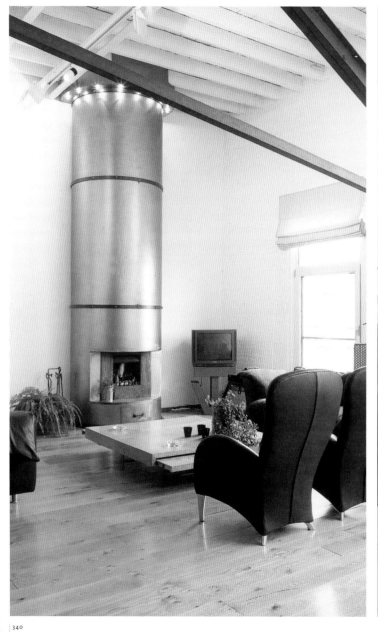
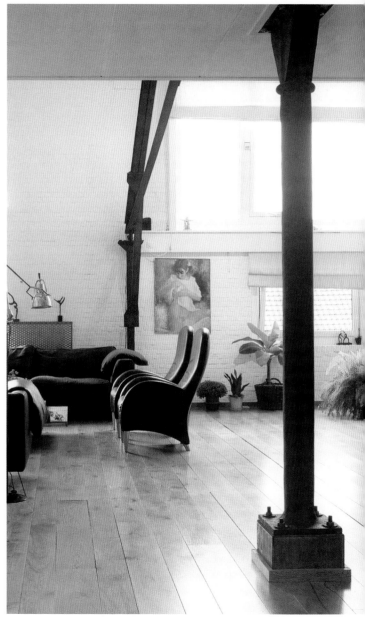

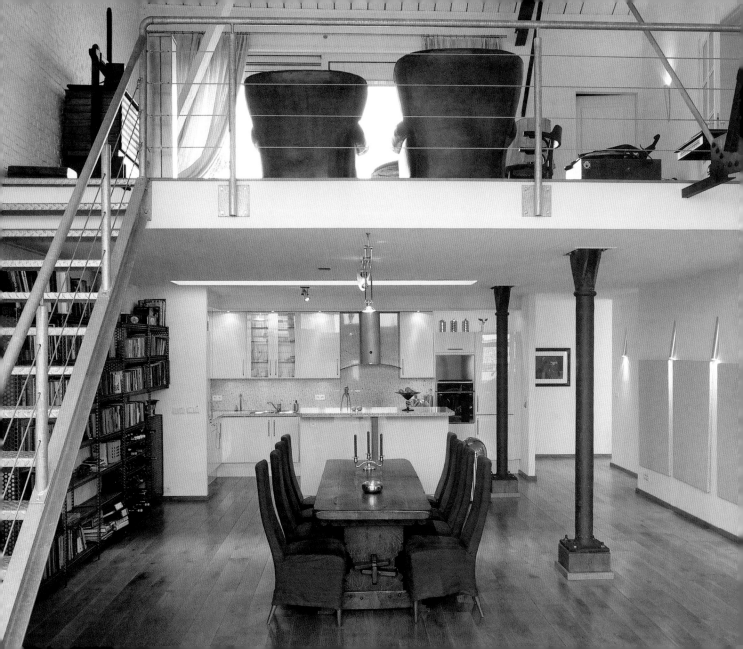

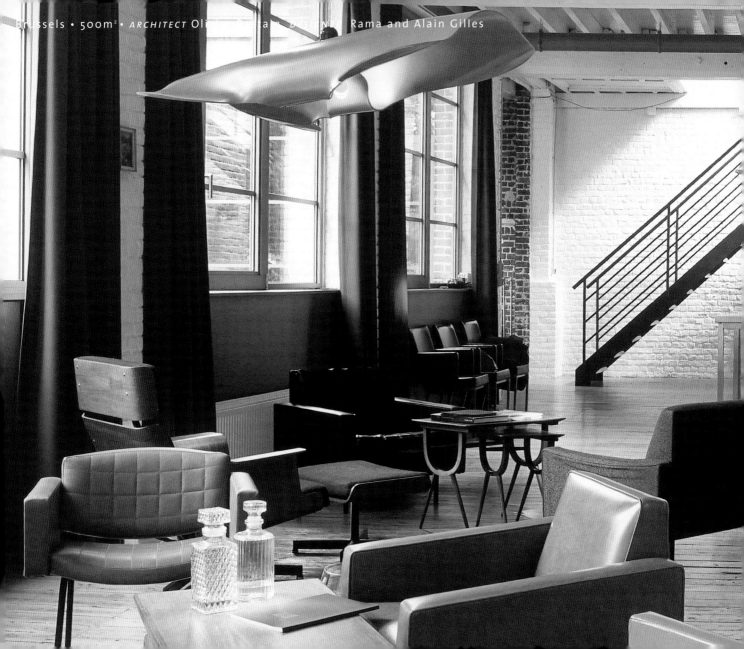

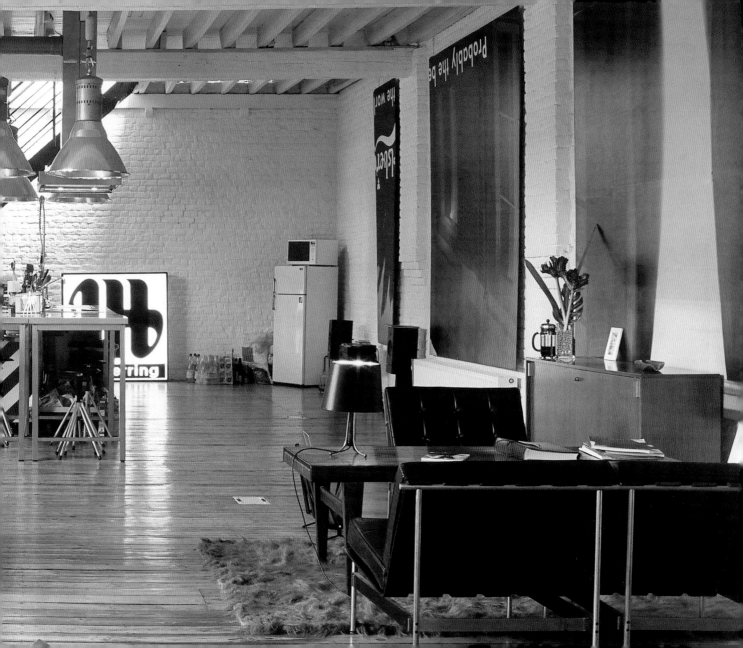

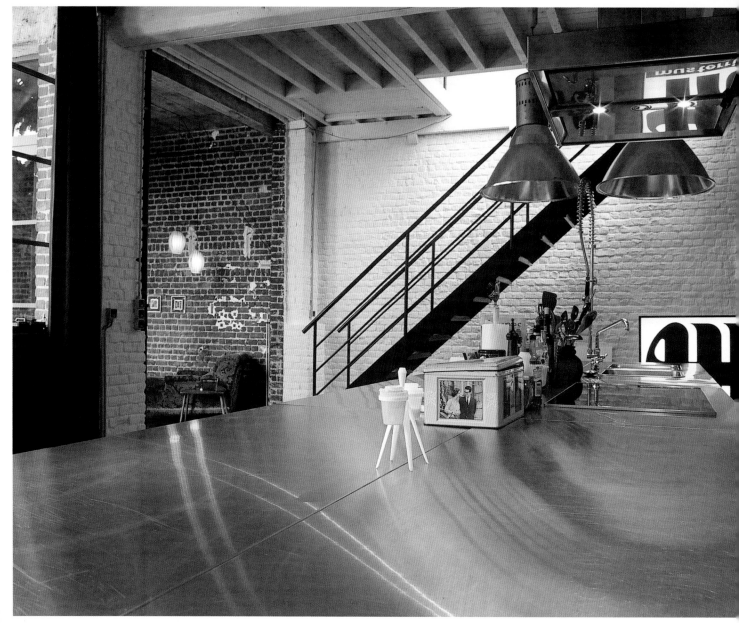

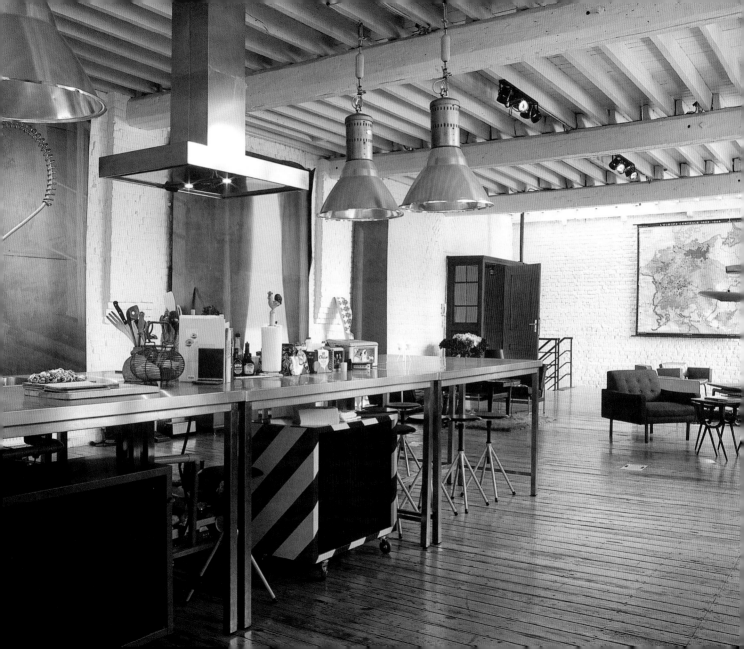

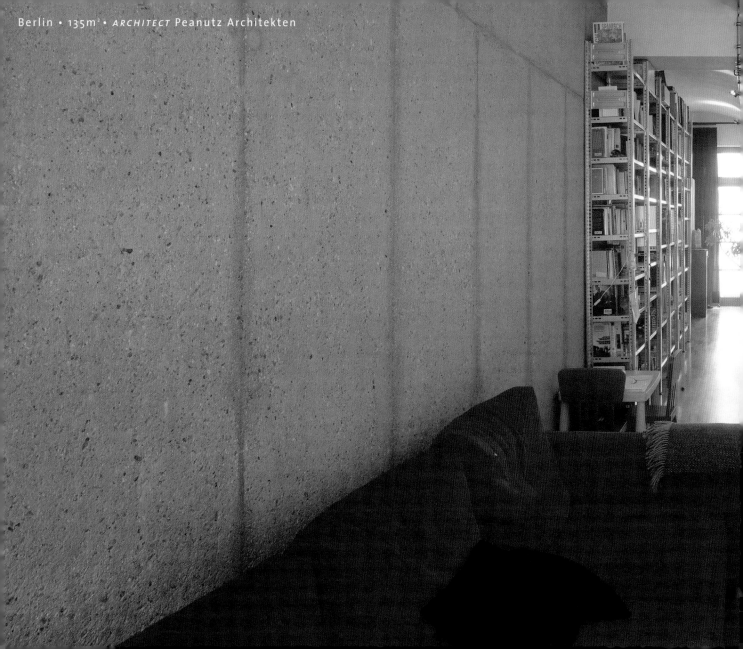

Berlin • 135m² • *ARCHITECT* Peanutz Architekten

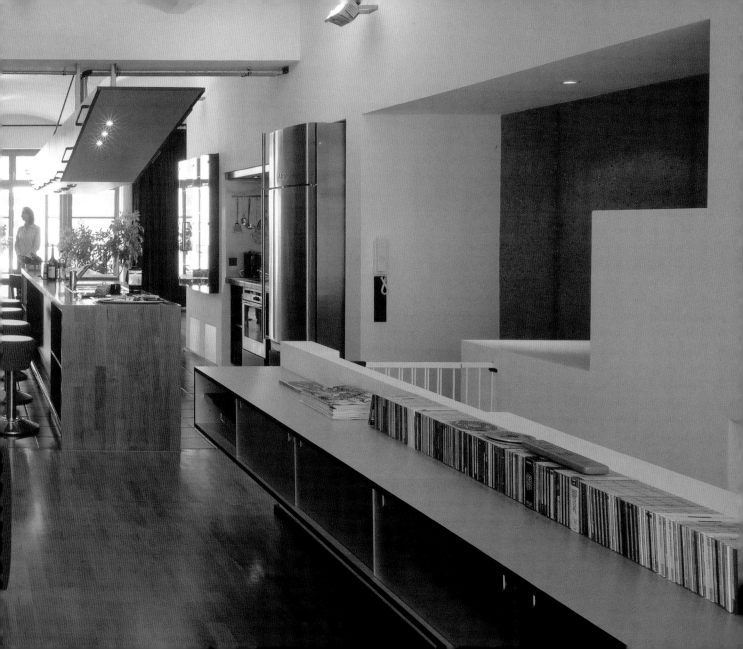

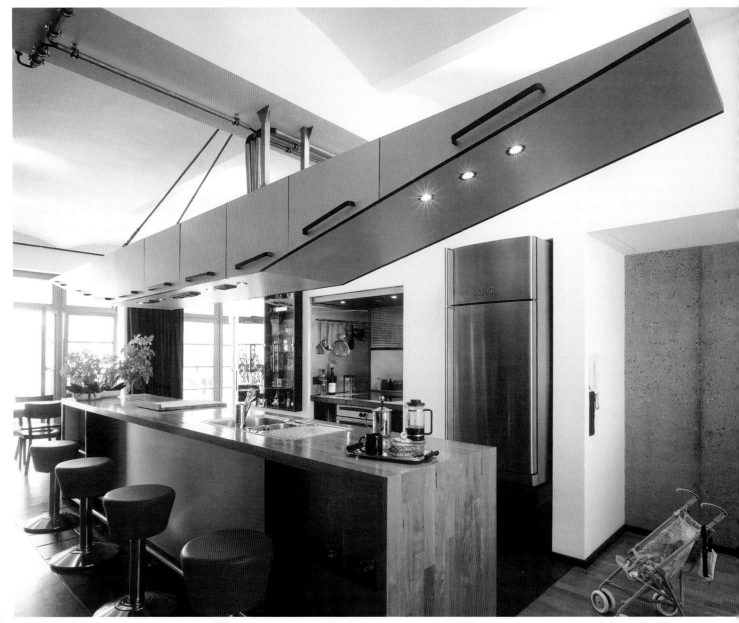

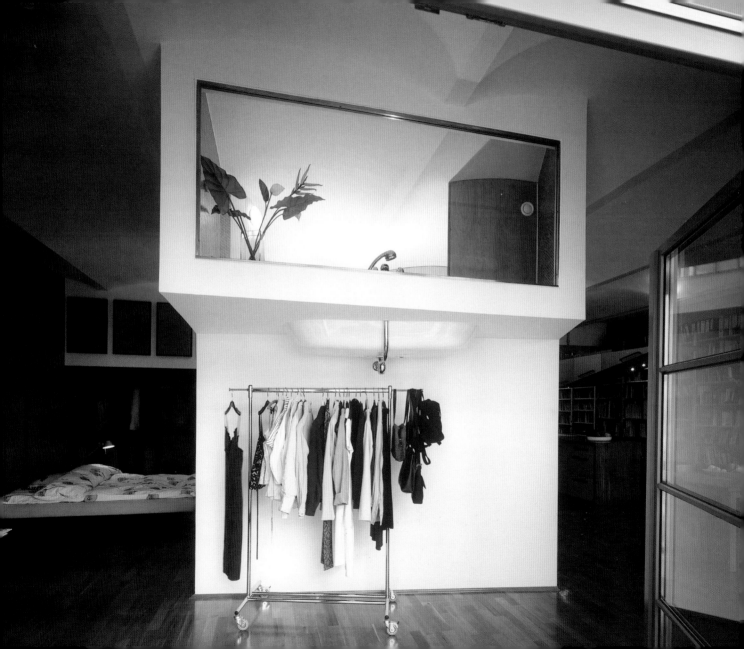

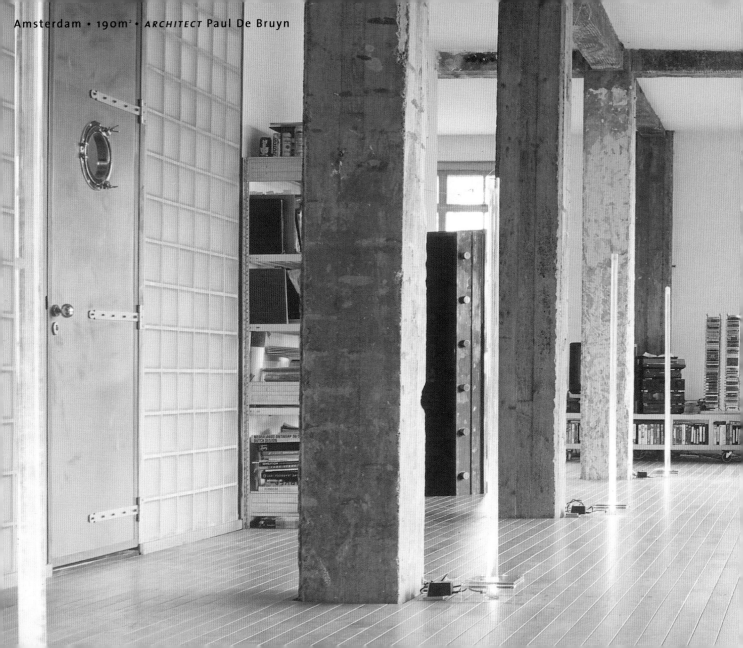

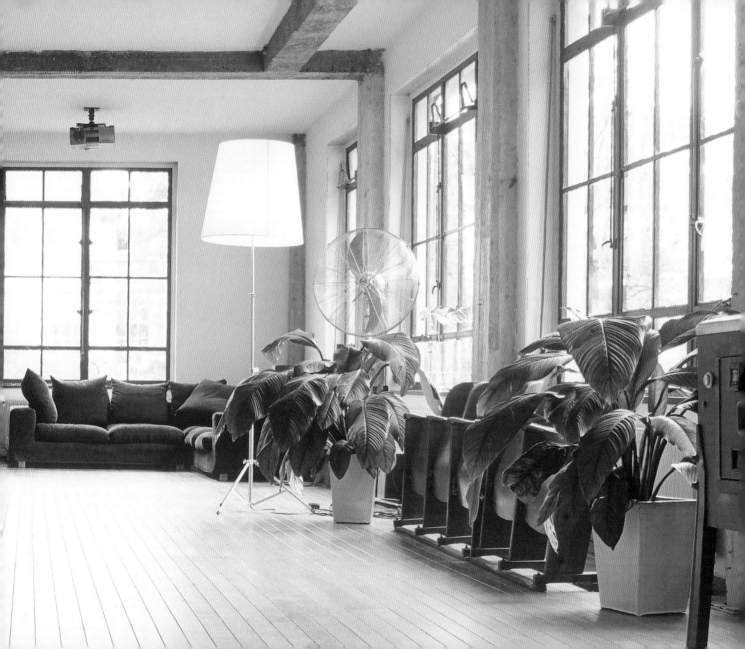

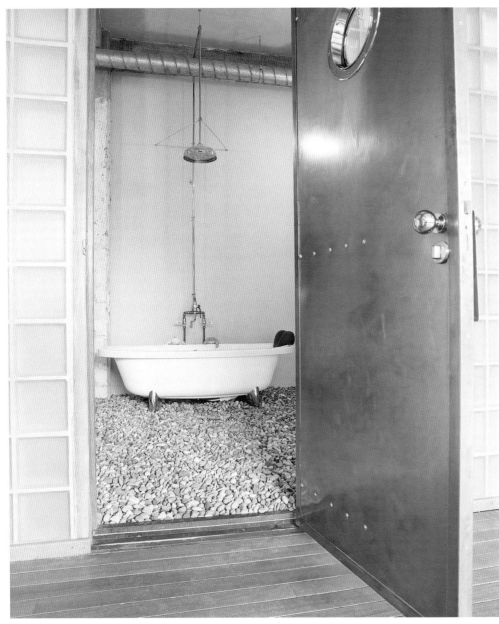

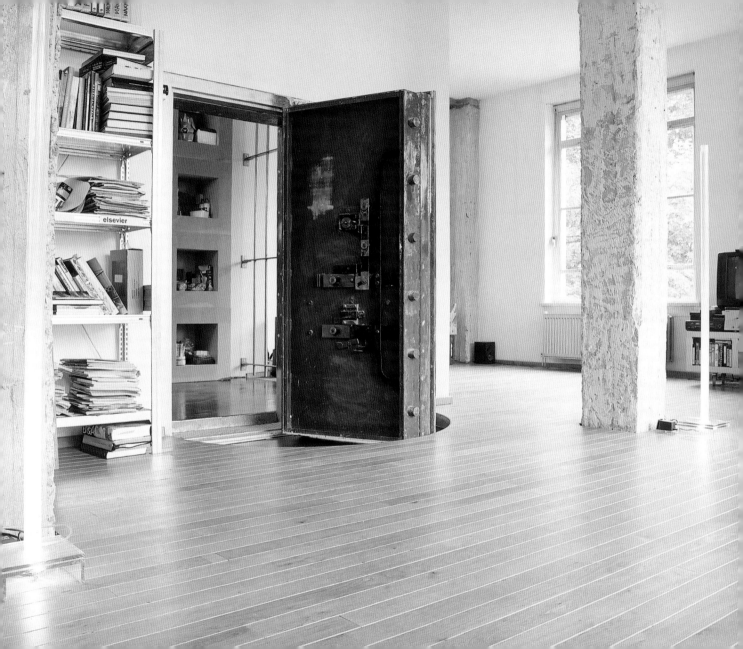

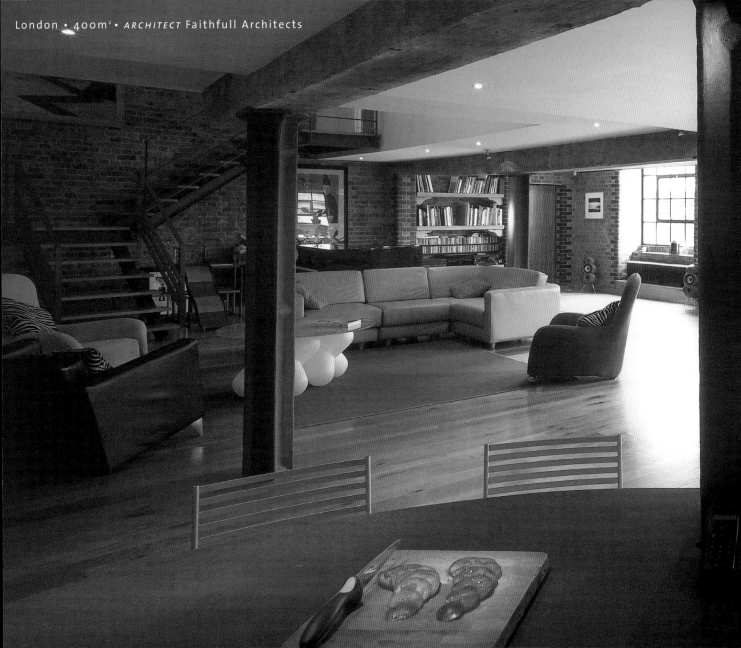

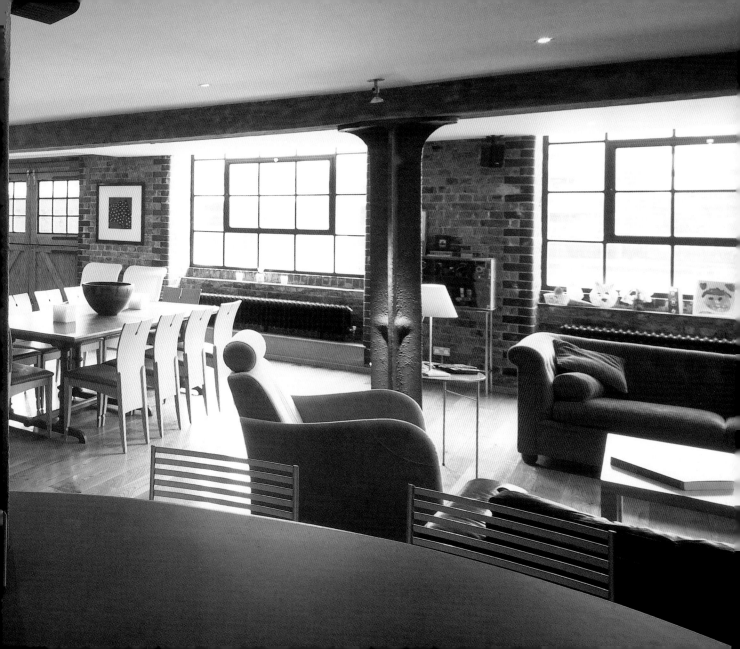

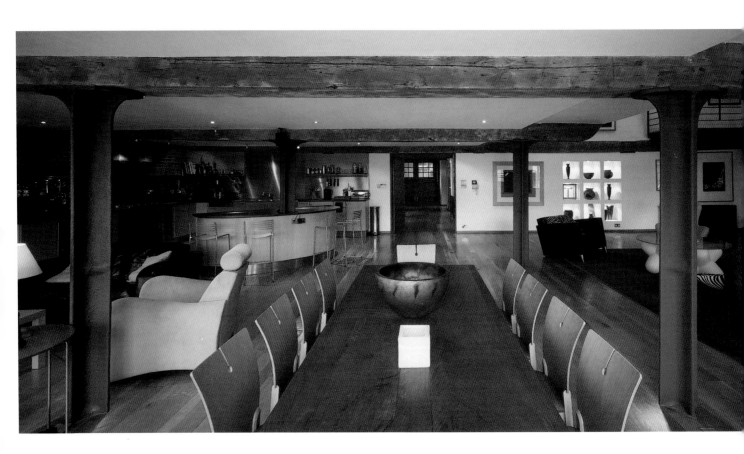

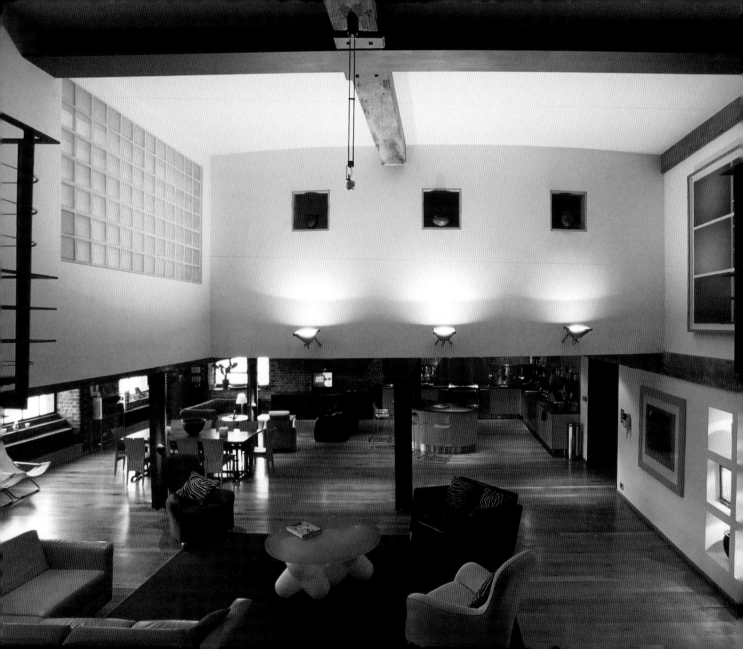

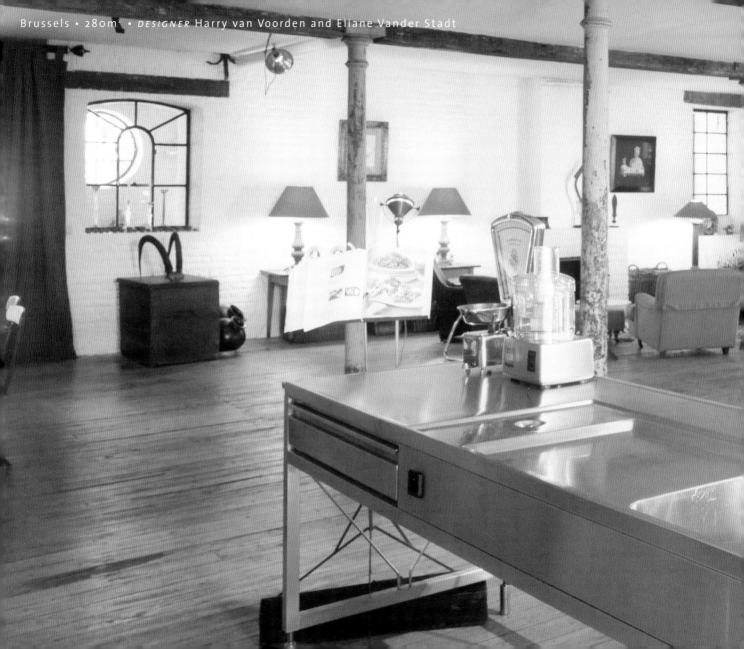

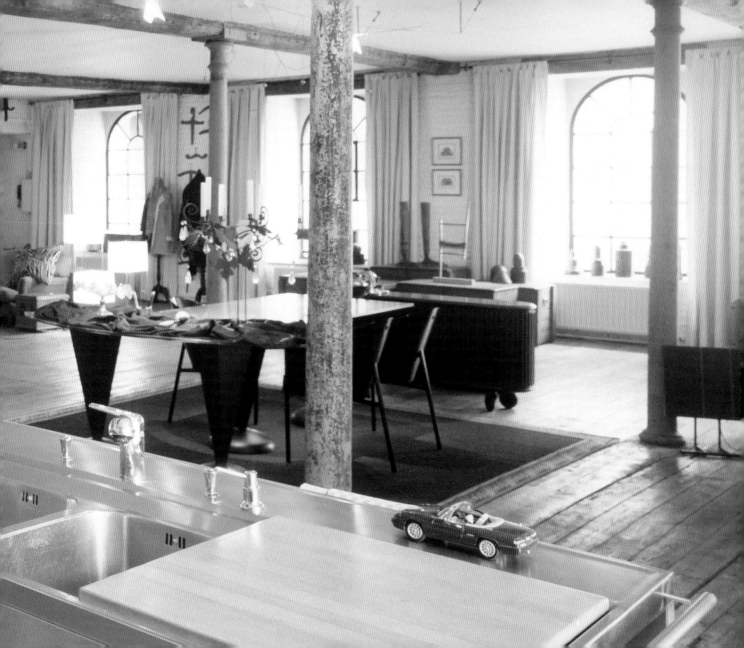

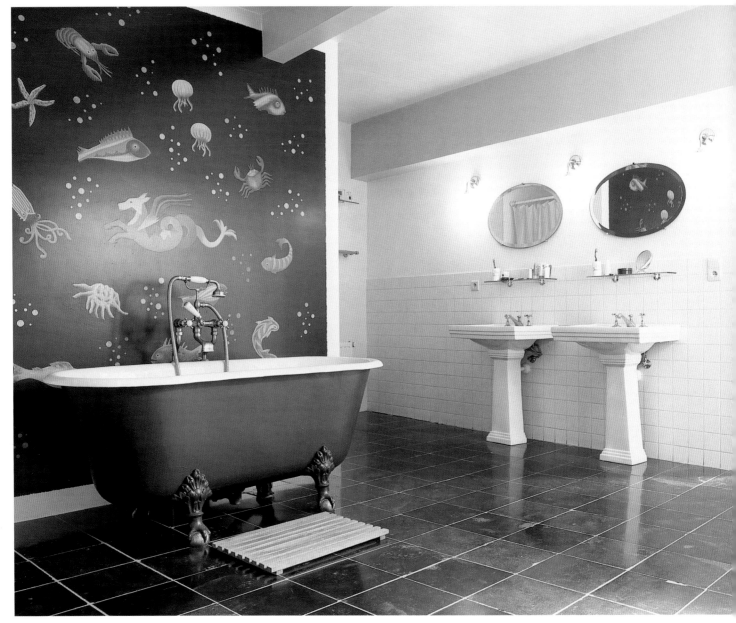

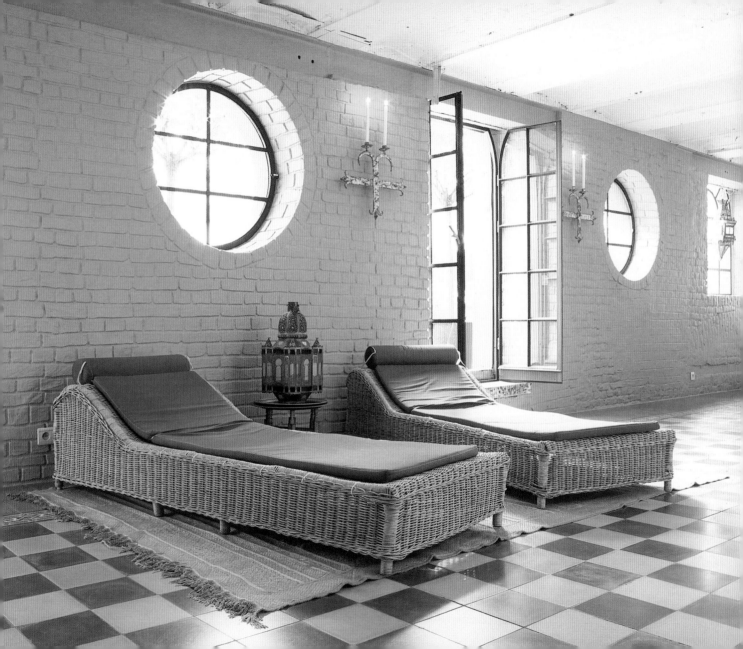

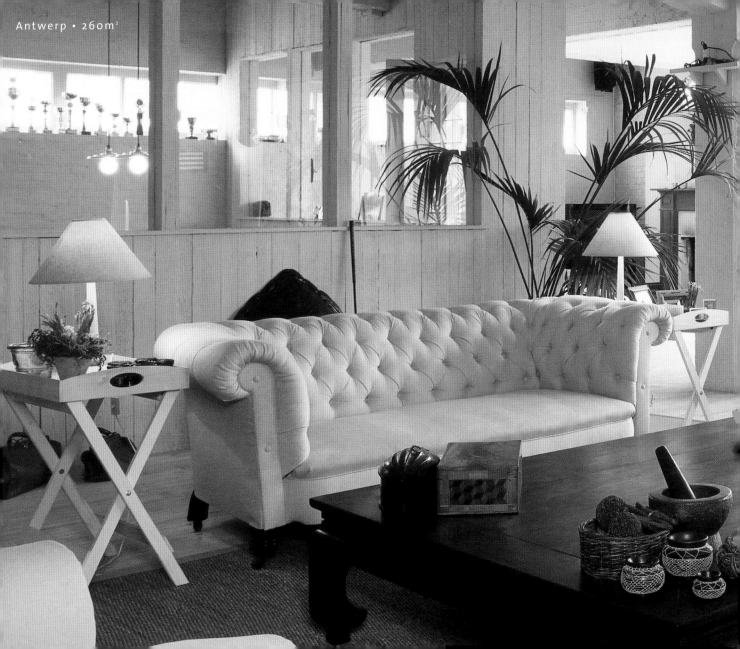

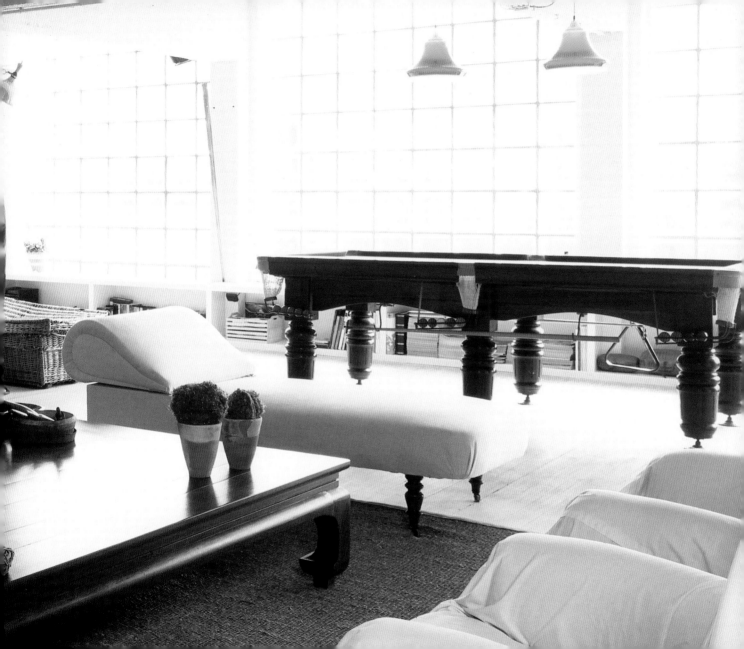

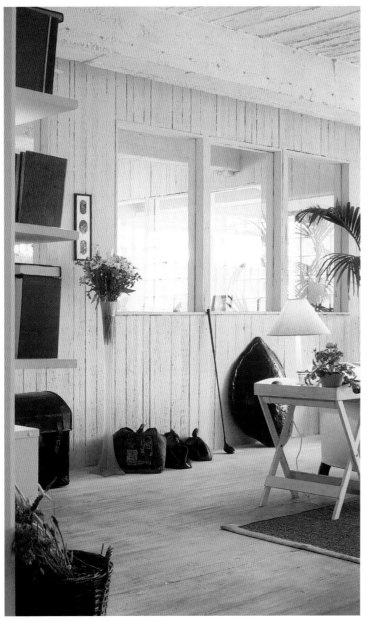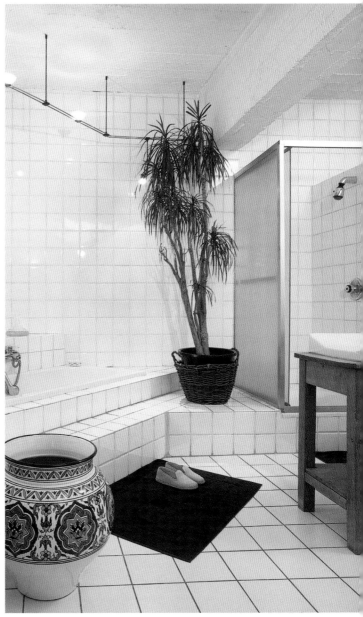

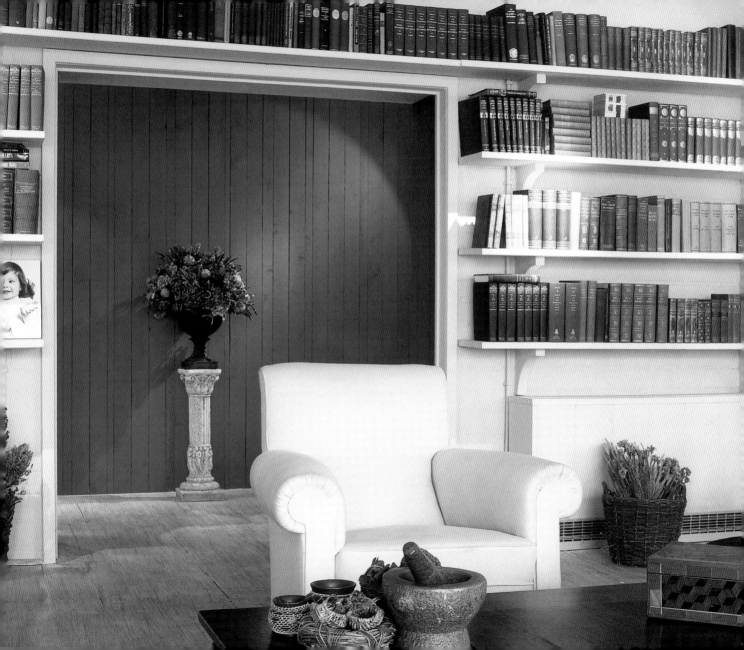

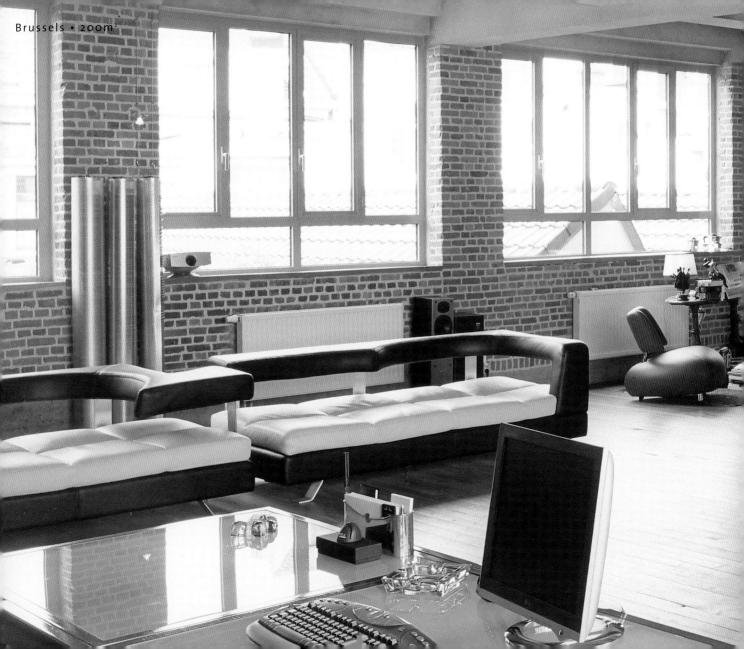

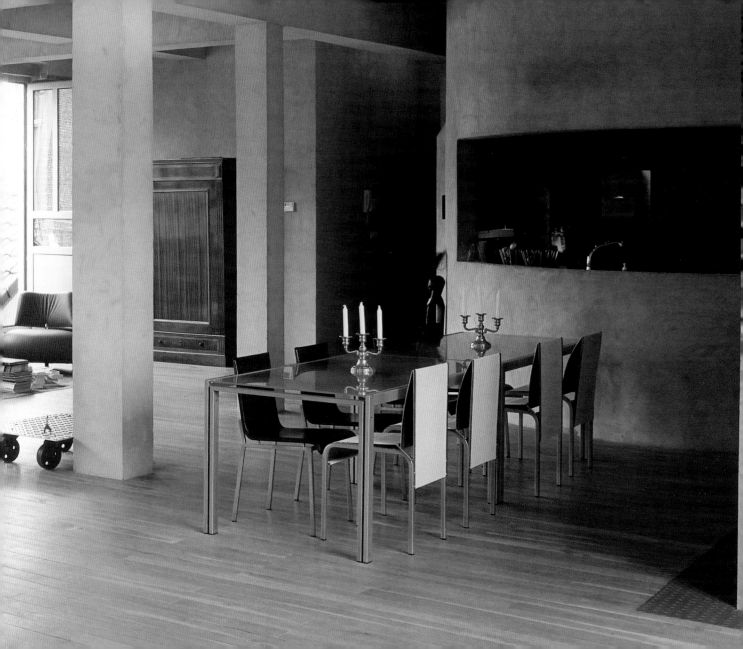

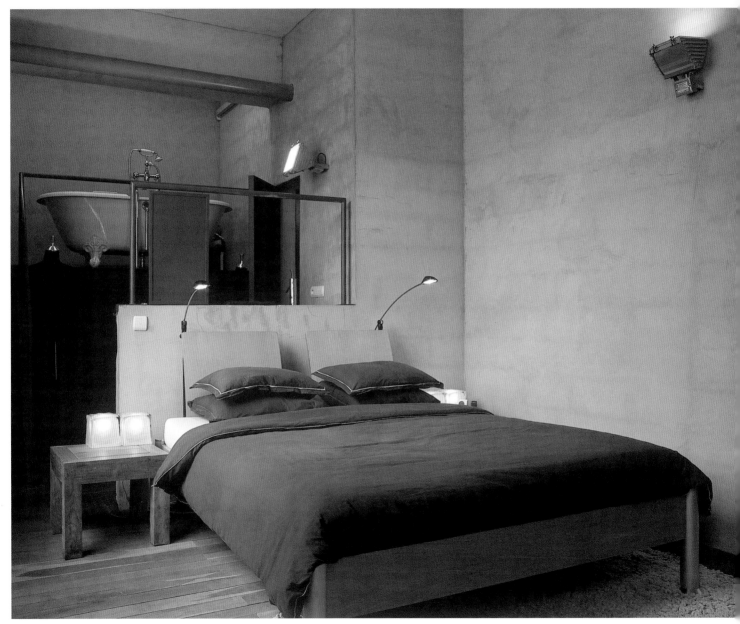

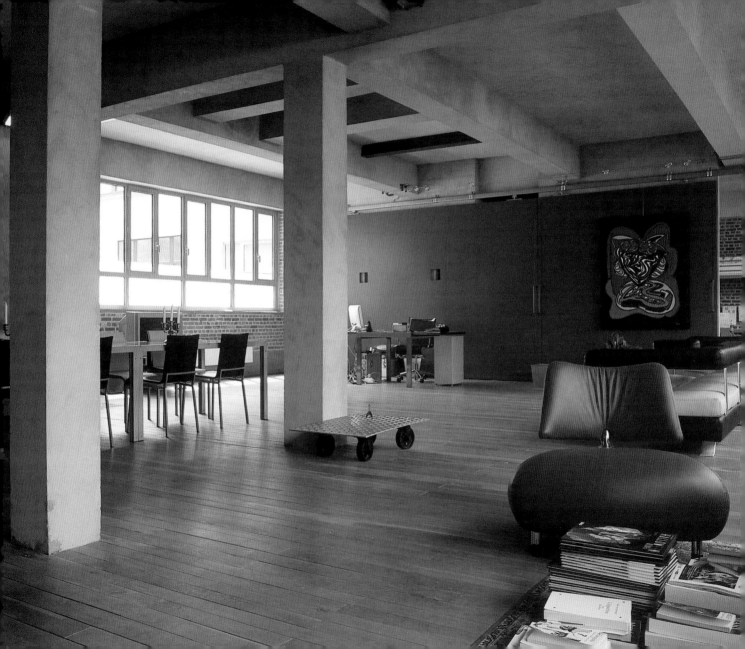

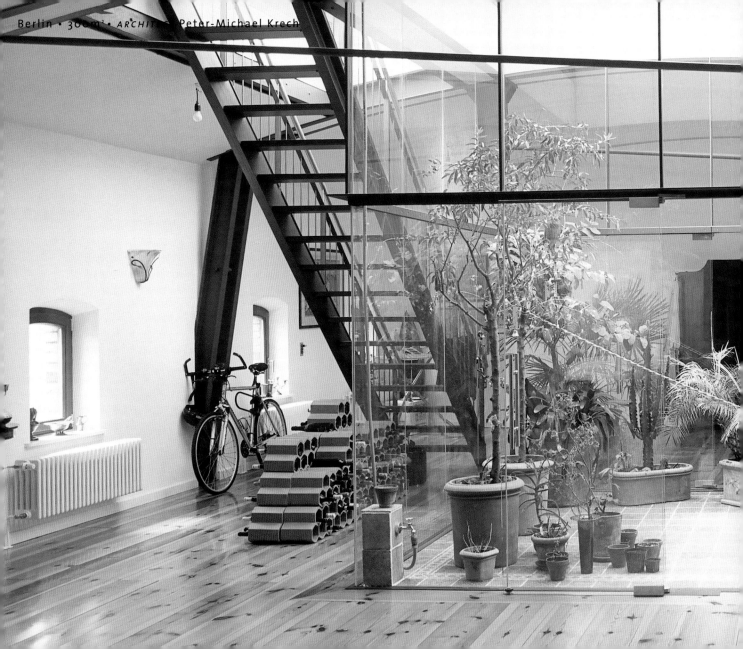

Berlin • 300 m² • ARCHITECT • Peter-Michael Krech

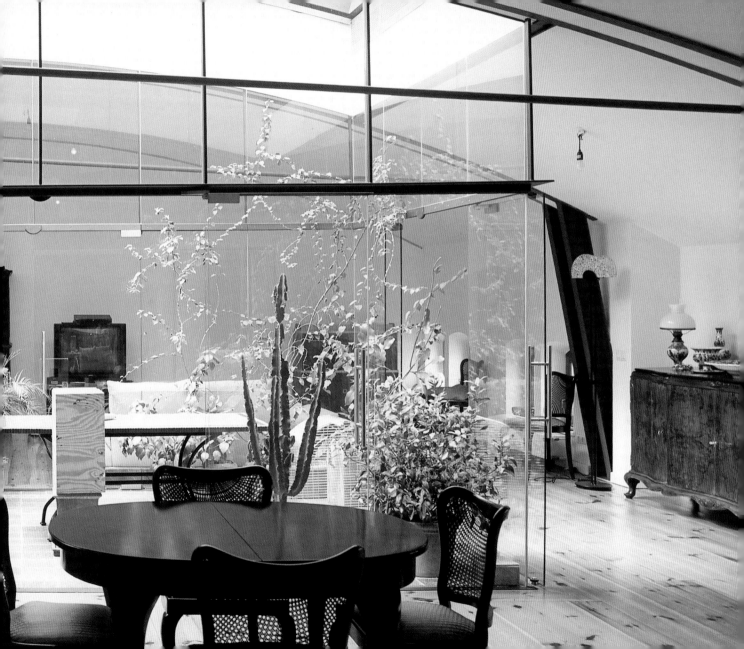

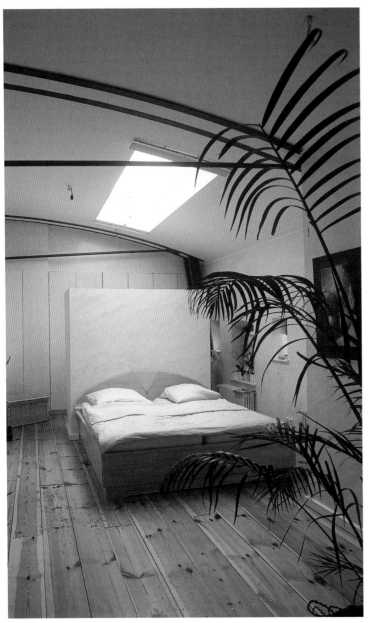
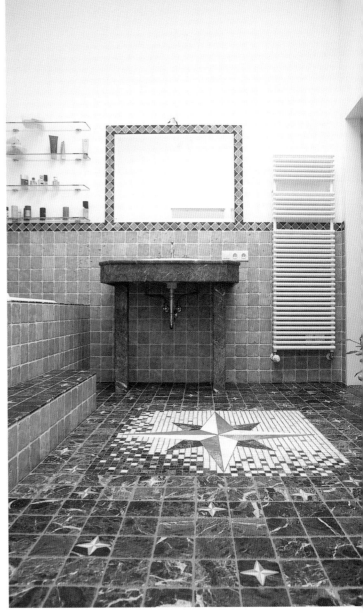

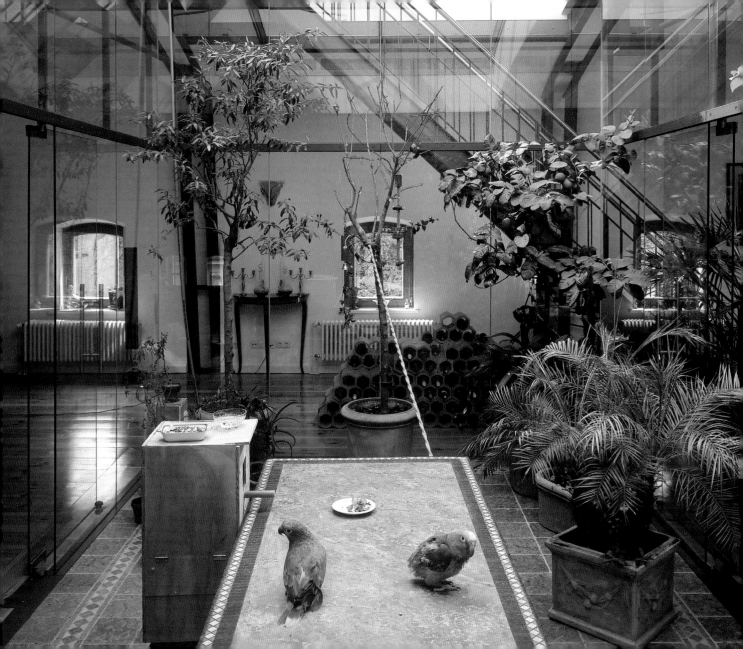

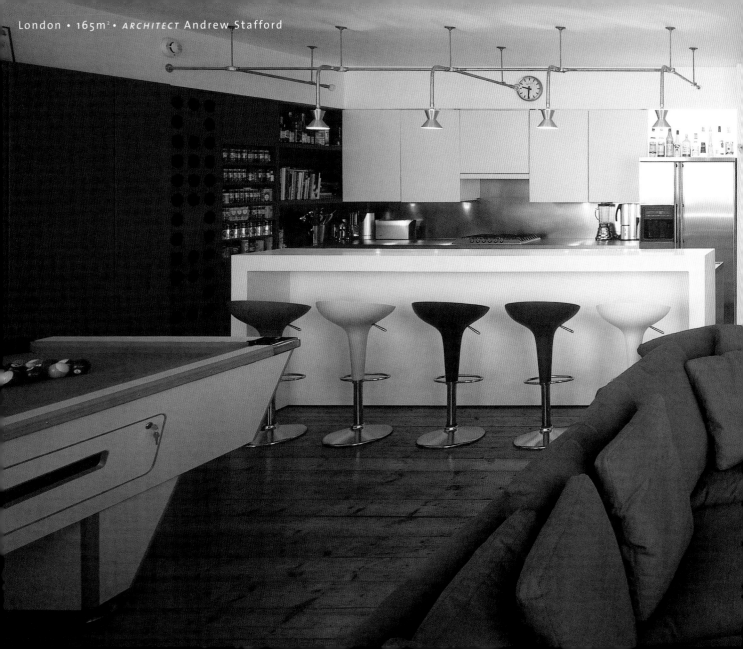

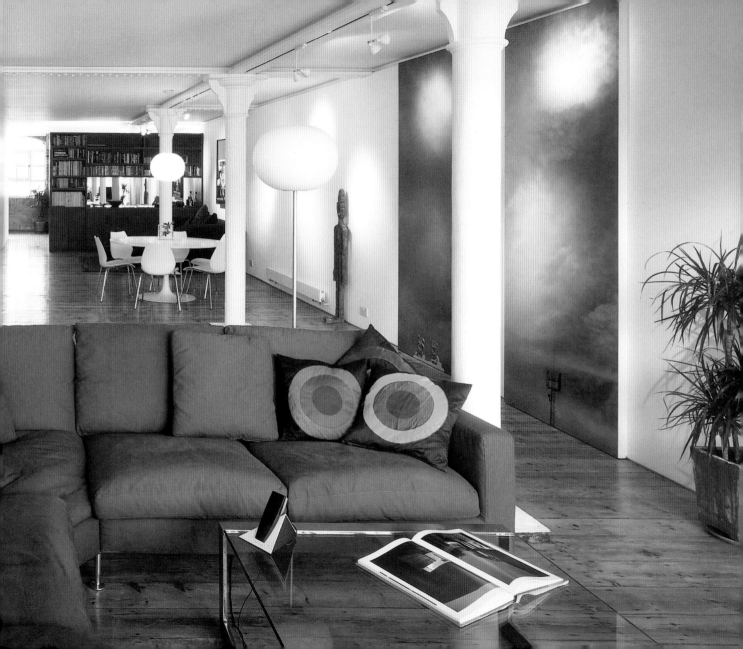

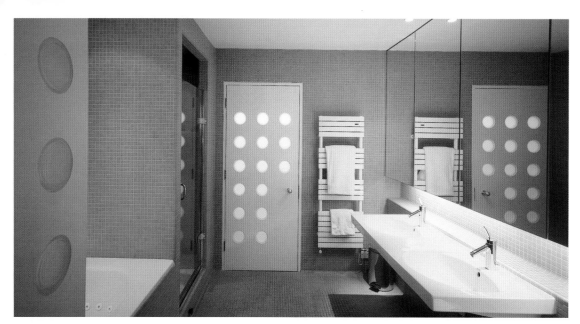

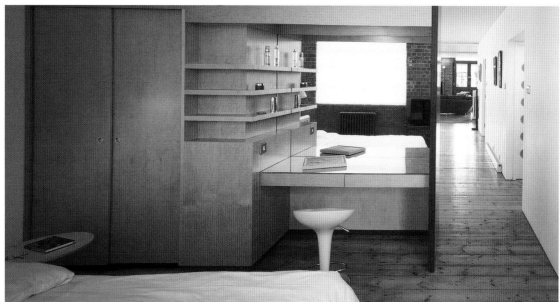

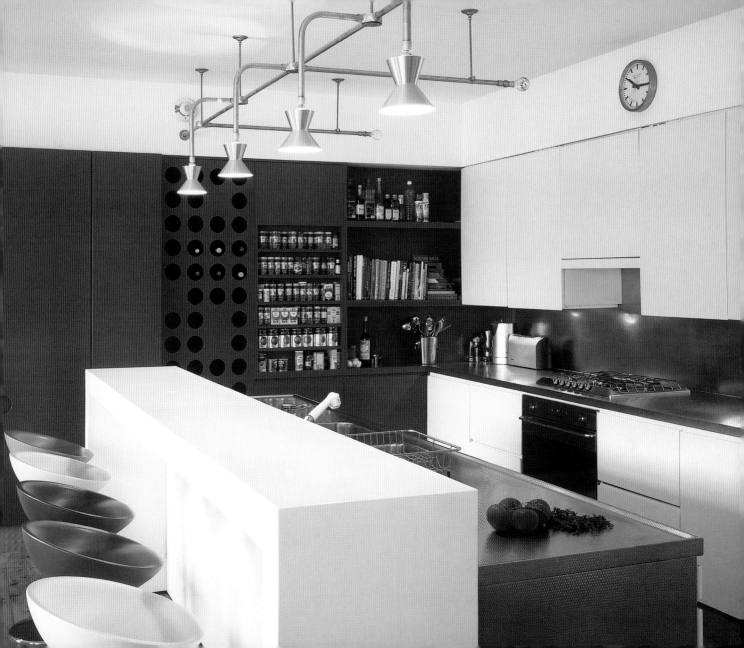

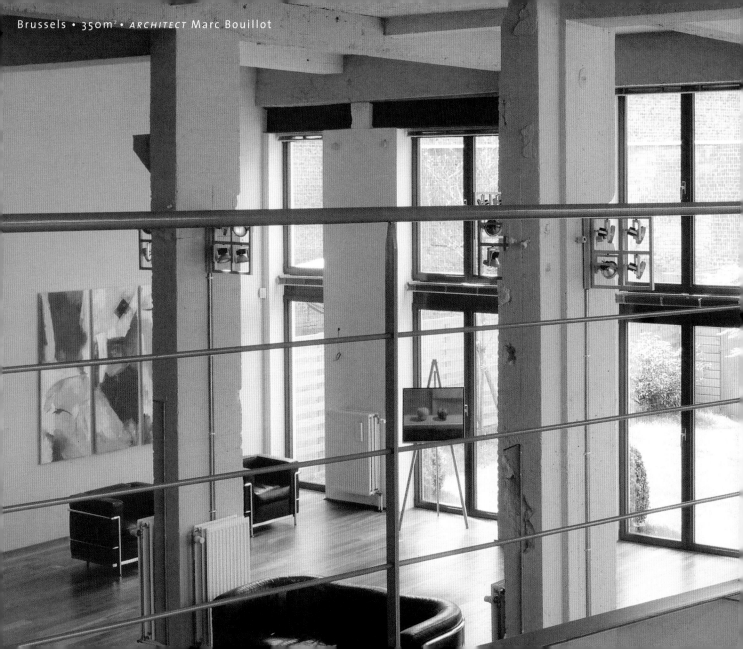

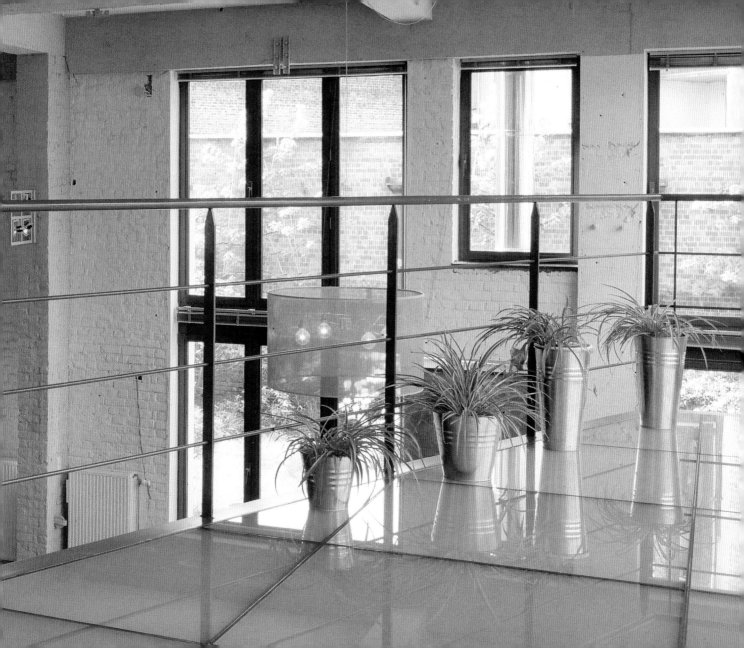

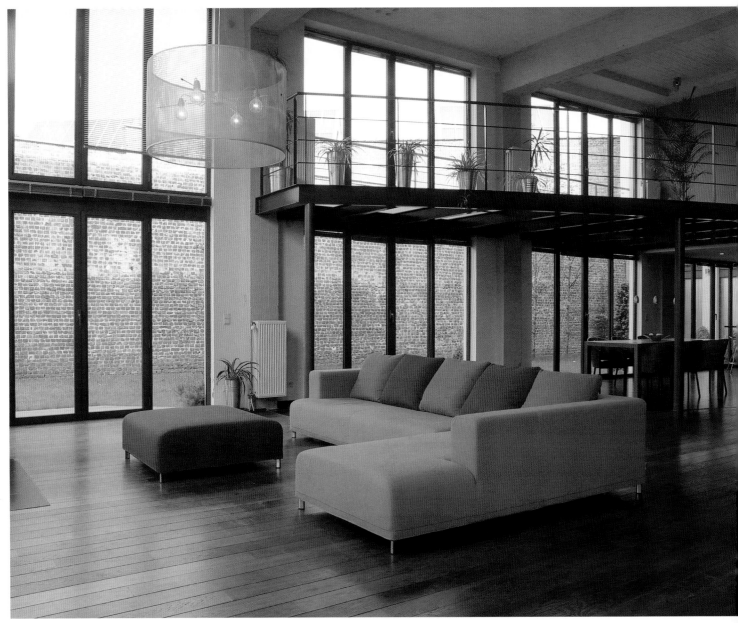

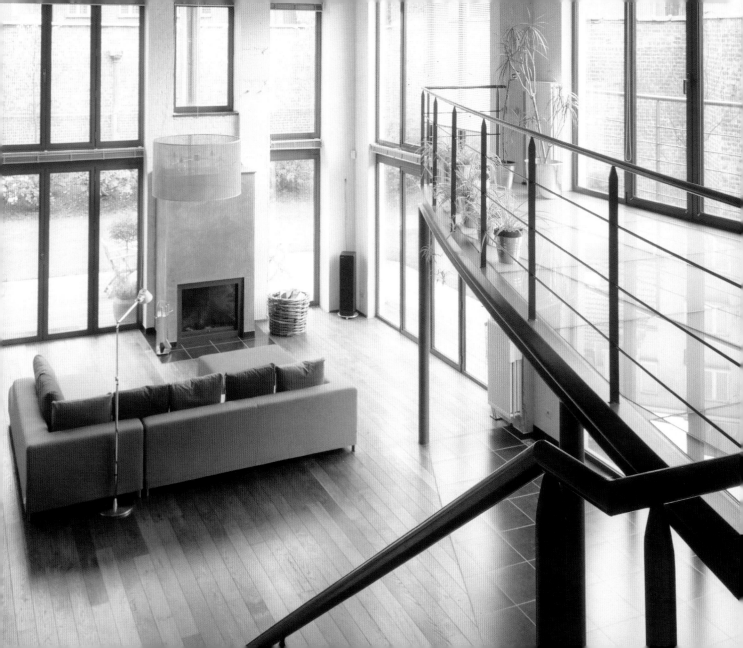

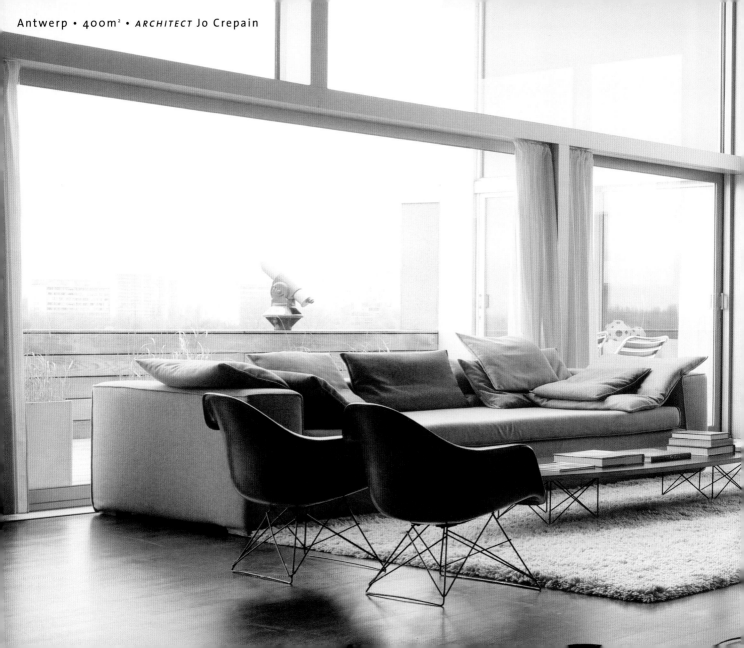

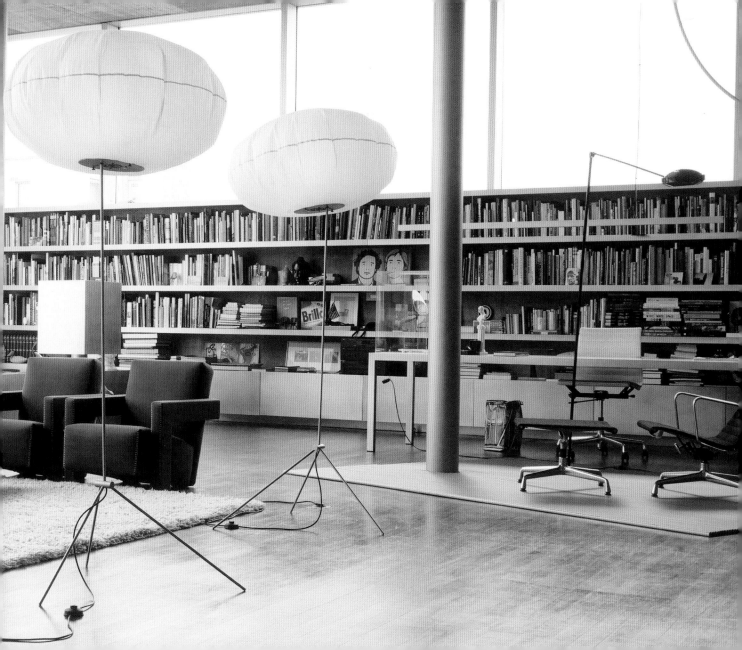

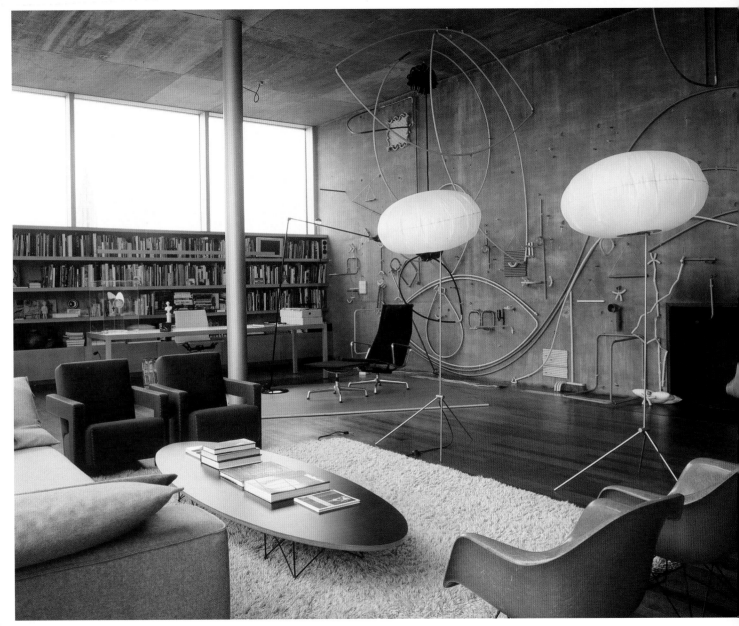

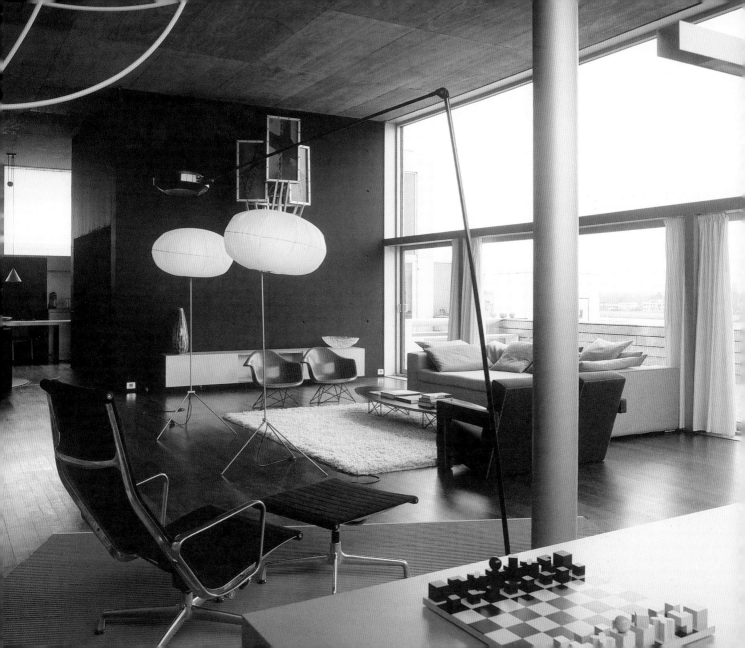

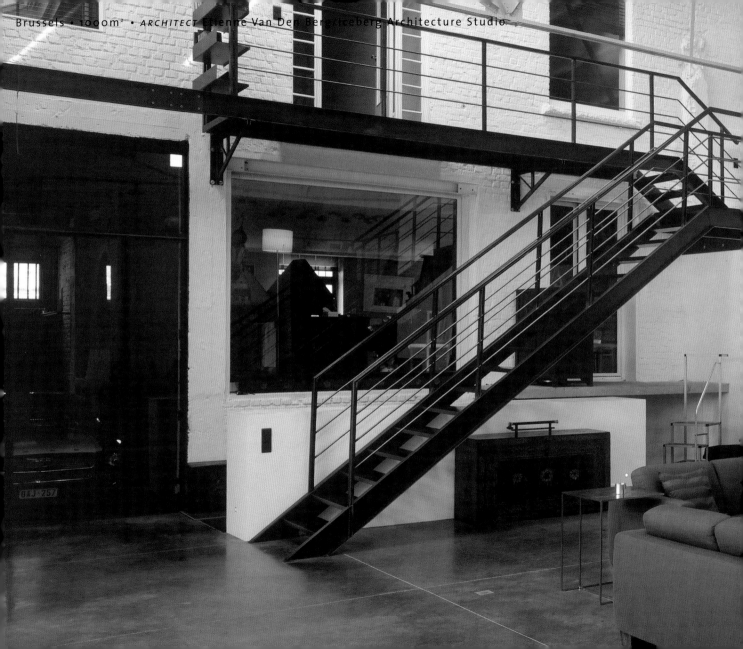

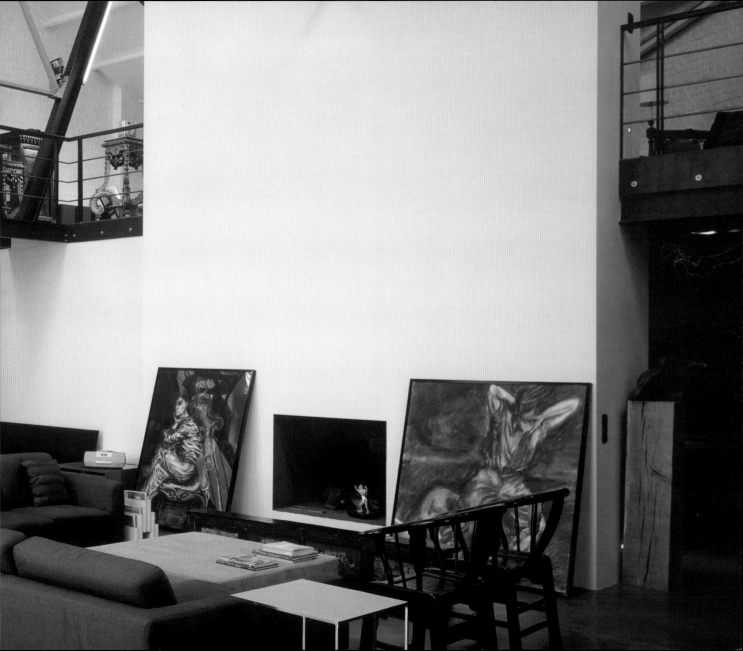

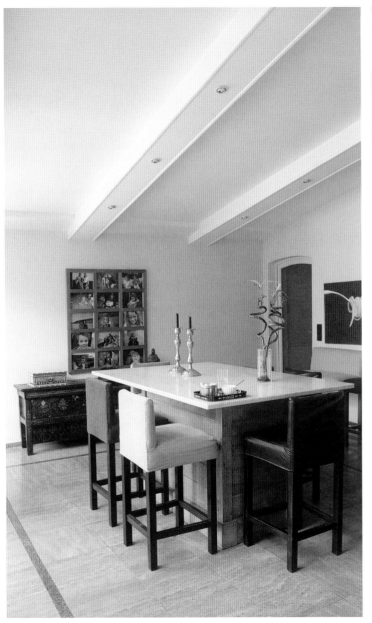
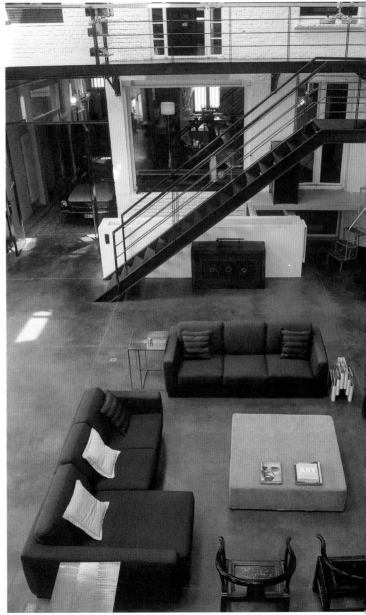

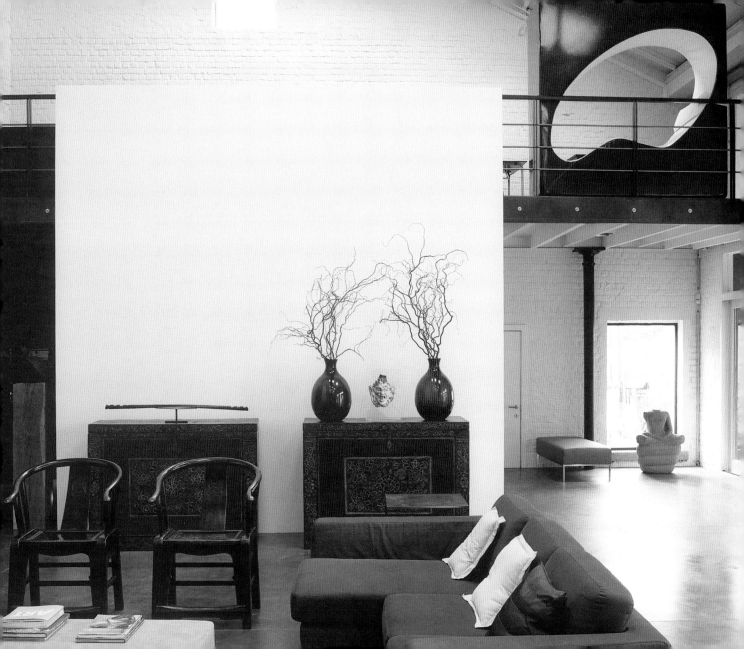

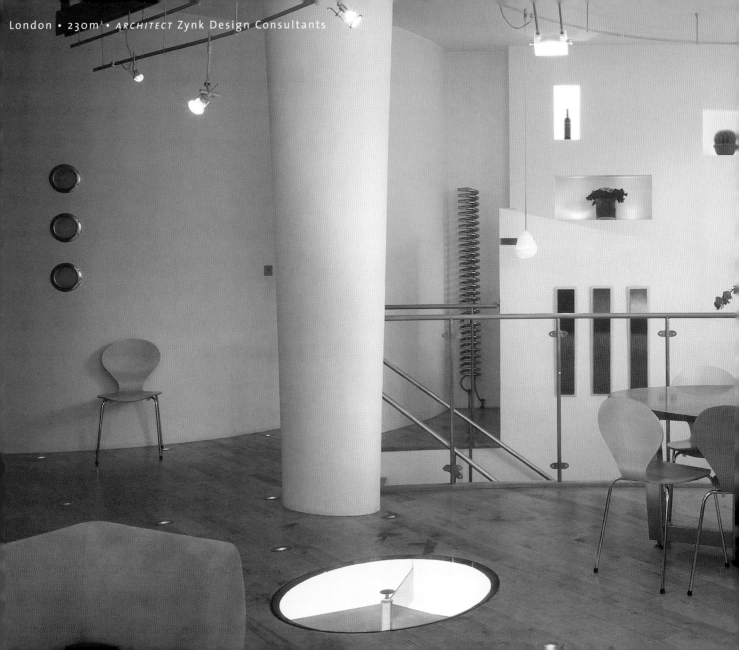

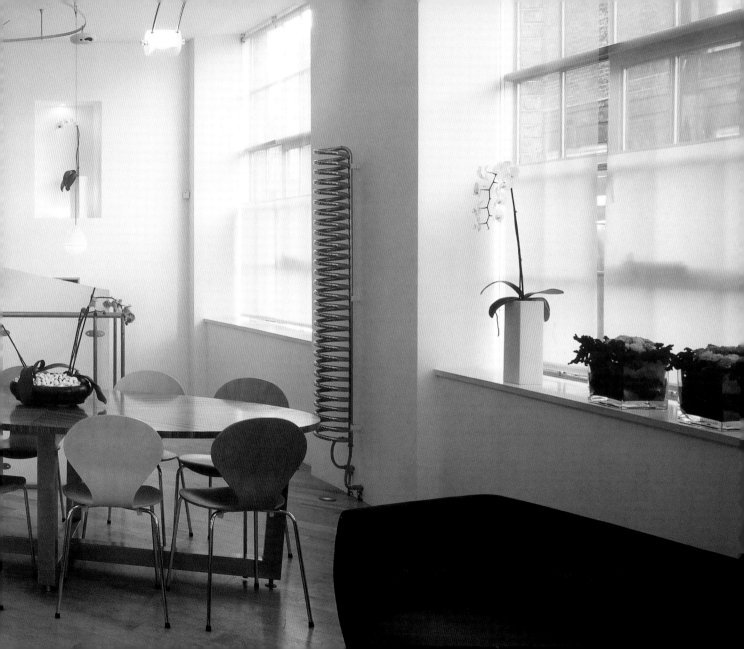

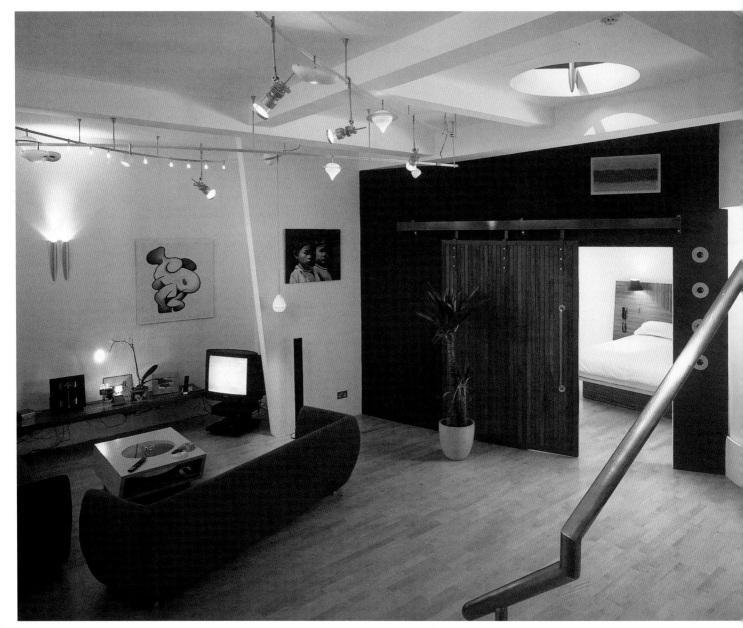

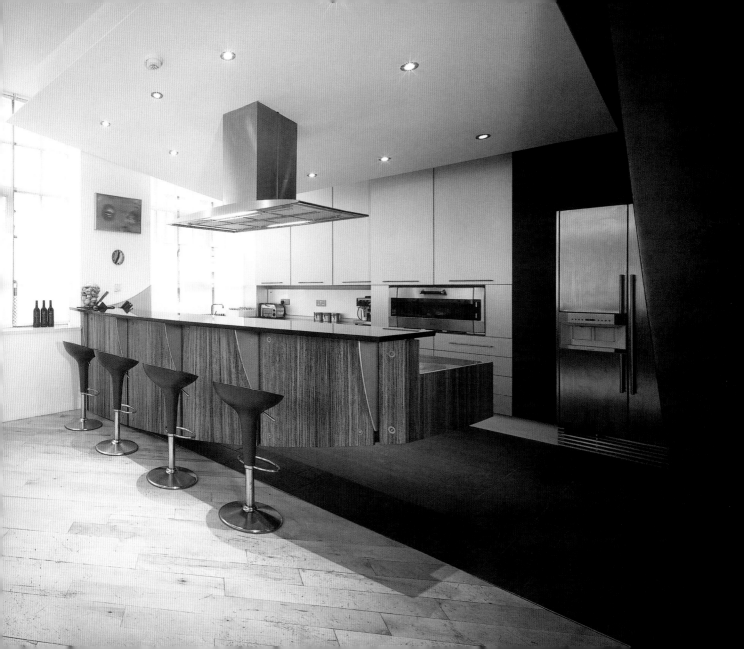

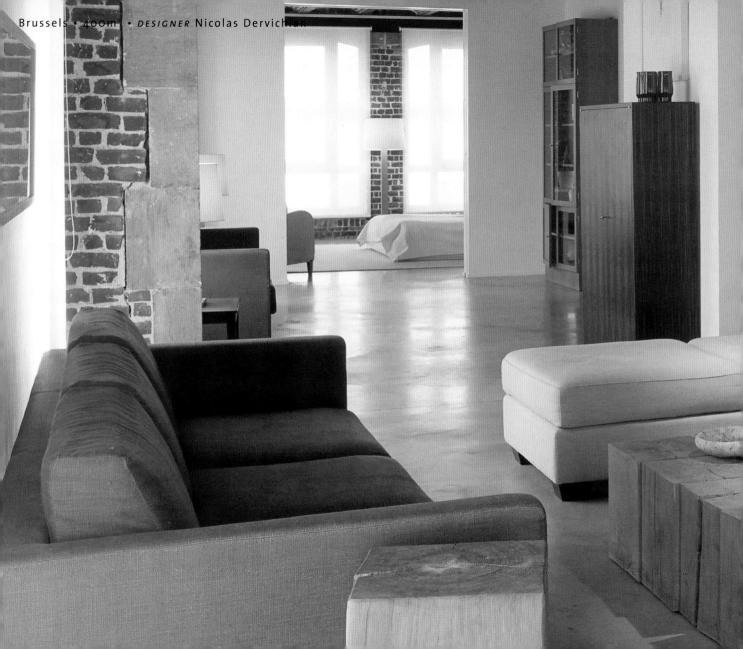

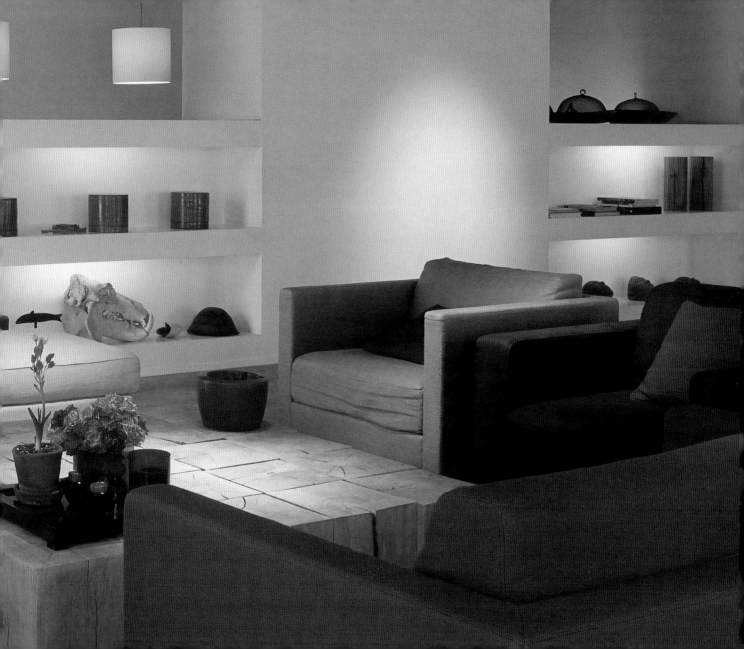

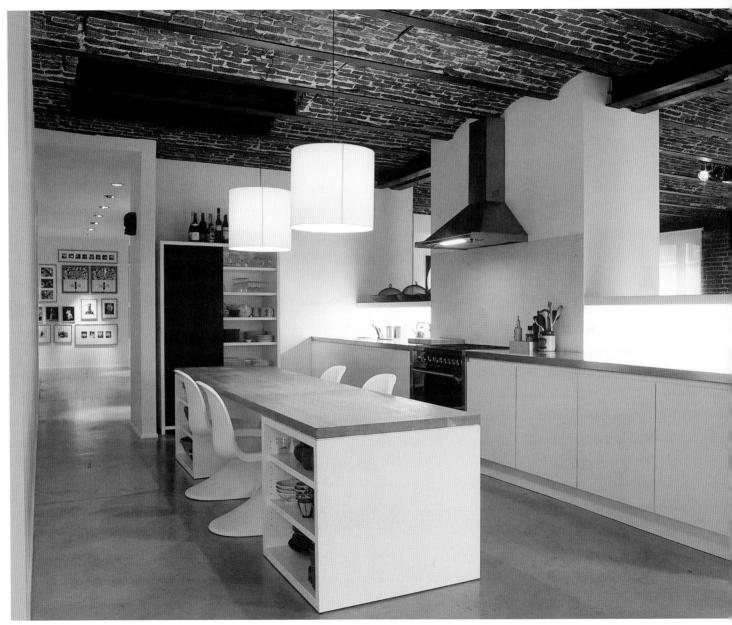

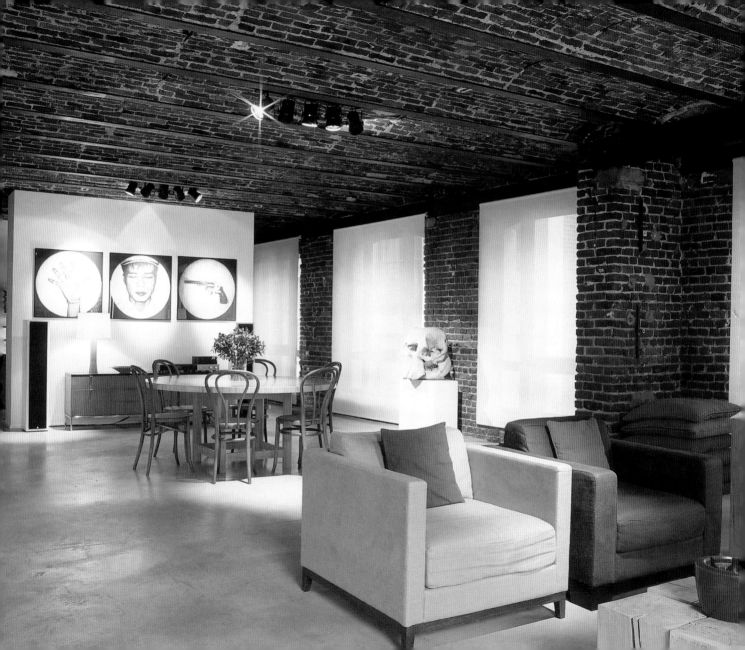

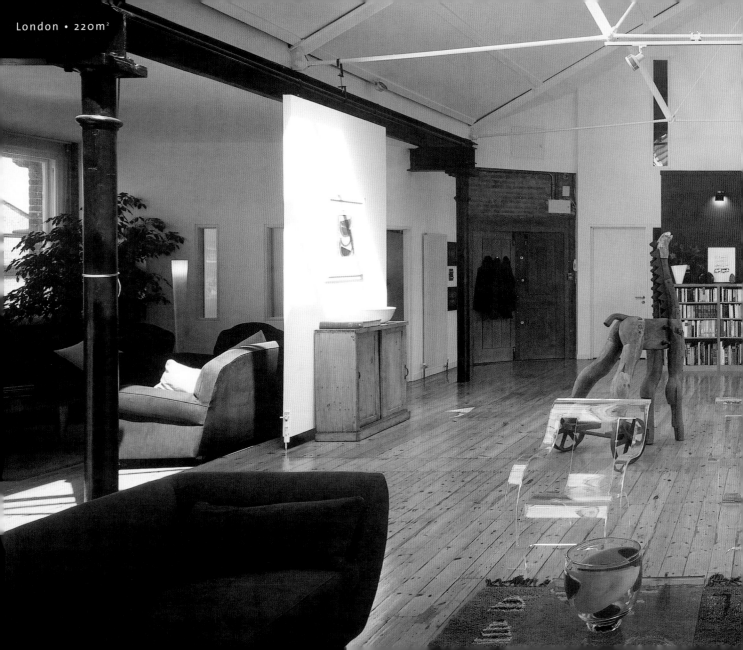

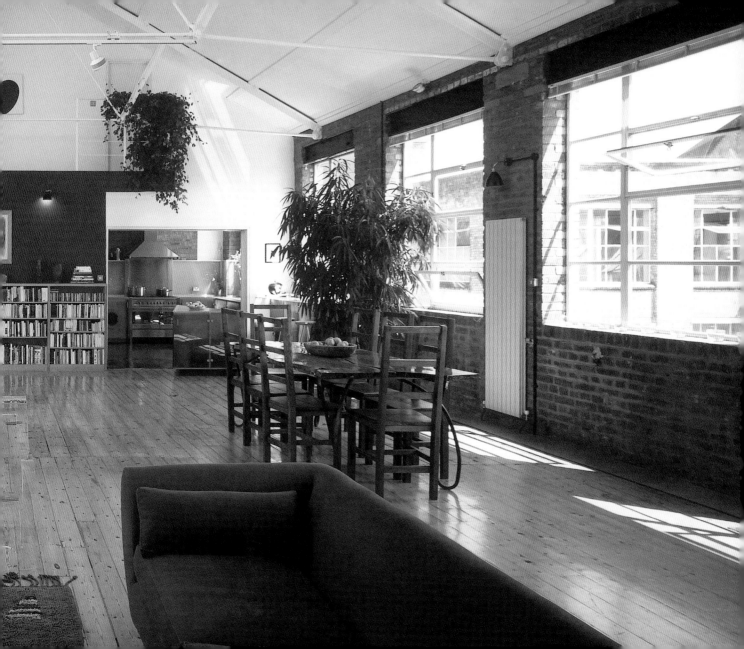

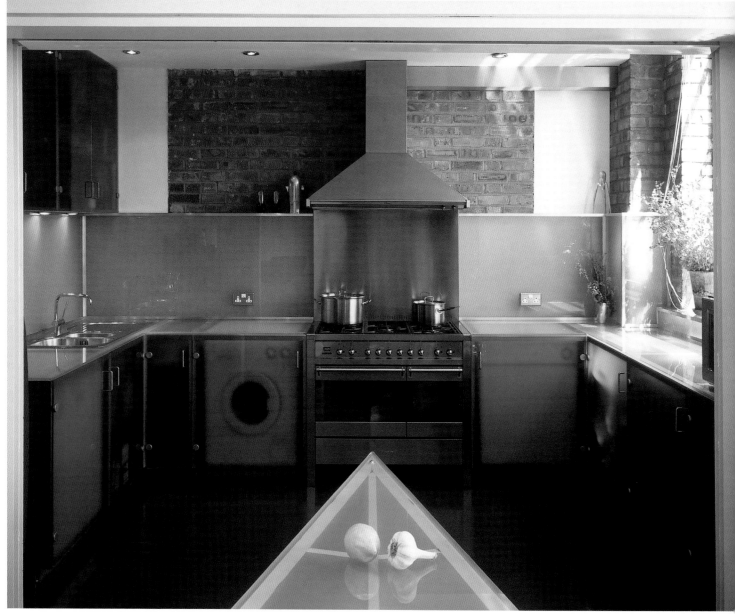

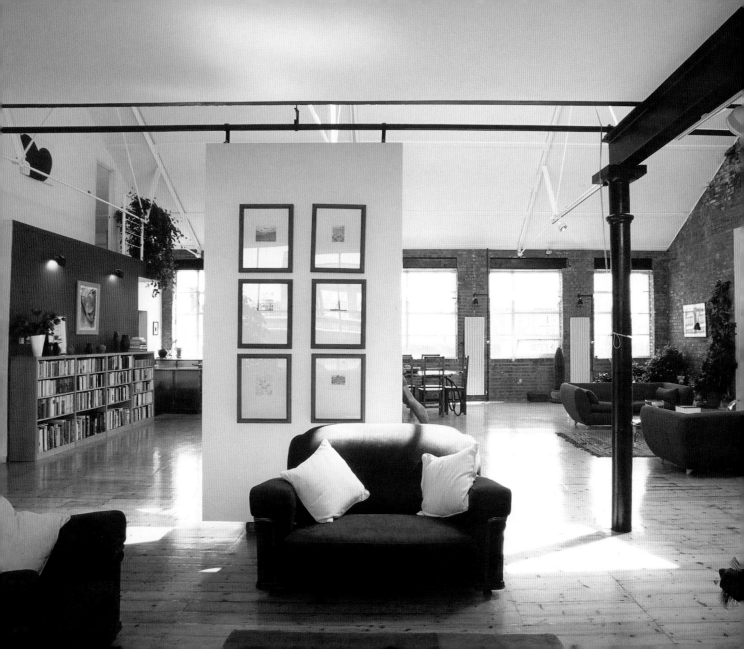

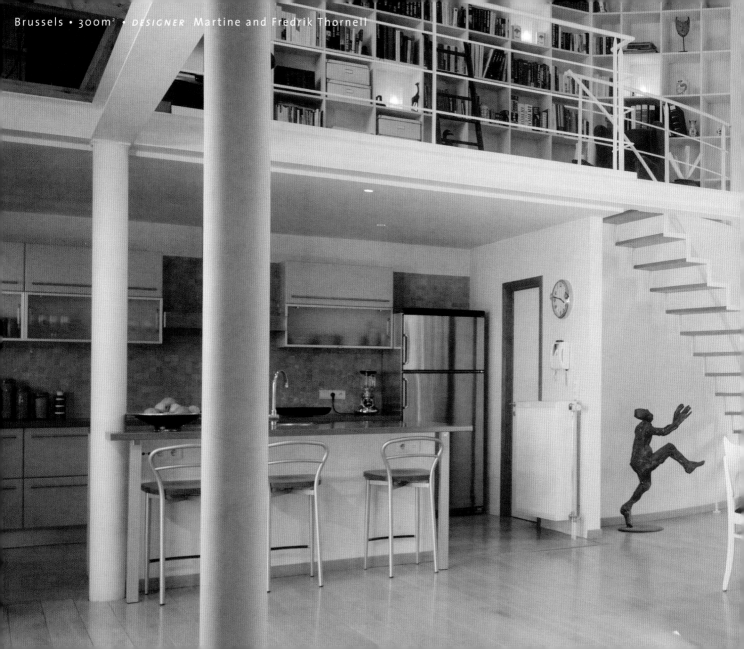

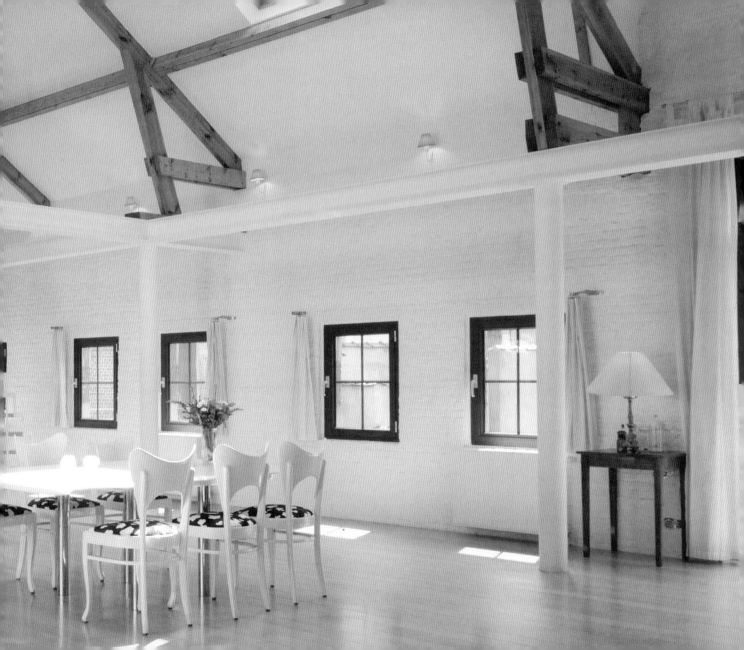

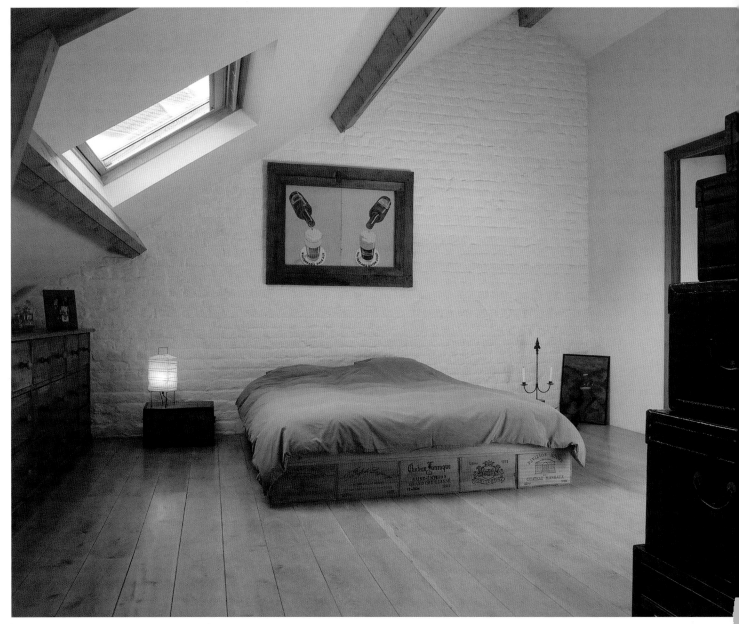

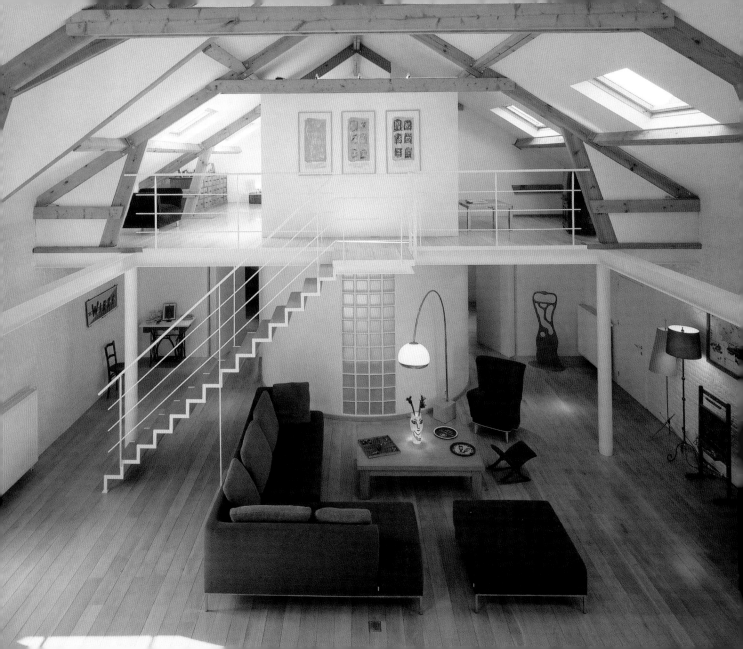

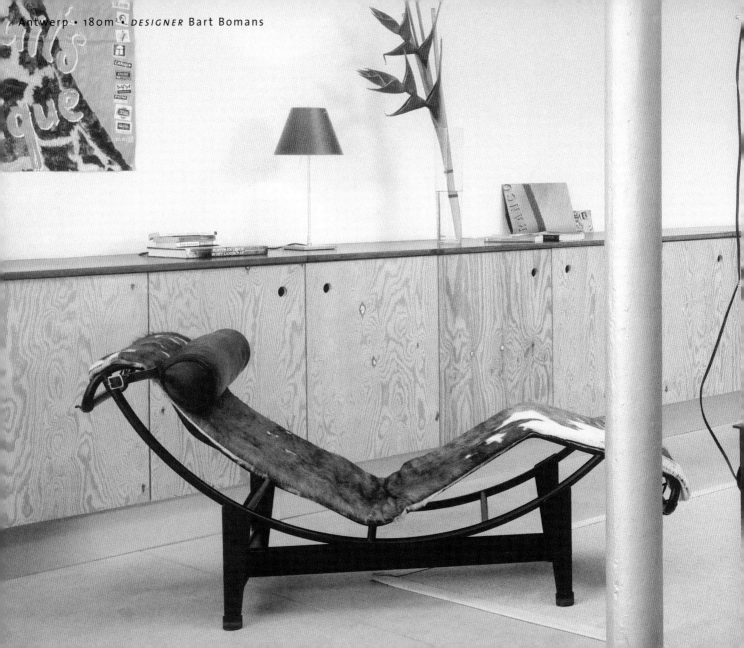

Antwerp • 180m² • *DESIGNER* Bart Bomans

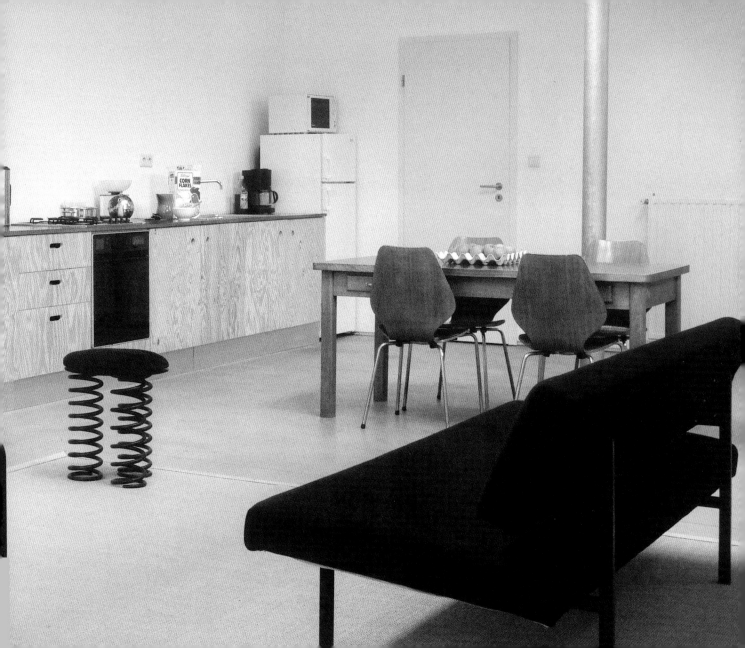

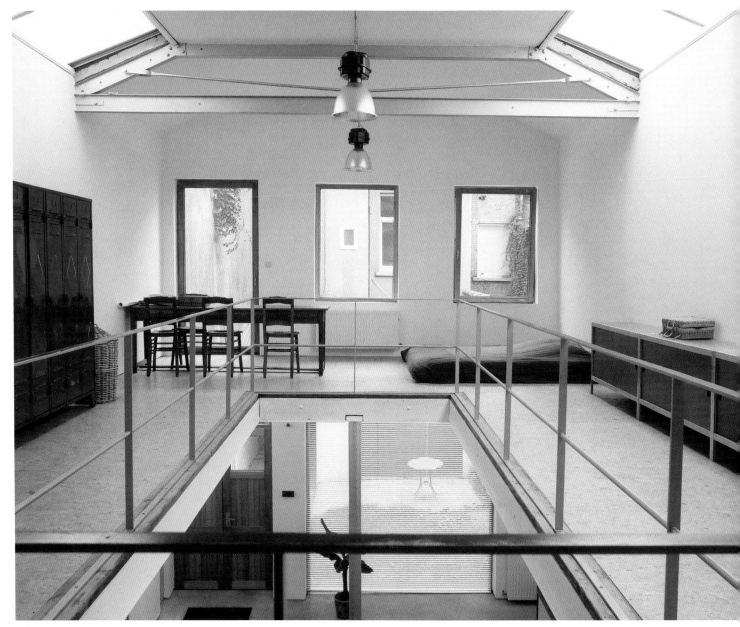

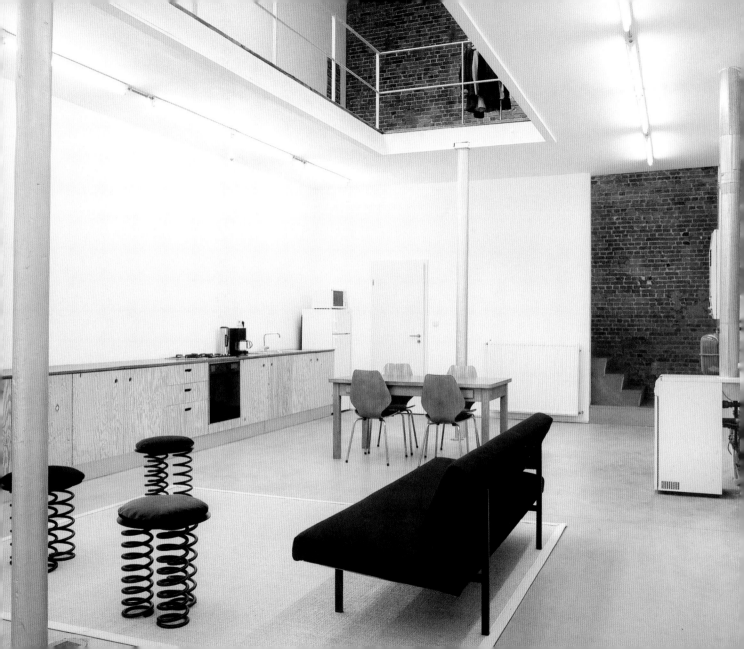

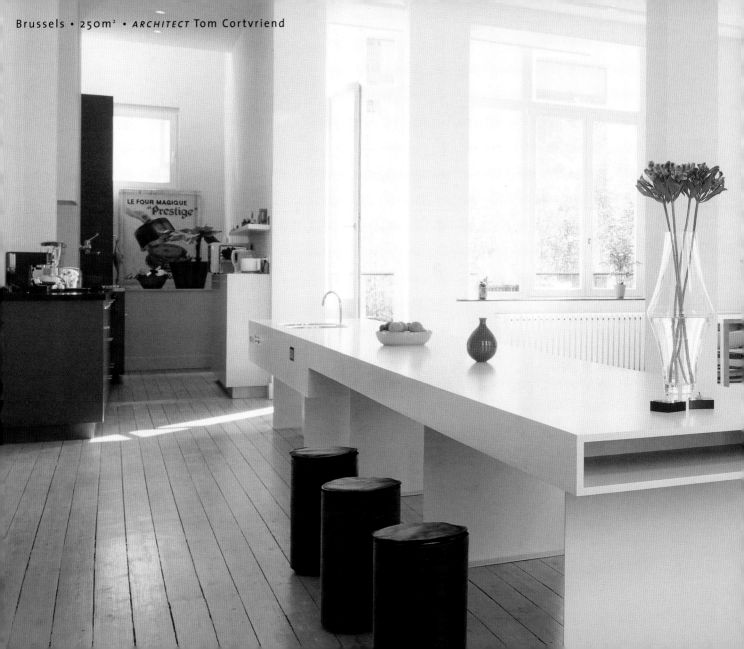

Brussels • 250m² • *ARCHITECT* Tom Cortvriend

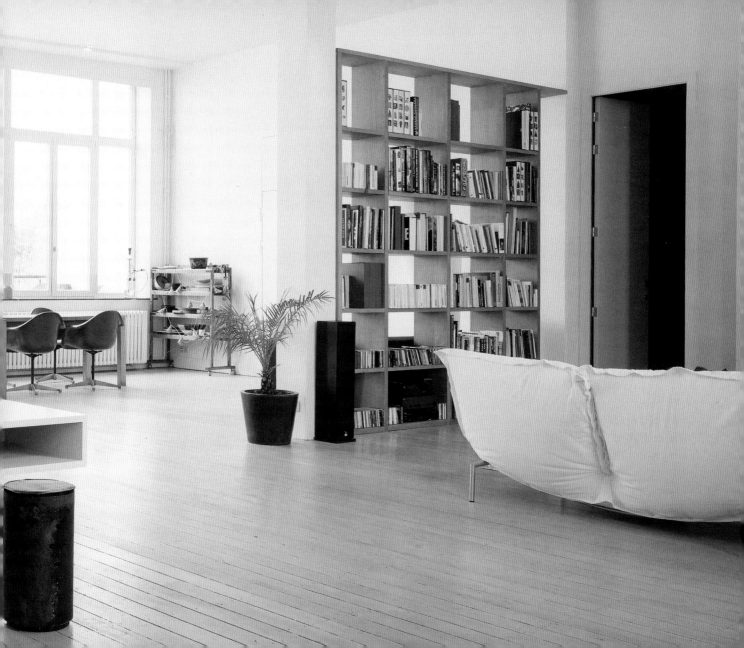

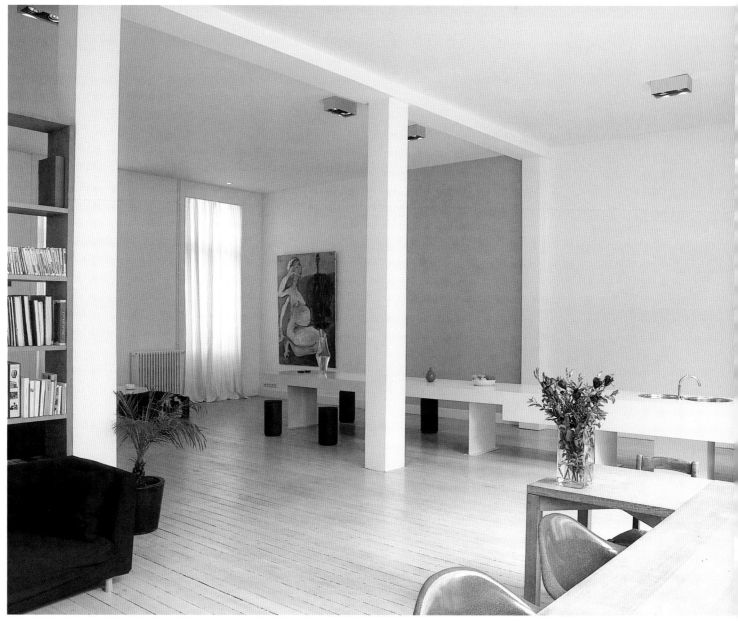

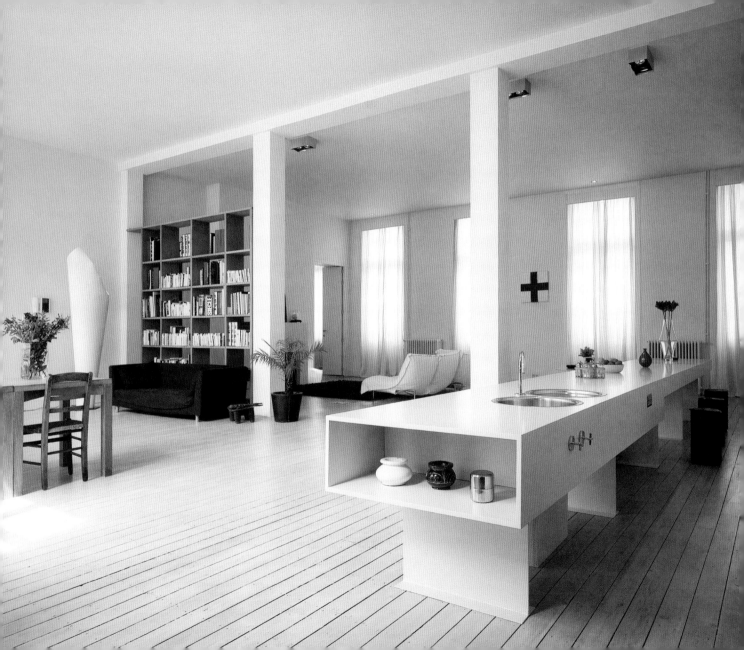

London • 450m²

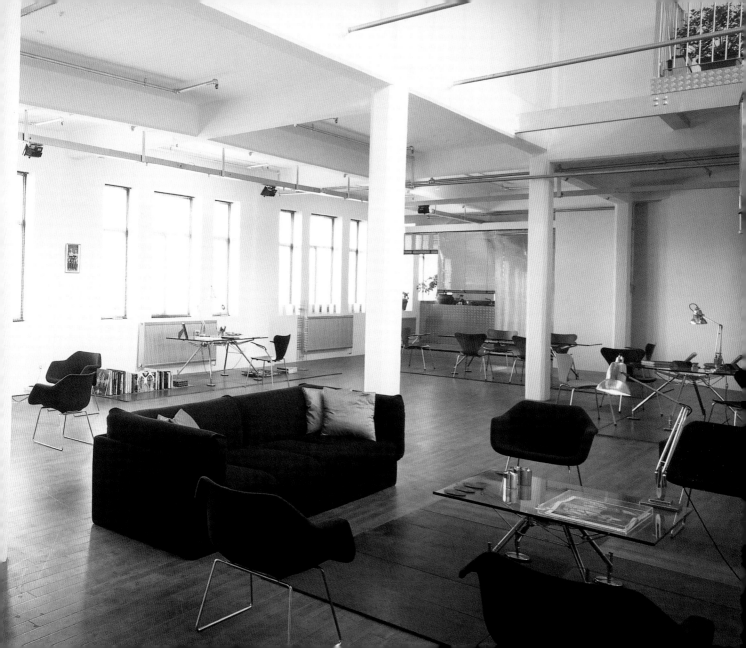

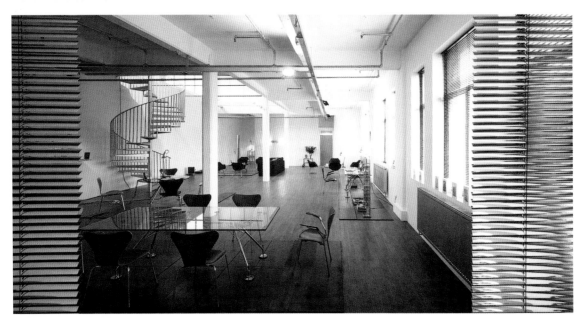

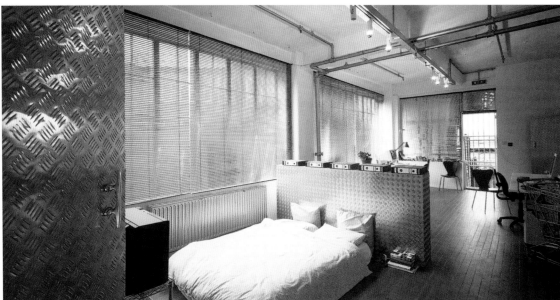

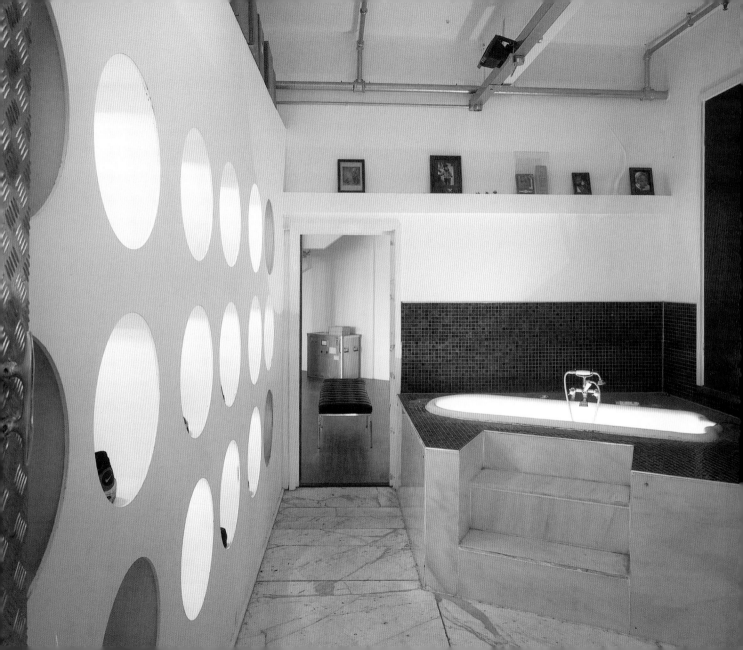

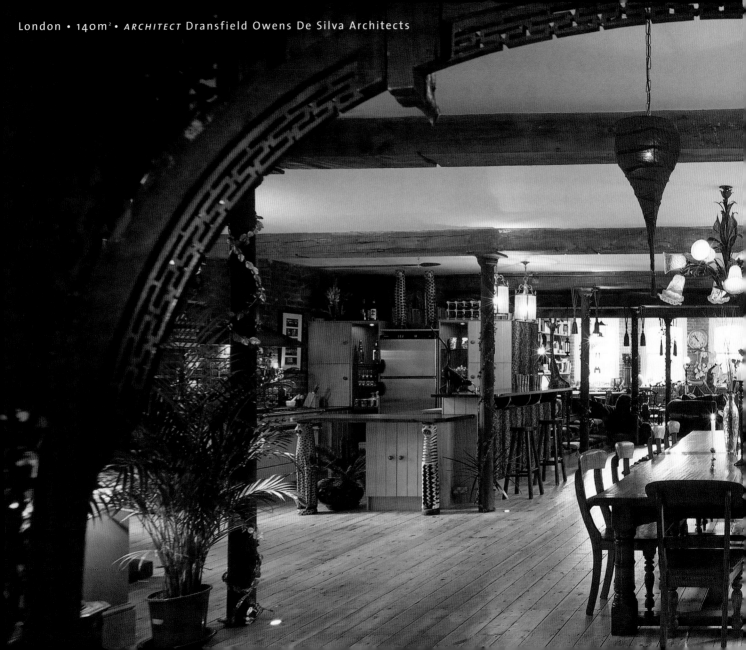

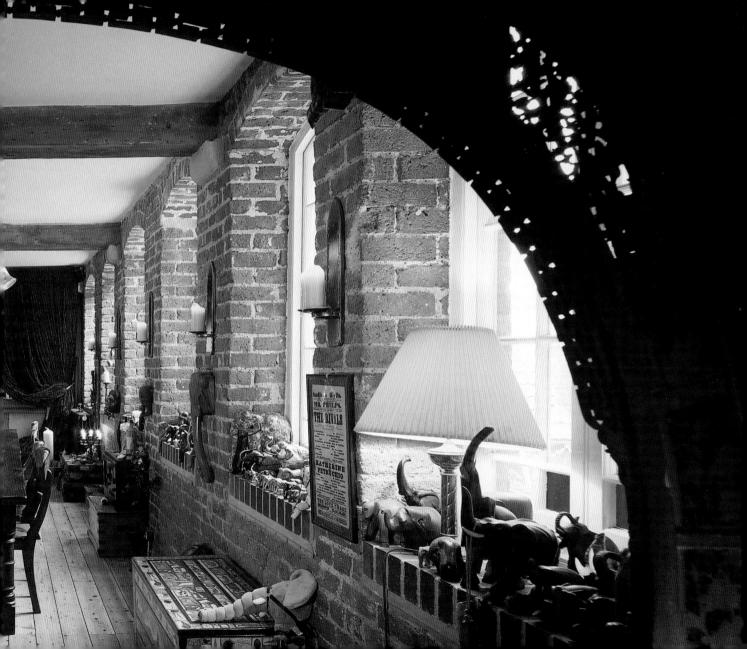

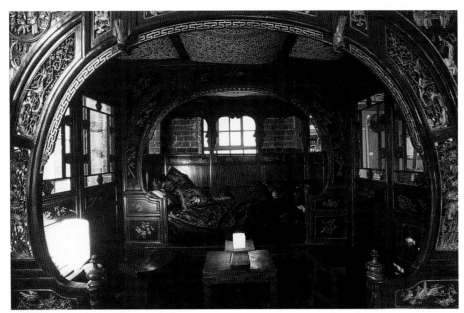

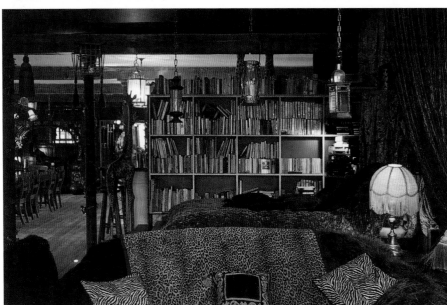

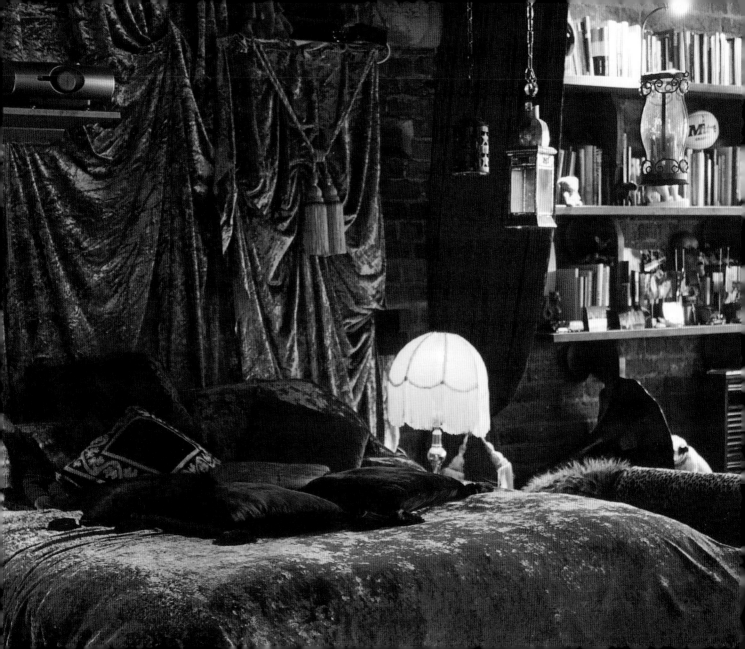

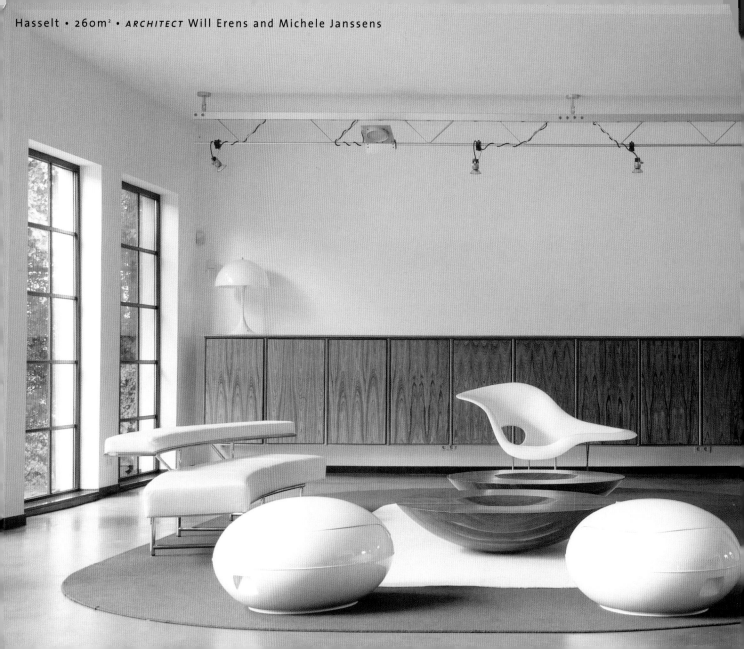

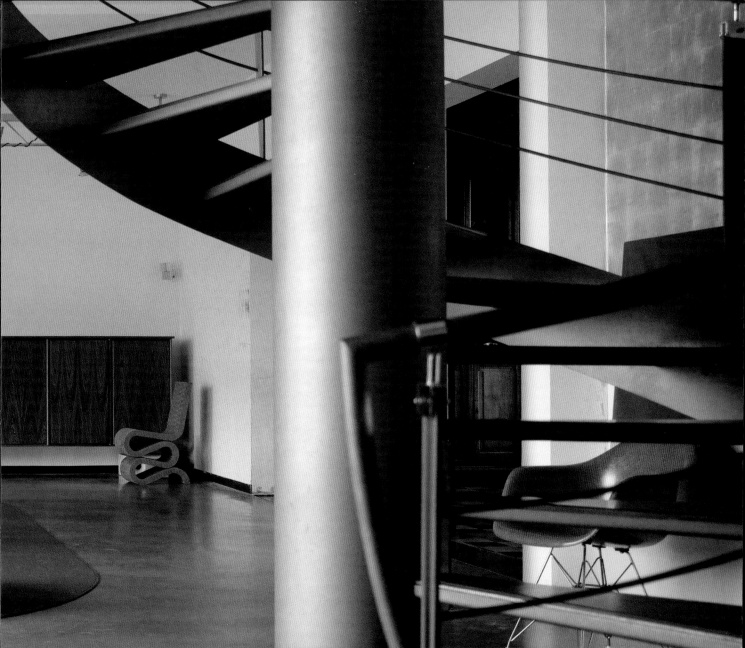

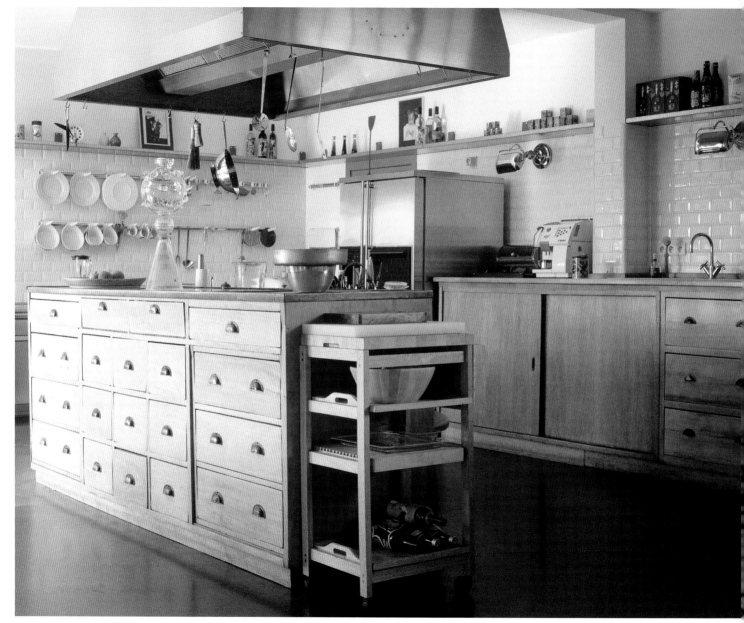

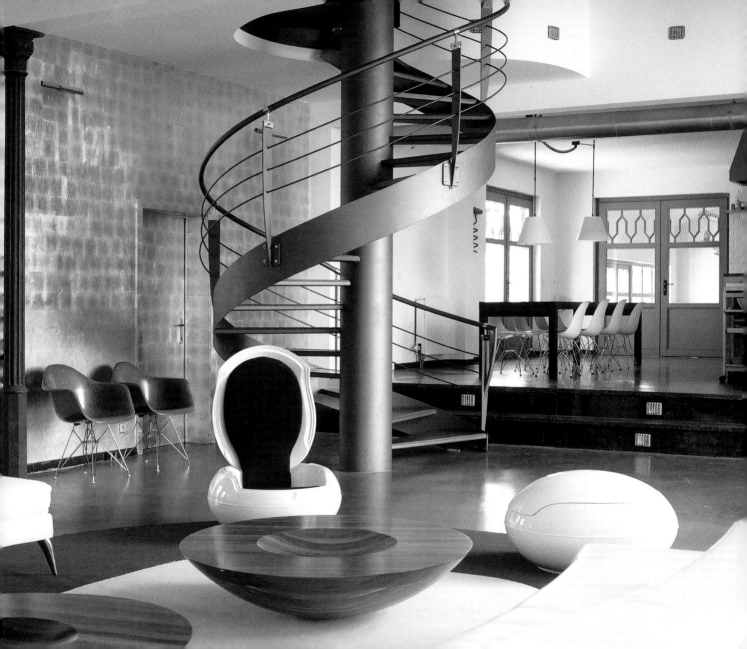

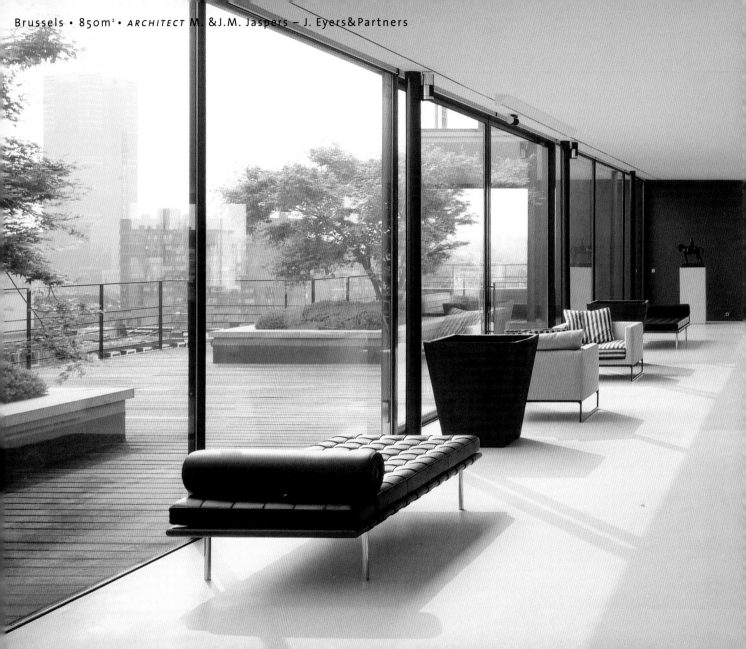

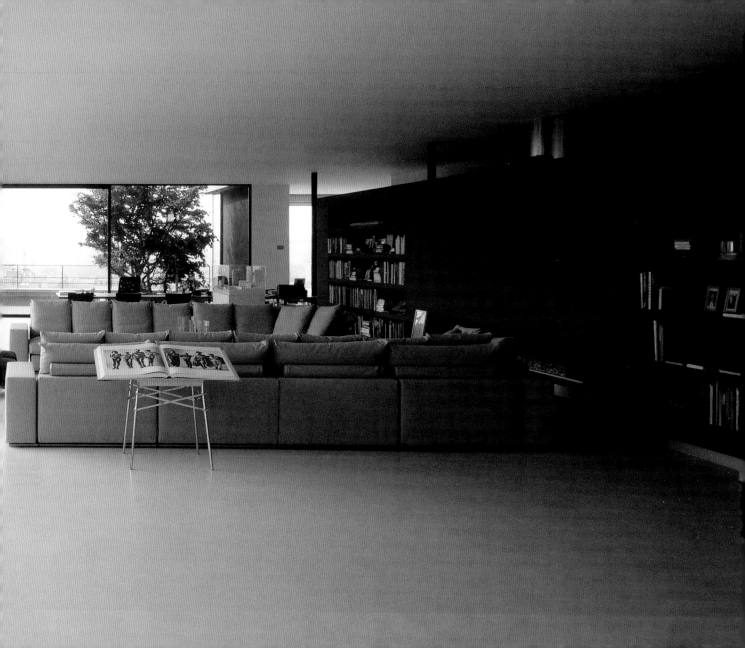

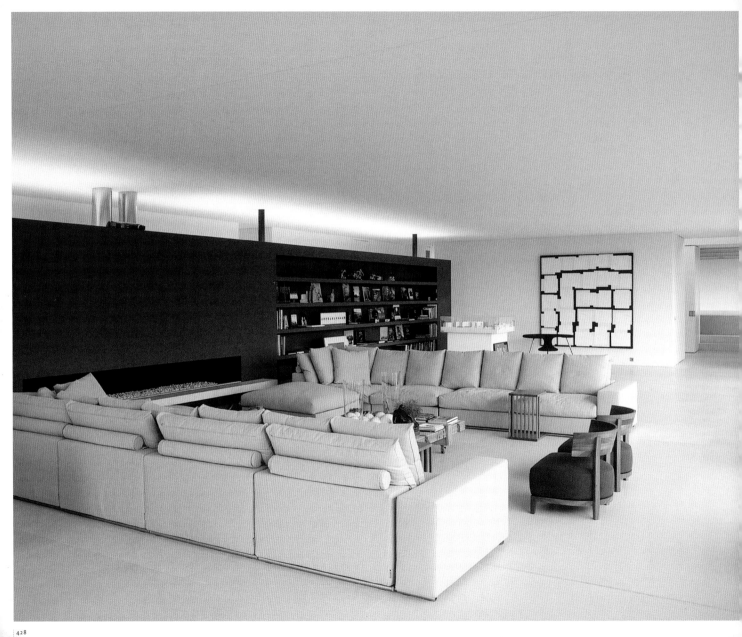

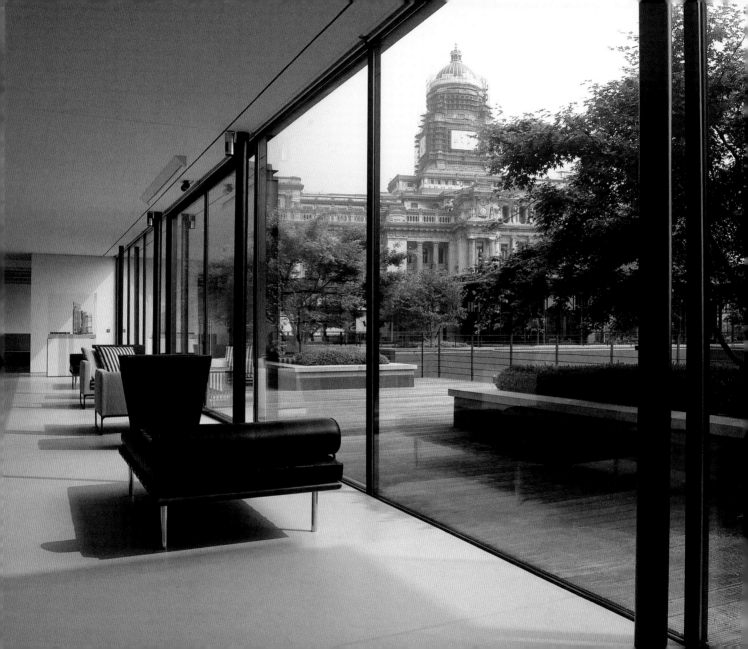

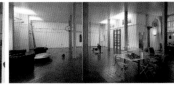

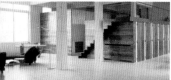 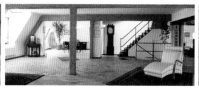 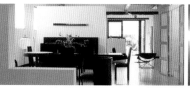

CREDITS

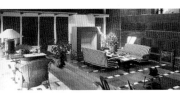
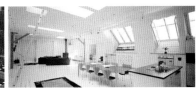
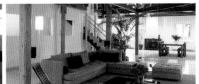
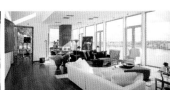